D1215303

GETTING THE PICTURE

From *"Wie eine Zeitung entsteht"* ("How a Magazine Arises"), double-spread centerfold composition with the embedded feature *"Kupfertiefdruck. Herstellung der A.I.Z"* ("Rotogravure: Production of the AIZ"), in *AIZ* 6, no. 31, 1927, p. 8. Staatsbibliothek zu Berlin—PK/Abteilung Historische Drucke/Signatur: 2″ Ue 526/12.:R

GETTING THE PICTURE

The visual culture of the news

JASON E. HILL AND VANESSA R. SCHWARTZ

Bloomsbury Academic
An imprint of Bloomsbury Publishing Plc

B L O O M S B U R Y
LONDON · NEW DELHI · NEW YORK · SYDNEY

Bloomsbury Academic

An imprint of Bloomsbury Publishing Plc

50 Bedford Square
London
WC1B 3DP
UK

1385 Broadway
New York
NY 10018
USA

www.bloomsbury.com

BLOOMSBURY and the Diana logo are trademarks of Bloomsbury Publishing Plc

First published 2015

© Jason E. Hill and Vanessa R. Schwartz, 2015

Jason E. Hill and Vanessa R. Schwartz have asserted their right under the Copyright, Designs and Patents Act, 1988, to be identified as Editors of this work.

All rights reserved. No part of this publication may be reproduced or transmitted in any form or by any means, electronic or mechanical, including photocopying, recording, or any information storage or retrieval system, without prior permission in writing from the publishers.

No responsibility for loss caused to any individual or organization acting on or refraining from action as a result of the material in this publication can be accepted by Bloomsbury or the Editors.

British Library Cataloguing-in-Publication Data

A catalogue record for this book is available from the British Library.

ISBN: HB: 978-1-4725-2422-5
 PB: 978-1-4725-2649-6
 ePDF: 978-1-4725-6664-5
 ePub: 978-14725-6665-2

Library of Congress Cataloging-in-Publication Data

A catalog record for this book is available from the Library of Congress.

Typeset by RefineCatch Limited, Bungay, Suffolk, UK
Printed and bound in India

CONTENTS

ILLUSTRATIONS

ACKNOWLEDGMENTS

The editors would like to thank the contributors for their cooperation and good cheer through the process. This volume is only as good as the work they have made possible. We also want to thank Davida Forbes at Bloomsbury for her support and rapid-fire work on behalf of the volume. The University of Southern California and the USC Visual Studies Research Institute have provided generous financial support for the execution of the project. Matthew Fox-Amato provided high-level research assistance and Elena Valeriote helped in the final stages. We both thank Nancy Troy and Richard Meyer and several of our authors and Suzanne Hudson and Mazie Harris for reading the introduction. Jason Hill would like to thank the Terra Foundation for American Art, Veerle Thielemans, Lisa Cherkerzian, Carolyn Weyneth, Ed Hill, and John and Mary Cherkerzian. Vanessa Schwartz would like to thank her graduate students, her colleagues at the USC VSRI, Rebecca Isaacs, Ron Schwartz and Rachel Schwartz.

DISCARD

CONTRIBUTORS

Nadya Bair is a doctoral student in the Department of Art History at the University of Southern California, where she completed the Visual Studies Graduate Certificate. Her dissertation examines the role of Magnum Photos in the increasingly global practice of photojournalism after World War II.

Jordan Bear is Assistant Professor of Art History at the University of Toronto. He completed a Ph.D in the Department of Art History and Archaeology at Columbia University, with the help of an ACLS/Andrew W. Mellon Fellowship. He has also served as the Chester Dale Fellow in the Department of Photographs at The Metropolitan Museum of Art. His writing, published in *History of Photography, Cabinet, Bookforum, Photography and Culture*, and *Grey Room*, among other venues, concerns the historical intersection of photography, knowledge, and belief. His book, *Disillusioned: Victorian Photography and the Discerning Subject*, is forthcoming from Penn State Press.

Martin A. Berger is Professor in the History of Art and Visual Culture Department and the founding director of the Visual Studies graduate program at the University of California, Santa Cruz. He is the author of four books, most recently, *Freedom Now! Forgotten Photographs of the Civil Rights Struggle* (2014).

Catherine E. Clark is Assistant Professor of French Studies at MIT. She is currently working on a book manuscript titled "Visual History in the Photographic Age: Archiving, Studying, and Displaying Paris, 1870–1970." She completed her Ph.D in History at the University of Southern California, where she received the Visual Studies Graduate Certificate.

Joseph Clark is a Visiting Assistant Professor in American Studies at Franklin and Marshall. He received his Ph.D in 2011 from the Department of American Civilization at Brown University. His dissertation, "Canned History: The American Newsreel and the Commodification of Reality, 1927–1950," examines the history of the sound newsreel and the way Americans experienced the real.

Mike Conway is Associate Professor in the Indiana University School of Journalism. He is the author of *The Origins of Television News in America: The Visualizers of CBS in the 1940s* (2009) as well as numerous journal articles relating to journalism history, emerging technologies, broadcast news content, and research methodology. Conway spent close to twenty years in broadcast news, most of that time in television working as a reporter, photojournalist, anchor, producer, and news director.

Christian Delage is a historian and filmmaker. He is Director of the IHTP and teaches at the University of Paris 8 and Sciences Po, and in New York at the Cardozo Law School. He has co-edited *The Scene of the Mass Crime: History, Film, and International Tribunals* (2013). His book, *La Vérité par l'image*, published in France in 2006, has been translated by the University of Pennsylvania Press as *Caught on*

Camera (2013). His most recent film, *From Hollywood to Nuremberg: John Ford, Samuel Fuller, George Stevens*, is available on DVD.

Erina Duganne is Associate Professor of Art History at Texas State University. In addition to numerous book chapters, articles, and reviews, she is the author of *The Self in Black and White: Race and Subjectivity in Postwar American Photography* (2010) and a co-editor and essayist for *Beautiful Suffering: Photography and the Traffic in Pain* (2007).

Matthew Fox-Amato is a Mellon postdoctoral fellow in the Modeling Interdisciplinary Inquiry program at Washington University in St. Louis. He completed a Ph.D in History and the Visual Studies Graduate Certificate at the University of Southern California. He is working on a book based on his dissertation, "Exposing Humanity: Slavery, Antislavery, and Early Photography in America, 1839–1865." The dissertation won the McNeil Center's 2014 Zuckerman Prize.

Michel Frizot is Research Director at the CNRS. He teaches the history of photography at the Université Paris IV-Sorbonne and at the École du Louvre. From 1982 to 1990, he was special advisor to the Centre National de la Photographie for the exhibitions *Identités* and *Le Temps d'un mouvement*, and for the collection Photo Poche. He has published numerous articles and works on photography, including *E.J.Marey: La photographie du Mouvement* (1977), *Histoire de Voir* (1989), and *André Kertész* (2010).

Victoria Gao is a doctoral student in the Graduate Program in Visual and Cultural Studies at the University of Rochester, with a focus on mid-twentieth-century street, documentary, and journalistic photography.

Thierry Gervais is Assistant Professor at Ryerson University, Toronto and Head of Research at the Ryerson Image Centre (RIC). He has served as editor in chief of *Études photographiques* and is the author (with Gaëlle Morel) of *La photographie. Histoire, Technique, Presse, Art* (2008). He was co-curator of the exhibitions *Views from Above* (2013), *Léon Gimpel (1873–1948), the audacious work of a photographer* (2008), and *L'Événement. Les images comme acteurs de l'histoire* (2007). He is currently working on a book about photographic illustration.

Patricia Goldsworthy-Bishop is Assistant Professor of History at Western Oregon University. She is presently completing her manuscript, *Colonial Negatives*, which examines the role of photography in early-twentieth-century Morocco. Her research has been supported by the Mellon Foundation, the American Historical Association, and the American Institute for Maghrib Studies.

Kristen Gresh is the Estrellita and Yousuf Karsh Assistant Curator of Photographs at the Museum of Fine Arts, Boston. Her dissertation, under the direction of Michel Frizot, at the École des Hautes Études en sciences sociales, was titled "The Family of Man: A Critical History of an American Photographic Exhibition," parts of which have been published in *Études photographiques* and *History of Photography*. She is the author of various other essays as well as the book *She Who Tells a Story: Women Photographers from Iran and the Arab World* (2013).

Zeynep Devrim Gürsel is an anthropologist and assistant professor in the Department of International Studies at Macalester College. She teaches courses on global media industries, photography, ethnographic film, and cultures of work. Her book manuscript, *Image Brokers*, is based on fieldwork conducted in the United States, France, and Turkey. It focuses on the production, distribution, and circulation of international news images and the changing cultures of photojournalism after the digital

turn. Most recently she has published on the June 2013 Gezi Park protests in Istanbul and the changing landscape of labor in photojournalism.

Robert Hariman is a Professor in the Department of Communication Studies at Northwestern University. He has published numerous essays and the book *No Caption Needed: Iconic Photographs, Liberal Democracy and Public Culture* (2007), which is co-authored with John Louis Lucaites. He and John Lucaites post regularly at nocaptionneeded.com, their blog on photojournalism, politics, and culture.

Jason E. Hill is a 2014/15 Andrew W. Mellon Foundation Fellow at the New-York Historical Society, where he is completing his manuscript on the the work of art in the mediation of public affairs in the 1940s New York City tabloid newspaper, *PM*. His writing has appeared in *American Art, Brooklyn Rail, Photography & Culture, Études Photographiques*, and *X-TRA*.

Katie Hornstein is Assistant Professor of Art History at Dartmouth College, specializing in nineteenth-century French art and visual culture. Her book in progress focuses on the relationships between visual representations of war and emergent modes of visual production across a range of media and structures of political power.

Ulrich Keller started out as a Renaissance/Baroque art specialist (with a Ph.D from Ludwig Maximilian University, Munich) but migrated into photographic history and has taught at The University of California, Santa Barbara, since 1982. He has published books and articles on photographers such as Roger Fenton, August Sander, Félix Nadar, and Walker Evans, on Art Photography around 1900, and on the role of pictorial reportage in the Crimean War (*The Ultimate Spectacle: A Visual History of the Crimean War*, 2001), World War I, and American presidential politics.

Liam Kennedy is Professor of American Studies and Director of the Clinton Institute for American Studies at University College Dublin. He is the author of *Susan Sontag: Mind as Passion* (1995) and *Race and Urban Space in American Culture* (2000), the co-editor of *Urban Space and Representation* (1999) and *City Sites: An Electronic Book* (2000) and *The Wire: Race, Class, and Genre* (2012), and the editor of *Remaking Birmingham: The Visual Culture of Urban Regeneration* (2004). He is currently editing and writing books on photography and international conflict.

Vincent Lavoie is Associate Professor in the Department of Art History, Université du Québec à Montréal. His current research concerns the ethical and aesthetic valorization of news pictures. Some of his publications include *L'instant-monument. Du fait divers à l'humanitaire* (2001), *Maintenant. Images du temps present* (2003), and *Photojournalismes. Revoir les canons de l'image de presse* (2010).

Anthony W. Lee is the Idella Plimpton Kendall Professor of Art History at Mount Holyoke College, where he teaches courses on modern and contemporary art. He writes mostly on American photography and modernist painting between 1860 and 1960, and has published books including *Picturing Chinatown: Art and Orientalism in San Francisco* (2001) and the co-authored *On Alexander Gardner's* Photographic Sketch Book *of the Civil War* (2007). Lee is also the founder and editor of the series *Defining Moments in American Photography*.

Michael Leja is the author of the prize-winning books, *Looking Askance: Skepticism and American Art from Eakins to Duchamp* (2004), and *Reframing Abstract Expressionism: Subjectivity and Painting in the 1940s* (1993). He is currently completing a study of the early mass production of pictures in the United

States between 1830 and 1860. A recent essay drawn from this project is "Fortified Images for the Masses," published in the winter 2011 issue of *Art Journal*. He teaches at the University of Pennsylvania, where he is a professor in the History of Art Department and director of the Visual Studies Program.

Ryan Linkof is Assistant Curator It in the Wallis Annenberg Photography Department at the Los Angeles County Museum of Art (LACMA). He received his Ph.D in History, and the Visual Studies Graduate Certificate from the University of Southern California in 2011. Essays from his dissertation on the origins of tabloid photojournalism in England have appeared in *Photography and Culture*, *Media History*, *Études photographiques* and the *New York Times*. He has worked as assistant curator on several exhibitions at LACMA, including *Robert Mapplethorpe: XYZ* and *The Sun and Other Stars: Katy Grannan and Charlie White*.

David Lubin, the Charlotte C. Weber Professor of Art at Wake Forest University, writes on American art and popular culture. His books include *Act of Portrayal: Eakins, Sargent, James* (1985), *Picturing a Nation: Art and Social Change in Nineteenth Century America* (1994), *Titanic* (1999), and *Shooting Kennedy: JFK and the Culture of Images* (2003). His book *Flags and Faces: The Visual Culture of America's First World War* will be published by the University of California Press in 2014. Another book, *Grand Illusions: American Art and the First World War*, will appear from Oxford University Press in 2016.

John Louis Lucaites is Associate Dean for Arts and Humanities and Professor of Rhetoric and Public Culture at Indiana University. He teaches and writes about the relationship between rhetoric and social theory. He is co-author with Robert Hariman of *No Caption Needed: Iconic Photographs, Liberal Democracy and Public Culture* (2007) and co-hosts the blog www.nocaptionneeded.com.

Daniel H. Magilow is Associate Professor of German at the University of Tennessee, Knoxville. He is the author, editor, and translator of several books, including *The Photography of Crisis: The Photo Essays of Weimar Germany* (2012), *Nazisploitation!: The Nazi Image in Low-Brow Culture and Cinema* (co-edited with Elizabeth Bridges and Kristin T. Vander Lugt, 2011), *In Her Father's Eyes: A Childhood Extinguished by the Holocaust* (2008), and, with Lisa Silverman, *Holocaust Representations in History: An Introduction* (2015). He has also published several articles about atrocity photography, Holocaust memorials, exile literature, and German film.

Patricia Mainardi is Professor of Art History at the City University of New York. A specialist in European art of the eighteenth and nineteenth centuries, her books include *Art and Politics of the Second Empire: The Universal Expositions of 1855 and 1867* (1987), which won the Charles Rufus Morey Award from the College Art Association of America as the best art history book of its year; *The End of the Salon: Art and the State in the Early Third Republic* (1994); and *Husbands, Wives and Lovers: Marriage and Its Discontents in Nineteenth-Century France* (2003). She is currently completing a book on the invention of illustrated print culture in nineteenth-century France.

Jordana Mendelson is Associate Professor in the Department of Spanish and Portuguese at New York University, with field specializations in early twentieth-century Spanish visual culture and the history of photography. She is the author of *Documenting Spain: Artists, Exhibition Culture, and the Modern Nation 1929–1939* (2005), which received the Association of Hispanic Art Historical Studies Book Prize in 2007. She has edited and co-edited several anthologies, including *Magazines, Modernity, and War* (2008) and *Postcards: Ephemeral Histories of Modernity* (2010). She has also curated notable exhibitions in Spain

and the United States, including *Magazines and War 1936–1939* (2007), *Other Weapons: Photography and Print Culture during the Spanish Civil War* (2007), and *Encounters with the 30s* (2012).

Richard Meyer is the Robert and Ruth Halperin Professor in Art History at Stanford University. He is the author of *Outlaw Representation: Censorship and Homosexuality in Twentieth-Century American Art* (2002) and *What was Contemporary Art?* (2013), and co-editor, with Catherine Lord, of *Art and Queer Culture* (2013). He guest curated *Warhol's Jews: Ten Portraits Reconsidered* (2008) for the Jewish Museum in New York and the Contemporary Jewish Museum in San Francisco as well as *Naked Hollywood: Weegee in Los Angeles* (2012) at the Museum of Contemporary Art, Los Angeles.

Gaëlle Morel is Exhibitions Curator at the Ryerson Image Centre (Toronto). Her research deals with the artistic and cultural recognition of photography from the 1970s, and photographic modernism in the 1930s. She has edited *The Spaces of the Image* (2009) and *Berenice Abbott* (2012), and co-authored (with Thierry Gervais) *La photographie. Histoire, Technique, Presse, Art* (2008).

John Mraz is Research Professor at the Instituto de Ciencias Sociales y Humanidades, Universidad Autónoma de Puebla (Mexico), and National Researcher III, who has published prolifically on doing history with modern media, directed award-winning documentaries, and curated international photo exhibits. His books include *Looking for Mexico: Modern Visual Culture and National Identity* (2009) and *Photographing the Mexican Revolution: Commitments, Testimonies, Icons* (2012).

Alexander Nemerov is the Carl and Marilynn Thoma Provostial Professor in the Arts and Humanities at Stanford University. His publications include *Wartime Kiss: Visions of the Moment in the 1940s* (2012) and *Acting in the Night: Macbeth and the Places of the Civil War* (2010).

Mary Panzer received a Ph.D in Art History from Boston University and teaches in the Department of Media, Culture and Communication at The Steinhardt School of Education, Culture, and Human Development at New York University; she is also an independent writer and curator. She is co-author of *Things As They Are: Photojournalism in Context Since 1955* (2005) and has contributed to numerous books and catalogs on photographers such as Mathew Brady, Lewis Hine, and Richard Avedon. Her essays regularly appear in the *Wall Street Journal* and *Aperture Magazine*.

Caitlin Patrick completed an interdisciplinary Ph.D thesis titled "Shoot & Capture: Media Representations of US Military Operations in Somalia 1992–93 and Fallujah" at Durham University (UK)'s Geography department in 2007. She is currently the Social Science Research Methods Coordinator at the King's College London Interdisciplinary Social Science Doctoral Training Centre (KISS DTC). Her research interests include the visual representation of the protracted conflicts in the Democratic Republic of Congo and Somalia, the roles of visual media in a world of new and expanding social media platforms, and the increased appearance of photojournalism and documentary photography in gallery and museum spaces. She is co-editor, with Liam Kennedy, of the forthcoming collection, *The Violence of the Image: Photography and International Conflict*.

Jeannene Przyblyski is an artist, historian and media critic. She has published widely on photography and urbanism in the nineteenth and twentieth centuries, and creates multi-media site-specific projects—most recently in conjunction with *International Orange*, commissioned by the FOR-SITE Foundation. She is Provost and Faculty in the School of Art at California Institute of the Arts.

Martha A. Sandweiss is Professor of History at Princeton University. She began her career as the Curator of Photographs at the Amon Carter Museum and later worked for twenty years at Amherst College. Her books on American photography include the prize-winning *Print the Legend: Photography and the American West* (2002) and the co-authored volume *Eyewitness to War: Prints and Daguerreotypes of the Mexican War, 1846–1848* (1989). She is editor of *Photography in Nineteenth-Century America* (1991) and co-editor of *The Oxford History of the American West* (1994). Her most recent book, *Passing Strange: A Gilded Age Tale of Love and Deception across the Color Line* (2009) was a finalist for the National Book Critics Circle Award and the Los Angeles Times Book Prize.

Vanessa R. Schwartz is Professor of History, Art History, and Film at the University of Southern California where she directs the Visual Studies Research Institute and Graduate Program. She is the author of *Spectacular Realities: Early Mass Culture in fin-de-siècle Paris* (1998) and *It's So French! Hollywood, Paris and the Making of Cosmopolitan Film Culture* (2007) and several edited volumes, including *The Nineteenth-Century Visual Culture Reader* (2004). She is completing a book on jet age aesthetics that considers color news pictures and news transport.

David Shneer is the Louis B. Singer Endowed Chair in Jewish History, Professor of History and Religious Studies, and Director of Jewish Studies at the University of Colorado, Boulder. His most recent book, *Through Soviet Jewish Eyes: Photography, War, and the Holocaust* (2011), examines the life and work of two dozen photojournalists working for the Soviet press, who were the first professional photographers to make pictures of the mass violence on the eastern front of World War II and the genocide of European Jewry.

Abigail Solomon-Godeau is Professor Emerita in the Department of the History of Art and Architecture at the University of California, Santa Barbara, and lives and works in Paris. She worked as a photo critic and photo editor for many years prior to writing *Photography at the Dock: Essays on Photographic History, Institutions, and Practices*, which was published by the University of Minnesota Press (1991) and *Male Trouble: A Crisis in Representation* (1997). A third book, *The Face of Difference: Gender, Race and the Politics of Self-Representation*, is forthcoming from Duke University Press.

Sally Stein is Professor Emerita of Art History at UC Irvine and is now an independent scholar based in Los Angeles who continues to research and write about twentieth-century photography and its relation to broader questions of culture and society. The interrelated topics she most often engages concern the multiple effects of documentary imagery, the politics of gender, and the status and meaning of black and white and color imagery on our perceptions, beliefs, and even actions as consumers of ideas, images, and things. Her books include *John Gutmann: The Photographer at Work* (2009) and the co-authored *Official Images: New Deal Photography* (1987).

Will Straw is Professor in the Department of Art History and Communications Studies at McGill University and currently serves as the director of the McGill Institute for the Study of Canada. He has written over 100 articles on cinema, urban culture, popular music, and the popular press. He is the author of *Cyanide and Sin: Visualizing Crime in 1950s America* (2006), and the co-editor of *The Cambridge Companion to Rock and Pop* (2001), *Circulation and the City: Essays on Urban Culture* (2010) and several other books.

Kim Timby is a photography historian living in Paris. She teaches at the EHESS, the École du Louvre, and Paris College of Art and is a former curator at the Musée Carnavalet and the Musée Nicéphore Niépce.

Her research explores the social history of photographic technologies. She is the author of numerous essays and has co-edited the book *Paris in 3D: From Stereoscopy to Virtual Reality, 1850–2000* (2000).

Jennifer Tucker is an associate professor of history at Wesleyan University and the author of *Nature Exposed: Photography as Eyewitness in Victorian Science* (2006, 2013). Editor of a 2009 special theme issue of *History and Theory* on the topic of "Photography and Historical Interpretation," she also has published recent articles on Victorian science as spectacle, contemporary street photography, scientific ballooning, and photography of microscopic phenomena in 1930s American art advertisement. Currently, she is in the process of completing a book manuscript about the art and visual politics of the celebrated Tichborne Claimant legal affair in Victorian England.

Gennifer Weisenfeld is Professor in the Department of Art, Art History, and Visual Studies at Duke University. She has published *Mavo: Japanese Artists and the Avant-Garde, 1905–1931* (2002) and, more recently, *Imaging Disaster: Tokyo and the Visual Culture of Japan's Great Earthquake of 1923* (2012), which examines how visual culture has mediated the historical understanding of Japan's worst national disaster of the twentieth century.

Diane Winston holds the Knight Chair in Media and Religion at the Annenberg School for Communication & Journalism at the University of Southern California. She specializes in the history of religion, politics, and news media. Her works include *Red Hot and Righteous: The Urban Religion of the Salvation Army* (1999), *Faith in the Market: Religion and Urban Commercial Culture* (2003) and *Small Screen, Big Picture: Lived Religion and Television* (2009).

Justine De Young teaches art history, theory, and prose writing in the Harvard College Writing Program. She has contributed essays on art and fashion to *Women, Femininity, and Public Space in European Visual Culture, 1789–1914* (2014), *Cultures of Femininity in Modern Fashion* (2011), and the catalogue of the 2012/13 Musée d'Orsay, Metropolitan Museum of Art and Art Institute of Chicago exhibition, *Impressionism, Fashion and Modernity* (2012). She is currently at work on a book about discourses surrounding fashion and feminine types in works exhibited at the Paris Salon (1864–1884). She received her Ph.D in Art History from Northwestern University.

Barbie Zelizer is the Raymond Williams Professor of Communication and Director of the Scholars Program in Culture and Communication at the University of Pennsylvania's Annenberg School for Communication. A former journalist, she has authored or edited thirteen books, including *About to Die: How News Images Move the Public* (2010) and *Remembering to Forget: Holocaust Memory Through the Camera's Eye* (1998).

Andrés Mario Zervigón is Associate Professor of Art History at Rutgers. His first book—*John Heartfield and the Agitated Image: Photography, Persuasion, and the Rise of Avant-Garde Photomontage* (2012)— examines the Weimar-era work of this German artist. He is currently writing about the *Die Arbeiter-Illustrierte Zeitung—The Worker's Illustrated Magazine, 1921–1938*. Zervigón has recently published articles and reviews in *New German Critique*, *Visual Resources*, *History of Photography*, *Rundbrief Fotografie*, *Études photographiques* and has contributed to the catalogues *Avant-Art in Everyday Life* (2011) and *Faking It: Manipulated Photography before Photoshop* (Metropolitan Museum of Art, 2012).

General Introduction

Jason E. Hill and Vanessa R. Schwartz

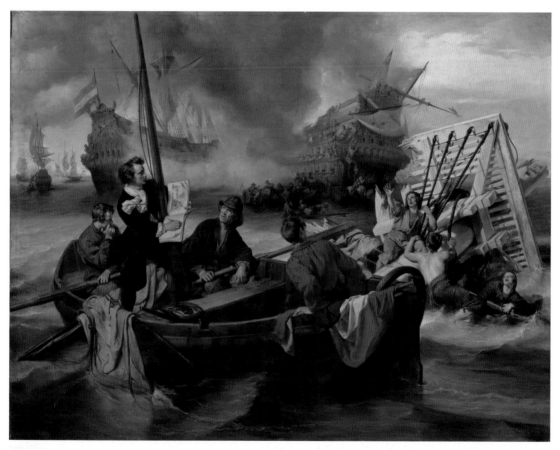

Figure I.1 J. De Hoij, *Willem van de Velde Sketching a Sea Battle*, Oil on canvas, 91 x 118 cm, 1845. Courtesy of Hermitage Museum, St. Petersburg. Photograph © The State Hermitage Museum/photo by Vladimir Terebenin, Leonard Kheifets, Yuri Molodkovets.

J. de Hoij's 1845 history painting, *Willem van de Velde Sketching a Sea Battle* (Fig. I.1), would appear to depict a Dutch master from an earlier century sketching a dramatic naval subject from life, yet its central allegorical drama asserts a more topical problem from its own mid-nineteenth century moment. De Hoij's

picture issued from his studio just as history painting came to be challenged by the lowly-illustrated press as the privileged platform for pictorial reportage. To the extent that we might consider it a history painting, the history it contends with is that of the news picture itself.[1] Painted six years after the announcement of photography's invention and three years after the launch of the first illustrated news weekly, the *Illustrated London News*, de Hoij's picture is, like this book, a meditation on the history of the practice of picturing the news, essayed at a moment when that practice is in a pronounced state of flux.[2]

De Hoij draws our attention to many of the major issues concerning the modern art of pictorial reporting. With sketchbook in hand, his subject, van de Velde, is intrepid as he gets close to the eventful scene. The two sites of action before him—the distant conflict of state powers figured in the background and the human-interest scenario that is its product advanced in the foreground—underscore the reporter's choice concerning what and how to observe and visually report a news item. De Hoij shows how the news is formed and selected rather than merely transcribed, while also suggesting a now familiar ethical critique of those who have pictured the news and favored observation over intervention.[3]

More interesting for our purposes, he also takes on the less-considered questions of medium and process and their appropriateness to a given subject in time. If de Hoij's tableau acknowledges the challenges of the "speed limits" of painting in the face of the onslaught of the news, it also recasts the painter as a sketch reporter. The viewer may be taking stock of the painter's work, but by depicting van de Velde drawing the news at a moment when lithography, wood-engraving, and photography were reshaping the public sphere, de Hoij also draws attention to the always historically specific means by which any artist figures the world outside the frame. At a moment of media transition characterized by the development of new modes of mechanical reproduction and dissemination, de Hoij flagged the question of a medium's historical suitability to its subject and thereby generated the kind of layered, historicized reflection about the production of news pictures taken up by this volume.

Defining the subject

This collection of essays poses and attempts to answer the questions, "What is a news picture and how does it work?" These deceptively simple inquiries are motivated by our recognition of the extraordinary powers of this understudied visual field and of the complex cultural assumptions which structure and enable it. News pictures—simply, those pictures that *report* within the orbit of journalism—are predicated upon the difficult idea and desire that a picture's immediacy and ability to condense and concretize knowledge might offer its viewer a privileged relationship to an otherwise unknowable world. The essays in this volume scrutinize such claims, consider how they came to be naturalized, and ask how that naturalization bears upon the function of images within public life up until today. But our concern is not only epistemological. We are interested in how visual journalism has worked as a practice in different moments: what were its procedures of production, dissemination, and reception? How did each of these relate to ever-shifting technologies and ideas about time, space, and social relations as key vectors in defining the social formation we have come to call modernity? We believe that in our present moment we have so integrated news pictures into our everyday access to the world that we hardly pause to understand their operations, both as points of entry onto the present and as windows into the past. Because we employ news pictures as orienting tools, we rarely set them down and look more closely at their workings.

The twenty-first century decline of print journalism, the rise of the Internet, and the advent of digital photography suggest that our current moment presents an obvious turning point in the history not only of the news but also specifically of the news picture. A volume such as this one, accounting for its history until now, could thus not be timelier. We are experiencing major shifts in the organization of this field of activity without the advantage of any clear accounting for how it used to be. It is not unrelated that we also have now arrived at a moment of critical mass in the production of outstanding scholarship treating questions and issues relating to news pictures which this volume represents. Although the essays here address different periods, places, and subjects, they each address an overarching question that has, rather astonishingly, not yet been satisfactorily answered: how does a person with a sketchbook or a camera in one place work with the support of an enormous, highly sophisticated, and global infrastructure to offer both the visual evidence of and the explanation for the goings-on of the contemporary world to another person hundreds or even thousands of miles away?

As Andrew Pettegree has suggested in his recent history of the news, on the heels of the revolution in print from 1450 to 1530, the news became part of popular culture for the first time. By the age of the American and French Revolutions at the end of the eighteenth century, news began to play a role in shaping unfolding events. Pettegree concludes that "the age of mass media lay at hand."[4] Yet, like so many histories of the news and the press that have preceded this recent volume, Pettegree does not really account for the key role played by the news picture in the development of news and mass media. We argue that verbal and visual journalism developed in tandem. Yet the advent of the penny press in Europe and America in the1830s advanced the link between the two as never before. The speed of the presses extended the audience of the newspaper who sought information in both modes, while the "industrialization" of the presses made it possible to reproduce images in a timely manner and eventually alongside words. This volume seeks to properly historicize the media of visual journalism in their particulars as a material and a cultural practice. We consider news pictures as a class of images, chart its history, and define its attributes. By so doing, the essays collectively help account for—and thereby denaturalize—the way photography has come to dominate the visual culture of the news.

This investigation contributes to the rapidly expanding scholarly literature treating the informational and communication-oriented quality of modern visual experience, prompted by the consolidation of the field of "Visual Studies."[5] Such a project assumes that it is important to focus on institutionalized and normative visual materials and practices, particularly where it has been the seemingly exceptional (or "avant-garde") ones—typically those that disrupt or refuse the very possibility of instrumental communication—that have generally drawn the sharpest analytical attention.[6] Informational images, often bound up in commercial culture, have frequently been understood as being nothing if not always already banal and repetitive. Yet visual practices committed to the possibility of communication—and news pictures are more than emblematic here—have played too central a role in the organization of modern visual experience to be overlooked.

The news picture as an object of study operates across the boundaries that have traditionally divided the fields of art history, history, communications, and media studies. As such, understanding news pictures requires a willingness to work collaboratively across these fields, taking the lessons of each seriously and seeking to bring their respective strengths to bear on the subject rather than attempting to identify their particular blind spots. This volume therefore offers a fully interdisciplinary and intermedial approach.

At the heart of our undertaking, then, is an investment in the news picture on its own terms, as an important means of communication and information. This is a view which sits quite uncomfortably within

the history of art, the discipline conventionally held to be most competent in its engagement with the pictorial, but which often holds journalism at bay as mass culture at its very worst: a simple, compromised, and misleading form—precisely the very kind of thing to which art offers a corrective. Nonetheless it is our conviction that, as an object of study, the news picture has a great deal to offer art history. With surprising frequency, modern art history's most sanctioned artists have cut their teeth in journalism, and where they have not, they have structured their practice either in refusal of its terms or through sophisticated strategies of appropriation and parody. But for the terms of modern art's complex engagement with the world of news pictures to be properly understood, the very real complexity of that latter field must be brought into fuller view than disciplinary habit has so far allowed. Indeed careful study of the news picture often reveals cases where the very distinction between two categories is challenged.

Called "the storehouse of history" by one nineteenth-century pressman, news pictures provide an archive of unmistakable value to cultural historians. As scholars in all fields become more attendant to the importance of vernacular visual forms, they will no doubt turn to the image-archive of the past, made increasingly accessible through digitization and through the transfer of vast print collections to research centers. More scholars outside art history recognize that pictures must never be treated as open windows. This volume provides examples where the full complexity of these ostensibly and ideally "transparent" pictures is not only addressed, but also fully foregrounded. It thus offers a model for and a means by which current scholars might fruitfully approach news images as evidence. The essays consider the mechanisms and history of news pictures as objects of historical scrutiny themselves rather than merely as vehicles for the transmission of knowledge about the events depicted. It is undoubtedly the case that we could understand a nation's or an era's ideas of heroism and sacrifice, or notions of crime or celebrity, by using the news images as sources. But when we do, we will need a context through which to evaluate the material support and practices that engendered the creation of the evidence as visual evidence rather than merely as a vehicle to transmit past lived experience. Such an approach locates the news image in the history of image-making as well as in the history of the press and its practices. Images stand as evidence of a practice whose history included the construction of the very objects and subjects they claimed to merely represent. But we do not hold that this construction obscures an evidentiary worth; it simply shapes it. This book's perspective holds in view both the news seen through the lens *and* the refraction built into that lens in the process of its very making. We needn't refuse the one in order to intelligently consider the other.

Defining the object

News pictures are images crafted with a commitment to transmit timely and reliable information held by journalists to be of consequence to a viewing public. News is information thought to be worthy of attention by those reporting it, with the idea that it will be of interest to the public they address.[7] While it has become conventional to categorize such exceptional instances as war, catastrophe, (natural or otherwise), and beginnings and endings (births and deaths) as news, our careful consideration of the press "archive" (the dailies, weeklies, newsreels, television broadcasts) has led us to cast a much wider net. To merely glance at the news is to find that its topics, as often as not, tend toward the commonplace and the everyday in sports, in fashion, and in the human-interest story. But whatever its subject, once generally known, news is thought to make an impact on those who learn about it—the news is a business, but at its best it is also a catalyst generating discourse, dialog, and debate about what matters in the present.

Southeast - Judith J.
Carrier Library
2100 Southeast Parkway
Arlington, TX 76018
817-515-3082
https://library.tccd.edu

LE, QUANG MINH

03/11/2022

Loans

Title: Getting the picture
: the visual culture of the
news / by Hill, Jason E.,
Barcode:
3400100107259
Due: 04/01/2022
17:00:00 CDT

of images such as those generally considered "art" that they are in at least two important ways, both to do with their status as embrace a privileged commitment to bearing some heightened tside the picture—those places and occurrences deemed most The news picture's optimal public is always the most generalized y" or the "photography community" or any given "counterpublic," that might, through consensus, operate in the conduct and its relation to its public, unlike that of art, is structured around use its purpose is instrumental and timely, the natural life of a an historical document, an icon and/or artwork, usually much uch things as museum-pictures. News pictures appear at the onditions of circulation at any given moment: they are produced, tituted publics as quickly as possible, and then are quickly and en forgotten.

ction of an artist-reporter and an editorial team getting an ideally The power of the news image as news inheres in the assumption e. The significance of such presence or immediacy derives from ansparent account of the reported event. This value is eventually phy where presence is the essential precondition for making the role photojournalism has come to play in the general enterprise hese images depends in surprising measure on the invariably

veracity are too familiar to trouble with here. We prefer to accept as a given condition: it is, as they say, not a bug but a feature. makes its creation continually interesting to its intended audience eans of making sense of their own world. This world is one that ity by assuming the importance of knowing it far beyond the simultaneously constructing ways through which individuals learn to be alert to that same mechanism's limits in delivering reality and the very partiality of such truth.[9] But that very pressure commands attention precisely because of the news picture's pronounced informational burden. Indeed, the news picture plays the key role it does because it informs twice: whether photographic or otherwise, it offers news and immediately stands behind its claim by delivering "proof" of the surrounding news narrative through the testimonial power of the visual depiction.

Picturing and modernity

A particularly important category of image with an enormously complex and unmistakably modern supporting infrastructure, the news picture stands at the crossroads of two elements that form collective identity in modernity: information and mechanical reproduction. It should not be overlooked that Baudelaire's famous formulation of the modern observer, also described as *"the flâneur,"* is none other than Constantin Guys, whose work as a sketch reporter defined his modernity according to the famous French critic.[10] In considering the news picture, we also suggest that classic sociological accounts, such as that of Chicago School scholar, Robert Park, are important to keep in view since such interpretations

sought to define and describe the key role played by "the news" in what has come to be called "modernity"—however limited and provocative such a term might now be.[11] "Ours is an age of news," Park wrote, "and one of the most important events . . . has been the rise of the reporter" whose purpose is "to orient man and society in an actual world."[12] Park began his classic consideration of the social function of the news in the 1920s and 1930s during the key years when the press itself was undergoing profound change, in no small part triggered by an increasing emphasis on pictorial reporting allowed by the proliferation of the halftone in newspapers and magazines in the first two decades of the twentieth century. Park's view of the news, despite the fact that he did not specifically concern himself with news pictures, was unconsciously inflected by this transformation and thus informs some of his key insights for the long-term power of news. Although transient and particular, news often survives, he noted, ". . . As a ghostly symbol of something of universal and perennial interest, an ideal representation of what is true of life and of human nature everywhere."[13] This observation is steeped in visual reference. That Park's discourse was so haunted by "representations" and "ghostly symbols" also reminds us that, during periods of significant media transition, where once a medium was so familiar as to be seemingly invisible, the introduction of new practices (such as the consolidation of the use of the halftone for photographic reproduction in the newspaper) brings such modes of representation at least momentarily into view.

The pictorial has long been a central metaphor and organizing principal of many accounts of the history of the news, and it is possible to trace a striking degree of continuity in the terms of its analysis across the longer history of the enterprise. Gisèle Freund, a German refugee living in Paris from the 1930s onward and writing in the 1970s, as the news magazine came to be eclipsed by TV news, analyzed the social role of photography in what remains one of the most insightful introductions to the subject:

> Before the first press pictures, the ordinary man would visualize only those events that took place near him, on his street or in his village. Photography opened a window, as it were. The faces of public personalities became familiar and things that happened all over the globe were his to share. As the reader's outlook expanded the world began to shrink.[14]

Freund's vision of access to the world outside the viewer's immediate experience summarizes much of the modern investment in the social function of the news, with vision and picturing as its guiding metaphors. She, however, zeroes in on photography as the key technology for effectively expanding the spatial range of what can be seen and therefore understood, whereas we seek a broader pictorial framing in this volume.[15]

We largely concur with Freund's observations but for her attachment to the primacy of photography rather than to pictorial reporting more generally. For this reason, we turn to Freund's contemporary across the Atlantic, journalist Walter Lippmann. Lippmann, concerned with the function of the press more generally, well understood the centrality of the visual to journalism's project. In his landmark 1922 study, *Public Opinion*, written as the halftone and therefore the photographic image came to a point of full blown journalistic saturation, he defined the news as an attempt to mend of the gap between "the world outside and the picture in our heads."[16] Like Freund, he claimed that news compensated for the lack of direct access to the entire world while also constructing that knowledge as essential. Lippmann wrote of democratic publics, "We shall assume that what each man does is based not on direct and certain knowledge, but on pictures made by himself or given to him." Such pictures then offered distorted lenses rather than perfect ones; people filtered the truths they were offered by their own preconceived

notions and expectations.[17] For this reason Lippmann harbored particular anxiety about the power of news picturing's newly dominant medium, lamenting: "photographs have the kind of authority over imagination today, which the printed word had yesterday, and the spoken word before that."[18]

Directly aggravated by the propaganda cultures of World War I, Lippman's concerns were also a response to the onslaught of the pictorial press that exploded in the fifty years prior. Among the many earlier journalists declaring the power of news pictures, Mason Jackson, art editor at the *Illustrated London News*, described the history of the phenomenon in his influential 1885 work, *The Pictorial Press: Its Origin and Progress*, written just as the halftone came to slowly threaten the wood engraving with journalistic obsolescence. This journalist, attached to advancing the fortunes of the picture press and those of his own paper, insisted that there existed a "Pictorial Taste Universal." Struck by the takeoff of the "illustrated" in his own era, Jackson's larger purpose in writing his book was to trace the even longer history of the picturing impulse in news, beginning in 1619 with the *Newes out of Holland*. Writing as he did before the common adoption of the halftone, and therefore before the reproduction of photographs in pictorial journalism, his interpretation reinforces that it was not photography as Freund would have it, but rather "the idea of illustrating the news of the day" by whatever means, that drove the expansion of the consumption of news in visual form.[19]

To leave aside the question of any given news form's topical content to attend instead to the relatively more stable news template itself, with its ever streamlining set of institutionalized protocols, is to discover a concentration of the forces associated most readily with modernity's project. From the impulse toward strategic universalization such as might render legible an otherwise inconceivably polyglot world, to the professionalized, globetrotting reporter who is that project's enabling proxy, the news picture trades unambiguously and aggressively in spectacle, contingency, commodification, humanitarianism, novelty, and even the aesthetics of medium reflexivity. These are the qualities that we not only associate with modernity but also which in fact constitute the condition that goes by that name. Mass visual media transmitted to its audiences a form of displacement—a displacement via the image—that paralleled the real-world displacement of the reporter, whose journey, made possible by mechanized transport, lay at the heart of the imperial dreams and myths of the modern world. The news picture and the mechanized transport through which it trafficked functioned as crucial contributing agents to the process that we call globalization today.

The modernity of the news derives in one key respect from its dependence on novel mechanisms of information-gathering and dissemination that were deeply tied to more general demands of the "modern mind." Writing for a new generation—really the first generation—of photographic news professionals in 1939, news editor Laura Vitray, photographer John Mills, Jr., and journalism professor Roscoe Ellard defined the newspaper's quintessential modernity: "The development of modern photographic and engraving processes might not have been so rapid and so amazing if what they had to offer had not so well answered the demand of the modern mind . . ." which they cast as an insatiable desire for fast knowledge at a distance.[20] Of course in the mid-nineteenth century, photography was anything but fast. Rather, sketching and engraving set the pace and were (almost) as fast as the modern mind might require.

Yet, there is little doubt that steam-powered, electric, and digital reproduction methods have provided the material support for the constitution of an "imagined community" through cheap and easy image production and distribution.[21] The shared consumption of such images forged and continues to forge a new basis of community made among strangers. Bluntly: images have always instructed and informed, but the period from the nineteenth century forward in the Western world finds their role fundamentally transformed. Where once the audience had to go to the image (to see a fresco by Giotto, for example) the image now

arrived at the neighborhood saloon, at one's doorstep, or eventually on a laptop. The support through which the news is communicated not only determines its relative social force but it also contains within it its own particular sense of temporality that defines an event as being in the present and even comes to define what the "present" might mean. Indeed, news pictures might be understood to visually construct every notion of contemporaneity that we might presume to enjoy.[22] Breaking stories streaming through our smartphones operate in a different temporal register than long-form investigative pieces in the pages of weeklies and monthlies. All these temporalities, however, stand for "news time," which also stands for what we can know of our present moment. Form structures the meaning and content of the news.[23]

The pictorial reporter's conduct raises issues about modern ethics: his and ours. On the one hand, the reporter is our professional voyeur and parasite whose commitment to reporting transcends the obligation to act in a newsworthy situation with anything other than the act of making a picture. The reporter's pursuit of the seemingly spontaneous and unstaged image stands in complex relation to his service in assuring democratic transparency. Additionally, the news depends on speed as a guarantor of transparency. How fast and how fully news pictures circulate is dependent on both the material limits of technology as well as on the social investment in either their dissemination or occlusion. Censorship can act as a powerful drag just as the velocity of a mode of transport can hinder or hasten the production and reception of an image.

In the mid-twentieth century, Daniel Boorstin observed the invention of the "pseudo-event"—experience performed in order that it be observed and pictured.[24] This formulation, however, overemphasizes the way modern life is contrived when really what delivers a newsworthy image is the pseudo-event rendered spectacular by fortune, good and bad, in which timing and luck frame the perfect news picture. In Boorstin's planned and organized world, contingency becomes thrilling. Clothing manufacturer Abraham Zapruder, who filmed John F. Kennedy's assassination, is the exemplar of pointing a camera in the right direction at the right time. Contingent events become narratives in the news whose unfolding assures their following by a loyal audience eager to see how things will turn out. This can develop in short and long temporal arcs. Soon after the event, *LIFE* magazine published the original amateur film slowed down as a photo essay so that readers might linger over that remarkable instant. Likewise, this moment has been indefinitely extended, most familiarly by the on-camera murder of Lee Harvey Oswald at the hands of Jack Ruby. Subsequently, it has been sustained by an obsessive investigation into the material condition of the film itself (there are claims that the film as developed is missing certain frames), which has kept these news pictures in view, and still news.[25]

Zapruder's status as an amateur, a reporter by happenstance, introduces the question of the specific competencies of professional makers of news pictures. From the artist to the editor, to the engravers, to the darkroom staff and now the IT team and web designer, a host of professionals have come on the scene to attend to the endless demands of the production of news pictures. Despite all efforts to professionalize, however, from guild memberships, journalism schools, and concepts such as the decisive moment held by professionals as their special competency, news picturing will always also require an access to the contingent and unexpected that cannot be anticipated. So much news picturing, whichever the pictorial technology in play, rests on a lucky shot.

The professionalization of the press is also part of its commercial logic. The news media is in the business of selling information, and news pictures have been one of its most valuable commodities. Capitalism demands new products and so the news, like fashion, runs on built-in obsolescence. The press constantly replenishes its supply of novelty, which is cut from the same old cloth. Newness also comes through the spectacle of technological change in the forms of such developments as wire transmission, rotary presses, innovation in cameras, faster film, color printing, and digital processing.

The most readily apparent technological change may also be the most important one—that concerning the very medium by which the news picture is figured. Like the history of news pictures, then, this volume represents painting, sketching, caricature, and engravings alongside the diverse array of photographic practices that emerge, combine and recombine in a cumulative ensemble of representational strategies. Newsreaders constantly encounter new pictorial media and adjust to them. Old pictorial media never quite die. Such media instability draws attention to the form of news while also continually reinventing what might indeed constitute the news in the first place.

It behooves us as historians to be as attentive to these matters as the consumers of news pictures always have been. We insist that we set aside the catalog of insults hurled in the direction of news pictures which has included charges that they threatened to displace the hallowed literary tradition of the press, that they willfully distorted the facts in favor of formal concerns, that pictures simplified complex narratives, that they were favored by the uniformed huddled masses and, worse, that papers used them as sales tools rather than in the service of providing better information. This prejudice has so endured into our own era that many of the same objections persist even among those scholars interested in both the history of the press and the power of images. In order to challenge such perspectives, we believe we need to free ourselves from the assumptions and values of the divisions of knowledge that have relegated news pictures to the dustbins of history.[26] The essays in this volume do just that.

For too long our scholarship has also advanced based on the assumption of the naïve consumer of news pictures, who has been subdued by an industry responsible for providing those pictures. Newsreaders have been more sharp-eyed than they have been credited with, and the makers of news pictures have always contended with knowledge of audience savvy. Getting the picture requires that we acknowledge the complex relation between image-production and reception and that we fully integrate the historical conditions, values and practices described in this volume into our interpretations of the visual culture of the news.

Notes

1 On contemporary history painting's brief flourishing and its relation to the news picture, see Edgar Wind, "Revolution in History Painting," *Journal of the Warburg Institute* 2.2 (1938): 116–27.

2 On the shifting conditions of visual journalism today, see Fred Ritchin, *Bending the Frame* (New York: Aperture, 2013).

3 For one recent discussion of this critique, see Susie Linfield, *The Cruel Radiance: Photography and Political Violence* (Chicago: University of Chicago Press, 2012).

4 Andrew Pettegree, *The Invention of the News. How the World Came to Know About Itself* (New Haven: Yale University Press, 2014): 2.

5 For a cogent overview of the heterogeneous field of "Visual Studies," see Keith Moxey, "Visual Studies and the Iconic Turn," *Journal of Visual Culture* 7.2 (2008): 131–46.

6 See Johanna Drucker, "Who's Afraid of Visual Culture?" *Art Journal* 58.4 (Winter 1999): 37–47.

7 "News" is notoriously difficult to define. See Bernard Roshco, "Newsmaking [1975]," in ed., Howard Tumber, *News: A Reader* (New York: Oxford, 1999): 32–6.

8 On the concept of a "public," see Michael Warner, "Publics and Counterpublics," *Public Culture* 14.1 (2002): 49–90.

9 Public controversies surrounding Arthur Rothstein's notorious skull in the 1930s are suggestive in this respect. See also ed. Mia Fineman, *Faking It: Manipulated Photography before Photoshop* (New York: Metropolitan Musuem, 2012).

10 Charles Baudelaire, "The Painter of Modern Life," in *The Painter of Modern Life and Other Essays*. Translated by Jonathan Mayne (London: Phaidon Press, 1995).

11 Robert E. Park, "The Natural History of the Newspaper," *The American Journal of Sociology* V. XXIX, n. 3 (November 1923): 273–89 and "News as a Form of Knowledge: A Chapter in the Sociology of Knowledge," *American Journal of Sociology* 45.5 (March 1940): 669–86.

12 Park, "News as a Form of Knowledge": 686 and 669, respectively.

13 Park, "News as a Form of Knowledge": 681.

14 Gisèle Freund, *Photography and Society* (Boston: Godine Press, 1980): 103.

15 See Christian Caujolle and Mary Panzer, eds, *Things as They Are. Photojournalism in Context Since 1955* (New York: Aperture, 2005) for an excellent survey of photojournalism.

16 Walter Lippmann, *Public Opinion* (New York: MacMillan, 1922): 3.

17 Lippmann, *Public Opinion*: 25.

18 Lippmann, *Public Opinion*: 92.

19 Mason Jackson, *The Pictorial Press: Its Origins and Progress* (New York: Burt Franklin, 1885): 1 and 284, respectively.

20 Laura Vitray, John Mills, Jr. and Roscoe Ellard, *Pictorial Journalism* (New York: McGraw-Hill, 1939): 4.

21 See Benedict Anderson, *Imagined Communities* (New York: Verso, 1991); and James Carey, *Communication as Culture: Essays on Communication and Society* (Boston: Unwin Hymen, 1989).

22 See Terry Smith, "Our Contemporaneity," in Alexander Dumbadze and Suzanne Hudson, eds, *Contemporary Art: 1989 to the Present* (Chichester, West Sussex : Wiley-Blackwell, 2013): 17–27.

23 Kevin Barnhurst and John Nerone, *The Form of News* (NY: Guilford Press, 2001).

24 Daniel Boorstin, *The Image: A Guide to Pseudo-Events in America* (New York: Atheneum, 1971).

25 David Lubin, *Shooting Kennedy: JFK and the Culture of Images* (Berkeley: University of California Press, 2003).

26 One special challenge to this field of study has been the wholesale pulping of historical newspapers in favor of space-saving but image-destroying microfilm. See Nicholson Baker, *Double Fold: Libraries and the Assault on Paper* (London: Vintage, 2002).

PART ONE

BIG PICTURES

Introduction

Jason E. Hill and Vanessa R. Schwartz

News pictures are limited in terms of the complete performance of their given function: to make the contemporary world, in all its "blooming buzzing confusion," seeable and therefore knowable.[1] The world is simply too irreducible and the forces shaping the production of any given news picture are too obscure for the practice to reliably produce an entirely satisfactory window onto affairs. But news pictures do stand as unimpeachable evidence in one respect: they invariably illuminate with almost perfect clarity the history of news-picturing itself, as a cultural field and as one of our time's most important communication technologies. This is precisely the history that concerns us here. Accordingly, **"Part One: Big Pictures"** offers an eclectic survey of provocative episodes within the modern history of the news picture in order to gain insight into the development of the tools, infrastructure, and practices that have fostered its development, as well as the intransigence of the technological and ideological factors whose friction has worked with equal force to shape it. These elements determined what could be made visible and knowable of the present, and have subsequently come to structure our visual understanding of the past.

We trace the movement of news pictures back to the years preceding the establishment in the later 1830s and early 1840s (especially but not exclusively) in the Western world of those three mechanisms most closely associated with journalism's accelerating development in expediting topical information: the railroad, the telegraph, and photography. We conclude with the years just after 2000, where the conditions for the production, distribution, and reception of news pictures (though always in flux) underwent an especially visible reconfiguration by new digital technologies and their increasingly entrenched journalistic and amateur application. The period highlighted in this volume marks an age that *LIFE* magazine editor Wilson Hicks described in 1952 as the "Age of the Visual Image—the visual image in its ink-on-paper, celluloid and electronic forms."[2] This is the age of the visual image's leap into helping to constitute a particular public culture made possible by the modern press and its attendant media. It is not, however, and as Hicks well understood, an age of public images exclusively dominated by the paper-based photographic practices we tend to associate with photojournalism, a practice that regrettably has become synonymous with news picturing. The short essays gathered here cast their net more widely in order to enfold different practices that (like lithographic caricature) precede, (like television news and home movies) coincide with, and (like the White House's Flickr page) postdate the age of classical photojournalism.

Although this section is organized around the presentation of individual case studies, we do not regard news pictures as singular pictorial achievements but instead as nodes operating within rich and varied networks of influence, production, distribution, and interpretation. The short essays assembled here therefore challenge the priority of the isolated image and "photo essay," either as a topical window onto a

distant or local present or, subsequently, as historical evidence, in favor of a consideration of the larger structures of meaning through which these images operated. This section argues that much of what matters most in these pictures cannot be seen on their surface. We maintain an ambivalent posture toward the news picture's iconicity, either in the semiotic sense of its containing some visual resemblance to its reported subject (no story is so simple that it can be reported in this way), or in its more current usage as theorized by our contributors Robert Hariman and John Louis Lucaites, where the very canonicity of a corpus of widely known images might itself be understood to yield heightened insight into the fabric of contemporary society.[3] Often (as in Hariman's and Lucaites' hands), these modes of iconicity will generate genuine insight. More often though, iconicity serves both to conceal the larger social, political, and technological structures of which any given news picture is but a symptom, and to obscure the astonishing formal, procedural, and topical heterogeneity of this emphatically public form of visual expression.

In some iconic cases we have even elected not to reproduce the image under discussion at all. The legal embargo against reproducing a famous Eugene Smith photograph of environmental poisoning in Japan, for example, may tell us more about the cultural work of that picture then and now than its reproduction today ever could. In other cases the discussion of a familiar case has been illustrated by an operationally adjacent image: instead of reproducing Joe Rosenthal's photograph of the flag-raising at Iowa Jima, we consider a San Francisco sculpture that Alexander Nemerov argues may have informed Rosenthal's own pictorial thinking.

We also reproduce many pictures that are anything but iconic, because they were never even seen by the contemporary public that would have constituted them as "news," conventionally defined, in the first place. For example, Matthew Fox-Amato writes about an 1850 abolitionist daguerreotype that could only be described but not reproduced in the newspaper. Likewise, Victoria Gao examines a Chinese photograph made during the Cultural Revolution but hidden away until regime change made it safer to publish years later as history rather than as news. Such pictures underscore the central importance of mass visibility to news pictures and the varied conditions—sometimes political, sometimes technological, sometimes both—enabling or disrupting its attainment. In other cases where we have reproduced the iconic image, the discussions invariably range far beyond its reception history or the formal properties and the heroic moment of its production in favor of a consideration of the challenges of bringing the image to its intended public, the unpredictable effects that such pictures subsequently produced, and the problems contained in the very notion of news-pictorial iconicity. Even with icons, we ground their histories in ways that enrich our understanding of their production and distribution so we are not left with the notion that they mysteriously replicate in a viral manner. This should also offer guidance in considering the digital environment in which phrases such as "viral videos" have become commonplace.

The very short contributions in this section are designed as a group to establish a host of issues in the history of news picturing that are more deeply described and questioned in the second part of the volume. Offering a compact survey, Part One can be read as a self-contained overview. Better still, the essays can also be paired with appropriate selections from Part Two that more thoroughly elaborate on the issues raised here. Readers might, for example, supplement Richard Meyer's discussion of a landmark sensational tabloid photograph in Part One with the broader thematic essays by Ryan Linkof and Will Straw on celebrity and crime in Part Two. Michel Frizot's essay on a sports montage in this section may likewise be further contextualized with regard to both Thierry Gervais's essay on the rise of the sports press and Andrés Zervigón's contribution concerning rotogravure.

The entries are titled descriptively and then dated as an incitement to strip their subject images of authorial attribution in the first instance and to complicate their typically unstable relationship to any given

"title" or particular publication context as well. Since our framework is historical, we favor their chronological ordering. Working through the essays here in order may well reveal the parameters of a history of news picturing as we have suggested in the general introduction, but we also recognize that the field is simply too vast and complex to fit comfortably into any single narrative.

Part One, like this volume as a whole, must be understood as a partial account and initial survey that attempts to broaden the base of the research regarding news pictures in order for deeper studies to be subsequently undertaken in light of this volume's approach. There is a great deal of work to be done, especially in understanding, for example, how the visual culture of the news has functioned in the global South, which the present volume has not to our satisfaction addressed.

"Big Pictures" introduces a series of provocative instances. It begins with an essay by Patricia Mainardi about an 1831 French caricature from the period in which the mass press began to form and in which censorship also shaped the simultaneously sharp and sometimes ambiguous contours of visual expression. This selection introduces the rich tradition of caricature, which constituted an important part of news picturing and reminds us that the news has been pictured in color as much as black and white, despite our post-photojournalistic association of the news with the latter. The essays run right up to the present era, concluding with Liam Kennedy's consideration of the 2011 photostreaming of "The Situation Room." The political uses of news picturing continued apace, in this case, political authority is depicted as witness to its own actions through the picturing of the assassination of bin Laden from afar. Simultaneously, the White House serves up the image of their watching as proof to the public that the action happened. The public sees nothing but the instantaneous image of the American government watching, which is disseminated through social media networks. Part Two, "Re-Thinking the History of News Pictures," develops many of the key themes from the short essays but treats them in greater depth. In both parts, we believe the volume invites further study, research, and scholarship in what remains a wide-open field of inquiry in a domain whose present is both so vital and so rapidly evolving that our grasp of its history seems more relevant than ever.

Notes

1 See Walter Lippmann, *Public Opinion* (New York: MacMillan, 1922).

2 Wilson Hicks, *Words and Pictures: An Introduction to Photojournalism* (New York: Harper, 1952): xv.

3 Robert Hariman and John Louis Lucaites, *No Caption Needed: Iconic Photographs, Public Culture, and Liberal Democracy* (Chicago: University of Chicago Press, 2011).

1.1
Dupinade, French Caricature, 1831

Patricia Mainardi

Caricature doesn't so much report the news as comment from a blatantly partisan point of view on news that everyone already knows. In periods of censorship, however, its message must be delivered obliquely, through visual symbolism and a complex interplay of visual and verbal puns and allusions. *Dupinade* stands as a watershed in the history of caricature; prosecuted because of its all-too-recognizable portrait of King Louis Philippe, it gave rise to the most famous symbolic representation of a monarch in the history of caricature: the pear.

Dupinade was published anonymously on 30 June 1831 in the journal *La Caricature*, founded the year before by Charles Philipon, the seminal figure in nineteenth-century French caricature. He published journals and prints, collaborated with the most important graphic artists of his day, and possibly drew *Dupinade* himself. *La Caricature* took strong positions on political events, and so Philipon soon found himself in difficulties with the authorities. Louis Philippe had been installed as king after the July Revolution of 1830 ushered in France's first Constitutional Monarchy. The Charter that the new king accepted as condition of his rule guaranteed basic freedoms, but he soon reneged and reinstated the press laws of the repressive Restoration monarchy. "Attacks by the press against the rights and authority of the King" would be punished with a prison sentence of three months to five years and a fine of 300 to 6,000 francs.[1] *Dupinade* was cited for mounting just such an attack; the criminal charge against Philipon was that he had depicted "Authority, recognizable as the King, dressed as a mason, covering up the inscriptions of July."[2]

Philipon's plasterer is, indeed, a recognizable portrait of King Louis Philippe. Known as "the citizen king," he is here portrayed wearing a mason's blue blouse, his arm tattooed with the names of the Revolutionary battles Valmy and Jemappes that were won by citizen armies. He is depicted eradicating the last vestiges of the July Revolution, symbolized by the graffiti on the wall. His means of doing so is contained in the trough at his feet labeled *Dupinade*, a reference to André Dupin, the royal Procureur Général [Attorney General] and Vice-President of the Chamber of Deputies. Dupin was its most outspoken conservative voice, opposing every reform that the revolution was intended to guarantee, from freedom of assembly to freedom of the press. The "dupinade" with which Louis Philippe is attempting to carry out this feat of collective amnesia is also a pun on the verb "duper"—to dupe, suggesting that the nation was misled when it installed its new king. The pun Dupin/duper/Dupinade invented here that fused the name of a repressive jurist with the abandonment of revolutionary promises proved fruitful in the literary realm

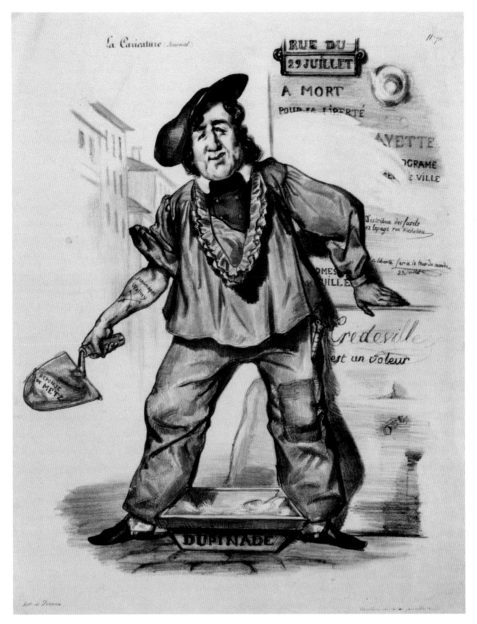

Figure 1.1 Anon., *Dupinade*, hand-colored lithograph. Lith. Michel Delaporte, Dist. Aubert, Published in *La Caricature*, 30 June 1831, plate no. 70.

as well, inspiring the neologism "dupinade" that soon made its way into popular literature.[3] This concision and interplay of visual symbolism and verbal shorthand is what gives caricature its many-layered charge.

Louis Philippe's trowel, loaded with "dupinade" is labeled "Response to Metz," the town in Eastern France whose mayor launched a movement of noted liberals united in opposing any return to repressive legitimist rule. Widespread riots against the regime followed, crushed by the military, and Louis Philippe's

response to Metz was this attempt, depicted symbolically, to eradicate all remnants of the revolution that had brought him to power. The inscriptions that he is erasing include the sign "Street of July 29"—the day the monarchy fell and was replaced by the provisional government that appointed him; the slogan "Liberty or Death"; and below that, already partially erased, the name of the Marquis de Lafayette, the leader of the National Guard and one of the most prominent signatories of the Metz petition. We also see "Distribution of rifles at Lepage rue Richelieu" (a gathering point for revolutionaries in 1830) and, just above Louis Philippe's hand, "Liberty will spread through the world July 29." "Crédeville is a thief" is written below; Crédeville was a popular character, a con man, criminal, and thief who became symbolic of the regime's dishonesty.[4]

The king was not amused. Philipon was arrested and tried on 14 November 1831. His defense was that there was no proof that his mason represented the king because his caricature bore no mention of the king's name or titles, nor any depiction of royal insignia: "It is Authority that I represent, through an image that could refer to a mason as well as to the king."[5] Claiming that his critics could see the king's resemblance in anything, he drew a series of images showing the head of Louis Philippe transformed into a pear. His conclusion: "You would condemn a man to two years in prison because he drew a pear that resembled the king!"[6] The jury was unmoved and sentenced him to six months in prison and a 2,000 franc fine. But Philipon had the last word. He published his image of Louis Philippe transformed into a pear in *La Caricature* on 26 January 1832, and even released it as a poster, the proceeds from its sale going to pay his fines. The pear became the symbol of the despised king, appearing everywhere, both in caricature and in street graffiti. Artists had found a way to evade the law against depicting the monarch and—since *poire* also meant dupe, dope or half-wit—managed to ridicule him twice over, both in word and in image.

Notes

1 "10 novembre = Pr. 1er décembre 1830—Loi qui punit les attaques contre les droits et l'autorité du Roi et les Chambres par la voie de la presse," in Jean-Baptiste Duvergier, *Collection complète des lois, décrets, ordonnances, règlements, avis du Conseil d'état*, 78 vols (Paris: Guyot et Scribe, 1824–78), vol. 30: 274.

2 A. A. "Cour d'assises. Procès du N° 35 de *La Caricature*, audience du 14 novembre 1831," *La Caricature*, 17 November 1831.

3 See, for example, Louis Reybaud and Auguste-Marseille Barthélemy, *La Dupinade ou La Révolution dupée, Poème Héroï-comique en Trois Chants* (Paris: A.-J. Denain, 1831), and the review in *Le Mercure du dix-neuvième siècle*, vol. 32 (1831): 546.

4 Traviès published a caricature, *The Pear has become popular!*, showing a street urchin drawing pears on a wall, one of which is labeled "Crédeville Voleur"; "*La Poire est devenue populaire!*," *Le Charivari*, 28 April 1833.

5 A. A. "Cour d'assises. Procès du N° 35 de *La Caricature*, audience du 14 novembre 1831," *La Caricature*, 17 November 1831.

6 A. A. "Cour d'assises. Procès du N° 35 de *La Caricature*, audience du 14 novembre 1831," *La Caricature*, 17 November 1831.

1.2

General Wool and His Troops in the Streets of Saltillo, 1847

Martha A. Sandweiss

It's the world's first photograph of war. And perhaps the world's earliest example of photojournalism; that is, a photograph made of an event for its newsworthy value. But the most remarkable thing about this image is that virtually no one ever saw it. The daguerreotype of General John Wool and his staff marching through the streets of Saltillo in occupied Mexico in early 1847 had absolutely no impact at all.[1] The anonymous daguerreotypist was almost certainly an American, one of several following the American troops through northern Mexico during the hostilities of 1846–48. The Americans called it the Mexican War. Many Mexicans still call it the US Invasion. Either way, it was an American land grab that resulted in the US acquisition of California and much of the present-day Southwest.

Daguerreotypes of the Mexican–American War are exceedingly rare. The photographic process had been announced only a few years before, in Paris in 1839, and though improved technology rapidly decreased exposure times, in 1847 it remained impossible to capture a clear image of a moving object. Photography was ill-suited to capturing combat, or action of any sort. For good reason, the vast majority of daguerreotypes were studio portraits, made in carefully controlled conditions, with subjects tightly clamped into special stands to keep them motionless while the photographer exposed his plate.

Nonetheless, the two extant collections of daguerreotypes relating to the Mexican–American War—at the Beinecke Library at Yale University and the Amon Carter Museum in Fort Worth, Texas—include a number of images made outdoors. The most dramatic depicts General John Wool parading with his troops down a street in occupied Saltillo. The photographer set up his tripod in the street, mounted his camera, and awaited the troops' arrival. He must have spoken to the General, directing him to halt the horses so he could make his photographic view. The General paused in his military duties; his men stopped behind him. The photographer made one image. The troops readjusted themselves slightly in the street. Then the photographer made another, as a dog looked on from the sidewalk and a bystander leaned out a window to watch.

The two resulting daguerreotypes are small, visually unimpressive objects, about 2 ¾ inches x 3 ¼ inches each. But examined up close, they are like magic talismans of the past. A daguerreotype is a unique image, made without a negative. The silver-coated copper plate, itself, is what is exposed in the camera. One winter day in 1847, light bounced off General Wool, hit a light-sensitive plate and left its lasting mark on its surface. Like a mirror with a memory, our plate still retains the impression of that fleeting moment. It was *there*.

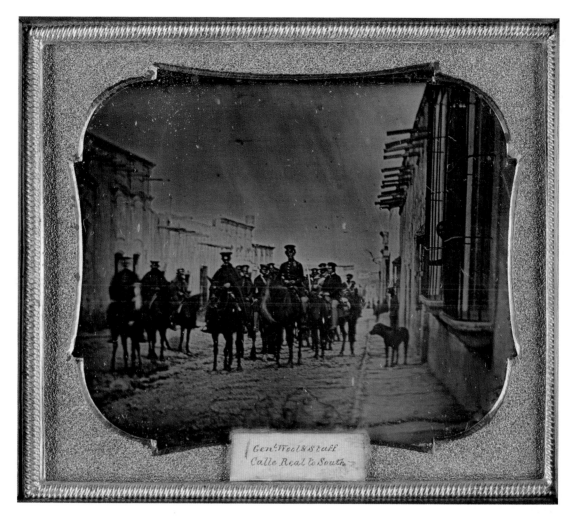

Figure 1.2 Unidentified photographer, *General Wool and Staff, Calle Real to South*, daguerreotype (sixth-plate image), c. 1847. Courtesy of Yale Western Americana Collection, Beinecke Rare Book and Manuscript Library.

But how could it be that the world's first photographs of war were never exhibited, never reproduced as engravings in the popular press, never given to the printmakers churning out imagined scenes of distant battles? Americans were hungry for news from the Mexican battlefields. Journalists took advantage of the new technology of telegraphs and steamships to convey their stories home with unheard of speed. And popular printmakers like Nathaniel Currier (later of Currier and Ives) hawked images on street corners to satisfy public curiosity about far-off events. But the daguerreotypes of the War found no market at all.

We now take for granted photography's value as a tool of documentation. But mid-nineteenth-century audiences didn't see things that way. They had to *learn* to value the literal realism of the new medium. They were accustomed to other ways of getting visual information about the war. Popular lithographs

conveyed dramatic narrative stories about heroic combat and brave deaths. These imaginative prints could compress events, highlight the moments that hindsight deemed decisive, and use printed captions to highlight the moral superiority of the American troops. Similarly, "transparencies" conveyed a heroic image of war no daguerreotype could match. These enormous back-lit paintings on wax-primed linen or cotton hung from buildings during public celebrations of the nation's military triumphs. They combined imagery of current-day events in Mexico with heroic images from the nation's past. Pictures from the American Revolution mingled with those from the Mexican battlefields; George Washington appeared alongside the generals who led the charge at Buena Vista and Vera Cruz. Daguerreotypes simply couldn't compete. The small difficult-to-see image on the reflective surface of the daguerreotype plate could convey no patriotic associations, no narrative drama, no heroism at all. And those were precisely the things Americans had come to expect from visual representations of important events.

If the American public couldn't quite figure out what to do with the photographic realism of the Mexican–American War daguerreotypes, it's also fair to say that the photographers couldn't quite figure out how to position their pictures in the visual marketplace. The daguerreotypes could not be mass marketed; they were singular objects. And although they could be given to printmakers to be redrawn and then printed as engravings or lithographic views, only one daguerreotype made in Mexico—a portrait of General Zachary Taylor—is known to have been reproduced. The photographers following the troops through Mexico were a ragtag bunch, without deep connections to American journalists or printers or consumers. Americans might have been interested in their work, but the daguerreotypists didn't know how to bring their images before the public eye.

How fast the world changed. Fifteen years later, the photographs from the Civil War were public sensations. The invention of the glass plate negative process had made it possible to produce multiple paper prints from a single negative, make large format views, and attach descriptive captions to the photographs themselves. Immersed in a world of shocking battlefield images, Americans learned to read them as art and evidence. And photographers learned to cater to that popular demand.

One wants to make a hero of the enterprising photographer who followed the American troops in Saltillo, to enshrine him as the first of a long list of heroic photojournalists who risked much to make sure the world could see the true human cost of combat. But our photographer was no role model at all. Just a precursor, perhaps, whose lack of success points us to larger stories about how photographs became valued as documents of newsworthy events.

Note

1 This essay is based on material developed at greater length in my essay, "Daguerreotypes of the Mexican War," in Martha A. Sandweiss, Rick Stewart, and Ben W. Huseman, *Eyewitness to War: Prints and Daguerreotypes of the Mexican War, 1846–1848* (Washington, DC: Smithsonian Institution Press, 1989).

1.3

An Abolitionist Daguerreotype, New York, 1850

Matthew Fox-Amato

On 21 August 1850, only two days after the Senate passed the Fugitive Slave Law, approximately 2,000 abolitionists gathered in Cazenovia, New York, where they enacted a social, written, and photographic protest.[1] Part of the Compromise of 1850, the law enraged abolitionists because, among other things, it penalized northerners for failing to aid in returning fugitive slaves.[2] A key purpose of the convention was to write "A Letter to the American Slaves from those who have fled from American Slavery," which was actually penned by white radical Gerrit Smith and endorsed by the fugitives in attendance. The letter characterized slavery as a state of war and urged slaves "to plunder, burn, and kill, as you may have occasion to do to promote your escape."[3] Many who authorized the letter also posed for Cazenovia daguerreotypist Ezra Greenleaf Weld.

While scholars have focused on artists, illustrated presses, technological shifts, and wars as the engines of American news photography from the 1840s to the 1860s, a look at the Cazenovia daguerreotype reveals social movement image-making as an important force in this history. At first glance, the photograph reflects the interracial and inter-gender composition of abolitionism. But for those at the convention, the daguerreotype held more specific purposes and meanings, which surrounded one particular white abolitionist: William L. Chaplin. Only a few days before the convention, Chaplin had been imprisoned for seeking to help the slaves of two Georgia congressmen escape in Washington, DC.[4] Since his arrest came so close to the start of the convention, Chaplin played an unusually prominent role in its activities. The "Letter to American Slaves" advised bondspeople of how Chaplin's "precious name . . . has been added to the list of those, who, in helping you gain your liberty, have lost their own."[5] At Cazenovia, abolitionists agreed to raise $20,000 to aid this "willing martyr."[6] As the abolitionist organ *The Liberator* reveals, they also sought to aid Chaplin with a photograph:

Novel Idea. — . . . in order to give him an idea of the meeting at which he was prevented by 'circumstances' from attending, a daguerreotype picture of the Convention, with some of the most prominent members on the stand, was taken, to be sent to him. This must be highly gratifying to him, as affording a sensible proof that the Convention are not unmindful to 'remember them that are in bonds.'[7]

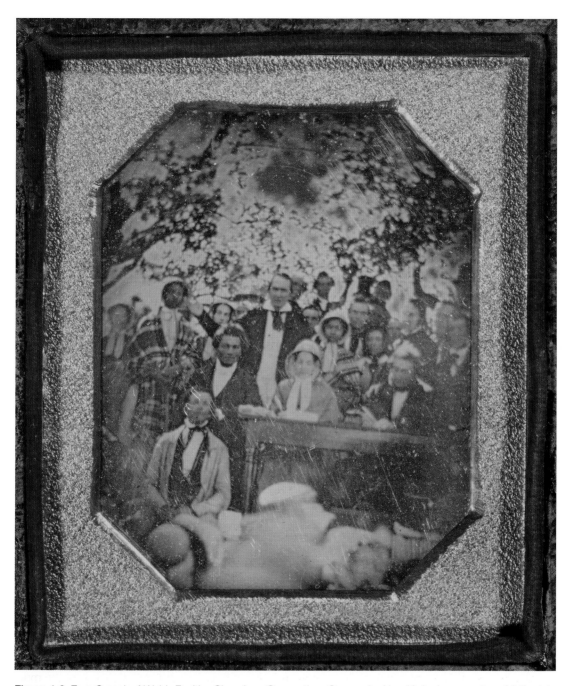

Figure 1.3 Ezra Greenleaf Weld, *Fugitive Slave Law Convention, Cazenovia, New York*, daguerreotype (sixth-plate image), 22 August 1850. The J. Paul Getty Museum, Los Angeles. Digital image courtesy of Getty's Open Content Program.

The notice suggests that the daguerreotype was intended as a concrete means of communication between the group and Chaplin, as well as a symbol of protest and togetherness. His fiancée, the bonneted Theodosia Gilbert, literally took center stage, seated next to Frederick Douglass. The Edmonson sisters, ex-slaves who had gained their freedom with Chaplin's help, stood behind the desk; white abolitionist Gerrit Smith stood between them.[8] It is not clear if Chaplin ever received the daguerreotype. But this much is clear: the intended circulation of the daguerreotype reveals a moment of experimentation in which abolitionists harnessed a new medium to convey movement news to a distant but familiar participant.[9]

If the daguerreotype was meant to spread news amongst activists, it became news through the press. Since *The Liberator* did not reproduce the daguerreotype as an engraving, the image reached the public through its written description. Words, alone, conveyed the power of this visual object in the media. By highlighting the activists' efforts to visually communicate with Chaplin, *The Liberator* stressed the capacity of photography to serve as proximate witness—and, thus, stand in for Chaplin's inability to see the convention firsthand. The paper drew upon an imagined sense of image circulation to emphasize his forced separation. But *The Liberator* also celebrated this image-making as notable in its own right. The notice—terming the instance a "Novel Idea"—reflected and fueled an emergent trope about photography *as* news that would grow more prominent in future decades. *The Liberator* considered the image as evidence of political struggle and of abolitionists' cultural ingenuity in the nascent years of photographic news pictures.

The Cazenovia daguerreotype fits uneasily into narratives about early American photography. Scholars have tended to define "photojournalism" in opposition to the conventions associated with unique, private images in the mid-nineteenth century—most notably the sentimental exchange of portraits amongst families and friends.[10] But this abolitionist portrait reveals a messier history of early photographic practices. Abolitionists fused the daguerreotype's capacity to document a public event and the newspaper's power to circulate information with the dominant practice of exchanging unique portraits to express affective ties. At Cazenovia, they created a picture that shared and became news in the service of radical politics.

Notes

1 John Stauffer, *The Black Hearts of Men: Radical Abolitionists and the Transformation of Race* (Cambridge, MA: Harvard University Press, 2001): 163–5; and Deborah Willis and Barbara Krauthamer, *Envisioning Emancipation: Black Americans and the End of Slavery* (Philadelphia: Temple University Press, 2013): 30–3.

2 James Brewer Stewart, *Holy Warriors: The Abolitionists and American Slavery*, rev. edn (New York: Hill and Wang, 1997): 124.

3 "A Letter to the American Slaves from those who have fled from American Slavery," *The North Star*, 5 September 1850. Accessible Archives: African American Newspapers.

4 Stauffer, *Black Hearts of Men*: 164; "An Affray—The Arrest of William Chaplin," *The National Era*, 15 August 1850. Accessible Archives: African American Newspapers.

5 "A Letter to the American Slaves. . . ."

6 "A Letter to the American Slaves . . ."

7 *The Liberator*, 6 September 1850. Accessible Archives: The Liberator.

8 Stauffer, *Black Hearts of Men*: 163–5.

9 There are two archived copies of the photograph. They are held by the Getty Museum and the Madison County Historical Society.

10 Michael L. Carlebach, *The Origins of Photojournalism in America* (Washington: Smithsonian Institution Press, 1992). On private exchanges, see David Henkin, *The Postal Age: The Emergence of Modern Communications in Nineteenth-Century America* (Chicago: University of Chicago Press, 2006): 57–60.

1.4

Antietam Sketches and Photographs, 1862

Anthony W. Lee

His name was John A. Clark, a lieutenant of Company D, 7th Michigan infantry. He was born to a large and prosperous family on an 80-acre farm near Ida Township, just across from the Ohio border, and almost as soon as the war began, he signed up for the Union cause. It's unclear what such a cause meant to him, whether to preserve the Union or to abolish slavery; Ida Township had no resident African Americans, though the farms in and around northwestern Ohio had been important stations in the Underground Railroad. What is clear is that he saw action almost immediately, fighting with the Army of the Potomac through much of McClellan's Peninsula campaign in Virginia. In late summer 1862, he caught some sickness, probably a virus or bacterial infection in the swampy region south of Richmond, and was sent home to recuperate. But by September, he was back at the front, as the two great armies prepared for battle at Antietam. He was then 21 years old.

The photographer Alexander Gardner could not have known any of Clark's story when he came across the young lieutenant on 19 September 1862. Clark had been killed two days earlier and, when Gardner arrived on the Antietam battlefields, was merely one of the staggering numbers of dead strewn about. The sight of so many bodies was grisly, "a pitiable sight," wrote Oliver Wendell Holmes after he, too, reached the area about the same time looking for his son, "truly pitiable, yet so vast, so far beyond the possibility of relief . . . it was next to impossible to individualize [them]."[1] By later reckonings, the numbers of Antietam dead and wounded amounted to more than 23,000, the bloodiest single battle in American history.[2] In trying to accommodate so many dead—to separate and straighten them, to dig grave after grave and bury them, all with some attempt at decency—the survivors were overwhelmed.[3] McClellan was so paralyzed by the task that he could not bring himself to pursue the Confederate army, even though he held a tactical advantage. A week later, the dead still remained mostly unburied, and the stench was such "as to breed pestilence," a Union surgeon reported with dismay, "at least a thousand blackened bloated corpses with blood and gas protruding from every orifice, and maggots holding high carnival over their heads."[4] Gardner tried to picture something of the battlefield's horrible scene (see Fig. 1.4a), showing a bloated corpse turned on its side and in rigor mortis. He also tried to show the ongoing efforts of burial, noting a grave already filled—Clark's, like those of Union officers who had been given immediate attention—and the all-too many unburied littered about, especially the Confederate infantry. And he included a survivor, who regards the gravesite and is confronted with the task of digging many more. The photographer may not have known Clark or his story, and perhaps never even learned

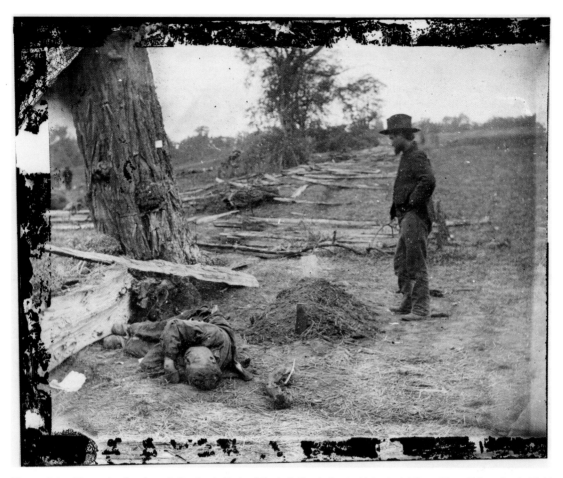

Figure 1.4a Alexander Gardner, *A Contrast. Federal Buried; Confederate Unburied, Where They Fell on Battle Field of Antietam*, 1862. Library of Congress, Prints and Photographs Division, Washington, LC-DIG-cwpb-01086.

his name, but he positioned his camera so as to capture the lieutenant's initials and military company ("JAC 7th M"), scrawled hastily on a makeshift tombstone, as if to give him some kind of recognition in the face of so many unnamed and unburied soldiers who lay everywhere else. Indeed, the marked grave stood in for those men who could not be otherwise identified and were "impossible to individualize." Gardner made sure to include in the background the wooden shards, remains of an old fence that had been blasted by gunfire and were now being used as materials for crude coffins and tombstones; the coffins often consisted of merely a wooden plank to keep the remains of a soldier from resting on cold ground. The grim process of laying the dead to rest had many more days to go.

Antietam marked the first time Gardner tried to photograph the aftermath of a battle of such traumatic proportions, and I suspect that he, like Holmes, was shocked by the "carnival of death," as the writer put it. Rummaging in the ruins, he found himself amidst a shadow army, which in the days and weeks after the battle included doctors and nurses trying to save the wounded, newspaper reporters trying to piece together the battle and its outcome, and then also coffin makers, embalmers, the local townspeople who

arrived with shovels and pickaxes to help with the enormous job of digging graves, parents searching vainly for their sons, even some tourists and relic hunters, and sketch artists and photographers. One of the artists, Alfred Waud, was also roaming about and, like Gardner, tried to summarize the awful scene; though in his mind it was best understood by the manic efforts to save the wounded and provide hope for the living (see Fig. 1.4b): on a makeshift surgical table, field doctors are desperately at work on an amputation; behind, more wounded awaiting their turn in the wagons; toward the right, a soldier, already having been attended to and having had his amputated leg bandaged, is being shuttled into a wagon for transport; and so on.

The sketch moves left to right in a kind of narrative tableau, so as to be "read" appropriately as a series of events across time, and lent itself to translation in the newspapers and magazines. A *Harper's* illustrator stayed mostly true to Waud's sequence when the picture was turned into a woodcut and appeared in the magazine a month later, in October (Fig. 1.4c), though for the sake of delicacy reversed the patient on the table to hide the amputated stump of a leg.

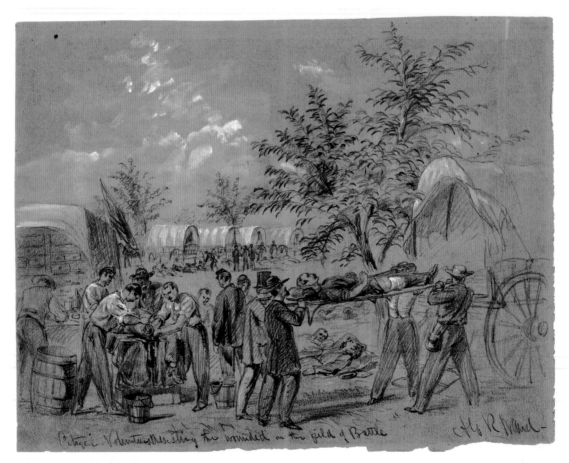

Figure 1.4b Alfred R. Waud, *Citizen Volunteers Assisting the Wounded in the Field of Battle*, 1862. From Morgan collection of Civil War drawings, Library of Congress, Prints and Photographs Division, Washington, LC-DIG-ppmsca-21468.

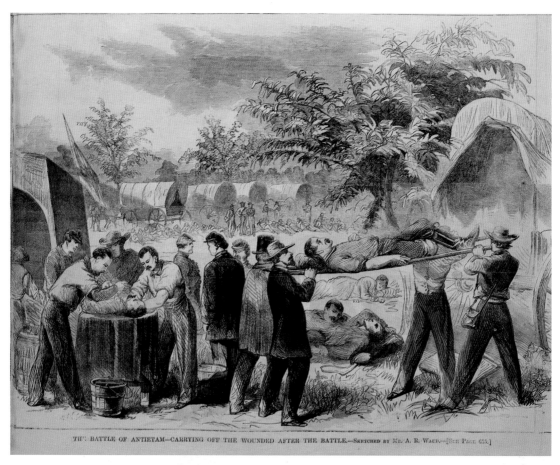

THE BATTLE OF ANTIETAM—CARRYING OFF THE WOUNDED AFTER THE BATTLE.—Sketched by Mr. A. R. Waud.—[See Page 655.]

Figure 1.4c Unknown Illustrator (after Alfred R. Waud), *The Battle of Antietam, Carrying Off the Wounded After the Battle, Harper's Weekly*, 11 October 1862.

With his big box camera and laborious wet plate method, Gardner could not approach any kind of subject moving so fluidly and, even if he wanted to, could not so easily impose such a tight narrative. But it was more than simply the limitations of his camera that dictated what and how he photographed. Or perhaps, more accurately, it was precisely because of his awareness of the camera's slowness and deliberateness that he was best able to picture in memorial terms, with an attention to the dead, not the living, and the anxious efforts to handle them. Whereas Waud's sensibility might be likened to a reporter's, trying to organize and picture the light-speed of events, Gardner's was more like that of the the coffin maker and embalmer who were, like the photographer in the field, arranging the dead for observance.

A week after *Harper's* published Waud's sketch, it published Gardner's photograph (Fig. 1.4d). The lag between the two was not uncommon; sketch artists could deliver their goods much faster, and the sketch, already in linear form, was much easier to translate into a woodcut. As with Waud's drawing, the magazine illustrator remained faithful to Gardner's photograph, making sure to include all of its major components. Clark's initials and military company are even more prominently cut and much easier to discern than in the original; for *Harper's*, like the photographer, any identifying marker was important.

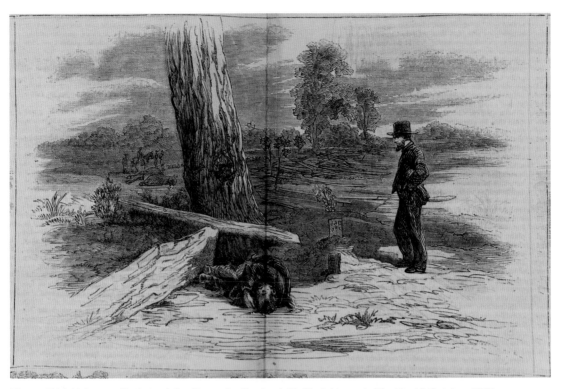

Figure 1.4d Unknown Illustrator (after Alexander Gardner), Untitled, *Harper's Weekly*, 18 October 1862.

And yet, in being published in *Harper's*, the photograph risked being transformed from memorial-like to journalistic-like. It was even accompanied by a long description of the sort that tried to provide a narrative for it, full of character and plot and moral. "There is such a dash of sentiment in it," observed a *Harper's* writer:

> that it looks more like an artistic composition than a reproduction of reality. A new-made grave occupies the centre of the picture, a small head and foot board, the former with lettering, defines its limits. Doubled up near it, with the features almost distinguishable, is the body of a little drummer-boy who was probably shot down on the spot. How it happens that it should have been left uninterred, while the last honors were paid to one of his comrades, we are unable to explain. Gazing on the body, with a pitying interest, stands in civilian's attire one of those seedy, shiftless-looking beings, the first glance at whom detects an ill-spent career and hopeless future. It is some time, perhaps, since that blunted nature has been moved by such deep emotion as it betrays at this mournful sight.[5]

I do not think Gardner cared for the embellishments in the text; he was one of the first in a long line of photographers who grew annoyed with the contrivances and liberties taken by newspaper editors. When he left Brady's studio to set up a shop of his own later that year, he took the negative of the picture with him, published it as part of his *Photographic Incidents of the War*, printed at least two versions, one of the whole scene and another of the grave and body, and gave it the title for which it has since become

known, *A Contrast. Federal Buried; Confederate Unburied, Where They Fell on Battle Field of Antietam*.[6] In his appraisal, there is no mention of artistic niceties, shiftless onlookers, or hopeless futures. Those were things better left to illustrations like Waud's, which could fashion a story from trauma. In time, Gardner and his fellow cameramen would come to understand the roles of news photographs and occasionally offer pictures that lent themselves better to texts. They would recognize and sometimes import the strategies of illustrators. When the war was going well, they would understand the hunger for information and the need for promising news for a northern readership. In bad times, they would learn how to ease anxieties and, in some cases when the moment demanded it, skirt the censor's hand. But at least in these early days of war photography in its regard of death on such a massive scale, the camera had more solemn purposes.

Notes

1 See the whole remarkable essay, Oliver Wendell Holmes, "My Hunt after the Captain," *Atlantic Monthly* (December 1862): 738–64.

2 The numbers sometimes vary, though 23,000 has become conventional. See James M. McPherson, *Battle Cry of Freedom: The Civil War Era* (New York: Oxford University Press, 1988): 544. An earlier estimate of more than 26,000 is given by Thomas L. Livermore, *Numbers and Losses in the Civil War in America, 1861–65* (Boston: Houghton Mifflin, 1901): 92–3.

3 On the traumas and meanings associated with the Civil War dead, see Drew Gilpin Faust, *The Republic of Suffering: Death and the American Civil War* (New York: Alfred A. Knopf, 2008); and Franny Nudelman, *John Brown's Body: Slavery, Violence and the Culture of War* (Chapel Hill: University of North Carolina Press, 2004).

4 *A Surgeon's Civil War: The Letters and Diary of Daniel M. Holt, M.D.*, James M. Grenier, Janet L. Coryell, and James R. Smither, eds (Kent, OH: Kent State University Press, 1994): 28.

5 *Harper's Weekly* (18 October 1862): 663.

6 On the two versions, which are stereoviews, see William A. Frassanito, *Antietam: The Photographic Legacy of America's Bloodiest Day* (New York: Charles Scribner's Sons, 1978): 178–81.

1.5
Barricades of Paris Commune, 1871

Jeannene Przyblyski

In 1871, photographs of the revolutionary crowds who posed in the streets of Paris on 18 March were not the "news." The mainstream press, when it referenced such images at all, treated them as a joke. The news-consuming public in turn saw them largely as an aberration—a momentary delusion that interrupted the seemingly inevitable chain of authentically newsworthy events that spring . . . the sounding of the tocsin, the uprising of the people, the building of the barricades, the battle in the streets, the city laid to ruins, the restoration of order, and so on.

For its subjects, however, the photographs were no laughing matter—like so many revolutionary gestures of the long nineteenth century, the improvised photo opportunities staged on the barricades that marked the beginning of the workers' insurrection known as the "Paris Commune" ended in disaster. In the days following the Commune's bloody suppression in May, the barricade photographs would be rounded up by the police and used as wanted posters, entering the archives as evidence, their apparent real-and-trueness mediated not by journalistic objectivity but by judicial authority. Case closed.

And yet, while not news photography as we understand it today, photographs like the one on the rue Saint-Sebastien establish some of its preconditions: the camera brought out of the studio and into the world at large, aspiring to be more mobile if not yet nimble—not yet able to be consistently "on the spot" and on the hunt for the "shot." At the same time, they demonstrate a faith in photography's origins in the studio, holding tight to the studio conventions of the stage (now the street), the prop (now the barricade), and the pose (I am . . . still . . . here). For the most part the news photograph would eventually aspire to excerpt from the world rather than to represent the world as a public stage—it would tend to obliterate the platform of public space in favor of the speed, flatness, and fluidity of the mediascape—one decontextualized image/crop yielding to another, producing a kind of iconic repetition—the news as collective imaginary, an endless circulation of mediated images of reductive sameness that is mistaken for reality.

But look again: as much as we should not mistake this for a news photograph, it also seems to leap ahead, propelling us past the classic conventions of news photography as they would be codified by the major picture agencies of the twentieth century, and finding common ground instead with a more recognizably contemporary experience of the news in which each person in the picture might choose, however provisionally, to mediate his or her own presence at history in the making.[1] It's no accident that this is an image of a *crowd* and its *source* is contested. It poses the question: do we give agency to the

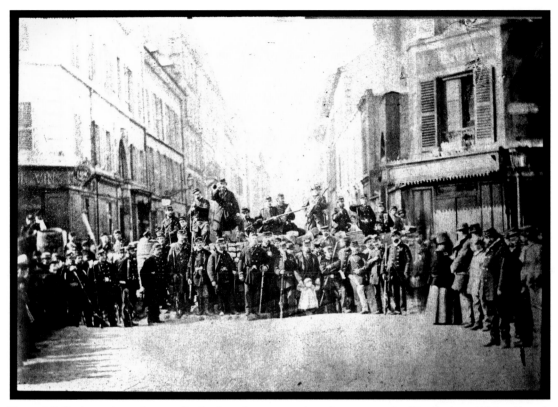

Figure 1.5 Photographer unknown, *Barricade and communards on the crossroads of the Boulevard Richard Lenoir and Rue Saint-Sébastien*, Paris, France, 18 March 1871. Collection of Bibliothèque historique de la Ville de Paris. © BHVP/Roger-Viollet/The Image Works.

anonymous person standing behind the camera (this is the dominant narrative of news photography as authoritative "eyewitness" waiting to be fulfilled) or do we also pause for a moment, letting agency remain with the people who claimed it, performatively, making up history by facing the camera head on?

My questions are predicated on the barricades themselves as a revolutionary device, a way of inhabiting the space of the street that instigates, to use Hannah Arendt's words, the "space of appearance" where the act of people assembling voluntarily and without hierarchy (re)opens the foundational conditions of collective speech and action—revolutionary politics as such (the lack of hierarchy is one reason why battle on the barricades so often gave the advantage to the suppressors).[2] Even more so, these questions proceed from the Commune's linkage of this volatile "space of appearance" to contemporary media. Consider again the willingness of the Communards to stand still before the camera. Exposure times were fairly long in 1871. If you moved too quickly you were out of the picture (and you can sometimes catch traces of these "ghosts-in-motion" around the edges of the barricade photographs). In this sense, the provocation of the barricade image as a counter proposal to the emergent conditions of photography as "the news" is paradoxical: it is enabled by an obdurate allegiance to the almost obsolete duration of the studio pose. The stillness of the Communards would seem to embody, prospectively, something like

"the paradoxical synthesis of social *movement* and *mobilization* with *immobility*, the refusal to move," that W. J. T. Mitchell has associated with "occupation" in his writings on the Occupy Wall Street movement.[3]

The barricade photographs prefigure this twenty-first century visual culture of media "occupation"— they are contemporary *again* in that regard. They stand as one of those intermittent moments when the official, editorial authority of the "news" is reconfigured as a more social, decentralized, distributed mediation of events. To be sure, despite somewhat giddy claims around the Arab Spring in 2010 and Occupy Wall Street in 2011, we still haven't quite figured out what the most recent conditions of "social media" might ultimately engender, and we would be foolhardy to be completely convinced of their power to change much of anything. But I take this nascent sense of possibility, this voluntary occupation of the media, as significant and newsworthy, however tenuously it must be held open *as possibility*, and however much I suspect it may be foreclosed yet again for the all-too-familiar alternative. In 1871 as now, the spectacle that preoccupied the news more often than not was the revolution in ruins.

Notes

1 For more on the quality of stillness with regard to these photographs, see Jeannene Przyblyski, "Revolution at a Standstill: Photography and the Paris Commune of 1871," *Yale French Studies* 101 (2001): 54–78. For more on the relevance of nineteenth-century photography to twenty-first-century media conditions, see Jeannene Przyblyski, "Loss of Light: The Long Shadow of Photography in the Digital Age," in Robert Kolker, ed., *The Oxford Handbook of Film and Media Studies* (Cambridge, UK: Oxford University Press, 2008): 158–86.

2 Hannah Arendt, *The Human Condition* (Chicago: University of Chicago Press, 1958): 199, quoted in W. J. T. Mitchell, "Image, Space, Revolution," in Bernard E. Harcourt, Michael Taussig, and W. J. T. Mitchell, *OCCUPY: Three Inquiries in Disobedience* (Chicago: University of Chicago Press, 2013): 103.

3 Mitchell, "Image, Space, Revolution": 105.

1.6
Interview of Chevreul, France, 1886*

Thierry Gervais

In the 1880s, the German Georg Meisenbach, the American Frederic Ives, and the Frenchmen Charles-Guillaume Petit and Stanislas Krakow all developed photomechanical printing processes that allowed photographs to be reproduced in the press without the intermediary of an engraver.[1] Although still very hands-on, these methods meant the photograph's grayscale could be accurately reproduced, as seen in Nadar's photographic interview with the scientist Eugène Chevreul, published in *Le Journal illustré* on 5 September 1886.[2] For this feature, which was intended to mark Chevreul's hundredth birthday, Nadar developed a unique strategy: a carefully orchestrated combination of photography and words, with the latter appearing as a direct transcription of the scientist's words as obtained during the interview process. "For the first time," Nadar said, "the reader is going to be the spectator, as if he were actually present."[3] An analysis of the interview reveals not only Nadar's illustrative methods, but also the venture's experimental character.

In 1880s France, the interview was coming to be seen as a means of conveying news to the reader in a more direct way.[4] Nadar added photography to this journalistic approach. With the photographic recordings being carried out by renowned scientists, such as Jules Janssen and Étienne-Jules Marey, attracting attention in France,[5] photography appeared to Nadar as a legitimate investigative tool. The photographic image was thought to offer direct access to events: "with the Nadar system there is no interpretation: this is exact reproduction . . . One has a document that is absolutely exact."[6]

This photographic interview is the result of meticulous efforts on the part of Nadar. He began by selecting thirteen photographs from among the extant fifty-eight, and of Chevreul's remarks chose only those that interested him, such as the scientist's views on aerial navigation. Last and most important, he was quite flexible in the way he associated image and speech. Historian Geneviève Reynes tried to match the transcripts of Nadar's three interviews with Chevreul with Nadar's photographs but found that this was impossible: "The captions for these photos were allotted at random: Chevreul says something in one photo, but in the following one we find words spoken on a different day about a different subject . . . Worse still, several prints of the same photo do not have the same caption or, conversely, the same sentence is attributed to two different photos. And sometimes the extract appended to a photograph cannot be found in the full text of the interviews."[7]

Despite his claim to an "exact reproduction," Nadar took a narrative approach unencumbered by any objective transcription. He numbered the images and re-wrote and ordered his subject's words as he

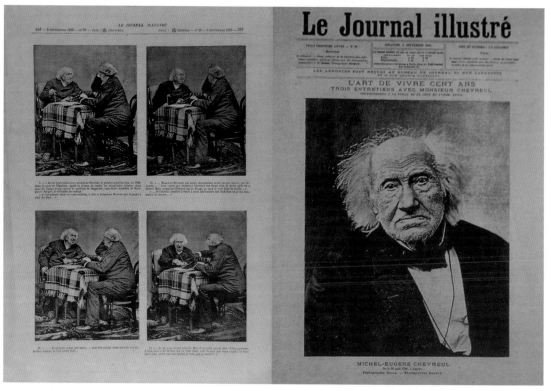

Figure 1.6 *Le Journal illustré*, vol. 23, no. 36, 5 September 1886, cover (right) and p. 288 (left). Private collection.

saw fit, constructing a coherent story for the reader that nonetheless had little to do with how the interviews actually unfolded. By way of an introduction, the first photograph shows Chevreul looking quizzically at Nadar's guestbook; the caption reads "and what would you like me to write here?" In the second, Chevreul's pose, less overtly expressive and so more manipulatable, allows Nadar to insert his subject's opinion of the work of Louis Pasteur. In the third, a pensive Chevreul is seen pen in hand and, according to the caption, about to write down his guiding principle—which he is doing in the fourth photograph, bent over the guestbook. The words he is writing are used as the caption: "One must strive for infallibility without laying claim to it. Chevreul." The narrative then continues with the other images, covering the everyday philosophy of this scientist "who drinks nothing but water" and declares himself willing to believe only what he sees. The thirteenth image concludes the interview: mouth open and hand outstretched emphatically, Chevreul is made to say, "I haven't told you everything. But telling is not enough, one has *to prove*, one has *to show*! I have to *make you see*! You have to *see*! *I want to show, because it's when I see that I believe!!!*" A fine ending, since it sums up Chevreul's scientific method and justifies Nadar's journalistic method, his joining of images and words in the illustrated weekly. Scientist and journalist are depicted as working together, pursuing the same goal: to provide his audience with visual evidence—the only kind that they, and we, will believe.

Nadar's photographic interview indicates a change in journalistic methodology, from one modeled on the art of literature to one modeled on the art of science. As a journalist, Nadar wished to align himself with Chevreul and be recognized as a man who, like his interview subject, was engaged in rigorous

investigation. But although photography was already playing a decisive role in journalism at the time, neither photographers, printers, nor even readers would accept it as a valid journalistic approach until the late nineteenth century, when the first magazines foregrounding photography appeared.[8] Nadar's reportage also reveals the adjustments that were necessary to the effective communication of news through photographs. His use of a recording method influenced by scientific protocol and a reproduction process—halftone—that captured the grayscale of photographs produced a story more realistic than any that had come before. But the mechanical precision of both the production and reproduction of the photographs were not enough; the photographs still had to be sequenced, numbered, captioned, and arranged on the page in order to create the image of Chevreul that Nadar wanted. Only then did they show the scientist as an erudite centenarian up to speed with the latest research methods common to both science and journalism.

Notes

* This chapter translated from the French by James Gussen.

1 Thierry Gervais, "La Similigravure: le récit d'une invention (1878–1893)," *Nouvelles de l'Estampe*, 229 (March–April), 2010: 2–29.

2 "L'art de vivre cent ans," *Le Journal illustré*, 23.36, 5 September 1886: 281–8.

3 Nadar, Bibliothèque Nationale de France, Mss, N.a.f, fol. 55.

4 Christian Delporte, "Information et reportage: début du règne," in *Les Journalistes en France, 1880–1950. Naissance et construction d'une profession* (Paris: Le Seuil, 1999): 60–4; and Vanessa Schwartz, *Spectacular Realities: Early Mass Culture in Fin-de-Siècle Paris* (Berkeley/Los Angeles/London: University of California Press, 1998): 40–2.

5 Marta Braun, "Aux Limites du Savoir. La photographie et les sciences de l'observation," in André Gunthert and Michel Poivert, eds., *L'Art de la photographie des origines à nos jours* (Paris: Citadelles-Mazenod, 2007): 140–77.

6 Thomas Grimm, "L'art de vivre cent ans," *Le Petit Journal*, 8649, 31 August 1886: 1.

7 Geneviève Reynes, "Chevreul interviewé par Nadar, premier document audiovisuel (1886)," *Gazette des beaux-arts* (November 1981): 154–84.

8 Only *Le Figaro* attempted the exercise, three years later: "Entrevue photographique," *Le Figaro*, "Supplément littéraire," 47, 23 November 1889: 1–3.

1.7
Zapata and Salinas, Mexico, 1911 and 1991

John Mraz

Some news images have the power to circulate in manifold forms, living on as icons of pivotal events and/or being appropriated for new situations. One that provides a complex demonstration of this process is Elsa Medina's 1991 photograph of Mexican President Carlos Salinas de Gortari (1988–1994), seated before a portrait of agrarian revolutionary Emiliano Zapata. Medina captured the juxtaposition between Zapata's image and President Salinas to criticize the party dictatorship that has been a persistent legacy of the Mexican Revolution (1910–17). A master at capturing spontaneous action in a fraction of a second, Medina also has the ability to provoke reactions in her subjects. Salinas was known among photojournalists to be particularly playful, and Medina—young and attractive—no doubt stimulated his roguishness. The collaboration between Medina and Salinas resulted in an image of the president gesturing grotesquely (perhaps making a face of derision) in front of a painting that replicates Zapata's famed photographic icon. This tableau issued from a meeting at the presidential residence whose purpose was the termination of agrarian reform, a cornerstone of Zapata's political program that became a pillar of the 1917 Mexican Constitution.

Photography is sometimes a dialectic between those who are being pictured and those who are doing the picturing. As seen from Medina's side of the camera, the photo is a penetrating critique of the ways that the PRI (Partido Revolucionario Institucional) has employed the revolutionary heritage—incarnated in the gigantic portrait—that has served to legitimate its party dictatorship, but which it has not respected. This contradiction was particularly pronounced in the case of Salinas, for his administration frequently utilized the figure of Zapata, both visually and verbally, in pushing its neoliberal, antiagrarian agenda. Although Medina pilloried Salinas, he was no doubt conscious of the backdrop and responded so as to create an image that was also an accurate representation of his position in relation to the Mexican Revolution. His policies broke fundamentally with the long-standing ideological subterfuge of pretending that the PRI was somehow an expression of revolutionary governance.

However, the publication that employed Medina, the leftist *La Jornada*, either did not want to spread that message or thought that the photo was too critical of Salinas, because it was censored. Instead, Medina's image has circulated in a left political pamphlet, a critical videotape, popular history books, and at expositions such as my 1996 Mexico City exhibit (and book) on the New Photojournalism of Mexico, *La Mirada Inquieta* (*An Unquiet Gaze*). Medina and the other New Photojournalists of Mexico look beyond a press photograph's usual life expectancy of 24 hours by insisting that authors have a right to their

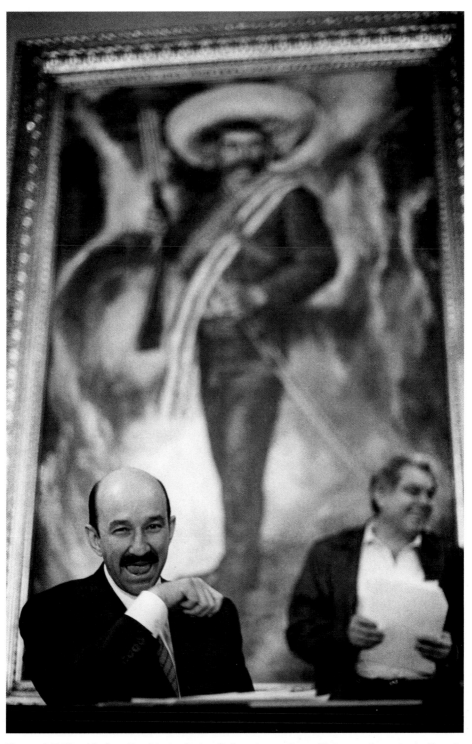

Figure 1.7 Elsa Medina, Presidente Carlos Salinas in meeting with campesino organizations to reform Article 27 of Constitution, presidential residence "Los Pinos," Mexico City, 1991. © Elsa Medina, courtesy of Elsa Medina.

negatives, which they later employ widely in expositions, books, magazines, and other media that make them visible, even if periodicals refuse to publish them.

The photograph of Emiliano Zapata also had an untypical history of circulation. The picture of the revolutionary leader in Cuernavaca during May of 1911 has become an international icon, and one of the most reproduced photographs from Latin America. Although authorship of the image was claimed by the Casasola family in their massive picture histories, Zapata's suspicions of Agustín Víctor Casasola's ties to conservative periodicals would have made that difficult. Later, it was argued that Hugo Brehme, a German immigrant, took the photo, and still later claims were made in support of Fred Miller, a US photographer. The fact that an outsider (whoever it was) could get close to the fearsome warrior reinforces the idea of Zapata's concern for constructing his own image; he may have felt that someone from another country would be more neutral than the capital's photojournalists, and that the image would thus reach eyes outside Mexico.

Zapata had little trust in the Mexico City press, and rightly so, considering the eventual use it made of this picture. The icon did not appear in a periodical until 1913, two years after it had been made, when it was employed as a front-page illustration for an attack on Zapata by the reactionary newspaper, *El Imparcial*, that characterized him as "Attila of the South."

The photograph may represent a startlingly graphic depiction of Zapata's triumph. The leader is dressed with the general's sash and sword that the previous authority in Cuernavaca had worn as a symbol of his status. Putting them on was apparently a demonstration of the prerogative Zapata had evidently acquired to determine who would govern the city and Morelos State. The photograph was probably made when Zapata arrived in Cuernavaca, and the city filled with photographers, foreign and Mexican, to register his assumption of power. Zapata's wearing of these emblems could represent an attempt on his part to counteract the Mexico City press, which portrayed him and his *campesinos* as cruel bandits and ferocious savages. Zapata may have been attempting to oppose that mindset by presenting himself as a professional soldier, with the rank of general, and thus a man deserving of Francisco Madero's political recognition—an allegiance buttressed by the crossed cartridge belts, a trope of the Maderista rebellion in 1911.

Before it was published in the newspaper, the image no doubt circulated as a postcard, a medium of extraordinary importance in that period. José Guadalupe Posada, the most famous of Mexican lithographers, must have seen the postcard, and created an engraving of it. After Posada's death in 1913, his lithograph was distributed on broadsheets, some of which were critical and others laudatory of Zapata. Posada was an artisan, and his contribution would have to be considered a form of popular culture, although the widespread distribution of broadsheets would also make them a mass medium of the era.

In sum, powerful news photos such as Medina's and that of Zapata live on in ever-transfiguring forms, shaping and being shaped by the different functions they serve. Sometimes they evolve into icons related to great transformations, at other times they are reduced to the crassest of commercial purposes.

1.8
Photographer on the Western Front, 1917

Caitlin Patrick

Lieutenant Ernest Brooks stands posed in a trench on the Western Front, holding his favored Goerz Anschutz plate camera, which was considered compact and reliable at the time. Although this photo is dated 1917, Brooks was the first professional photographer to cover British forces at this key battle site. After a military ban on unofficial troop photography in 1915, Brooks was expected to provide a record of battles that, to a large extent, were happening unseen by the citizens of countries sending their troops by the hundreds of thousands into the "Great War" begun in 1914. Photographic representation of this unprecedented conflict has been deeply affected by various forms of censorship. Beyond regulated controls, official photographers appear overwhelmingly to have believed in the necessity and righteousness of the fighting. This outlook undoubtedly shaped their approach to their subject matter. Outside of the official photographic collections, the estimated thousands of "unofficial" photographs produced mainly by soldiers, mostly on small, affordable Kodak and Brownie cameras, remain dispersed throughout private and public archives. Yet Brooks, among other official World War I photographers, has provided a large and rich collection of photographs, which remain difficult to access.

In their imaginings of the Great War, popular literature, poetry, and film have given particular attention to the horrors of trench warfare, and there is certainly photographic documentation to support these accounts. Much of the photography tells a different story, however; one that testifies to the pride and camaraderie of the war's participants, as well as the daily practicalities of managing and supporting millions of fighting troops.[1] Though the concept of the "war photographer" was still very much in its infancy, publications of the time already attributed many now-recognizable traits of those in this profession to Brooks. He apparently had "no nerves" and showed remarkable dedication to capturing photographs under heavy fire and in extremely difficult conditions.[2]

Such intrepid behavior was not only in the face of battle but also in dialog with strict governmental regulation. From August 1914, the War Propaganda Office organized for photographs first to be censored in the field and then sent to the London-based Press Bureau for final approval and distribution. Approximately a dozen official photographers were eventually commissioned to shoot on the Western Front, covering the major allied nations. Assigned vast swathes of territory and large numbers of troops to cover, the photographers were responsible not only for battle shots but also for pictures of troop leisure time, visiting dignitaries and equipment shots.[3] Although he was supported by photographers in

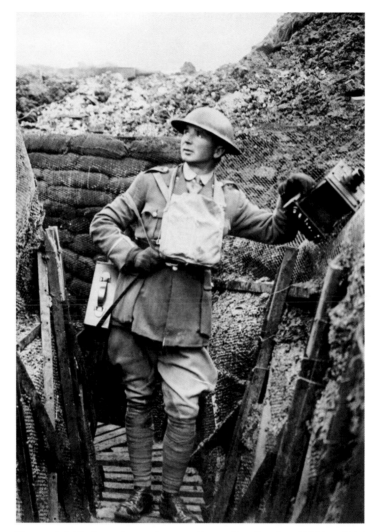

Figure 1.8 Photographer unknown, Ernest Brooks, first British official photographer to be appointed, seen in a trench on Western Front, 1917. Imperial War Museum. © Crown Copyright. IWM.

the Royal Engineers, Ernest Brooks, the first official British photographer of WWI, was eventually responsible for covering nearly two million troops on the Western Front.[4]

Getting close to the action during battles involving large morasses of destroyed "no-man's land," and heavy artillery use was difficult, but Brooks managed to photograph some dramatic explosions during the Battle of the Somme in 1916. Newspapers eagerly used such photographs when they arrived in London a week after 1 July 1916. Occasionally the stagnation of fighting allowed for the capture of powerful images of daily conditions for front-line troops, such as William Rider-Rider's photo of Canadian troops "holding the line" in a flooded mud field of shell-holes in 1917. Due to censorship and patriotic attitudes, as mentioned above, few photographs of "our" dead or extremely wounded were taken by the official photographers, though some exist in archives. Allied official photographers' and German military

photographers' photos of "enemy dead", often in destroyed trenches or in "no-man's land," constitute a more common iconography.

In assessment of official photography, some commentators have argued that it remained limited to "archaic images of individual suffering and heroism," failing to challenge the promoted government propaganda narrative.[5] Historians such as Holmes, on the other hand, defend the many photographs showing camaraderie and moments of happiness amongst the troops, insisting on the legitimacy and importance of these experiences as well as those of death, injury, and horror. Although by the era of the Great War, the war photographer was already becoming a recognizably intrepid "type," the imagery he produced, that audiences were able to view in the press, were visually less exciting than the action at the front. Regardless of how publicly-available press photographs of the time are read, there can be little question that they were constrained and limited. At present, archives can offer up many photographs which did not clear censorship of the day and provide the possibility of richer interpretation of how photographers, if not the public at large, saw the Great War.

Notes

1 See Richard Holmes, *Shots from the Front*, London: HarperPress, 2010.
2 Basil Clarke (Special Correspondent at the Front), "Camera Correspondents," in *The War Illustrated*, 7 July 1917.
3 Jane Carmichael, *First World War Photographers*, London: Routledge, 1989: 16.
4 Howard Chapnick, *Truth Needs No Ally: Inside Photojournalism*, Columbia: University of Missouri Press, 1994.
5 Matthew Farish, "Modern witnesses: foreign correspondents, geopolitical vision and the First World War," *Transactions of the Institute of British Geographers* 26.3, 2001: 279.

1.9
Sports Photomontage, France, 1926

Michel Frizot

The end of the 1920s in France was characterized by the widespread use of rotogravure printing to reproduce photographs in weekly magazines. The creation of *VU* (21 March 1928) provides a concrete example of this expansion, and was followed by a number of similar publications. *VU* firmly established a number of aesthetic and graphic practices in the mass circulation of photographs, particularly the presence of multiple photographs on every page and the use of photomontage as tool for social or political commentary.[1] I would like to highlight one of *VU*'s predecessors—the groundbreaking but little-known *Match l'intran*[2]—to demonstrate the causal relationship between techniques used to print images and the formal, iconic, and aesthetic possibilities available to "graphic designers," page layout specialists, and art directors.

The introduction of halftone printing in the 1890s made it possible to publish an abundance of photographic illustrations. The 1910s then saw the spread of rotogravure, an intaglio process that provided more subtle reproduction of the formal nuances and tonal gradations characteristic of photography. Its establishment coincided with World War I and facilitated the publication of numerous magazines richly illustrated with photographs of the war, although they rarely took advantage of the technical possibilities of rotogravure. What were those possibilities? In intaglio printing, the tonal variation of the photograph is systematically broken down into microscopic squares forming an orthogonal grid. These squares are etched in an acid bath then filled with ink; their depth determining tonal density. This had major repercussions for the process of preparing images for print.

In halftone printing, each image became a metal plate, which was inserted into the form containing type for each page. The steps in rotogravure were completely different, and new, giving them transformative potential. First, positive prints of the images to be used (enlarged or not) were made on individual pieces of transparent celluloid *film*, which were used to prepare the printing plates. Metal plates for each photograph were replaced by these films—supple and inexpensive, quick to reprint in different sizes, and easy to add things to and to retouch. Above all, these film images could be *cut* with scissors and assembled—glued one next to another, or even one over the other, with adhesive paper. The process of assembling films carrying photographs, texts, and headlines (either cut out or painted) was the most innovative stage of rotogravure. It was done on a backlit table, an instrument inexistent in halftone or letterpress studios. Each magazine page became a large film mounted on a glass plate, and resulted from the careful composition of multiple smaller *positive* films. The strict, geometric organization of the

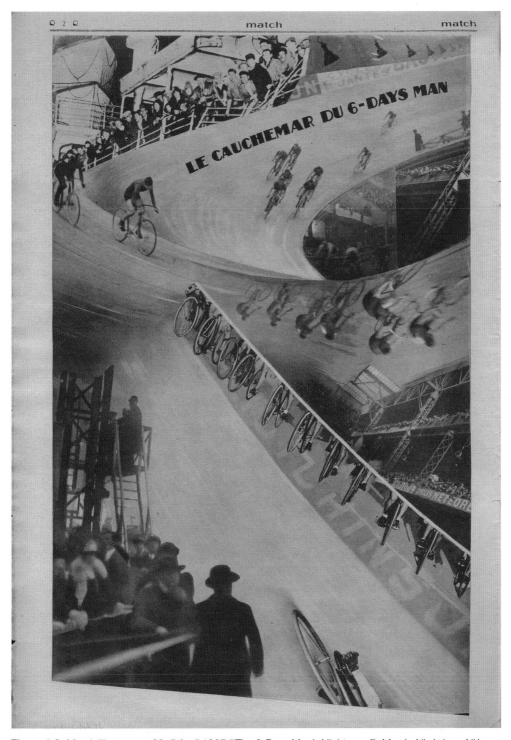

Figure 1.9 *Match l'intran*, no. 22, 5 April 1927 ("The 6-Days Man's Nightmare"). Musée Nicéphore Niépce, Chalon-sur-Saône.

halftone page gave way to the manifold possibilities created by the process of assembling photographic fragments that could be infinitely and easily manipulated, moved, and modified. This technical procedure led naturally to the production of "photomontages" (*montage* refers to the process of assembly in French), or compositions of individual cut-out photographs forming a new entity—an image that looks photographic but that wasn't recorded as a unit. In this phase of magazine production, the artistic director becomes a graphic artist.

The principle of photomontage had been known since the 1850s and was given a new life by the Dada movement, but rotogravure revolutionized it, granting it unprecedented exposure. Although the ties between photomontage and the use of film in rotogravure haven't gone unnoticed, they are generally associated with *VU* and the demands of its elaborate layouts. Other rotogravure magazines preceded *VU*, however—in particular *Match l'intran*, dedicated to sports and created by the publisher of *L'intransigeant*, a daily paper in existence since 1880.[3] At the end of the nineteenth century, sports had become a theme for weekly French periodicals such as *La Vie au grand air* (1898–1914), printed in halftone.[4] This publication elaborated a limited sort of photomontage using halftone, mainly presented in the central double page spread and sometimes on the cover.[5] *Match l'intran, le plus grand hebdomadaire sportif* (its full title) was launched on 9 November 1926; it had sixteen pages and measured 45 x 31 cm. The first issue was printed with purple-brown ink, with the color changing each week (green for the second, greyish-brown for the third, etc.) which contributed to the magazine's appeal. Graphic innovation related to rotogravure was conspicuous and regular from the start: spectacular full-page photographs appeared on the front and back covers, a large portrait was printed over the text on page 7, and there were photomontages on pages 10 and 12. Photomontages appeared on pages 2 and 10 starting with the seventh issue (then pages 2, 10, and 15); they were also published on the front and back covers (and in issue 23 ran on one and the other, and sometimes occupied the centerfold. There was lasting interest in the systematic use of photomontage and the superimposition of elements (photo films and text films) on at least three pages and sometimes up to six. Another characteristic of *Match l'intran* was the complexity and liveliness of its photomontages, especially on page 2, and the subtle intermingling or even fusion of elements obtained by retouching several photographs to unite them in a way that tricked visual perception. The consummate example presented here is impressive and surprising, with its strong diagonals.[6]

This handcrafted undertaking served to glorify sports. Visual energy, built using lines and apparent depth, became a metaphor for the athlete's gestures and movements. A few years later, *VU*'s photomontages were more biting and in synch with current events, as practiced by professionals like Alexander Liberman and Marcel Ichac who were very much aware of the artistic and media-related developments of photomontage in Germany and the USSR in the wake of Moholy-Nagy and Rodchenko. The designers and technicians at *Match l'intran* may not have had the same references. More likely, they were playing with their new freedom from the constraints of the halftone process and with the modernity of cutting and assembling elements, leading them to push the expressive potential of rotogravure and its malleable films and images to an exciting new level.

Notes

1 Michel Frizot and Cédric de Veigy, *VU, The Story of a Magazine that Made an Era* (New York: Thames and Hudson, 2009).

2 Despite its quality and inventiveness, *Match l'intran* isn't mentioned in Robert Lebeck and Bodo von Dewitz's excellent study *Kiosk, Eine Geschichte der Fotoreportage, A History of Photojournalism* (Göttingen: Steidl, 2001).

3 Also in 1928, *L'intransigeant* created *Pour vous l'intran* (1928–40), a cinema weekly printed in rotogravure.

4 See Thierry Gervais, "L'invention du magazine. La photographie mise en page dans *La Vie au grand air*," *Études photographiques* 20 (2007): 50–67. See also Gervais, chapter in this volume.

5 Halftone photomontages were more like collages, with a juxtaposition of geometrically shaped images, as opposed to photomontages of the 1920s, which fused their elements.

6 *Match l'intran* 22 (5 April 1927): 2. Thanks to the Musée Nicéphore Niépce in Chalon-sur Saône, which owns a set of *Match l'intran*.

1.10
Public Execution, Sing Sing Prison, 1928

Richard Meyer

On the night of 12 March 1927, Albert Snyder, an art editor for *Motor Boating* magazine, was bludgeoned and strangled to death in his home in Queens, New York. Snyder's wife, Ruth, described the murderers as a pair of overweight Italian-speaking intruders who attacked without warning. As was quickly ascertained by the police, Ruth's story was entirely fictional. The actual intruder was Ruth's lover, corset salesman Judd Gray of East Orange, New Jersey, and the killers of Snyder were Gray and Ruth herself. Shortly before the murder, Ruth had taken out a $48,000 life insurance policy on her husband. The policy carried a so-called "double indemnity" clause, which meant that, in the case of a violent death, the beneficiary (Ruth) would be paid twice the face value.

The double trial of the lovers created a media sensation in the local, national, and even international press. The *New York Daily Mirror*, the *Daily News*, and *Evening Graphic*, the city's major tabloids, covered the trial with a disproportionate degree of visual attention focused on Ruth. Photograph after photograph of the accused murderess was published alongside written accounts of her physical, sartorial, and emotional state. No other criminal event up to 1927 allegedly generated as many images.[1]

Both Gray and Snyder were found guilty of first-degree murder and sentenced to death by electrocution at Sing Sing prison. No photography was permitted in the execution chamber but this did not dissuade the *Daily News* from commissioning a picture of the event. Because the presence of a local photographer at the execution would have been deemed suspicious, the *News* dispatched Tom Howard, a Chicago-based photojournalist, to attend the electrocution. Howard strapped a miniature plate camera to his ankle and then ran a shutter release cable up his pant leg and into his pocket. Because of its small size, Howard's camera could carry one glass plate, meaning that the photographer had but one opportunity to get the desired picture. At the precise moment when Snyder was executed, Howard pointed his foot toward the electric chair, raised his pant leg, and snapped a shot of the scene.

The uncropped version of Howard's picture shows Snyder seated in the electric chair near the background corner of the photograph, with the fragmented figures of various prison officials in nearer space. As cropped, enlarged, and printed by the *Daily News*, the picture seems to provide head-on, unmediated visual access to Snyder. It is, perhaps, because of the degree of enlargement and retouching that was necessary to achieve this view that Howard's picture loses a certain degree of pictorial resolution or crispness, and achieves a visual quality somewhere between photographic and hand-drawn. In this

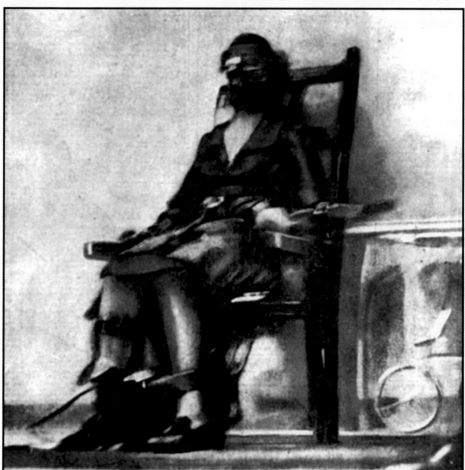

RUTH SNYDER'S DEATH PICTURED!—This is perhaps the most remarkable exclusive picture in the history of crimi-nology. It shows the actual scene in the Sing Sing death house as the lethal current surged through Ruth Snyder's body at 11:06 last night. Her helmeted head is stiffened in death, her face masked and an electrode strapped to her bare right leg. The autopsy table on which her body was removed is beside her. Judd Gray, mumbling a prayer, followed her down the narrow corridor at 11:14. "Father, forgive them, for they don't know what they are doing?" were Ruth's last words. The picture is the first Sing Sing execution picture and the first of a woman's electrocution. *Story p. 3; other pics, P. 28 and back page.*

Figure 1.10 Tom Howard, Execution of Ruth Snyder on New York *Daily News* cover, "Dead!", 13 January 1928. *NY Daily News* via Getty Images.

sense, it is almost as though the picture were combining the different sorts of visual images—photographs and illustrations—that the *News* used in its coverage of the trial.

Together with the exclamatory headline ("Dead!"), the picture stood virtually on its own as front-page news. Indeed, an extra half million copies of the newspaper were sold on 13 January 1928, the day the electric chair photograph ran on the front page. A caption running beneath the picture emphasized its lurid audacity:

Ruth Snyder's Death Pictured! This is perhaps the most remarkable exclusive picture in the history of criminology. It shows the actual scene in the Sing Sing death house as the lethal current surged through Ruth Snyder's body at 11:06 last night. Her helmeted head is stiffened in death, her face masked and an electrode strapped to her bare right leg. The autopsy table on which her body was removed is beside her. Judd Gray, mumbling a prayer, followed her down the narrow corridor at 11:14. "Father, forgive them, for they don't know what they are doing?" were Ruth's last words. The picture is the first Sing Sing execution picture and the first of a woman's electrocution.[2]

In reading this caption today, we cannot fail to register the grim parallel between the electrode strapped to Snyder's leg and the camera covertly strapped to Howard's. If camera and electrode became peculiarly twinned devices at the moment of Snyder's execution, so the illicit commission of Howard's photograph came to rival the Snyder–Gray case as a topic of public fascination and, in certain circles, outrage.

The New York State Commissioner of Corrections, for example, asked the Attorney General to prosecute the *Daily News* but, in the end, no legal charges were brought against either Howard or the newspaper. But *the News* did issue an editorial in response to the controversy:

We doubt that many readers of *The News* want any apology from us for having obtained and printed this picture. Considered a feat of newspaper enterprise, the publication of the photograph was remarkable and will not soon be forgotten . . . the incident throws light on the vividness of reporting when done by camera instead of pencil and typewriter . . . Why other newspapers, which gave column after column of infinitely more gruesome descriptive language to the Snyder execution, should criticize THE NEWS for publishing a photograph thereof is something we cannot understand.[3]

Tabloid newspapers had long recognized (and exploited) the unique power of photographic images to render the news vivid and immediate. The difference between the *News'* visual capture of the Snyder execution and the "descriptive language" of its rivals in covering the same event would have been clear to the paper's editorial staff. Yet the primary claim of the editorial—that the publication of the photograph was "a feat" that would long be remembered—has proven quite accurate.

Today, the photograph is typically recalled not because of the crime that occasioned the execution. Indeed the crime is not even very sensational by today's more violent standards. Instead, the photograph is remembered because of Howard's ingenuity at capturing it. On display at the Newseum in Washington, DC is both a facsimile blow up of the "Dead!" front page of the 13 January 1928 edition of the *Daily News* and, on loan from the Smithsonian, the modified miniature plate camera, complete with ankle strap, that Howard used to capture the photograph. It is the surprise attack of photography—rather than the murder of one's husband for money—that now seems to capture the public imagination.

Notes

1 V. Penelope Pelizzon and Nancy M. West, *Tabloid, Inc: Crimes, Newspapers, Narratives* (Columbus: Ohio University Press, 2010): 124.

2 *New York Daily News*, 13 January 1928: 1.

3 *Daily News* editorial, cited in William Hannigan, "News Noir," in *New York Noir: Crime Photos from the Daily News Archive* (New York: Rizzoli, 1999): 15.

1.11
Photo of Kellogg–Briand Pact Meeting, Paris, 1931

Daniel H. Magilow

In the late 1920s and early 1930s, the German-Jewish photojournalist Dr. Erich Salomon (b. 1886, Berlin–d. 1944, Auschwitz) covered trials, political summits, and society functions. He avoided attracting attention by dressing appropriately (sometimes in tuxedos), and mimicking his subjects' manner and style.[1] To cite his 1931 photo book's title, Salomon captured "famous contemporaries in unguarded moments," when they would, in principle, reveal their true faces.[2] Using specially modified hats, walking sticks, and tiepins to conceal lenses and cufflinks to conceal the shutter release, he secretly photographed in low light conditions. He voluntarily surrendered dummy negatives to authorities to keep them from confiscating his real ones, which he then published in illustrated magazines (*Illustrierten*), notably the *Berliner Illustrirte Zeitung* and *Uhu*. Editors marketed him as a celebrity photographer, "Dr. Salomon," the intrepid journalist who revealed the difficulties (and boredom) of parliamentary democracy and served as readers' advocate against the powerful.[3] He stands out as Weimar Germany's most famous photojournalist and an innovator of candid-camera style photojournalism.[4]

Yet to end here is to bypass an opportunity that the work of this foundational photojournalist offers for reflecting on the aesthetic, ethical, and political questions that candid snapshot form invites. Salomon's secretive, transgressive, and sometimes illegal approach heralded activist photojournalism that exposes atrocities and injustices. But did his role in legitimizing the easily (re)produced, exchanged, and consumed candid snapshot also help pave the way for celebrity voyeurism and an erosion of personal liberty and privacy? The issue is complex because *thematically*, Salomon's candids promote a vision of democratic society based on legal norms and transparency. Yet the latent aesthetic politics of Salomon's approach are not as unambiguously progressive.

Useful for this examination is a signature photograph Salomon took in August 1931 after he infiltrated a state dinner at the French Ministry of Foreign Affairs held for German Chancellor Julius Curtius and Foreign Minister Heinrich Brüning. At this banquet, French Foreign Minister Aristide Briand caught Salomon in the act of photographing. The image depicts Briand, Minister of the Colonies Paul Reynaud, and several other Ministers. Reynaud is blurry, having turned just as Briand recognized Salomon. The looks on the officials' faces disrupt the image's function as an objective, behind-the-scenes, third party view of politics. After Briand catches Salomon *in flagrante*, it becomes an image about Salomon's efforts to efface his involvement. But rather than react angrily, Briand's smile betrays the ministers' friendly, symbiotic relationship with Salomon. Whereas Weimar Germany's politically extremist press tarred such

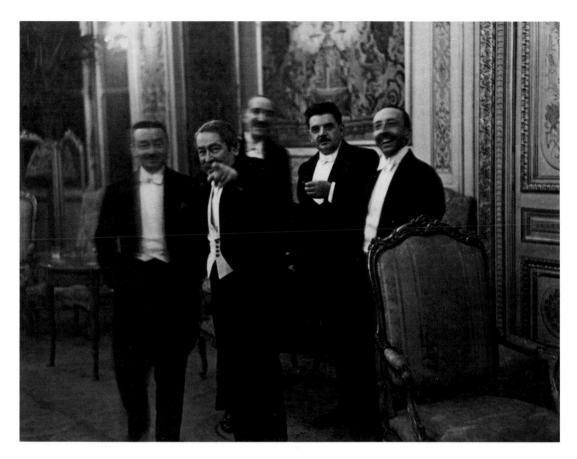

Figure 1.11 Erich Salomon, *Aristide Briand discovers the photographer who had procured himself unauthorized admission to a reception at the Quai d'Orsay. Briand comments: "Ah, le voila! Le roi des indescrets!"* Also pictured: Paul Reynaud, Alexandre Champetiers de Ribes, Edouard Herriot and Léon Bérard, 1931. Berlinische Galerie, Berlin/ Erich Salomon/Art Resource, NY.

politicians as incompetent, corrupt plutocrats, Salomon humanized them with candid but not-unflattering photos and only worked with politically mainstream publications. In turn, his subjects tolerated his infiltration of their functions. Briand reportedly once said, "There are just three things necessary for a League of Nations conference: a few Foreign Secretaries, a table, and Salomon."[5]

While this photograph's manifest content promotes political transparency, its historically specific form—the instantaneous snapshot, created in exceptional circumstances and circulated as a commodity in the illustrated press—arose in a historically specific setting, amid the late-Weimar Republic's political, economic, and social crises. In this milieu, right-wing political and photographic theorists fetishized dangerous instants, states of exception, and moments of decision as occasions of heightened and authentic experience. For instance, Ernst Jünger argued in "On Danger," the preface to *Der gefährliche Augenblick* (The Dangerous Moment), a photobook of high-speed crashes, political assassinations, and other catastrophes, that accidents, violence, and danger offer heightened access to authentic experience precisely because they bypass the bounds of bourgeois rationality and social convention. Modern

technology can now capture this special moment by freezing it in the candid snapshot. Jünger praised the candid snapshot for the disinterested, objective coldness with which this form—regardless of its content—could offer proprietary access to the fundamental struggles of existence.[6]

Moreover, conservative social theorists conceived the project of rendering political order in Weimar Germany's dangerous moment in terms analogous to the task of rendering aesthetic order through the candid snapshot. In his *Political Theology* (1922), for instance, Carl Schmitt argued that "Sovereign is he who decides on the exception," meaning that the sovereign alone decides when it is appropriate to transgress laws in the public interest.[7] Schmitt's approach to rendering *political form* in a state of exception resembles Salomon's method for photographing dangerous moments when doing so wasn't allowed. He simply claimed the right to do so and used whatever guises necessary to achieve his goals. Fortunately, Salomon had the wherewithal not to abuse his power, even as he sovereignly arrogated to himself the right to bypass laws and convention in pursuit of news.

Today, the German Society for Photography's lifetime achievement award for photojournalists, the "Dr. Erich Salomon Prize," honors its namesake because, "Even today, his vision and standards of value still form the norm around which a critical profession orients itself."[8] Its recipients are those who, like Salomon, used photojournalism to laudable ends. Yet it is worth reconsidering the history of Salomon's snapshot approach. While some exceptional situations may justify a photographer's "stealing" of the moment, historically, an uncomfortably similar logic permeated right-wing thought on the eve of Hitler's rise.

Notes

1 Allan Sekula, "Paparazzo Notes," in *Photography Against the Grain: Essays and Photo Works, 1973–1983* (Halifax: Nova Scotia College of Art and Design, 1984): 29–30.

2 Erich Salomon, *Berühmte Zeitgenossen in unbewachten Augenblicken* (Stuttgart: Engelhorn, 1931).

3 See for instance "Eine neue Künstler-Gilde. Der Fotograf erobert Neuland," *Uhu* 6, Nr. 1 (October 1929): 34–9 and "Das Kabinett des Dr. Salomon, des Photographen mit der Tarnkappe," *Das Leben* 9, Nr. 6 (December 1931): 5–11.

4 Gisèle Freund, *Photography and Society* (Boston: Godine Press, 1980): 118. Nachum T. Gidal, *Jews in Germany: From Roman Times to the Weimar Republic* (Cologne: Könemann, 1998): 379.

5 Quoted in Beaumont Newhall, *The History of Photography from 1839 to the Present Day* (New York: Museum of Modern Art, 1982): 220.

6 Ernst Jünger, "Über die Gefahr," in *Der gefährliche Augenblick. Eine Sammlung von Bildern und Berichten*, ed. Ferdinand Buchholz (Berlin: Junker and Dünnhaupt, 1931): 11–31. Translated by Donald Reneau as "On Danger," *New German Critique* 59 (Spring/Summer 1993): 11–16.

7 Carl Schmitt, *Politische Theologie: Vier Kapitel zur Lehre von der Souveränität* (Berlin: Duncker & Humblot, 1922): 13.

8 "Dr. Erich Salomon Preis der DGPH," *Deutsche Gesellschaft für Photographie E.V.* http://www.dgph.de/english/dr-erich-salomon-award-of-the-deutsche-gesellschaft-fuer-photographie (accessed 5 December 2013).

1.12
A Decisive Moment, France, 1932

Catherine E. Clark

Does the accepted view of photojournalism rest on the myth of the decisive moment? Analyses of Henri Cartier-Bresson's work, and in particular *Paris, la Gare St. Lazare* (1932), certainly seem to. They tend to focus on the combination of chance and skill needed to produce the clever image's strong formal elements: the scene's echo in the poster of a dancer in the background; the doubling of the man in his reflection; the tension between stillness and motion; and the geometry of its composition.[1]

This particular photograph has come to embody Cartier-Bresson's ability to freeze the "decisive moment."[2] The photographer's 1952 photo book by that name first introduced this interpretative term to rebut charges that his photos lacked technical skill.[3] The idea redefined good photography as the "simultaneous recognition, in a fraction of a second, of the significance of an event as well as of a precise organization of forms which give that event its proper expression."[4] Cited and evoked in almost every Cartier-Bresson exhibition and review since, the decisive moment still dominates interpretation of his work.[5] By encouraging attention to singular pictures such as *la Gare St. Lazare,* not known to have been published in any particular photo essay, the concept has dominated Cartier-Bresson's corpus and propagates an idea of the singularity of the photograph that obscures the collaborative nature of the profession.[6] At the same time, it has allowed his photographs to avoid definitive categorization, moving fluidly between photojournalism, photographic publications, and art.

The myth of the decisive moment, as well as the Magnum cooperative's general practice of republishing work in photo books and art publications, has helped mask the photo story's importance to Cartier-Bresson's career and photojournalism writ large. Cartier-Bresson's 1952 essay explains that the photographer needs multiple photos to convey the entirety of an event or situation. Only "rarely" can she produce a "single picture [which] is a whole story in itself."[7] As early as 1970, *New York Times* photo critic Allan Douglass Coleman argued that the essay's reduction to its title "distort[ed] our perception of Cartier-Bresson."[8] Instead Coleman proposed labeling Cartier-Bresson the master of the "picture-story," which would encompass his varied output, from "classic" pictures to "functional images, [. . .] employed in reinforcing central ideas or probing tangential ones."[9]

By anchoring the photograph's excellence in the instant of its capture, the myth of the decisive moment erases the teamwork that underlies all photographs, photojournalistic or otherwise. Cartier-Bresson did not, as a rule, work in the darkroom, and thus depended on developers for his prints. His 1952 essay also stresses the importance of the picture editor and the "layout man" who create whole

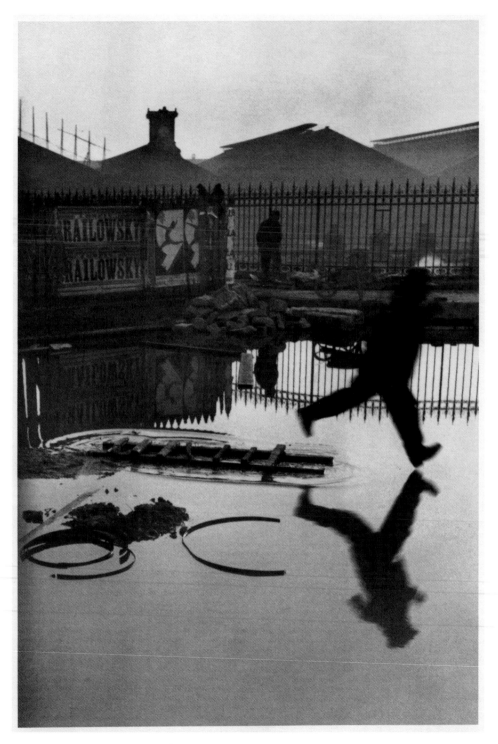

Figure 1.12 Henri Cartier-Bresson, *Paris. Place de l'Europe. Gare Saint Lazare*, 1932. Reproduced courtesy of Magnum Photos.

stories out of the photographer's "raw material."[10] Indeed, although subsequent interpretations of Cartier-Bresson's work have emphasized his vehement rejection of cropping, the same essay admits that "the layout man will often have to crop one picture" in order to give each page "its own architecture and rhythm."[11] Even Magnum relied on a picture editor, John G. Morris (its first executive director). Despite Cartier-Bresson's own insistence, the myth has relegated postproduction work to secondary importance.

The decisive moment has simultaneously freed Cartier-Bresson from any one identity as a photographer. Fellow photographer and Magnum co-founder Robert Capa warned Cartier-Bresson early in his career not to let "himself be labeled a surrealist." While Capa had encouraged him to adopt a photojournalistic identity, later considerations of his work sloughed off even this label.[12] Yet in the seventy years since *The Decisive Moment*'s publication, the idea has seemed equally applicable to the breadth of Cartier-Bresson's photographic practices and contexts.[13] Critics and scholars have used it to describe non-newsworthy photographs such as *la Gare St. Lazare* and current events such as George VI's coronation parade.[14] In 1952 photographer Walker Evans, for example, summed up the decisive moment as the ability to both open the shutter to catch a subject in motion and deliver "*the* definitive summation of a topical event."[15] In contrast, just three years later, Georges Hourdin, a French critic writing for *Le Monde*, attributed the decisiveness of the "really decisive images" of Cartier-Bresson to their "universal value." They were images, he insisted, "upon which one can fruitfully meditate at one's leisure."[16] This discourse has thus given the photographer an identity that works in and beyond the immediacy of news photography.

Notes

1 See art historian Carol Armstrong's deft description in "Automatism and Agency Intertwined: A Spectrum of Photographic Intentionality," *Critical Inquiry* 38, 4 (1 June 2012): 710. Art historian Ernest Gombrich declared it "the luck of a lifetime:" "Henri Cartier-Bresson," in *Henri Cartier-Bresson: His Archive of 390 Photographs from the Victoria and Albert Museum* (Edinburgh: Scottish Arts Council, 1978): 10.

2 It is the only illustration for "The Decisive Moment" essay in Henri Cartier-Bresson, *The Mind's Eye: Writings on Photography and Photographers* (New York: Aperture, 1999).

3 The term appeared first as the title (and a subheading) of the English-language edition. The French title translates to "images on the sly." Henri Cartier-Bresson, *The Decisive Moment* (New York: Simon and Schuster, 1952); Henri Cartier-Bresson, *Images à la sauvette* (Paris: Éditions Verve, 1952). For more about how the idea migrated to France as the "instant décisif" see Agnès Sire, "De l'errance de l'oeil au moment qui s'impose[. . .]," in *Revoir Henri Cartier-Bresson*, eds. Anne Cartier-Bresson and Jean-Pierre Montier (Paris: Editions Textuel, 2009): 55–67.

4 Cartier-Bresson, *The Decisive Moment*: np.

5 Clément Chéroux, "Le 'tir photographique,'" in *Revoir Henri Cartier-Bresson*, 50.

6 The Fondation Cartier-Bresson's clippings files do not include an "original" photo-story. The 2014 retrospective at the Centre Pompidou, however, combatted this myth by resituating much of Cartier-Bresson's other work in the context of the photo story.

7 Cartier-Bresson, *The Decisive Moment*, (New York: Simon and Schuster, 1952).

8 A. D. Coleman, "Photography: More Than the Decisive Moment," *New York Times*, 29 March 1970.

9 A. D. Coleman, "Photography: More Than the Decisive Moment," *New York Times*, 29 March 1970.

10 Cartier-Bresson, *The Decisive Moment*, (New York: Simon and Schuster, 1952).

11 Cartier-Bresson, *The Decisive Moment*, (New York: Simon and Schuster, 1952).

12 Yves Bourde, "Un entretien avec Henri Cartier-Bresson," in *Henri Cartier-Bresson 70 photographies* (L'école d'art de Marseille-Luminy, 1977) np.

13 It has persisted in the *New York Times,* for example, since the 1950s.

14 See for example: Walker Evans, "Cartier-Bresson, a True Man of the Eye," *New York Times*, 19 October 1952; Armstrong, "Automatism and Agency Intertwined."

15 Evans, "Cartier-Bresson, a True Man of the Eye," *New York Times*, 19 October 1952 (original emphasis).

16 Georges Hourdin, "Henri Cartier-Bresson," *Le Monde,* 23 November 1955.

1.13
Republican Soldier, Spanish Civil War, 1936

Sally Stein

As early as the US Civil War, photography's entry into the field of reportage inspired some invidious depictions of traditional illustrators as innocents diverted by toy soldiers while insulated from the heat of battle.[1] To get the real picture, such caricatures implied, one at a minimum had to be in view of the action.

Comparable charges have rarely been leveled at press photographers. Even after we have grown accustomed to occasional reports of news pictures restaged, we still assume that the photographer "was there," in the thick of it, or at least very close. While almost buried in a longer list of journalistic questions, the press image is expected to address—who, what, where, when?—the issue of location is essential to the basic credibility of the press photo, and it is this issue that recently has come to the fore in reconsiderations of Robert Capa's arguably most famous image.

Not only is Robert Capa's "Falling Soldier" (1936) the best-known photograph from the Spanish Civil War, but it is verily a storied picture, starting with the famous photojournalist who varied his own accounts of its making, thus raising doubts even among his friends and admirers. Decades since Capa's death in 1954 while covering the rout of the French from Vietnam, debates continue as to whether the felling of the partisan soldier was simulated or actual.

I was one of many participants in that debate. After sifting through myriad first- and second-hand accounts, I thought I had arrived at a judiciously nuanced interpretation: the photograph was neither patently true nor false: rather, the photographer when fooling around during a lull in battle had lured some partisans to pose, and that the two thus diverted were fatally surprised by snipers. This "lucky shot" of "death in the making" (the latter phrase Capa used to title his 1938 book on Spain) brought instant fame to the photographer soon after the photo's first publication. The celebrity resulting from such hapless circumstances must have left the photographer immensely guilty for the role he had played in what was conceived as a "time-killing" mock scenario that then turned deadly. Invoking Heisenberg's "Uncertainty Principle," I further speculated that this scenario should provoke us to rethink that favored trope of "photographer as witness," so that we consider more closely the extent that the "witness" unwittingly affects the conditions of the scene.[2]

But within a year, that interpretation, along with most others, lost its evidentiary foundations. The debate and its contours shifted as research about the war revived in Spain. Previously, all had accepted that the locale, repeatedly identified in published captions, was Cerro Muriano outside Córdoba, where fighting raged in early September 1936 when the photograph was made. Lately a Basque communications

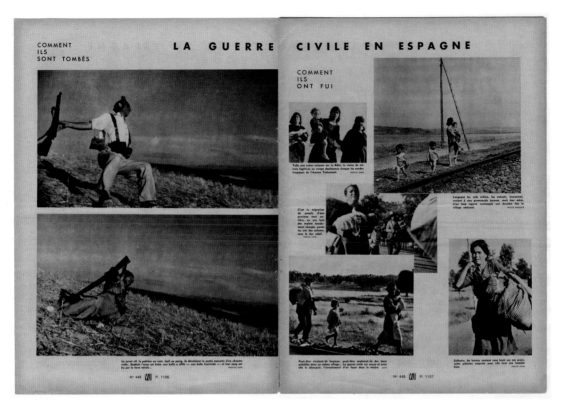

Figure 1.13 *VU*, 23 September 1936, pp. 1106–7, including Robert Capa's *Falling Soldier* (top left), Córdoba front, Spain. Collection International Center of Photography.

scholar José Manuel Susperregui wondered if even that location should be taken at face value. Recognizing that any review of this most famous photo would elicit stock responses, Susperregui ingeniously cropped out all the recognizable action on the left, posting online only the right half of the picture while soliciting help from local teachers and librarians in identifying that particular configuration of bare hillside in foreground, valley plain below, and low mountains in the background. One student volunteered that the topography resembled that of Espejo, 35 miles from Cerro Muriano, as such quite far from any documented heated battle or snipers in early September of 1936. Questioning an early report of this novel finding, the regional press dispatched reporters and photographers who confirmed a solid match between that site and the background of Capa's two most dramatic photographs from "Cerro Muriano."[3]

This raises new questions, yet to be answered, as to what either Capa or the soldiers he was with were doing in the first days of September, gathered at Espejo a safe distance from the fighting. Since the annals of war are rarely complete, the finding doubtless will provoke further research. However, at least for now, the long-revered photograph is discredited as a battlefront record. Without clear claim to the pantheon of photojournalism, will it be reclassified as a bit of staged propaganda, as Philip Knightly rather early proposed in *The First Casualty*?[4] Or will it enjoy renewed appreciation as theatrical art made rather close to but still removed from the "theater of war"? The future for this image is hard to predict,

depending as it does not only on continued findings, but also on the ever-changing criteria for, and boundaries between, photography, propaganda, and art. Still, the image in question will be hard to mothball; even lacking the bona fides of heroism by both partisan fighters and photographer, its semiotic instability proves unforgettable. For if we conventionally give it the moniker of "iconic," there is something persistently indexical in its striking blow to all valiant preconceptions of martial sacrifice.

I can think of no better word than *arresting* to describe the way Capa's *Falling Soldier* depicts *the* "decisive moment" and rebounds that shock directly and frontally to the viewer. The sheer awkwardness of both framing and figure may explain its persistent claims on us. Never has the phrase "stop-action" seemed so pertinent for this whiplash splaying of limbs. The body in its performative repertoire lacks the grotesque knowledge of what it may mean to be thrown in reverse. That the figure cannot recover either his grip on his rifle or his balance is already presaged by the shadow cast backward on the ground. But for this split second there is no stasis, only the horror of suspended animation in advance of the loss of all animation. Capa's "Falling Soldier" is one of the first in a still rare genre in which the photograph intimates that moment where life and death appear to face off.[5] No surprise that Capa's famous photograph has provoked as much avowal as disavowal of the figure's vital status. Yet for all the ambivalent reception, we may have missed fully recognizing the picture's terrifying approximation of that terminus we would rather envision as both distant and predictable.

Notes

1 Jan Zita Grover, "The First Living-Room War: The Civil War in the Illustrated Press," reproduces two such satirical sketches from 1861 and 1862 issues of *Vanity Fair; Afterimage*, February 1984, 9.

2 Sally Stein, "Close-ups from Afar: Contested Framings of the Spanish Civil War in U.S. Print Media, 1936," in Jordana Mendelson, ed., *Magazines, Modernity and War* (Madrid: Museo Nacional Centro de Arte Reina Sofia, 2008): 117–139. My 2008 article cites many conflicting accounts, including quite a few supplied by Capa in various contexts. For yet another discrepant account in the form of a recently rediscovered recording of Capa made in New York thirteen years after the photograph on 20 October 1947, see http://www.icp.org/robert-capa-100; in this radio interview, Capa asserts that the press photo is chiefly the work of editors, while personally denying any role as witness, since here he claims he made the exposure sight unseen by raising the camera above eye-level from the safety of a trench (although the fact that the exposure includes the valley below conflicts with this description of a worm's eye or entrenched sightline).

3 José Manuel Susperregui, *Sombras de la fotografía: los enigmas desvelados de Nicolasa Ugartemendia, Muerte de un miliciano, La aldea española y El Lute* (Universidad del País Vasco, 2009); for a summary in English by Sussperregui, see, "Visual Resonance of Robert Capa's Falling Soldier": https://www.academia.edu/3608024/; see also, Larry Rohter, "New Doubts Raised Over Famous War Photo," published in the *New York Times*, 17 August 2009.

4 Phillip Knightly, *The First Casualty: From Crimea to Vietnam: The War Correspondent as Hero, Propagandist and Mythmaker* (New York and London: Harcourt Brace Jovanovich, 1975): 209–12.

5 For an overview of such moments, including this one, and their importance to news culture, see Barbie Zelizer, *About to Die: How News Images Move the Public* (New York: Oxford University Press, 2010).

1.14
Soviet War Photo, Crimea, 1942

David Shneer

In January 1942, seven months after the German invasion of the Soviet Union, Soviet press photographers descended into the region around Kerch, in Crimea, to document the Red Army's counteroffensive against the Wehrmacht. In the first week of December, the Gestapo had registered 7,500 Jews in Kerch, who were marched to an anti-tank ditch on the outskirts of town, separated men from the women and children, and all shot by Einsatzgruppen D.[1] On 31 December, the city was liberated from Nazi occupation, offering one of the first scenes of the Nazi war against European Jewry.

In March 1942, *Ogonyok* ran a photo essay about Kerch with images by Dmitri Baltermants. Among the eight published photographs, three are of lone women in a state of grieving. The most visually dominant photograph, on the left side of the two-page layout, depicts a woman, whose surrounding landscape is obscured by an overlaid image of a corpse. The caption reads, "Residents of Kerch search for their relatives. In the photo: V. S. Tereshchenko digs under bodies for her husband. On the right: the body of 67-year-old I. Kh. Kogan." On the same page, the editor placed Baltermants' photograph of P. Ivanova, whose head is thrust backward, body contorted, as her hands clutch a kerchief as she weeps.

None of Baltermants' published Kerch photographs conjure up the mass murder of Jewish men, women, and children. They show living non-Jewish women mourning dead, presumably Jewish men, even though just beyond the frame were thousands of dead Jewish women and children lying in the same trench. Baltermants' choice of subject—massacred men—as well as the way he photographed grieving women encouraged readers to see the aftermath of battle, rather than the racially motivated murder of Jews and others. His photographs echo a long history of wartime images documenting the aftermath of battle or civilian massacre. Art historian Elisabeth Bronfen coins the phrase "pathos formulas of battle," following Aby Warburg's concept of the pathos formula. Pathos formulas of battle "organize the visual experience of battle in such a way as to . . . sustain the illusion that the audience is in control of the spectacle, rather than being overwhelmed by the intensity of slaughter," in this case, the horror of the Holocaust.[2]

The paragraph introducing the photo essay shows how editors contextualized his pictures: "These photographs were taken at a moment after the German occupiers drove [these people] out to this place. 7,500 residents from the very elderly to breast-feeding babies were shot from just a single city . . . They were killed indiscriminately—Russians and Tatars, Ukrainians and Jews. [. . .]" While the captions under

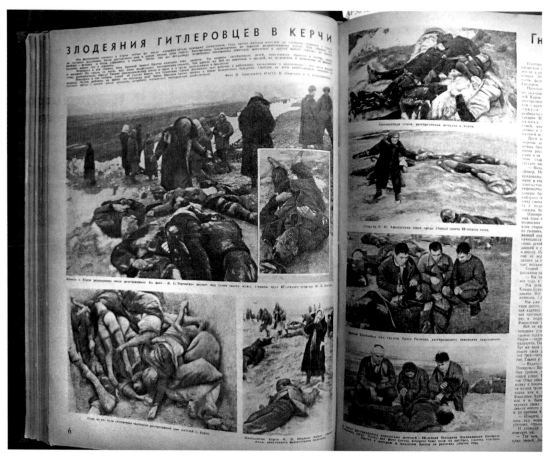

Figure 1.14a Dmitri Baltermants and Israel Ozerskii, "Hitlerite Atrocities in Kerch," in *Ogonyok,* 2 March 1942. P.I. Ivanova appears on the left page, lower right corner.

each photograph emphasize that the occupiers murdered civilians, while obscuring the racial nature of the murders, the article accompanying the photographs euphemistically drew attention to Jewish deaths by noting that the first to be shot had been "Soviet citizens of one particular nationality."[3]

Very few Soviet photographs of the war were republished until the early 1960s, when the state began to commemorate the war. Baltermants' photographs of grieving women at Kerch, most significantly the photograph of Ivanova, were presented differently twenty years later. During the war, *Ogonyok* editors had cropped her small and placed her low and off to the right. When Baltermants returned to his archive to find signature war images, he found four versions of Ivanova. He selected a different negative from the 1942 published photo, this one with dramatically outstretched arms and head bowed in a heightened state of pathos (Fig. 1.14b).

It was not published during the war, because his favored negative had been damaged in the developing process. As he turned his news picture into a commemorative art photograph, he had the luxury of time to repair it. By darkening the sky and increasing the contrast, he also repurposed Ivanova for her new function: as an image encouraging universal meditation on loss rather than one about the Nazi racial war.

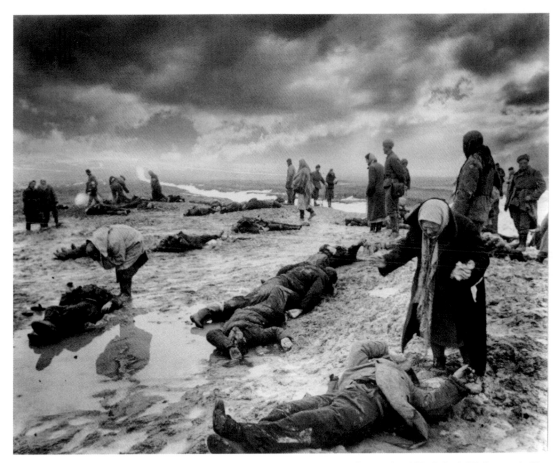

Figure 1.14b Dmitri Baltermants, *Grief*, photo taken in 1942, published in *Ogonyok,* 1965. © Dmitri Baltermants/The Dmitri Baltermants Collection/Corbis.

In 1962, for his fiftieth birthday, there were plans to host a solo show for Baltermants in Moscow. He produced a maquette of an exhibition catalog, which included the new, retouched version of Ivanova with a title, rather than a caption: *Gore* or "Grief."[4] Although the 1962 show never happened, "Grief" appeared one year later in a Czech publication and was exhibited in London in 1964 at "People and Events of the USSR," a show which aimed to educate the British viewing public about Soviet everyday life using contemporary photography.[5] A visitor to the exhibition may have been surprised to find that it opened, not with daily life, but with Baltermants' images from the war.[6] Ivanova was third on the wall, although she was now titled "Sorrow (Ditch of Kerch)," rather than "Grief."

A few months later, in January 1965, Baltermants' own magazine, *Ogonyok*, of which he now served as photo editor, published "We Will Not Forget," a glossy two-page layout of Ivanova. Printed next to the photograph was Heinrich Böll's comment "these women's cry becomes humanity's cry." The same year, Baltermants exhibited "Grief" in a group show at New York's Gallery of Modern Art. *New York Times* critic Jacob Deschin raved that "One picture in particular—a post-battle scene with mourners searching the field for their dead—may possibly go down as one of the great wartime landscapes of all time."[7] "Grief"

became so well known that, in the late 1970s, the German magazine *Die Zeit* reviewed a book of Soviet war photographs calling "Grief" "world famous."[8]

Never did anyone identify the dead in the picture or why they had been killed. Media outlets from the wartime British *Picture Post*, which published Baltermants' Kerch photographs, to the *New York Times'* review of the redone Ivanova, called this early Holocaust liberation photograph a scene of post battle tragedy, just as the photographer seems to have always wanted it. From the moment Baltermants turned away from massacred Jewish women and children and photographed living women in dramatic bodily displays, Ivanova's cry stopped being her own and became the cry of humanity encapsulated by its eventual title—"Grief."

Notes

1 See Maxim Shrayer, *I Saw It: Ilya Selvinsky and the Legacy of Bearing Witness to the Shoah* (Boston: Academic Studies Press, 2013): 31–58.

2 Elisabeth Bronfen, *Spectres of War: Hollywood's Engagement with Military Conflict* (New Brunswick, NJ: Rutgers University Press, 2012): 113–23.

3 Zvi Gitelman, "Internationalism, Patriotism, and Disillusion: Soviet Jewish Veterans Remember World War II and the Holocaust," "Occasional Paper: Holocaust in the Soviet Union," US Holocaust Memorial Museum, November 2005: 116–17.

4 Catalog maquette in the Teresa and Paul Harbaugh Archive, Denver, CO.

5 Eleonory Gilburd, "The Revival of Soviet Internationalism in the Mid to Late 1950s," in D. Kozlov and E. Gilburd, eds, *The Thaw* (Toronto: University of Toronto Press, 2013): 362–401.

6 Collection of USSR-Great Britain Society in Leeds University Archives, MS 1499/23/6 and 7.

7 Jacob Deschin, "Gallery Exhibits on View," *New York Times*, 16 May 1965: X16.

8 "Abgrund des Krieges," *Die Zeit*, 24 August 1979: 35.

1.15
Child in Warsaw Ghetto, 1943

Barbie Zelizer

The role of photos in understanding the Holocaust, when pictures of people near death or dead helped prove Nazi brutality, has long been central to the broader understanding of news images. Reflecting a complicated and unstable tension between the truth-value of what they depict and the symbolic force of what they represent, Holocaust images are a litmus test for the parameters by which news images work. What to show, when to show it, to whom, and for which purposes, are among its related issues, many of which surface whenever news photos of difficult events appear.

But Holocaust pictures can also teach us about how creatively a photograph stretches across time. Going beyond the issues of accuracy, fidelity, and reliability associated with a photo's display as news, Holocaust pictures show how news images build renown by moving beyond the news. Specifically, these photos show us that news images persevere by often orienting to the messiness involved in the symbolic nature of mnemonic representation, rather than the truth-value of what was depicted as news.

Perhaps nowhere is this as much the case as with what is widely known as the image of the Warsaw Ghetto boy. The photo, which portrayed a young boy being herded from the Warsaw ghetto under a Nazi machine gun, came to emblematize the deportation of thousands of Jews from Poland in 1943. Taken after an attempted ghetto uprising, it caught the deportees on their way to Treblinka where they were believed to have perished. The picture documented one moment in that process, as a group of women, men, and small children was being shepherded from the ghetto under the watchful eye of Nazi guards. Front and center to the image was a small boy, his arms raised in terror above his head.[1]

The photo, now emblematic of the depravity of life under the Nazis, embodied the sheer helplessness of people in the throes of mass eviction. Looking frightened and confused, they anxiously peered in all directions. Only the guards' movements remained steady, their guns turned solidly on the group. The boy stood somewhat apart from the others. Half their size, he was simply dressed—dark-colored knee socks, short pants, an oversized beret, and knee-length pea jacket. Eyes widened in vulnerability and fear, he was the only figure in the photograph to look frontally at the photographer. The photo, in later views, became "one of the indelible images of history," called a "symbol of the Holocaust."[2]

But widespread familiarity with the picture was not always the case. The conventions by which it emerged as iconic speak to how memorability can emerge more in conjunction with an image's recycling into non-news environments than with the news itself.

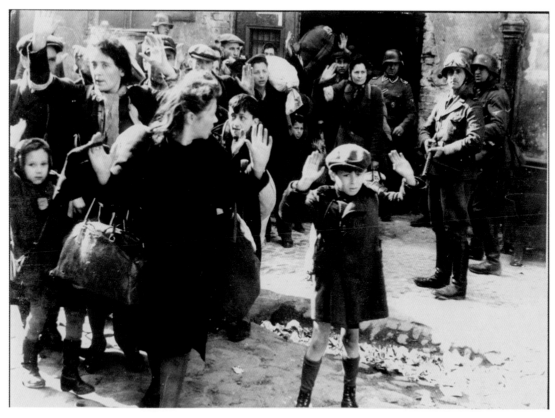

Figure 1.15 Unknown photographer, Untitled, Warsaw, Poland, 19 April 1943–16 May 1943. Courtesy of United States Holocaust Memorial Museum/Dodge Chrome.

The photo did not initially appear as a news photo. Taken by the personal photographer of the Nazi officer who masterminded the ghetto's evacuation and used it for a 76-page scrapbook on the action, the picture first came to attention after the war when Allied forces found the scrapbook. It was publicly displayed during the Nuremburg Trials of 1945 and 1946, when it helped convict the soldier holding the gun on the boy, but received no major media coverage and remained largely unknown beyond tribunal discussions. Only ten years later did it begin to achieve renown: In 1956, it appeared in Alain Resnais's Holocaust film, *Night and Fog,* and over the next five years graced the first book of Holocaust-related photographs (*Der gelbe Stern*, or *The Yellow Star*), a German exhibition of photographs of Nazi crimes against European Jewry, and at the opening remarks of the second public tribunal connected to the Holocaust—the internationally televised trial of Adolf Eichmann in 1961. By the early 1960s, news organizations began reproducing the photo in reports on the trial or the guard's execution, and it subsequently inhabited books on the Holocaust, museums such as Jerusalem's Yad Vashem or Amsterdam's Anne Frank House, and Holocaust paintings, films, poems, and TV series. By then, ghetto survivors had begun to give the boy in the photo constructed identities that mirrored their own loss.

Key to the photo's recycling into non-news venues was how easily its universal dimensions could be transported into other contexts. Its representation of broad suffering, facilitated by the fact that the boy remained anonymous and his actual death was never confirmed, made his depiction a stand-in for the

suffering of others. When people later attempted to identify the boy as a depiction of themselves, there was a strong resistance to his identification. Each time a person made claims of being the boy, newspaper headlines celebrated his emergence. But much of the public remained suspicious, in *The Times*' words, "concerned that the symbolic power of the picture would be diminished were the boy shown to have survived."[3]

Each display of the photo has enhanced its memorability. Through it all, the suggestion of bodily harm, the child's anonymity, and the image's ambiguous end were central to maintaining the image's power as a depiction of universal suffering. As one observer noted, "Whose child is he? It doesn't matter, because they will all eventually perish. Yet the child alone is surely all of us."[4]

The image of the Warsaw Ghetto boy thereby shows how a news photo's durability often has little to do with its initial function as news. Rather, its use-value is enhanced when news pictures stretch beyond the news environment. The less initially made clear about what a picture depicts, the farther can it move from the news, showing that the power of news images derives as much from their neighboring environments as from the news itself.

Notes

1 See Barbie Zelizer, *Remembering to Forget: Holocaust Memory Through the Camera's Eye* (Chicago: University of Chicago Press, 1998) and Barbie Zelizer, *About To Die: How News Images Move the Public* (Oxford: Oxford University Press, 2010), where I discuss it as an image of "possible death."

2 David Margolick, "Rockland Physician Thinks He is the Boy in Holocaust Photo Taken in Warsaw," *New York Times,* 28 May 1982, B1; Clay Harris, "Warsaw Ghetto Boy: Symbol of the Holocaust," *Washington Post*, 17 September 1978, L1.

3 Margolick, "Rockland Physician," B1.

4 David Roskies, *Against the Apocalypse* (Cambridge, MA: Harvard University Press, 1984): 295.

1.16
Flag-Raising, Iwo Jima, 1945

Alexander Nemerov

It is not true that Joe Rosenthal staged his famous flag-raising photograph taken atop Mount Suribachi on Iwo Jima on 23 February 1945.[1] The persistent skepticism, however, illuminates an important and until now overlooked quality of the photograph.

This quality is the distinctive composition of Rosenthal's picture. That it should even have a composition at all is remarkable and an ongoing source of suspicion for some, given how instantaneously and almost inadvertently the image was made. Rosenthal shot the photograph at 1/400th of a second, having glimpsed the flag-raising out of the corner of his eye before swinging his camera around to get the shot. We are left then with the question of how the flag-raising achieved such monumental clarity in his lens.

The answer will be familiar to artists. Like any skilled picture-maker, Rosenthal carried a bank of images in his mind, pictorial designs and themes he collected not as a set of conscious sources but as a background—a visual lexicon—on which he could rely without thinking when out in the field. The Mount Suribachi photograph intuitively draws from his image bank.

What is the source that allowed Rosenthal to compose the photograph instantly, without thinking? I propose it is Douglas Tilden's monumental sculpture of 1901, *The Mechanics Fountain* (Fig. 1.16), located at the corner of Market, Battery, and Bush Streets in San Francisco, where Rosenthal had lived since 1930. Rosenthal worked in the city as a photographer soon after he arrived, covering events such as the Longshoreman's Strike of 1934, and when he left for the Pacific, he did so from San Francisco, on 27 March 1944. My research has not located a Rosenthal photograph showing Tilden's sculpture, but such a photograph is not necessary to see a connection between *The Mechanics Fountain* and the flag-raising picture. It is plausible that Tilden's well-known sculpture—operating in some intuitive, background way in Rosenthal's mind—gave his photograph the instantaneous good gestalt that has made skeptical critics doubt its genuineness.

Of course there are many differences between the two works. Tilden's sculpture, showing apprentices and master craftsmen operating a massive punch-press, is a recognizable turn-of-the-century fantasy: the near-naked apprentices dangling from the giant lever are a combination of Peter Pan and Tarzan. Nothing like them appears in Rosenthal's picture. Yet the similarities are notable—the comparable angles of the punch-press lever and the flag pole, and the concerted effort of the men, culminating in a steadying

Figure 1.16 Douglas Tilden, *The Mechanics Fountain*, San Francisco, 1901. Photo © 2003 Lee Sandstead.

figure or figures at the base (the master craftsmen in Tilden's work; Harlon Block anchoring the flag in Rosenthal's picture).

The fact that Rosenthal's photograph was turned into a sculpture is fitting. In 1954 in Arlington, Virginia, Felix de Weldon unveiled his colossal bronze of the flag-raising—an acknowledgment that the photograph itself had always been sculptural. Rosenthal himself sensed this, recalling how atmospheric conditions on Iwo Jima that day gave "the figures a sculptural depth."[2] Others saw the photograph the same way almost as soon as it appeared in 1945. Plans were afoot right away to create public sculptures based on it in Los Angeles and Columbus.[3] A newspaper editorial in March 1945 proposed the same idea for San Francisco.[4] If that San Francisco sculpture had gone up, a comparison with Tilden's *Mechanics Fountain* would have been impossible to miss. As it is, the connection to Tilden's work has continued to escape notice.

That connection opens up two unexpected meanings of Rosenthal's picture. One is its relation to a long history of American–Japanese imperial competition in the Pacific. Tilden's sculpture commemorates the ship-building prowess of the Donahue family in San Francisco; the massive press might be punching holes in the sheet armor of warships; the sculpture pays homage to San Francisco as a center of the early twentieth-century American imperial fleet.[5] Not far from it is the monument to Admiral Dewey, hero of Manila, at Union Square; and about twelve blocks up Market Street is Tilden's heroic equestrian group extoling white American valor in the Spanish–American War.

Rosenthal's photograph follows from this rhetoric. Made in a fraction of a second, it had a long run-up dating to the first years of the twentieth century, the origin of its lexicon of American battle valor in the Pacific. With a logic surpassing the photographer's own ambitions and intelligence (just as Hamlet is smarter than Shakespeare), the Mount Suribachi photograph refers to a whole history of American military ambition in the Pacific.

The second meaning is more important but more difficult to define. It is the photograph's relation to space—specifically, the many thousands of miles' distance between Iwo Jima and San Francisco. The photograph was always about spatial command: the large 8 × 4-foot flag went up on Mount Suribachi so that all those on the island and on the surrounding ocean could see it (the smaller flag that had gone up earlier was not visible enough for this purpose). Rosenthal's photograph, transmitted to the American media, grandiosely followed through on the flag's initial semaphore—extending the range by thousands of miles back to the mainland American press and its readers. Tilden's sculpture is a homing signal within Rosenthal's photograph—an implicit acknowledgment of the picture's homeward-seeking energy.

At the same time, there is something plaintive in that great distance. That sadness of space evokes the mortal peril of the soldiers Rosenthal photographed during a respite in the weeks-long battle that three of them would not survive.[6] The photograph asks that we contemplate the whole expanse known as the Pacific Theater as a wide emptiness traversed by small human signals: the flag-raising at one end, Tilden's sculpture at the other. The Iwo Jima photograph sends back feelers to the first American shore it can find, suggesting that the goal of the picture—a goal obscured amid the official hoopla that made it a propaganda masterpiece—is not to show a feat of heroism, writ loud and clear and sledge-hammered upon the skies, but to indicate some delicate quality of sending a small signal, human and frail, contingent and mortal, against an overwhelming blankness.

Notes

1 For the history of skepticism about the photograph and for information about Rosenthal's biography, see
 Andrew Ratchford, "Joe Rosenthal (1911–2006)," in *Dictionary of Literary Biography: American World War II
 Correspondents*, ed. Jeffrey B. Cook (Detroit: Gale Cengage, 2012): 229–35.

2 Joe Rosenthal, "The picture that will live forever," *Collier's* (13 February 1955): 66.

3 "Iwo picture will be model of memorials," unspecified newspaper clipping, stamped 28 March 1945. Joe
 Rosenthal File, California Historical Society, San Francisco.

4 "Memorial art," unspecified newspaper clipping, stamped 17 March 1945. Joe Rosenthal File, California
 Historical Society, San Francisco. The editorial begins: "If the art of sculpture can capture in the dimensions of
 bronze the spirit that Joe Rosenthal caught in his photographic masterpiece of the Marines on Mount Suribachi
 on Iwo Jima, it would make a magnificent war memorial for San Francisco."

5 For an account of the commission and iconography of Tilden's sculpture, see Melissa Dabakis, "Douglas
 Tilden's *Mechanics Fountain*: Labor and the 'Crisis of Masculinity' in the 1890s," *American Quarterly* 47 (June
 1995): 204–235.

6 For the identities and fates of the men in the photograph, see, for example, James Bradley with Ron Powers,
 Flags of Our Fathers (New York: Bantam, 2000) and Karal Ann Marling and John Wetenhall, *Iwo Jima:
 Monuments, Memories, and the American Hero* (Cambridge, MA: Harvard University Press, 1991).

1.17
New York in Color, 1953

Vanessa R. Schwartz

"We have to shoot far more color . . . This again should not be indiscriminate but on subjects which demand color."[1] Soon after Magnum's report to stockholders described the growing importance of the editorial uses of color in magazines, *LIFE* published an unprecedented twenty-four page full-color feature by one of the agency's rising talents, the Austrian émigré photographer Ernst Haas, across two issues as "Images of a Magic City."[2] As the news began to go from black and white to color in magazines over the course of the 1950s and 1960s, in Haas' hands, color became the very subject of news pictures.

"Images of a Magic City" presented an essay made of photos rather than one that used photos to illustrate a print story. Haas used color to render the city both beautiful and unfamiliar. In the full-page image on the left side of the spread's first page, the white lights seen through the windows of the United Nations building look like flickering candles, while the surface simultaneously reflects what could be seen across the street. This image suggests we look beyond the subject represented in order to see more deeply. Cropping and close-ups emphasized a "sharp geometry of lines and shadows" as one caption reads, but the "Magic City" images used color to foreground depth. The balustrade shown inside the United Nations stands out in a brighter yellow than the object behind it while also hosting the shadows cast by the exterior windows. In the top right-hand corner, an unclear abstraction appears. Only upon more careful observation can the meaningful juxtaposition of the Atlas sculpture at Rockefeller Center, mirrored through a shop window onto Saint Patrick's Cathedral, clarify the proximity of celestial and earthly powers in New York. Other images in the essays contrasted objects in ironic or playful ways while defamiliarizing a much-pictured city. Color and its striking contrast and unusual juxtaposition in the real world transformed mundane street signs, parked cars, painted billboards, and a rainbow made by a pool of oil resting on water, into magical space of subjective vision where readers grasped the experience of a world in motion.

Haas suggested that color, which led him to consider what lies between moments rather than within a moment, changed even the most fundamental of photojournalistic notions: "The decisive moment in black and white and color are not identical."[3] Color offered the occasion to "see as the eye sees, not in fixed images but in a blended flow of color."[4] In many of his subsequent photo essays, he experimented with blurred images of bullfights and football games, among other subjects. In these color photos, he

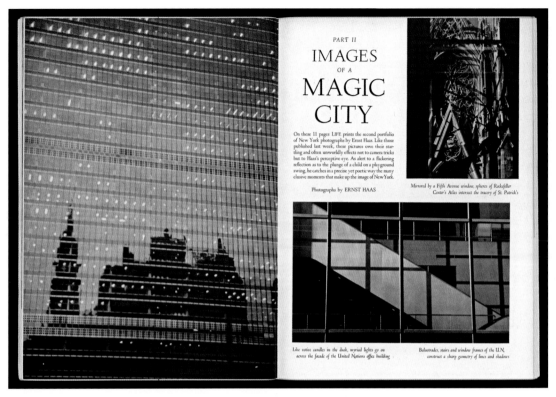

Figure 1.17 Ernst Haas, "Images of a Magic City, Part II" *LIFE*, 21 September 1953, 116–117. Photography: Ernst Haas/Getty Images; Text: 1953 Text©Time Inc; Image reproduction: The Getty Research Institute, Los Angeles (2575–989). 1. Ernst Haas/Getty Images 2. 1953 Text©Time Inc. 3. The Getty Research Institute, Los Angeles (2575–989).

interrogated motion in a way that was simultaneously true to life without relying on the realism of photography or the objectivity of journalism to do so.

More than twenty years before the consecration of color photography as fine art, color news pictures challenged firm and naïve distinctions between reporting and pictorialism, news and art.[5] The success of "Magic City" led to many new color assignments. Within a few years, Haas was named one of the ten most important photographers in the world (nine of whom were press photographers), became President of Magnum from 1959 to 1962, wrote and hosted a PBS Television Program, "The Art of Seeing," and MoMA dedicated an exhibition to his color work in 1962.[6] Haas' color photographs may have garnered both critical and popular attention in their day, but they were also subsequently dismissed. In his 1975 declaration of a new era in color, one with less sensationalizing, Max Kozloff derisively labeled Haas the "Paganini of Kodachrome."[7]

Although news magazines had published color photos beginning with the arrival of the autochrome in 1907, by the late 1960s, most magazine news photos transitioned to color for a host of technological reasons, including cheaper and faster means to develop color film and to print in color, as well as the advent of color television and widescreen movies to draw the public's visual attention.[8] Color photography has been called everything from glamorous to garish, realistic to fantastic, but the power of its post-war

context in Europe and America cannot be underestimated. As Haas put it, "I will remember all the war years and the last five bitter post-war years—as black and white years . . . I wanted to express that the world and life had changed . . . As at the beginning of a new spring, I wanted to celebrate in color . . ."[9] Photographers understood color's difference as both technological, formal, and contextual. The equipment was heavier, the film speed slower, making it difficult to capture instantaneous images, and the control of composition offered a major challenge. As Haas noted, "Color is really basically much more difficult because it is an addition . . . If you would have to photograph the President of the United States and next to him there would be a man in a red pullover, everybody would look at the man in the red pullover."[10] The photographer could not choose the interrelation of colors in the world.

Haas therefore defined color photography as a photo whose subject is color. He sought to make photos rather than take photos, but did not question his identity as a press photographer wedded to representing the world outside his viewfinder. As news pictures transitioned from black and white to color, Haas sought to create a "color consciousness" in press photography. He called for photos that were "less descriptive—more imaginative; less information—more suggestion; less prose—more poetry."[11] Color press photographers used color to ask viewers to look more deeply, through the photographer's eye, rather than the camera's lens.

Notes

1 Magnum Stockholders Report, 15 February 1952, 17 pages, Center for Creative Photography.

2 "Images of a Magic City," *LIFE*, 14 and 21 September 1953.

3 Bryan Campbell, *Ernst Haas* (London: William Collins, 1983): 4.

4 "The Magic of Color in Motion," *LIFE*, 18 August 1958: 66–74.

5 Fine art color photography begins with William Eggleston's 1976 MoMA Show and was codified by Sally Eauclaire, *The New Color Photography* (New York: Abbeville Press, 1981) and has been somewhat revised first by Kevin Moore, James Crump, and Leo Rubinfien, *Starburst: Color Photography in America 1970 to 1980* (Ostfildern: Hatje Cantz, 2010). More recently by Catherine Bussard and Lisa Hostetler, *Color Rush. American Color Photography from Stieglitz to Sherman* (New York: Aperture Foundation Inc., 2013) and John Rohrbach and Sylvie Pénichon, *Color: American Photography Transformed* (Austin: University of Texas Press, 2013).

6 "World's Ten Greatest Photographers," *Popular Photography* (May 1958): 63–84.

7 Max Kozloff, "Photography: The Coming to Age of Color," *Artforum* (January 1975): 30–5.

8 See Kim Timby, this volume.

9 Bryan Campbell, *Ernst Haas* (London: William Collins, 1983): 4 and Phillip Prodger, *Ernst Haas: Color Correction*, William A. Ewing, ed., 1st edn (Göttingen: Steidl, 2011).

10 Bryan Campbell, *Ernst Haas* (London: William Collins, 1983): 4 and Phillip Prodger, *Ernst Haas: Color Correction*, William A. Ewing, ed., 1st edn (Göttingen: Steidl, 2011).

11 "Haas on Color Photography," *Popular Photography*, Color Annual, 1957: 30.

1.18
Rosa Parks Fingerprinted, Montgomery, Alabama, 1956

Martin A. Berger

On 22 February 1956, Gene Herrick took a series of photographs that captured Rosa Parks being fingerprinted following her arrest for boycotting Montgomery's city buses. Each photograph depicted a well-dressed, diminutive, and compliant Parks being processed by Lieutenant D.H. Lackey. In the most frequently reproduced version (included here), the neatly dressed officer towers above Parks as he grips her left hand and manipulates her ring finger in an effort to coat it with ink.

The scene illustrates Parks's second arrest in Montgomery—eleven weeks after the bus boycott began and almost three months after her famous act of defiance on a bus led to her initial arrest in December 1955. The photograph circulated widely in 1956, appearing in such influential publications as the *New York Times*, the *Washington Post* and *LIFE* magazine.[1] Today it is among the best-known images of the Montgomery Bus Boycott, used to illustrate numerous scholarly and popular books, articles, and documentaries on Parks and the civil rights struggle. Its familiarity suggests the powerful role the mainstream press has played in establishing the visual (and political) terms by which early civil rights history is understood.

In February 1956, a Montgomery grand jury handed down 115 indictments against some of the city's most prominent black religious, business, and civic leaders for the misdemeanor offense of "conspiring to boycott." Parks was among them. In the weeks that followed, a number of mass-circulation periodicals in the North used the famous Herrick photograph to illustrate their first stories on Parks's struggle and the ongoing black boycott of the city's buses. The indictments, and subsequent arrests, made newsworthy to whites a conflict that had already dragged on for several months. In reproducing the photograph, such publications highlighted the officer's physical control of the petite Parks. The visual emphasis on white authority is in keeping with the captions and stories that accompanied Northern white publications' coverage of the boycott. White reporting consistently focused on the "humiliating conditions" under which blacks suffered and their so-called "passive" protest against the status quo.[2]

What was then called the "Negro press"—publications owned by black businessmen and aimed at a black readership—covered Parks's activism and the Montgomery Bus Boycott in a manner distinct from that of the mainstream media. In contrast to the limited reporting by the white press, most black periodicals devoted attention to events in Montgomery from the start. Early stories were routinely illustrated with passport-like headshots of a respectable Parks gazing out toward viewers, or of larger images of her in domestic or public settings with friends, family, and fellow civil rights activists.[3] And yet,

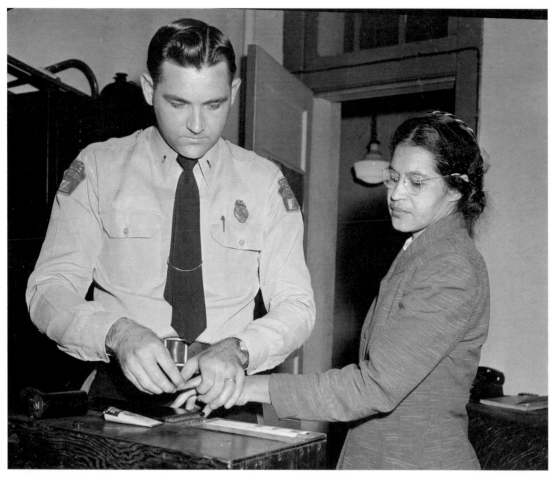

Figure 1.18 Gene Herrick, *Rosa Parks Fingerprinted,* Montgomery, Alabama, 22 February 1956. AP/Wide World Photos and Gene Herrick.

despite its generous use of photographs in reporting on Parks, the black press showed reluctance to publish photographs of her in custody. The widespread availability of Herrick's arrest photographs through the wire service of the Associated Press notwithstanding, the photographs were *not* published in the following black newspapers: *Atlanta Daily World*, *California Eagle*, *Chicago Daily Defender*, *Detroit Tribune*, *Journal and Guide*, *Philadelphia Tribune*, and the *Pittsburgh Courier*. For most black periodicals, the bus boycott was better illustrated through a collection of images (and news stories) that depicted Parks as a respectable middle-class woman, along with photographs of boycotters walking to work, attending rallies, and strategizing. Both the Baltimore and the Washington *Afro-American* and *Jet* did publish a Herrick photograph of Parks being fingerprinted, but in each case the editors presented the event to their readers in a manner unique to the black press. None of the periodicals selected the Herrick arrest photograph reproduced here; instead they each used a version showing the officer bent at the waist as he manipulated Parks's hand. In the black press, Lackey did not tower over his arrestee. And all

three periodicals cropped the right side of the policeman's body, diminishing his visual importance within the frame.[4]

In contrast to white publications' penchant for focusing on the abuse of African Americans, black media reports celebrated the strength and resolve of protestors. Periodicals cited pamphlets circulated by the boycotters, which urged black support of "economic reprisal" against the bus line; they quoted approvingly Parks's comment on the need for blacks to "fight it out" and a white reporter's observation that the boycotters exhibited "military discipline." They described the boycott as "a graphic lesson to Negroes in other sections of the South that they, too, have a weapon of devastating and destructive power." Black editors surely knew that photographs of Parks under arrest posed a threat to her respectable reputation as a "Christian, church-going woman" and increased the likelihood of her being defined foremost as a victim of white authorities.[5] They had little interest in furthering the narrative of victimization that was a staple of the white press.

In the 1950s, the Herrick photograph clearly held more appeal to whites than blacks. Its racialized publication history offers a cautionary note to contemporary scholars who reproduce the photograph to narrate the history of the Montgomery bus boycott. After all, it is hard to imagine capturing the story of black activism with a photograph that has historically represented the civil rights movement from the perspectives of whites.

Notes

1 "Negro Leaders Arrested in Alabama Bus Boycott," *New York Times*, 23 February 1956: 1, 23; "10 Pastors Seized in Boycott Case," *Washington Post and Times Herald*, 23 February 1956: 15; "A Bold Boycott Goes On," *LIFE*, 5 March 1956: 40–1.

2 " 'Crime Wave' in Alabama," *New York Times*, 24 February 1956: 24; "Race Talks Urged by Adlai," *Chicago Daily Tribune*, 28 February 1956: 1; "Alabama . . . Why Race Relations Could Grow Even Worse," *Newsweek*, 5 March 1956, 24–5; "City on Trial," *Time*, 5 March 1956: 21.

3 "Negroes Stop Riding Montgomery Buses in Protest over Jim Crow," *Jet*, 22 December 1955: 12; "Bus Ban Within States," *Chicago Daily Defender*, 24 April 1956: 1; "Boycott! Montgomery Bus Co. 'On Ropes,' " *Pittsburgh Courier*, 14 January 1956: 1–2; Ethel L. Payne, "The Boycott Story and Montgomery," *Chicago Daily Defender*, 8 May 1956: 5; "Boycott Still On," [Baltimore] *Afro-American*, 17 December 1955: 1.

4 [Baltimore] *Afro-American*, 3 March 1956: 7; [Washington] *Afro-American*, "Arraignment Today for 115 Accused in Ala. Bus Protest," 25 February 1956: 1; "Negroes Protest Bus Arrests with Prayer," *Jet*, 8 March 1956: 8.

5 "Vote to Continue Ala. Bus Boycott," *Chicago Defender*, 24 December 1955: 1–2; "Negroes Stop Riding," *Jet*, 15; "Boycott!": 1–2; "Bus Boycott Effective in Dixie City," *Pittsburgh Courier*, 17 December 1955: 3. For other examples of the black press stressing the power of Montgomery's black community, see Payne, "The Boycott Story,": 5; "Bus Boycotters Stand Firm," [Baltimore] *Afro-American*, 21 January 1956: 2; "Help Needed Now," *Philadelphia Tribune*, 25 February 1956: 8; "Bus Boycotters Won't Give Up!" *Journal and Guide*, 3 March 1956: 1; "Negroes Refuse to Ride Busses in Montgomery, Ala.," *Detroit Tribune*, 17 December 1955: 1; "Montgomery Bus Strike Still Going Strong, Race Holds Out," *Atlanta Daily World*, 23 December 1955: 1, 3.

1.19

An Essay on Success
in the USA, 1962

Mary Panzer

In the early 1960s, roughly five years after he joined *LIFE* magazine, prizewinning photographer Grey Villet introduced a new style of pictorial journalism to the shiny pages of the big picture magazines. His work delivered broad emotional power and an almost unthinkable proximity to his subjects, surpassing the intensely intimate portraits achieved by his colleagues W. Eugene Smith and Leonard McCombe in the late 1940s and early 1950s. Like them, Villet's method depended upon the Leica and available light. But Villet often relied on a long lens (180mm, f/2.8 Sonnar was a favorite), and used cropping to refine his compositions. As a result, Villet's images achieved distinct formal properties that differed from work by Smith and McCombe: grainy texture, large areas in soft focus, bold blocks of light and shade. His images bring viewers uncomfortably near his subjects and respect no conventional social boundaries. We come so close that we can see the nicotine stains on a fingertip, the dark pricks of a man's afternoon beard on a cheek that was smooth that morning. Villet called these portraits "psychegraphs"—as if his photographs could capture the thoughts and feelings of his sitters and get inside their minds.

"The Lash of Success" began when *LIFE* editors assigned Villet to work with veteran writer and researcher Barbara Cummiskey on a series she conceived exploring myths associated with the American Dream—Fame, Success, and Wealth. Though five decades later the premise seems mild, in 1961, this critical approach to accepted national ideals was something new to *LIFE*, widely known for its relentlessly upbeat approach to modern American culture. Through a friend in public relations, Cummiskey found Victor Sabatino, owner of a national chain of foam rubber furniture stores, whose lust for success was palpable to everyone who met him. Happy to appear in the nation's most widely read magazine, Sabatino allowed Villet and Cummiskey to accompany him everywhere. Cummiskey did the talking and listening, while Villet silently made pictures.[1]

As veteran reporters, Cummiskey and Villet knew how to melt into the woodwork; after weeks on the assignment, Sabatino ignored them, as did his colleagues and family. The picture story shows Sabatino bully his employees, manipulate his wife, visit his tailor, talk to an old friend, and kiss his young daughter good night. We see portraits of his grandfather, his best friend, and his customers. One affecting portrait showed Sabatino alone, logically impossible if the cameraman and writer had come along with him. But we accept the fiction. The "fly on the wall" style of photojournalism was nothing very new. Villet and Cummiskey broke new ground because they openly showed Sabatino as a flawed person, without patronizing him or passing judgment. Every aspect of his personality added depth to the portrait, and

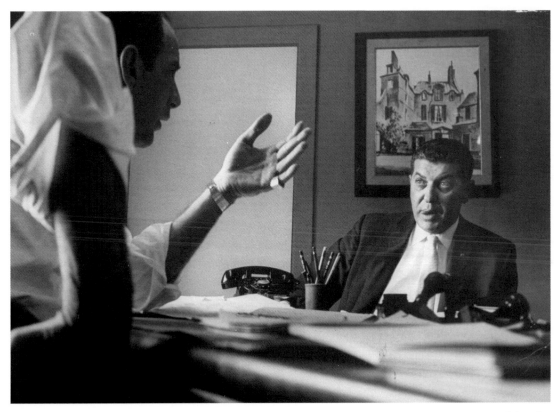

Figure 1.19 "Shrewd inquisition leads him along the trail. Talking to Herman Horowitz, a manager on the administrative side in Chicago, Vic was a butterfly collector wielding a pin . . ." Grey Villet, "The Lash of Success," from *LIFE* 16 November 1962, pp. 88–97.

brought the reader closer to him. What might have put us off in real life, becomes the source of fascination when experienced through the medium of the printed page.

Cummiskey's pitch-perfect text matched the almost unnatural proximity provided by Villet's lens. As Sabatino's business began to fail, and his marriage crumbled, he talked to the reporters about his life. "I know what Lillian wanted . . . She wanted me to see her—look at her . . . But I had to do what I had to do." Divorce was a relief. But he could not give up the business. " 'Everybody told me, 'Walk away Victor. Take what you can and walk away.' But I wouldn't. I fought and I talked and I fought.' "

The story ran eleven pages, with a bold layout sometimes three images to a full spread, all close-ups, just fragments of faces, along with more conventional images of Sabatino in conversation with wife, friends and employees, or alone. Images, text, and layout combined to eliminate the comfortable distance readers might expect a magazine story to offer. Instead we share his space, and as a result we see the world from his point of view.

Grey Villet considered "The Lash of Success" his most successful story. But in dozens of essays he demonstrated the same talent for crossing personal and social boundaries, and the same ability to bring readers close to subjects they might otherwise resist. Working with the *LIFE* team, Villet covered the race

beat during the Montgomery Alabama bus boycott, the contested integration of Little Rock Central High School, and Martin Luther King's lead up to the March on Washington, also photographing the white citizens and politicians who supported segregation. By working all sides of the story, his images made events suspenseful and interesting even to distant or disengaged readers. One notable story appeared in 1965 when he and Barbara (Cummiskey) Villet produced a story on Richard and Mildred Loving, the couple whose Supreme Court Case challenged the Virginia miscegenation laws which made their marriage a crime. The Villets placed the focus on the Loving's warm and modest home, challenging viewers to forget, for a moment, that Richard was white and Mildred was black. (Two years later, the Lovings won their case, changing the laws in eighteen states.)

The Villets went on to produce stories on homosexual rights, drug addiction, Castro's Cuba, and other risky topics. In hindsight, their once surprising stories can seem almost ordinary, in part because their too-close-up style was soon copied by photographers and New Journalists, and also because society has grown more tolerant. More poignant is the loss of the big picture magazines, the medium that Grey and Barbara Villet mastered, creating emotional, informative stories that opened their readers' eyes to a newly complex world, where nothing was ever purely black or white.

Note

1 "The Lash of Success. A Modern Parable: Vic Sabatino's Fierce Vision of Money and Power." Photographed for *LIFE* by Grey Villet, *LIFE* Magazine, 16 November 1962.

1.20
Burning Monk, Saigon, 1963

Diane Winston

In 1961, Malcolm W. Browne became AP's first full-time correspondent in Vietnam. The 30-year-old reporter joined the small American press corps just as the United States began escalating support for South Vietnam's war against the Communist-led North. Over the next two years, President John F. Kennedy, fearing a domino effect if Saigon fell to Hanoi, sent 12,000-plus military advisors and 300 helicopters to aid Ngo Dieh Diem, the South's Roman Catholic leader. Focused on the fight against Communism, American advisors either failed to see or ignored the Catholic government's oppressive treatment of the country's Buddhist majority. But reporters noticed, and when Buddhist leaders informed foreign correspondents about a big protest on 11 June 1963, several showed up to see what would happen. Only Browne brought his camera. His subsequent photos, capturing a shocking act of martyrdom, would jolt global awareness of the plight of Vietnam's Buddhists and provide American clergy with a religious image to challenge US involvement in the war.

At a busy intersection in central Saigon, Browne and his colleagues watched as 200 monks formed a human circle. A sedan pulled up and an elderly monk stepped out. He moved to the center of the circle and sat cross-legged in the street. Two younger men doused him with gasoline, and the monk dropped a lit match on his lap. Immediately he was ablaze. Browne, who had started shooting before the fire began, later recalled, "I was thinking only about the fact it was a self illuminated subject that required an exposure of about, oh say, f10 or whatever it was."[1]

Using a Petri, a "cheap Japanese camera," Browne kept reloading, eventually shooting ten rolls of film. The challenge was to get them to AP's New York headquarters as soon as possible. The 9,000-mile journey began with a passenger on a commercial flight to Manila (civilian couriers, called pigeons, were common at the time). In Manila, the film was edited, printed, and transmitted via radio to San Francisco, then New York. There, editors selected an image, edited the story, and sent the package to newspapers worldwide. The entire process—from Browne's Saigon office to the morning paper, took 15 hours and 20 minutes.[2]

The AP photo showed Thich Quang Duc, the burning monk, in the foreground, and behind him are the sedan and witnesses. Caught in black and white, the monk's suffering and imminent death—his body is engulfed in flames—is no less shocking for its rendering in shades of gray. Although many newspapers deemed the photo too disturbing for morning readers, it appeared in the *Philadelphia Inquirer* with the caption, "An elderly Buddhist monk, the Rev. Quang Duc, is engulfed in flames as he burns himself to

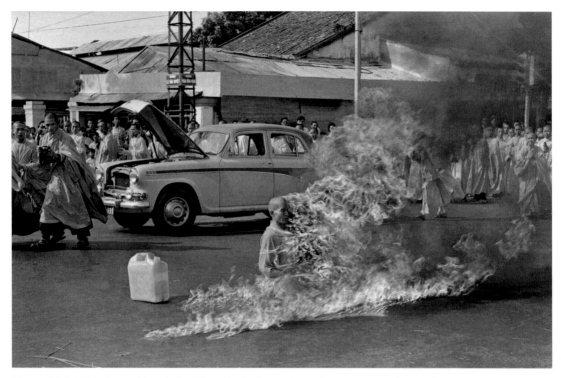

Figure 1.20 *Thich Quang Duc, A Buddhist Monk, Burns Himself to Death on a Saigon Street*, 11 June 1963. AP Photo/Malcolm Browne.

death in Saigon, Vietnam, in protest against persecution."[3] Seeing the morning papers, Kennedy was said to have cried, "Jesus Christ!"[4] He later noted, "these were the worst press relations in the world today."

Kennedy was distressed because Duc's self-immolation focused public attention on Vietnam. The administration had tried to hide the extent of US involvement in the war, often providing reporters with misinformation on combatants as well as casualties. Several months earlier, when the "Buddhist crisis" began, tensions worsened between the American press corps, the Diem government, and Washington. The Diem and Kennedy administrations complained that coverage of "alleged" religious persecution undermined efforts to fight Communism as well as American support for Saigon's leaders. Diem and his American supporters even claimed many Buddhists were Communist sympathizers. The photo of the "burning monk" raised troubling questions for leaders in the US and Vietnam: Who was persecuting Buddhists? And if the Diem government was involved, why was the US supporting it?

According to Hal Buell, a deputy photo editor when the image appeared, "That picture put Vietnam on the front page more than anything else that happened before that."[5]

Americans in the early 1960s knew little about Vietnam and less about Buddhism. Cognoscenti on either coast may have heard of the Beats and Zen Buddhism, but the average citizen had no reason to know about an Eastern tradition with only a small American following. Newspapers typically covered Buddhism as an exotic practice of benighted Orientals and their Western acolytes.[6] But Browne's photo stirred curiosity among readers and reporters. Moreover, at a vexed moment for religion's role in American society—the Supreme Court had ruled against school prayer and theologians contemplated the death

of God, while religious leaders shaped a civil rights movement and weekly church attendance remained high[7]—a dramatic spectacle against state-sanctioned religious persecution hit a nerve.

American clergy seized on the image to mount a campaign against their own government. The Ministers' Vietnam Committee placed a full-page ad in the *New York Times* protesting American involvement in Vietnam. The ad featured Browne's photo, cropped closely on Duc's body as it is consumed by flames.[8] "WE, TOO, PROTEST" read block letters under the picture, both eliding and subsuming Buddhist opposition to religious persecution with American dissent against involvement in the war.[9] When more of Brown's images circulated, a second photo of the burning monk, an earlier shot of the body half-consumed by flame, became the more familiar and widely-used image.

Browne's Vietnam reportage subsequently won the 1964 Pulitzer prize, and his photo of the burning monk has been hailed as one of the iconic images of the Vietnam War. It also contributed to more informed coverage of Buddhism by stoking "the media's slowly evolving appreciation for religions as collective experiences . . . and of the interplay between religious movements and the political, cultural and physical environments they inhabit."[10] It was and remains a potent symbol of the entwining interests of religion and politics—and the power of a polysemous image.

Notes

1 http://lightbox.time.com/2012/08/28/malcolm-browne-the-story-behind-the-burning-monk/#1 (accessed 17 January 2014).

2 http://www.ap.org/explore/the-burning-monk (accessed 17 January 2014).

3 Malcolm Browne, "The Burning Monk," *Philadelphia Inquirer*, 12 June 1963.

4 Lisa M. Skow and George N. Dionisopoulos, "A Struggle to Contextualize Photographic Images: American Print Media and the 'Burning Monk,'" *Communications Quarterly* 45.4, Fall 1997: 396.

5 Ula Ilnytzky, "Vietnam War burning monk photographer Malcolm Browne dies," *USA Today*, 28 August 2012 http://usatoday30.usatoday.com/news/nation/story/2012–08–28/malcom-browne-vietnam-war-obit/57363884/1 (accessed 6 April 2014).

6 Nick Street, "American Press Coverage of Buddhism from the 1870s to the Present," in the *Oxford Handbook of Religion and The American News Media* ed. Diane Winston (New York: Oxford University Press, 2012): 275–88.

7 http://www.gallup.com/poll/166613/four-report-attending-church-last-week.aspx. By 1963, church attendance was down from a high of 49 percent in the mid to late 1950s but it was still stronger than it would subsequently be (accessed 1 March 2014).

8 Ministers' Vietnam Committee ad, *New York Times*, 15 September 1963.

9 Michelle Murray Yang, "Still Burning: Self-Immolation as a Photographic Protest," *Quarterly Journal of Speech*, published online 16 February 2011 http://www.tandfonline.com/doi/abs/10.1080/00335630.2010.536565 (accessed 1 March 2014).

10 Street, "American Press Coverage": 276.

1.21
Kennedy Assassination, Dallas, 1963

David Lubin

Whatever we might call Abraham Zapruder's home movie, it is more than simply accidental footage of a world-historical event. Integral to the official investigation of the Kennedy assassination that occurred in successive stages from the early 1960s to the early 1990s, it has long exceeded its forensic status to stand as a landmark cultural artifact, suffused with emotional and philosophic complexities. Far from revealing the "truth" about a mysterious, unsolved crime, it reveals instead the impossibility of knowing, of seeing beyond the frame, of getting to the bottom of one specific imbroglio or, more generally, the human capacity for violence, terror, and evil.

As the motorcade of President John F. Kennedy rolled through Dealey Plaza in Dallas shortly after noon on Friday, 22 November 1963, the assassin Lee Harvey Oswald shot the President with a P Mannlicher-Carcano carbine rifle loaded with 6.5 mm shells. At the same moment, a Dallas dressmaker named Abraham Zapruder (1905–70), stationed nearby, shot home-movie footage of the president with a Bell & Howell home movie camera loaded with 8 mm color film. Those twenty-six seconds of footage, comprising some 400 individual frames, have come to be known as the Zapruder film. It is perhaps the most celebrated, infamous, and controversial news artifact in the history of the United States.

Immediately following the assassination, the Secret Service requisitioned Zapruder's reel for processing at a local Dallas film laboratory. The next day, Zapruder sold publication rights to *LIFE* magazine for $150,000, with the condition that the film be used in a dignified, non-exploitative manner. On 29 November 1963, *LIFE* published thirty blurry black and white frame enlargements. Its special memorial edition a week later reproduced some of these in color, but it was not until the release of the Warren Commission report on the assassination in October 1964 that *LIFE* printed a selection of frame enlargements in bright and devastating hues.

A decade later, on 6 March 1975, ABC's *Good Night America* nationally broadcast the film for the first time. Viewers were dismayed by what they saw, and debate about a possible government cover-up intensified. In 1978, the Zapruder family, while retaining their rights to the film, had it physically transferred to the National Archives and Records Administration for safekeeping. Oliver Stone reproduced the home movie in his 1992 feature *JFK* with an enhanced color, sharpened focus, and magnitude of size that had not previously been possible. Under these conditions, it proved stunning to viewers in its power, intimacy, and reach.

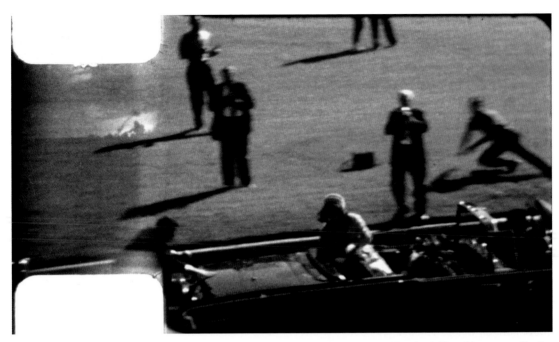

Figure 1.21a Enlargement of Zapruder frame 347, 1963 © 1967 (renewed 1995). The Sixth Floor Museum at Dealey Plaza.

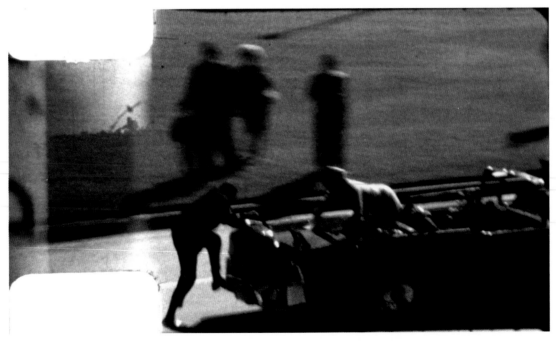

Figure 1.21b Enlargement of Zapruder frame 371, 1963 © 1967 (renewed 1995). The Sixth Floor Museum at Dealey Plaza.

From the start, the Zapruder film *conveyed* news (providing visual information about an important current event) and *made* news (Zapruder was interviewed on television and *LIFE* took forceful legal action to guard its copyright). Moreover, in the intervening half century, the movie has implicitly *critiqued* news, insofar as it accentuates the epistemological limitations of camera vision: despite the countless close viewings this "eyewitness" and "impartial" document has received over the years, it has told us nothing, finally, about who shot Kennedy and why.

In highlighting senseless tragedy and inexplicable death, the film embodies the modernist art, theater, and philosophy emanating from advanced circles in Europe and America in the postwar era. Indeed, it is an outstanding emblem of that era. With its aristocratic hero tumbling from the pinnacle of power, it seems to be a modern-day encapsulation of classical tragedy. Yet there's no catharsis here, no beam of illumination amid the darkness. From *Hamlet* or *Oedipus Rex* we come away with self-knowledge, having seen our flaws writ large in the lives of the doomed prince and king. But what does this modern tragedy teach? Only that even the best, most powerful, most charismatic of us, shining in glory, riding in triumph, may be felled without notice by the meteorite from the sky.

It's a domestic tragedy, as well. A man is stricken suddenly, and his wife turns to him in befuddlement, not recognizing his plight. His elbows fly up and his hands jerk uncontrollably. She hastens to his side but is powerless to restore him to himself. Like some Halloween skeleton dangled on strings, he performs a demented *danse macabre* with those pumping arms and wagging hands, his nervous system twitching out of control, while she looks on aghast and makes a futile effort to stay his flailing appendages.

It is sad, too, because it is a home movie, and home movies, no matter how joyful in subject or lighthearted in tone, ultimately infuse their viewers with regret, for they show *temps perdu*—time lost, never to return, eroding the youth, beauty, and vitality of those whom we love. Even though suppliers and advertisers of home movie merchandise have done everything in their power to promote the idea that home movies or videos are about fun and joy and good times, all the same, they are melancholy documents. They make visible the decay that besets us all. They remind us that we rust.

Though miniscule in scale and thoroughly unplanned in what it shows, the Zapruder film is a modern masterpiece along the lines of Picasso's *Guernica* (agonizing violence, political murder, death from above by unseen assailants) or Proust's *A la recherche du temps perdu* (the frailty of the rich and powerful, the fragility of their relationships, the irreversible flow of time). To construe the movie as modern art does not diminish its status as one of the most noteworthy pieces of pictorial news in the history of the medium. It does acknowledge, however, that the film has always had a conspicuously complex and ambiguous relationship to the historical happening it is thought to have recorded. Its ontological status is equally complex: made as a private document of an insignificant local event that instantly attained global significance, it was quickly transformed into a news-industry commodity while also serving as key evidence in a series of highly publicized criminal investigations by government organizations.

1.22

Political Persecution, Red Square, Harbin, 1966

Victoria Gao

On 26 August 1966, tens of thousands of people gathered in Red Guard Square in the northeastern Chinese city of Harbin to participate in a surprise public criticism of Ren Zhongyi, the province's Communist Party secretary.[1] According to photographer Li Zhensheng's testimony, the Red Guard faction had announced Ren's name in front of the amassed crowd without the secretary's prior knowledge and proceeded to tie his hands behind his back and force him into a 90-degree angle on an unstable folding chair. Li's own photograph focuses tightly on Ren's profile as he stands in his bowed position, a placard inscribed with the words "black gang element" hung around his neck and a meter-long dunce cap protruding from his head towards the chanting, seated throng. Black ink stains his face and his white shirt, eerily invoking the imagery of dripping blood in the sharp black-and-white contrast. The shouting around both Ren and Li is almost palpable, a wall of sound made visible by the cameraman on the left side of the image cupping his hands around his headphones. This disturbing scene is just one of an immeasurable number that occurred between 1966 and 1976 during the Great Proletarian Cultural Revolution of China, a period of criticism, revision, and complete cultural transformation during which high-ranking party members were purged and 17 million *zhiqing*, or educated youths, were 'sent down' to the countryside for manual labor.[2] Li Zhensheng had been a photojournalist for the *Heilongjiang Daily* just before the start of the revolution and, despite the oppressive political environment, used his camera, notes, and personal memories to weave together an account of a history that the public would go on to ignore and repress for decades. Fearing persecution for the images he had captured, Li developed and processed all of his own film before hiding away 30,000 negatives, stored in paper pouches with detailed captions and wrapped in oil cloth, under floorboards. He was finally able to publish a selection of them in 2003 as the book *Red-Color News Soldier: A Chinese Photographer's Odyssey through the Cultural Revolution*.

Photography's history in the Cultural Revolution has long been complicated by the active destruction of images, the limited availability of equipment, and the small range of styles permitted by state-imposed restrictions on the press. Broadly speaking, the medium was split between private and public spheres as a commercial tool for family portraiture and as a means for disseminating officially sanctioned messages whose compositions paralleled those of propaganda posters.[3] News photography, popularly understood to be comprehensive documentation of real events and people, became highly skewed to emphasize the salubrious effects of labor and communal living and to celebrate formal party gatherings. Li Zhensheng's

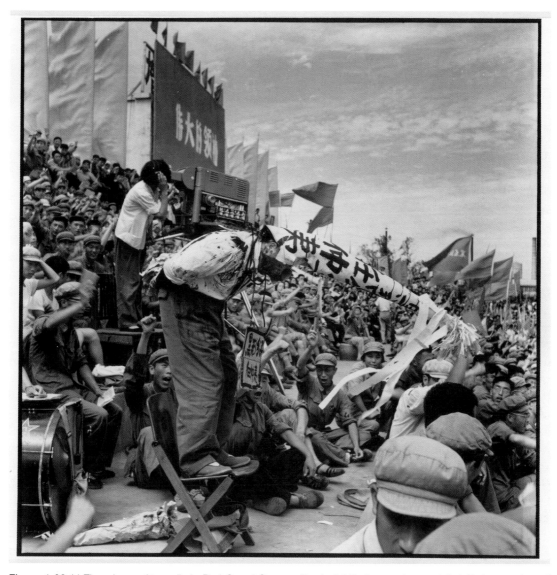

Figure 1.22 Li Zhensheng. At a rally in Red Guard Square, Provincial Party secretary and first Party secretary of Harbin, Ren Zhongyi, stands on unstable chair with his hands behind his back. His face has been smeared with black ink, a placard around his neck has the accusatory label "black gang element," and he holds a string attached to an ill-fitting dunce's cap. Harbin, 26 August 1966. © Li Zhensheng/Contact Press Images, Courtesy of the artist.

brutal but stunning series of images transgressed this private/public binary to reveal a more physically and psychologically violent facet of the Cultural Revolution than had previously been seen in print; he photographed the public criticisms and executions that would come to embody the horrors of the revolution. With a background in painting and filmmaking, Li drew on influences from a variety of artistic, photographic, and filmic traditions—including Goya's images of war, Cartier-Bresson's documentary journey across China and Soviet Socialist realist cinema—as well as his own experiences of forced

relocation and manual labor during the earlier Socialist Education Movement, which sent thousands of artists, performers, writers, and other "cultural professionals" to the countryside in order to solidify the Communist Party's control over such restless urban factions.[4] Even as he attempted to distance himself from the public events by consciously framing his photographs within conventions of objective reporting, Li's most striking images are those that position him and the viewer in the center of action. His involvement as both participant and documentarian is keenly felt as he describes his process: "When I wasn't taking a picture, if the crowd chanted, I chanted; if everyone raised their fist, I raised my fist also. Revolutionary passions ran high, and if you didn't follow the crowd they could easily turn on you."[5] In the photograph of Ren Zhongyi's criticism, Li's physical presence is alluded to in the direct stare from a woman seated in the aisle just below the secretary's angled dunce cap. He plays a part in the history to which he also acts as witness, using camera and memory together to record the events playing out before him.

The censorship during the revolution created a marked absence of images like Li's in the public sphere, and family photographs and propagandist images became the sole tangible legacies of the tumultuous decade. Passed on to new generations and contrasted against the increasingly capitalist culture of contemporary China, these remnants would alter the perception of the tumultuous decade from one of trauma to one of nostalgia. When Li finally unveiled his photographs, first in the late 1980s as political tensions began to ease and ultimately with the 2003 publication, many people in China and abroad experienced their first visual exposure to some of the worst tragedies that had been sidelined by the official state response to the Cultural Revolution.[6] The photographs he captured and their accompanying memoir-style text took on the unique role of reconstructing a lost narrative that encapsulated collective experience mediated through personal memory. Li Zhensheng destabilized notions of fixed truths by proving that history is formed not only through the documentation that is disseminated but also by the documentation that is excluded, and in doing so, he opened up new lines of dialog about confronting past traumas within changed political contexts on both a personal level and a global scale. *Red-Color News Soldier* is thus a portrayal for past and present audiences, public and private spheres—a site for protest, reinscription, and remembrance that makes the forgotten visible once more.

Notes

1 Li Zhensheng, *Red-Color News Soldier: A Chinese Photographer's Odyssey through the Cultural Revolution*, edited by Robert Pledge (New York, London: Phaidon, 2003): 73.

2 Paul Clark, *The Chinese Cultural Revolution: A History* (New York: Cambridge University Press, 2008): 18.

3 Nicole Huang, "Locating Family portraits: Everyday Images from 1970s China," *Positions: East Asia Cultures Critique* 18 (2010): 672–9.

4 Li Zhensheng, *Red-Color News Soldier*: 22–7.

5 Li Zhensheng, *Red-Color News Soldier*: 79.

6 Susie Linfield, *The Cruel Radiance: Photography and Political Violence* (Chicago: University of Chicago Press, 2010): 102.

1.23

Street Execution of a Viet Cong Prisoner, Saigon, 1968

Robert Hariman and John Louis Lucaites

Two Vietnamese stand in an open city street. The man to the left aims his pistol at the man on the right and pulls the trigger; the man on the right is in the liminal state between life and death, his face distorted by the force of the bullet that has entered his right temple but not yet exited the other side. Not yet dead, his death is nevertheless imminent.[1] The photograph, commonly dubbed "Saigon Execution," became iconic and remains one of the images explicitly tied to America's questionable involvement in the Vietnam War.

Iconic photographs represent significant historical events, create strong emotional responses, and circulate widely across media, genres, and topics.[2] These signature images also exemplify basic conditions of all photography, not least how the meaning of the image exceeds the intentions of the photographer, how it is from the start a complicated assemblage of facts and values, and how it can change over time. The corresponding difficulties in interpretation are evident in the history of "Saigon Execution." The image depicts actual conditions of warfare during the Tet Offensive, when Saigon was under martial law: civilians were being killed (e.g., by the prisoner before he was captured), enemies were not always in uniform, and the street battles required close, vicious fighting. Yet even when this contextualization was provided, the image of a bound prisoner being summarily executed on a city street also evoked strong emotional reactions that encompassed justification of the war itself. This moral shock and its strong resonance with the controversy over the war may have accounted for the prominence of the image among the many others taken during Tet, as well as its subsequent use on behalf of both progressive and conservative ideologies.

The photograph was taken on 1 February 1968, the second day of the Tet Offensive, a comprehensive surprise attack against US and South Vietnamese troops by the North Vietnamese army and the Viet Cong. The photographer Eddie Adams, a seasoned AP war photographer, had been in and out of Vietnam since 1965. As Adams reported, he came across several South Vietnamese soldiers in the Chinese neighborhood of Cholon who were marching a man in civilian clothes down the street with his hands secured behind his back. Adams followed them, snapping photographs, when another man approached from the left, raised a pearl handled revolver to the prisoner's temple, and pulled the trigger. Thinking that the man with the gun was trying to intimidate the prisoner, Adams took the photograph

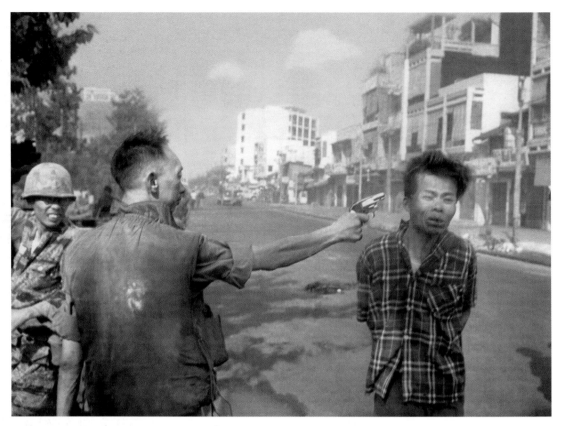

Figure 1.23 South Vietnamese Gen. Nguyễn Ngọc Loan, chief of national police, fires his pistol into the head of suspected Viet Cong officer Nguyễn Van Lem (also known as Bay Lop) on a Saigon street, 1 February 1968, early in Tet Offensive. AP Photo/Eddie Adams.

never imagining that he was actually witnessing an execution.[3] He took other photographs of the aftermath, including several of the man laying on the ground with a river of blood flowing from his head, but it was the photograph taken at the very moment of execution that appeared on the NBC nightly news that evening, was reprinted the next day on the front pages of newspapers across the United States, appeared in many major weekly news magazines, was almost immediately taken up by anti-war protestors and displayed on posters and T-shirts, and subsequently earned the World Press Photo Prize of 1968 and the Pulitzer Prize for news photography in 1969.

As reported in the caption to the photograph as it was printed in the *New York Times* on 2 February 1968, the executioner was General Nguyễn Ngọc Loan, the national chief of police for South Vietnam, and immediately upon shooting his prisoner, a Viet Cong guerilla (later identified as Nguyễn Văn Lém), he announced to Adams, "They killed many of my people, and yours, too." The image featured the act rather than any single justification, however, and this tableau along with filmed footage from the scene shot by an NBC crew was widely broadcast on television on 2 February.[4] The execution quickly became a rallying point for opposition to the war in Vietnam, and then for revisionary accounts as well.[5]

Adams went to his grave bemoaning the fact that the photograph was used to condemn General Loan and US involvement in the war. This response, while understandable in respect to Adam's beliefs, nonetheless is based on a blinkered understanding of both the Vietnam War and photographic meaning. An image of what appeared to be cold-blooded vigilante justice crystallized an attitude of official indifference to human suffering that far exceeded the reach of this one event, including the use by American forces or allies of napalm, Agent Orange, assassination programs, relocation camps, tiger cages, and similar tactics that inflicted severe civilian casualties in a war that many believed to be both unnecessary and unjust. Nor is such extension of the photograph secondary to its original meaning, as many features of the scene are already part of that wider and inherently controversial context.

Iconic photographs challenge conventional wisdom about the meaning of any photograph. That meaning often cannot be reduced to the simple facts of the case at hand or relegated to the photographer's intention or understanding. The facts are neither simple nor self-sufficient, but depend rather on selection, framing, depiction, contextualization, and imaginative extension in terms of larger narratives. The significance of "Saigon Execution" was not that it represented or misrepresented an execution, but that it embodied the moral ambiguity of violence that characterized US involvement in the Vietnam War. Its continued circulation suggests that, in more ways than one, the war is not yet over.

Notes

1 See Barbie Zelizer, *About to Die: How News Images Move the Public* (New York: Oxford University Press, 2010).

2 Robert Hariman and John Louis Lucaites, *No Caption Needed: Iconic Photographs, Public Culture, and Liberal Democracy* (Chicago: University of Chicago, 2007).

3 Eddie Adams, ed., *Eddie Adams Vietnam* (New York: Umbrage, 2008): 140–51; and *An Unlikely Weapon,* dir. Susan Cooper (2008, Morgan Cooper Productions).

4 George A. Bailey, and Lawrence W. Lichty, "Rough Justice on a Saigon Street: A Gatekeeper Study of NBC's Tet Execution Film," in P. Braestrup, ed., *Big Story: How the American Press and Television Reported and Interpreted the Crisis of Tet 1968 in Vietnam and Washington,* v.2 (Boulder: Westview, 1977): 266–81.

5 See Bruce H. Franklin, *Vietnam and Other American Fantasies* (Amherst: University of Massachusetts, 2000).

1.24
Industrial Poisoning, Minamata, 1972

Gennifer Weisenfeld

A sublime image of unconditional maternal love and sacrifice, the iconic 1971 photograph by veteran photojournalist W. Eugene Smith (1918–78) of Minamata disease victim Tomoko Kamimura being bathed by her mother is a visual lamentation.[1] Echoing the tearful lament of victims' families, who wept, "How long will those of us who have been sacrificed have to cry ourselves to sleep?" this photographic pietà evokes the symbolic sacrality and martyrdom of its pictorial referent.[2] Yet the photograph's mournful serenity belies a story of extreme violence against the environment, humanity, and decades of sometimes violent physical and political struggle by the fishing communities and victims' families in their efforts to receive recognition and compensation for unimaginable suffering and loss.

Published in the 2 June 1972 issue of *LIFE* magazine as a double-page spread, the photograph is the emotional denouement of Smith's powerful photoessay titled "Death-Flow from a Pipe" that documents Chisso Corporation's industrial pollution of Minamata Bay and the Shiranui Sea on the southern island of Kyūshū.[3] Starting with a stunning photograph of a massive pipe discharging industrial effluent into a residue-encrusted waterway below, the project instantly brought international attention to the company's dumping of toxic wastewater, containing methyl mercury from acetaldehyde production, into Hyakken Harbor and the Minamata River; this had been poisoning local inhabitants through contaminated seafood from 1932. Initially comprising eleven photographs, including a commanding close-up of Tomoko's twisted hand juxtaposed with the polluted landscape, the photo essay was expanded into book form in Japan in 1973 and in the US in 1975.[4] The Minamata series marks a pivotal moment in the history of activist photojournalism's fight against environmental pollution on a world stage. Smith and his wife Aileen produced the works while they lived in Minamata for three years from 1971 to 1973, when local activists were shifting their political strategy to increasing the visibility of disease victims through direct appearances and mass media.[4] Despite years of grass roots activism regarding this egregious case of industrial pollution, neither labor unions nor victims' families made significant headway in getting legal recognition or fair compensation until 1973.

While Smith's photograph became a national emblem of collective suffering and an icon of the Japanese cultural value of "*gaman*" (stoically enduring the seemingly unbearable with patience and dignity), it also expresses the subjects' extreme social isolation and the unshakable bonds of family in the midst of communal rupture. Minamata is a palimpsest of Japanese modernity. Its history of exploitation reveals the conflicted status of Japan's periphery in the face of the nation's rapid industrialization when

national interests were often privileged at the expense of individuals and local communities—in many ways, it is the story of Fukushima as well.

As Smith states in the Prologue to *Minamata*, "This is not an objective book. The first word I would remove from the folklore of journalism is the word objective."[5] This aptly describes his immersive and emotive method, and his dedication to pioneering the photoessay, with acclaimed works for *LIFE* such as "Country Doctor" (1948) and "Nurse Midwife" (1951), and his opus on the city of Pittsburgh (1955–8). Smith's deeply humanistic approach to image-making precluded detached observation; instead, he chose to embed himself within the story to personalize it.[6] Indebted to modernist formalism, Smith's Minamata series is so affecting because it mobilizes the jarring yet alluring aesthetics of deformation—the contortion of the diseased body—to draw the viewer into a relationship with the subjects; to experience their suffering, sorrow, and strength.

Smith ultimately sacrificed his own body for the sins of others when he incurred permanent physical injury from violent clashes with Chisso company strongmen, amplifying his already heroic artistic identity in the American press to near mythic proportions that practically occluded the Minamata cause.[7] For him, the photoessay was a medium through which to convey his "passionate" concern for a myriad of environmental threats proliferating on a daily basis.[8] The project reflects a broader trend in awareness of the environment that began in the early 1960s and launched the environmental movement around the world with landmark publications such as Rachel Carson's *Silent Spring* in 1962 about the dangerous use of pesticides.[9] Three days after Smith's photoessay ran in *LIFE* in 1972, the first global environmental conference was held in Stockholm—the United Nations Conference on the Human Environment—and Minamata disease patient Sakamoto Shinobu and her mother stunned everyone in the audience into silence by ascending the stage and publicly displaying the girl's afflictions; like the image of Tomoko, she was a visible embodiment of the woefully incomplete project of social justice.[10] Ironically, even the photograph itself became a source of contention as it grew in national and international currency. Widely reproduced, and selected as the poster image for the major 1996 Minamata Tokyo Exhibition, the photograph of Tomoko was plastered across the capital, much to the family's distress and the consternation of some Minamata victims, who had already unfairly accused prominent victims' families of seeking the limelight and benefiting from the pain of others. Due to these stresses, and the personal toll of seeing Tomoko's vulnerable, naked body circulated for prying eyes and prurient consumption in the public sphere for decades, Aileen Smith, respecting the family's wishes, decided in 2001 to stop granting permission to reproduce the image in order to prevent it from "turning to profanity."[11] Tomoko deserved eternal peace.

Notes

1 Although the Smiths read Tomoko's family name Uemura, the family pronounces their name Kamimura. Uemura, however, is still most commonly used in descriptive titles of the photograph.

2 A statement made by the Minamata Disease Patients Families Mutual Aid Society (*Minamatabyō kanja katei gojokai*) in 1959. Quoted in Timothy George, *Minamata: Pollution and the Struggle for Democracy in Postwar Japan*. (Cambridge, MA: Harvard University Press, 2001; paperback 2002):107.

3 The company Japan Nitrogenous Fertilizers, Inc. commonly abbreviated as Nitchitsu, was renamed Chisso Corporation in 1965. On industrial pollution, Brett Walker, *Toxic Archipelago* (Seattle and London: University of Washington Press, 2010).

4 W. Eugene Smith, *Minamata: Life—Sacred and Profane* (Tokyo: Sojūsha, 1973); W. Eugene Smith and Aileen M. Smith, *Minamata* (New York: Holt, Rinehart and Winston, 1975).

5 A full partner who produced half of the photographs, Aileen Smith's Japanese heritage and language abilities provided essential skills.

6 Smith, *Minamata*, 1975: 7.

7 On Smith, see especially, *W. Eugene Smith: Master of the Photographic Essay* (Millerton, NY: Aperture, 1981); and Brett Abbott, *Engaged Observers* (Los Angeles: J. Paul Getty Museum, 2010).

8 Martha Rosler, "In, around, and afterthoughts (on documentary photography)," in Richard Bolton, ed. *The Contest of Meaning* (Cambridge: MIT Press, 1999 [1992]) 308, 336.

9 Rachel Carson *Silent Spring* (New York: Houghton Mifflin, 1962).

10 Smith, *Minamata*, 1975: 7.

11 "Declaration of the United Nations Conference on the Human Environment," 1972, http://www.unep.org/Documents.Multilingual/Default.asp?documentid=97&articleid=1503

12 For Aileen Smith about her decision, see http://archive.today/e84c (accessed 22 October 2014).

1.25
Police Beating, Los Angeles, 1992

Christian Delage

When, on 3 March 1991, Tim and Melanie Singer, both California Highway Patrol officers, stopped a Hyundai on the 210 freeway for traveling too fast, they anticipated a routine experience. As they prepared to arrest the offender, however, four LAPD officers intervened, striking the driver, Rodney King, with fifty blows, resulting in his hospitalization. The case might have stopped there, even if King had tried to file a complaint against the officers, whose reputation for mistreatment of African Americans was regularly singled out. But it turns out that just across the parking lot from where King's car was stopped, George Holliday, a neighbor alerted by the sound of sirens and the presence of helicopters, decided to use, for the first time, the Sony Handycam he had recently acquired as a gift. He filmed the beating of King, thus opening the possibility of transforming this moment into a newsworthy event.

The next day, Holliday carried the tape to a local television station, KTLA, which in turn took it to the LAPD, and also aired it that evening. Two days later, CNN broadcast the tape, thus precipitating an FBI investigation. On 6 March, other networks aired the video, and soon thereafter the LAPD Chief Daryl Gates announced that the officers involved in the case would be prosecuted. Influenced by viewing the tape, a grand jury returned an indictment against the four officers on 11 March 1992. The subsequent trial, held in predominantly white and conservative Simi Valley, resulted in a jury acquittal of three of the officers of all charges. The jury could not reach verdict on one charge against the fourth officer.

Barely two hours later, South Central Los Angeles fell into riots, resulting in the death of more than 50 people, 2,000 people injured, and more than $1 billion in property damage.[1] In turn, the unprecedented images of domestic urban violence forced President George H.W. Bush to intervene by holding a press conference broadcast live on TV. On 30 April, he announced that he had ordered the Department of Justice to investigate the possibility of filing charges against the LAPD officers for violating King's civil rights.

A second, now federal, trial would eventually take place, resulting in penalties for the officers. The prosecuting attorney, Allan Tieger, said: "The significance with the Rodney King case, I think, is that it represented a kind of breakthrough in public awareness of the ways in which, and to some extent the legal ways in which, video can be used. Now those who might consider crimes have to know that, surprisingly, what they do can be preserved. And it can be preserved and can be used essentially in a way that is beyond dispute."[2]

During the trial of the LAPD's officers, the prosecutor said: "the videotape shows conclusively what occurred that night and it's something that can't be rebutted. It's there for everyone to see. It is the most objective piece of evidence you can have."[3] Remarkably, the defense also understood Holliday's footage as a useful piece of evidence, but as evidence of their clients' innocence. Discussions went far in order to describe exactly what was shown, and mostly, to interpret the behavior of King as well as of the officers.

Consistent with American jurisprudence since the 1920s, which privileges the photographic still over the moving picture in its hierarchy of evidence, the defense decided to argue by using the video as a series of still images.[4] First, it is easier to proceed pedagogically in front of the jury, inserting the image into a discursive argument. In addition, the defense wanted to show that the police respected the codes of behavior in the context of an inquiry where the suspect seems to be aggressive.

The "stop-motion," as Fritz Lang used it in *Fury* (1936), isolates, one by one, the segments of an action. Through such a method, you can more easily cross-examine the video, which is probably the best way to recognize—while at the same time to trivialize—the value of film and video as evidence. But a still image is not a photograph. It is one out of the thirty frames that make up one second of video. If then it were not possible, today you can slow down a video, which allows you to simultaneously observe the movement of the filmed images and the cutting in sequential frames.

The images of Rodney King's beating have played in different venues since 1992. In LA, the Police Department decided to henceforth generate their own film evidence through the implementation of surveillance cameras to self-monitor routine police work. The King images are considered, too, as the start of so-called "citizen journalism." And they were immediately used in and by Hollywood: Spike Lee's 1992 *Malcolm X* begins with a title sequence featuring an American flag being consumed by fire intercut with extracts of the video. In such feature films, the video is used as an icon, something that doesn't provoke any doubt about its meaning. The first African American audience of *Malcolm X*, in Harlem, was shocked by the revelation that the man who shot the leader of the Nation of Islam was a member of the organization and not a white man.[5] But they took as evidence the footage of the beating of King, just because they were so many others who had suffered the same fate. The video was perceived as a generalized revelation of what each of them had endured, which had been willfully hidden from the camera by the police.

While a filmmaker such as Spike Lee might re-use such footage, originally journalists played a critical role as mediators, giving the tape to the police and pushing the FBI to open an investigation. But the discussion of the accuracy of the video did not come from the media, but from justice. This may seem contradictory, but it is not. By qualifying the video as evidence, it opens the process of cross-examining it, as it would for any other piece of evidence. Establishing the truth is a construction, which admittedly is based on documents considered true and authentic, but subject to interpretations proposed by each party present in the trial. Usually, the news shown on TV is not subject to a sort of permanent criticism, because the journalists work in compliance with the ethics of their profession. The video amateur cannot avail himself of such a contract, even if he may be considered an impartial witness. The fact that George Holliday's footage was the subject of debate in the courtroom has increased its probative value.

Notes

1 See http://www.laweekly.com/microsites/la-riots (accessed 2 October 2014).

2 See http://www.coursehero.com/file/7536626/The-Rodney-King-trials/ (accessed 2 October 2014).

3 Proceedings of the LAPD's Officers Trial, http://law2.umkc.edu/faculty/projects/ftrials/lapd/lapd.html (accessed 2 October 2014).

4 See Christian Delage, "The Jurisprudence of Film as Evidence," *Caught on Camera. Film in the Courtroom from the Nuremberg Trials to the Trials of the Khmer Rouge*, edited and translated by Ralph Schoolcraft and Mary Bird Kelly (Philadelphia: University of Pennsylvania Press, 2014): 13–18.

5 See the magazine *24 heures* aired on Canal+ in February 1992.

1.26
The Situation Room, Washington, DC, 2011

Liam Kennedy

The photograph widely referred to as "The Situation Room" was posted with eight others at 1:00 p.m., Eastern Standard Time, on 2 May 2011, on the White House's Flickr site. The caption states, "President Obama and Vice President Joe Biden, along with members of the national security team, receive an update on the mission against Osama bin Laden in the Situation Room of the White House, May 1, 2011."[1] It rapidly became one of the most viewed images on Flickr (1.4 million views within twenty-four hours) and has been subject to multiple interpretations. It was published on the front pages of leading national newspapers across the globe. Mainstream media such as CNN and the *Washington Post* lined up experts to comment on varied features of the images, including body-language experts, and remarked in particular on the facial gestures of Clinton and Obama. On-line, legions of conspiracy theorists have questioned every aspect of the image's production and framing, while Photoshoppers have created multiple memes.

All the commentary on and remediation of this image exemplify its production and circulation as a significant visual event, and it has been widely labeled "iconic." However, there has been little reflection on what this labeling of the image means beyond assertions that it is "historic." The definition and function of *iconicity* requires more careful attention. As Robert Hariman and John Louis Lucaites have observed, iconic images foreground the affinities between the democratic ethos of photojournalistic image-making in American culture and moral and national investments in collective memory, but they also register the tensions inherent in the formation and transmission of collective memory.[2] The iconicity of the Situation Room image is symptomatic of the conditions of visuality under which it has taken on meanings about the power of the state.

While this image was widely disseminated as a news image, it was not initially produced as such; rather, the White House photographer, Peter Souza, produced it for archival purposes. The White House photographer produces a documentary record of the President's day-to-day life. Although the primary objective in creating the imagery is archival, the White House also uses it to publicize the President's current activities. Obama's communications team created a Flickr page for the White House in February 2009 and has released a much greater volume of imagery than any previous administration. Souza and his three assistants take between 20,000 and 80,000 photographs each month. The White House photo editor, together with Souza, choose images for the Flickr site, and the White House Communications

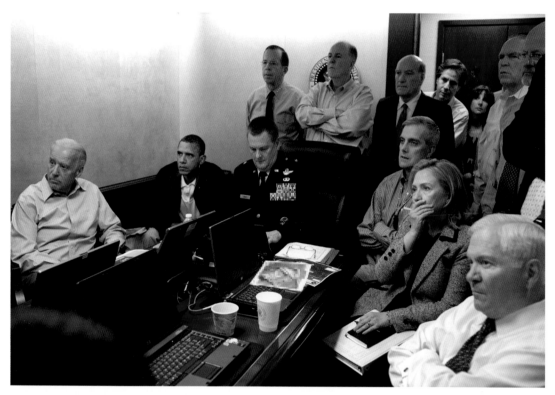

Figure 1.26 Pete Souza, President Barack Obama and Vice President Joe Biden, with members of the national security team, receive update on mission against Osama bin Laden in the Situation Room of the White House, 1 May 2011. Reused in accordance with the terms of Creative Commons Attribution 3.0 License (http://creativecommons. org/licenses/by/3.0/us/).

Office signs off on these. This volume and form of distribution is claimed as a democratization of the documentary visualization of the presidency, an opening of new windows on the man and the environment.

The Flickr stream sends out the message that there is nothing to hide, that we have visual access to the events as they unfold. The illusion is enhanced by the irreducible if fragile "reality effect" of the documentary image that denotes the authenticity of the moment, the slice of time captured in the frame. With this image the reality effect is activated and enhanced, first, by the viewer's sense of seeing "behind the scenes" of power—of having special, momentary access to a reality usually unseen—and by the apprehension that this is a singular moment of national import (there is an added *frisson*, of course, of the possibility that the people in the room are watching the killing of bin Laden).

The sense of reality effect is also enhanced by its banality. The room appears a bland example of corporate conference rooms, and we note the general informality of dress and gesture—the image challenges our assumptions, influenced by movies and TV shows, about what such a space looks like. The scene presents an intimate, unguarded moment when power is in play and leaders appear vulnerable in relation to the unknown outcome, and so they become humanized, revealed as something more than figures of power. This reading of the image was common in the national media. In the *Washington Post*,

Joel Achenbach remarked: "Protocol fell away. They were all, in that moment, spectators to an historic event—and they didn't know which way it was going to go."[3]

This illusion of transparency needs to be resisted and debunked. This idea ignores the various ways that the image is staged or edited (not faked). The sense of tension that commentators rightly pick up in the image is due mostly to the composition, for Souza has selected a very tight frame, with the actors confined in a space that is much smaller than the Situation Room—the effect both dramatizes the tension of the moment and levels the actors. His point of view also optimizes his own invisibility and hence that of the viewer and so increases our sense of watching a scene to which we would not normally be privy. He also edited the image digitally before its publication. Details on paperwork in front of Clinton have been erased, and the lighting in certain areas has been highlighted, most notably on Clinton's face. We should also note that many images were taken between this image and those on either side of it in the Flickr sequence, further evidence of the careful process of selection.

Beyond these technical issues, the illusion of transparency should be questioned as an ideological conceit. In particular, the claim that the people in the image were "spectators" who "didn't know which way it was going to go" displaces the agency of power and violence to a distant, invisible elsewhere. It describes actors as spectators and focuses on the reactions of those exposed to the event rather than on the event itself, or, more correctly, the staging-as-reaction—the "situation"—becomes the event. What occasioned most of the media commentary was this fixation on reading the meaning of the event off the gestures and expressions of the people in the room and off their arrangement within the confined frame of the "situation." Following such readings, we might conclude that the "shock and awe" of this image resides precisely in the dramaturgy of human vulnerability and anxiety of those in power. It is an apt conclusion, perhaps, for viewers are implicitly asked to identify with the role of spectatorship that those in the Situation Room appear to take up on our behalf. But this reading elides recognition of the agency of power and violence that appears to be offscreen but is before us in this room. In the age of drones, this is indeed an iconic image of war, which confirms the now commonplace disavowal of the "costs" of a war that is hidden in plain sight.

Notes

1 See photograph P050111PS-0210 in "The White House's Photostream," Flickr, posted 2 May 2011, http://www.flickr.com/photos/whitehouse/5680724572 (accessed 21 October 2014).

2 Robert Hariman and John Louis Lucaites, "Public Identity and Collective Memory in US Iconic Photography," *Critical Studies in Media Communications* 20.1 (2003): 38.

3 Joel Achenbach, "That Situation Room Photo." http://www.washingtonpost.com/blogs/achenblog/post/that-situation-room-photo/2011/05/04/AFrx7KmF_blog.html (accessed 2 January 2014).

RE-THINKING THE HISTORY OF NEWS PICTURES

INTRODUCTION

Jason E. Hill and Vanessa R. Schwartz

The essays in Part One challenged the predominant orientation in the history of news pictures that has until now focused extensively on the single iconic photograph. By using that familiar structure, they probed and denaturalized the icon in favor of a much richer history of the relation between what is pictured and the process of picture-making itself in the era of the mass press, from the late 1830s onwards. Those essays foreshadowed what this section now foregrounds: that no understanding of a news picture and its significance can bypass the material history of the making of the picture itself, nor the history of the media institutions and people that organize such pictures and transmit them to an eager and interested public. That public has its own investments and responses that then come to shape and remake the media and institutions of news picture making. These varied receptions also help foster the longer life that many news pictures have, in which they go on to multiple uses beyond their initial topical function as reportage, itself ephemeral by definition.

The essays gathered here offer a rich array of sketch artists, history painters, photojournalists, photo editors, and newspaper and magazine editors. They consider the question of "access" to the news (whether that of the journalist or the viewing public) but also account for the censorship or poor distribution of images once made. They describe an ever-changing host of imaging technologies: engraving, photo technologies from flash to the telephoto lens, different camera sizes and negative formats, varied light-sensitivity of film stock, and the preferences concerning color that made news pictures look the way they did. The essays are attentive to print techniques: the halftone process and rotogravure, the advent of speedier presses, vast new paper rolls, and the actual means and pace of the transport of materials.

The essays in this part have been organized in order to identify the essential questions and problems investigated by the scholarship on news pictures. Beyond looking through the news picture as through a window, as inert evidence of the pictured thing or as a discursive construction of the object in the world outside the frame, the essays here concern the complex histories of the news pictures themselves. Going beyond the image as an evidentiary record, much good work on photojournalism, especially, has focused on the ethical and moral dimensions of this kind of pictorial reporting.[1] But too often scholarship overlooks the messy, procedural work of the production of images and their embeddedness within a larger, dynamic system of news picturing—which function as invisible matters upon which all subsequent interpretive possibilities depend.[2] The essays here offer a history that is contingent, and one whose specificity shapes the very possibility surrounding the social power of news picturing.

The essays also ask deceptively simple questions about such images: How are they secured? What can and should be their subject? What technologies and materials support the system that especially comes to define the speed of what's news? How and where does the public meet and receive the images? What professional and connoisseurial criteria have evolved over time for their evaluation? As in Part One, the essays are organized more or less chronologically within each section. They do not trace a single course of development, because the multiple contexts and cultures under interrogation here are neither universal nor exhaustive.

Part Two also moves more intentionally away from the singular fascination, scholarly and otherwise, with images of war, disaster, anguish, and trauma that have largely dominated this field of study.[3] It is true that scenes of conflict have tended to mobilize the news picture enterprise at its most sophisticated and controversial. But, as any consumer of the news will know first hand, news pictures often attend to rather less sensational fare.

In **News Pictures and Press Genres** we identify and explore five dominant rubrics: fashion, celebrity, sports, and crime, as well as war, in order to examine the diverse visual culture of the news that they enable. In **News Picture Media**, essays explore the places where the public meets the image. While we naturally consider a wide range of media throughout the volume, here we focus on the illustrated newspaper, the magazine, the newsreel, television, and the Internet as important sites that suggest that news pictures constitute a public as much as they inform it through their mechanisms of support and delivery. Through these essays, we are not only with the professional press photographer or amateur in the field but we also are exposed to such spaces as editorial offices, cinemas, and the home. Such a diverse approach to news image media we believe helps render the specificity and impact of the digital platform, in which we are currently immersed, even more visible. Originally circulated online before being publicized in the *New Yorker* and *60 Minutes II*, and later mediated variously in documentaries and Hollywood dramas, the nightmarish images produced in the Abu Ghraib prison—the subject of Abigail Solomon-Godeau's essay—have activated all of these media.

This volume's authors are particularly attentive to how the interplay of technological possibility shapes notions of speed and duration. News is predicated upon notions of immediacy, and in **News Picture Time**, essays explore temporality as a material experience facilitated by complex networks of information, transportation, and mobility, as these reshape imaginative horizons amidst a culture of heightened expectations around speed. So if, as Jordan Bear argues, Géricault's painting, *The Raft of the Medusa*, offers a meditation on the challenges of transmitting visual information over long distances, Zeynep Devrim Gürsel observes that, once the wire made all news pictures potentially "fast," it also then put greater pressure on making them "good" instead.

In **Speaking of News Pictures**, the essays examine the many instances in which the picture and the act of picturing behind it—its making and transmission—became the news itself. As we have seen with Tom Howard's photograph of Ruth Snyder's execution, the taking of pictures and their publication often become their own locus of interest (as in Patricia Goldsworthy-Bishop's discussion of the King of Morocco's pictures of his harem). But essays in this section also remind us that the pictorial reporter not only pictured the news but also, in doing so, started to establish the limits of what could be pictured at all, and therefore what could be, in a very real sense, "the news."

Perhaps more surprising is encountering the news picture in the art museum, an institution that seems inherently averse to mass culture at its most ephemeral but which has been more invested in the "art" of pictorial reporting than scholarship has generally recognized. This history is examined in **News Picture Connoisseurship**, which considers attributions of value and the rise of professional standards

among press photographers, the emergence of international juried prizes, and the evolving rhetoric through which institutions police the tenuous border dividing high culture from low commerce, and which permits the migration of press pictures into fine art.

The volume is deliberately broad in its mapping of the field of the news picture, and offers a more complete picture of what news was, is, and will be than those volumes oriented to the darkest and most painful moments in current events that survive in public memory as a form of collective trauma. The news, after all, reports great triumphs as well. We have sought to attain a large temporal sweep in order to establish a sense of news picturing as it has changed over time. We have also looked beyond photojournalism as the predominant visualizing practice. Our geographic coverage is broad but hardly exhaustive: we do not have contributions focused specifically on sub-Saharan Africa or South America, for example. Although many societies have "chronicled" their times since antiquity, the essays in this volume establish a news picturing system that emerged as part of the mass press in the Western world. This press created a consciousness regarding the rest of the world made concrete through picturing, which is as powerful and irreversible a force as the development of large-scale finance to the history of what we now call globalization. Back in 1938, A. J. Ezickson of New York Times World-Wide Photos, whose book *Get That Picture!* inspired this volume's title, honed in on the process of news picturing and its powerful effect in bridging the gap between the world "over there" and the reader's field of vision when he wrote, "Into the far corners of the world went the man with the camera, using the fastest conveyance to get to and from the scene . . . Distances mattered not; it was the slogan of the editor then, as it is today: 'Get the picture! And bring it back first.' "[4] The history of the news and its picturing is so fundamental a domain through which experience of the world in the last two centuries has passed, that these essays, which examine the cultural expectations and practices it entailed, promise a clearer image not only of where we have been but also of where we might go next, and how fast we will be able to get there.

Notes

1 Sharon Sliwinski, *Human Rights in Camera* (Chicago: University of Chicago Press, 2011); and Ariella Azoulay, *The Civil Contract of Photography* (New York: Zone Books, 2012).

2 For an exemplary work that does not have this problem, see Joshua Brown, *Beyond the Lines. Pictorial Reporting, Everyday Life, and the Crisis of Gilded Age America* (Berkeley: University of California Press, 2002).

3 Susie Linfield, *The Cruel Radiance: Photography and Political Violence* (Chicago: University of Chicago Press, 2012); Geoffrey Batchen, M. Gidley, Nancy K. Miller, and Jay Prosser, *Picturing Atrocity: Photography in Crisis* (London: Reaktion, 2012); and the fundamental, Susan Sontag, *Regarding the Pain of Others* (New York: Picador Press, 2002).

4 A.J. Ezickson, *Get That Picture! The Story of the News Cameraman* (New York: National Press Library, 1938).

News Pictures and Press Genres

2.1
Not Just a Pretty Picture: Fashion as News

Justine De Young

Just over the toupée a broad white or sky-blue ribbon is drawn from one side to the other, upon which the twelve signs of the zodiac are either painted or embroidered with silver or gold, or woven in, (all which sorts of ribbons may be had ready made at Paris) and tied behind in a large knot, the bows of which ascend, and the streamers are left flying.[1]

The Lady's Magazine in July 1777 thus describes the latest fashion news out of Paris and its newest fashion plate (Fig. 2.1a). The *Zodiaque* represents the absolute *"newest* French Ladies Head Dress,"* based on first-hand reports "from our correspondent at that seat of gallantry and fashion." Together with a gentleman's hairstyle, *en Medaillon*, they are, "the newest head dresses of what is called *le beau monde* at Paris."[2] *The Lady's Magazine or Entertaining Companion for the Fair Sex, appropriated solely to their Use and Amusement* (1770–1837) was the first journal to include regular fashion news and engravings of contemporary fashions, and this is one of its earliest plates. It combines the two most common categories of fashion news: reporting on what is new (products, trends, styles) and describing what is happening (who wore what where and when). Indeed, we already see many of the characteristics of fashion news and illustration that would be so typical later: the emphasis on newness, on accuracy, and on Paris as the center of fashion.

The image conforms to what's expected of a fashion news picture: "The primary purpose of any fashion picture, locally produced or not, is to show a new style pleasantly and in clarity of detail. It's like any other news picture worth printing; it must tell the story."[3] This advice from a 1951 guide on presenting fashion in newspapers could just as easily describe this 1777 engraving, which positions the figures to highlight the most important details of the new styles. Thus the woman appears in profile to best display her hair's hemispheric shape and the Zodiac ribbon and the man is in lost profile so that we can make out the *Medaillon*—his hair shaped to appear "in imitation of a medal." No setting or background distracts us and the name of the style is elegantly inscribed below. This spare presentation of the essential details of the style and its careful textual description is typical of late eighteenth- and early nineteenth-century fashion news pictures.

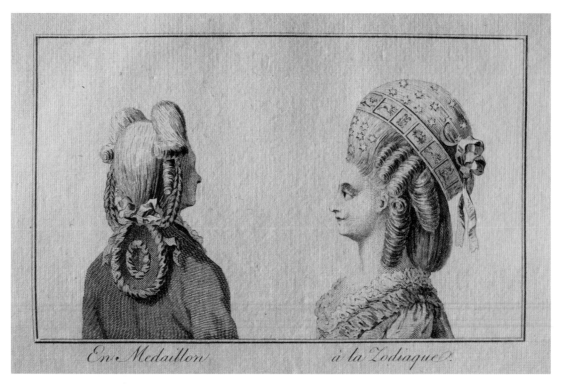

Figure 2.1a "The Gentlemens [sic] Head-Dress, *en Medaillon*; and The last new Ladies Head-Dress, *à la Zodiaque*," copper-plate engraving, *Lady's Magazine*, July 1777. Harvard University.

Of course, this sort of image differs rather dramatically from the elaborate photoshoots included in magazines today to highlight the latest styles, but only a hundred years later, we find a much closer precedent as well as some dramatic changes in the presentation and purpose of fashion news pictures. In an 1876 plate (Fig. 2.1b) by Paris-based illustrator Jules David, we see an elegant Parisienne with her two daughters walking past a wall filled with posters and images advertising theatrical events.

To make our public, urban, and particularly Parisian setting even more obvious, David includes in the background a Morris column, typical Haussmannian street furniture that would have displayed even more advertising, and two men—one reading a newspaper. The veiled woman stares out at us, seeming self-confident and savvy as she shepherds her two children through the streets of Paris. The image encourages the magazine reader to identify with this self-assured Parisienne and to admire her sophisticated chic (and that of her smartly outfitted daughters).

The differences between these two plates in many respects encapsulate the dramatic changes the fashion press would undergo over the course of the nineteenth century, setting the shape of the fashion press and fashion news picture today. Instead of an anonymous, small, black and white near-diagram set against a plain background, we have a large, folio-sized, signed, hand-colored narrative scene set in modern Paris. The focus is no longer on a single new item (head dress designs), but on goods for the whole body and family; the inscription below the 1876 plate advertises where to buy not only the fashions depicted, but also lingerie and corsets, Eau Figaro (a hair dye) and *lait antephelique* (an early face lotion, known even then to be toxic, but thought to remove freckles). Where *The Lady's Magazine* simply said

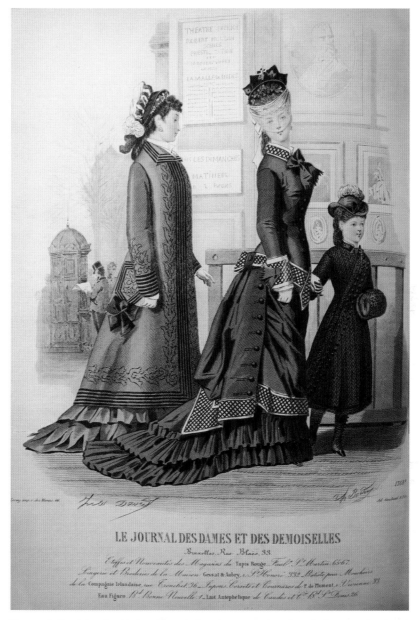

Figure 2.1b Jules David, *Le Journal des dames et des demoiselles*, hand-colored lithograph, 15 November 1876. New York Public Library.

the Zodiac ribbons could be bought "ready made at Paris," the 1876 plate gives the names and addresses of specific *local* shops where the goods could be obtained. The image is pointedly Parisian, produced by perhaps the most famous nineteenth-century fashion plate illustrator, but its circulation was international, appearing here in the *Journal des dames et demoiselles*, published for the French journal *Le Moniteur de la Mode* out of Brussels, but reproduced also in the *Englishwoman's Domestic Magazine* in London and

Le Bon Ton in New York.[4] Its impromptu staging seems to offer a snapshot of what women were wearing then on the streets of Paris, which doubtless appealed to its far-flung viewers. Indeed, the audience for the image was no longer a few hundred aristocratic Londoners, but more than a hundred thousand bourgeois readers all over the world. In keeping with this shift in audience, the 1876 plate promotes dress for everyday wear, not aristocratic head dresses "with jewels representing stars" and ribbons of gold and silver thread. While Paris remains the "seat of fashion," the subject of fashion coverage has shifted; in place of equal attention to aristocratic men's and women's styles, we find a gendered focus on the dress of bourgeois women and children.

Fashion news pictures thus both reveal and instantiate changing period ideas about fashion and its proper audience. By the 1870s, fashion plates celebrated a decidedly sophisticated, urban vision of bourgeois femininity—promoting especially the woman as discriminating consumer and shopper.[5] With the rise of the fashion press, fashionable display was no longer merely about personal wealth, elegance, style, and taste, but also about conforming to a specific visible image as the embodiment of the latest fashion; one had to keep up with the news to ensure one's *chic* (a nineteenth-century neologism). Fashion plates facilitated this continual re-fashioning, as a woman could bring the plate to her dressmaker to be copied or, by the late nineteenth century, could buy the exact fashions depicted.

Fashion news was often discussed in terms of "novelties," thus avoiding the serious political implications of "news," but feeding the rising capitalist culture of consumption at the same time. The fashion press and fashion news picture were both limited and enabled by the changing technologies of print and economics of publishing. Fashion plates were among the first commercial usages of lithography; themselves both material objects and commodities, they encouraged the further capitalist pursuit of goods and commoditized knowledge. From the very start, what counted as fashion news and who was creating the news was constantly changing, as was the form of the fashion magazine and its conventions. But remarkably, by the mid-nineteenth century the fashion magazine as we know it today—international, advertising-supported, centered on visually striking editorial news pictures, and reporting on dress at glamorous events, with fashions for every budget and products for every need—would already be established.

The rise of fashion news

Illustrated plates of foreign and contemporary costume, often as worn by royalty and aristocrats, had circulated in Europe since the sixteenth century; by the late seventeenth century, text began to accompany the illustrations, but such plates served as documentation of past fashions rather than counsel as to what to wear in the future. Dress slowly began to attract attention in the contemporary press, with the *Mercure Galant* (1672–1832) in France emerging as the first periodical to semi-regularly report on fashion, though it only featured plates one year (1678). Men's fashion was covered first and frequently in more detail than women's dress. *Le Courrier de la nouveauté* (1757) was the first journal to announce an intention to specialize in fashion news, but is known only by its prospectus. *Le Courrier de la mode* (1768–70) lasted only slightly longer and included no plates. Thus it was *The Lady's Magazine* (Fig. 2.1a), founded in 1770, which first included regular fashion coverage and engravings of contemporary dress and hairstyles. From its first issue, the journal promised to inform readers of "every innovation that is made in the female dress," with "an assiduity which shall admit of no abatement, and by an earliness of intelligence which shall preclude anticipation."[6] It frequently emphasized the recentness and specificity of its fashion news by recording the date and location where the depicted fashion was seen in the caption.

For example, a June 1775 plate showing "Two Ladies in the newest Dress" was subtitled, "From Drawings taken at Ranelagh. May 1775." These plates presented the latest fashions as models for emulation rather than clothes for sale; after all, in this era there was no ready-made clothing—all clothing was individually made by dressmakers or women themselves.

In France, *Cabinet des modes* (1785–93) was the first journal to regularly feature fashion plates, promising readers "an exact and prompt knowledge of all the new clothing of both sexes." Appearing on the first and fifteenth of every month, each issue included three hand-colored engravings and eight pages of fashion news. While the plates themselves made no mention of specific shop names, from its inception *Cabinet des modes* practiced the particularly French form of advertising: the *réclame*, or covert editorial ad, in which promotional mentions of shops were made in the context of reporting the latest news. Thus fashion news was, almost from the very start, bound up in commerce and the promotion of the latest goods found in Parisian shops.[7] In England, more direct advertising was favored. Indeed, the English fashion magazine, *La Belle Assemblée* (1806–68), was the first to include a separate advertising supplement, which compiled "literary, fashionable, and domestic advertisements . . . addressed to the elegant, polite, and economical," and to attribute regularly the fashions it described to a sole commercial source—Mrs. Bell, an inventive London shop owner.

Recognizing the publicity a fashion magazine could generate, the fashion house Popelin-Ducarre in 1839 began producing an illustrated monthly brochure describing its new products, which, under the enterprising editorship of Adolphe Goubaud, was soon transformed into the lavish *Moniteur de la mode* (1843–1913), one of the most dominant French fashion journals of the nineteenth century. Jules David (Fig. 2.1b) created nearly all of its plates and was among the first illustrators to include elaborately detailed backgrounds; his fashionably dressed figures appear indoors and out, in the city and in the country. Indeed, fashion plates by the mid-nineteenth century resemble modern editorial photoshoots commissioned by magazines today, appealing to readers not only by presenting the latest fashions, but also through their novel and seductive staging.

The expanding audience for fashion news

Newspapers and journals in the eighteenth century were largely a luxury product with a small number of subscribers; fashion journals circulated only in the hundreds, mostly to society women and men. In eighteenth-century France, about a dozen journals included some fashion coverage, but in the nineteenth century more than 400 journals devoted to fashion would be published, testifying both to the increasing interest in and market for fashion news.[8] With the advent of the Second Empire (1852–70), the fashion press underwent a massive proliferation as Napoléon III and Empress Eugénie actively promoted the French textile trades and drove fashion innovation. Not just the number of fashion journals, but also their circulation, attained new heights. For example, in December of 1866, *La Mode illustrée* (1860–1937)—*Le Moniteur de la mode*'s chief rival—had a circulation of 58,000, which was more than ten times the circulation of its July Monarchy (1830–48) counterparts.[9] By way of comparison, at the same time the bourgeois journal *Le Figaro* had a circulation of 55,000 and the most popular journal of the day, the apolitical *Le Petit journal*, had a circulation of 259,000.[10] Notably, to adapt to the surge of interest in fashion, *Le Petit journal* and other *grands journaux* added illustrated fashion supplements and included regular fashion columns. This proliferation and increased circulation can be attributed in part to the demand for advice from a new and growing category of readers: bourgeois women, anxious for the fashion

knowledge the journals could provide, but it's clear that men also followed the latest fashion news. By 1890, *La Mode illustrée* had a circulation of 100,000 and *Le Moniteur de la mode* claimed 200,000.[11]

While subscriber numbers were rising and becoming more diverse in terms of class, notably over the course of the nineteenth century the subject of fashion news became increasingly female.[12] While early fashion plates featured both men and women, images in the mainstream fashion press after 1850 virtually never featured men, only the occasional boy. Flügel's theory of the male renunciation of fashion at the end of the eighteenth century has been dramatically overemphasized, but it's true that discussion of men's fashion was increasingly consigned to tailoring journals, particularly as Paris began to dominate the fashion press and especially women's fashion.[13]

Fashion as international news—Paris as fashion capital

The fashion press operated out of the great capitals of Europe—chiefly London and Paris; fashion news was thus by definition urban and, from its earliest days, international as well. The first Italian fashion magazine explicitly reported on foreign trends, as its title makes clear: *Giornale delle nuove mode di Francia e d'Inghilterra* (Milan, 1786–94). The first journal devoted to fashion in Germany, the *Journal des Luxus und der Moden* (Weimar, 1786–1826) included reports and plates of French, English, and Italian fashions. The first American fashion magazine, *Graham's American Monthly Magazine of Literature, Art, and Fashion* (Philadelphia, 1841–58), directly copied French and English plates for its fashion coverage—making the "news" the images reported sometimes up to a year old.

While London would remain the center for men's fashion and women's riding dress, Paris by the 1830s would become the dominant center of women's fashion and its pre-eminent fashion journals would enjoy an international circulation, spanning six continents. The demand for French fashion news was such that, as early as 1823, *Townsend's Selection of Parisian Costumes* arranged to import French plates accompanied with English descriptions.[14] By 1847, *Le Moniteur de la mode* reported it was printing 700,000 fashion plates annually; it published eight foreign editions, including a bilingual French–English edition and a Franco–American edition starting in 1851.[15] *La Mode illustrée* accepted subscribers from as far away as China, Australia, and the Marquesas.[16]

That the nineteenth-century fashion news media had become entirely dependent on Paris was demonstrated dramatically by the 1870–1 Franco–Prussian War, which placed Paris under siege for months and sent fashion publishers outside the city into a tailspin (*La Mode illustrée* remarkably continued to publish despite the siege). Initially journals simply printed notices that they had no plates, but as the siege dragged on, they were forced to publish vastly inferior locally produced plates and—in a testament to their desperation—rely on miniaturized fashion news and images smuggled out of Paris by carrier pigeon and hot air balloon. Thus an international media culture had arisen, centered on the Parisian fashion plate as news picture.

Photography and the fashion news picture

In 1880, *L'Art de la mode* (1880–1967) broke new ground as the first journal to reproduce a fashion photograph, though photography did not become common in fashion magazines until the twentieth

century, when advances in halftone printing made it more feasible and economical. *Les Modes* (1901–37) was the first journal to regularly feature photographs, often shot by the Reutlinger Studio in Paris; it included both halftone prints and tipped-in color photographs of single, full-length figures on glossy paper. By 1909, drawings and descriptions of dress at events (the "newest Dress" at Ranelagh) would slowly be replaced by documentary-style fashion photographs, like that by the Seeberger family of the latest haute couture as worn by the finest society in Paris and Biarritz.[17] Fashion photography would follow a similar evolution from single figures set against plain backdrops to more elaborately staged shoots—from deliberate aristocratic decadence (Fig. 2.1a) to the impromptu aesthetic seen in our 1876 plate (Fig. 2.1b). Indeed, the shape of the fashion news picture and its thirst for novelty had been set long before photography, and would continue to drive the fashion press long after.

Notes

1 *"Description of the newest* French Ladies Head Dress, *à la* Zodiaque," *The Lady's Magazine* (July 1777): 374.

2 *"Description of the newest* French Ladies Head Dress, *à la* Zodiaque," *The Lady's Magazine* (July 1777).

3 Garrett Davis Byrnes, *Fashion in Newspapers* (New York: Published for American Press Institute by Columbia University Press, 1951): 8.

4 See the December 1876 issues of both.

5 Justine De Young, "Representing the Modern Woman: The Fashion Plate Reconsidered (1865–1875)," in *Women, Femininity and Public Space in 19th-century European Visual Culture 1789–1914*, eds Heather Belnap Jensen and Temma Balducci (Burlington, VT: Ashgate, 2014).

6 "Address to the Fair Sex," *The Lady's Magazine* 1 (August 1770): 2.

7 H. Hazel Hahn, *Scenes of Parisian Modernity: Culture and Consumption in the Nineteenth Century* (New York: Palgrave Macmillan, 2009): 63.

8 Raymond Gaudriault, *La gravure de mode féminine en France* (Paris: Éditions de l'Amateur, 1983): 193–96.

9 Raymond Gaudriault, *La gravure de mode féminine en France* (Paris: Éditions de l'Amateur, 1983): 156. Claude Bellanger, *Histoire générale de la presse française: 1815 à 1871* (Paris: Presses universitaires de France, 1969): 290.

10 Christophe Charle, *Le siècle de la presse, 1830–1939* (Paris: Seuil, 2004): 103, 109, 189.

11 Annie Barbera, "Des journaux et des modes," in *Femmes fin de siècle, 1885–1895: Musée de la mode et du costume* (Paris: Éditions Paris-Musées, 1990): 103.

12 Jennifer Jones, *Sexing la Mode: Gender, Fashion and Commercial Culture in Old Regime France* (Oxford: Berg, 2004).

13 J. C. Flügel, *The Psychology of Clothes* (London: Hogarth Press, 1930).

14 Vyvyan Beresford Holland, *Hand Coloured Fashion Plates, 1770 to 1899* (London: Batsford, 1955): 64.

15 *Le Moniteur de la mode* (30 December 1847): 214. Valerie Steele, *Paris Fashion: A Cultural History*, rev. edn (New York: Berg, 1998): 106.

16 "Prix de *La Mode illustrée*," *La Mode illustrée* 52 (December 1873): 416.

17 Nancy Hall-Duncan, *The History of Fashion Photography* (New York: Alpine Book Co., 1979): 26.

2.2

Celebrity Photos and Stolen Moments

Ryan Linkof

Let us take, as a point of entry, an image of Elizabeth Taylor and Richard Burton, lying atop a yacht off the coast of the Italian island of Ischia in June 1962 (Fig. 2.2a). Taken by the paparazzo Marcello Geppetti during a pause in the filming of *Cleopatra*, the photograph is exemplary of the work of the Italian paparazzi in their heyday. This purloined moment exposes a private indiscretion, capturing a scene of physical intimacy between two figures who were married to other people at the time. By offering a revelation of a hidden, scandalous truth, the image was news of the most sensational variety, featured in newspapers and magazines around the world. Despite that fact, it might reasonably be asked: what kind of news picture is this, exactly?

In her influential study *Photography and Society*, Gisèle Freund addressed this question in a chapter revealingly entitled, "The Scandal-Mongering Press." Periodicals trading in such scandal, she wrote:

> feed millions of readers, mostly women, with stories about the love affairs and intimate lives of famous and rich people, allowing them to dream of escaping the mediocrity of their own everyday existence. Scandal sheets also serve as an outlet for the reader's frustration with life's problems and her envy of those with better luck, for while readers want to daydream about the lives of celebrities, they also want to be privy to every bit of dirt.[1]

In paparazzi photography, and the periodicals that reproduced it, Freund identified a deep fascination with accessing the lives of others; a longing to bear witness to human interactions, no matter how fabulous or degraded. She suggested, in other words, that celebrity photojournalism of this type is rooted in a desire to see how the other half lives. We are accustomed to thinking about this impulse from the opposing direction, as an elite practice of investigating the lives of the less fortunate, most vividly expressed in Jacob Riis's photography of the New York slums from which the phrase derives.[2] By focusing on this element of the popular media, however, Freund reveals how photojournalism serves as a point of access to the lives of those at the top of the social hierarchy, and can work to bring them into closer contact with ordinary people, if only virtually.

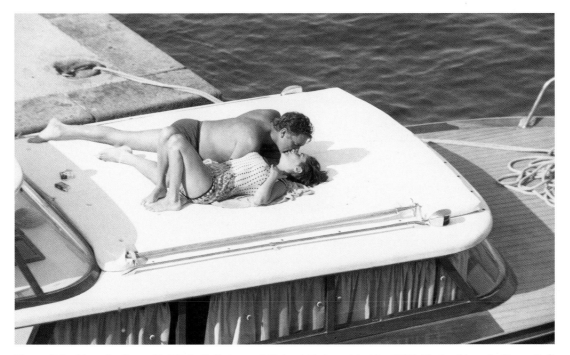

Figure 2.2a Marcello Geppetti, Elizabeth Taylor and Richard Burton at Ischia, 1962. Photos Marcello Geppetti © Marcello Geppetti Media Company Ltd.

Freund's is a rare example of the inclusion of celebrity photojournalism within a broader study of news photography. Even scholars who have analyzed paparazzi photography have tended to focus more on its relationship to ideas about celebrity than to the history of photographic news reporting.[3] As Freund's analysis indicates, this bias against celebrity photojournalism is animated by a sense that such imagery is frivolous, that it is mere escapism, and, at its worst, invasive and inhumane. The insults hurled at the producers of these images are manifold and enduring, and have worked to make the paparazzo less a real person than a projection of fears and anxieties.

Celebrities, as figures of public interest, have been the most reliable and consistent subjects for press photographers, long before the term "paparazzi" was even coined. It might be argued that celebrity culture itself emerged alongside, and in large part because of, the rise of photojournalism.[4] Celebrity is an effect of mass visual media, and the press photographer and celebrity culture share a long and complex history that has only barely begun to be explored in any depth.

This essay examines a particular mode of celebrity photography (exemplified by the paparazzi) in order to identify one of the fundamental elements of photojournalistic practice: the desire to communicate, through photographic images, information about the activities and intimate lives of other people. It is a simple, but significant, point. What unites the paparazzi and Jacob Riis, photographs of war and documentary images of daily life, is the desire to see people in new and revealing ways. In the process, photojournalism works to diminish psychological boundaries between disparate social groups.

The rhetoric of the stolen image

The roots of the photographic methods utilized by the paparazzi run deep in the history of photography. Parallel practices can be found in the mid-Victorian attempts to photograph the royal families of Europe, as well as the late nineteenth-century snapshot photographers who came to be referred to as "camera fiends" due to their intrusive practices.[5] The "documentary impulse" that film historian Tom Gunning has identified in Victorian hidden camera photography has played a crucial role in the history of photojournalistic practice.[6]

The emergence of the candid press snapshot in the years around 1900, in capital cities across Europe and America, represented perhaps the most significant reconfiguration of how popular audiences consumed images of famous people. The instantaneous press photograph—often acquired without the consent or approval of the subject—created a mode of rapidly produced portraiture that challenged conventional ideas about what constituted "good" and "bad" likenesses. While various compromises were struck between photographers and celebrities—most notably, the semi-formal "photo-op" image— it is the image acquired against the wishes of the subject, which significantly departed from established conventions, that is analyzed here.[7]

The popularity of photographs of people caught off-guard was rooted in a desire to see beyond the flattery and idealizations of the "mask" of portraiture. Writing in 1914, one advocate of the press snapshot suggested, "Rarely is the snapshot marred by that self-consciousness—or camera consciousness— which spoils the portrait. The constraint of a pose disguises the real man: the snapshot catches those elusive characteristics which reveal him."[8] Of course, this claim to truthfulness was its own aesthetic conceit, and such images were not any more "real" than their studio counterparts, but they relied upon the belief that the spontaneous, unsolicited image revealed something essential about the subject.

The two decades following World War I marked a high point in a broader popular discussion about the role of the so-called "candid camera" photographer, exemplified by the hidden camera work of Erich Salomon, discussed by Daniel Magilow in this volume.[9] The development of roll film cameras, telephoto lenses, and camera-mounted flashbulbs brought photographers into closer, less conspicuous contact with their subjects.

As Freund and others have argued, the photographic philosophy animating Salomon's practice was taken to its logical extreme in the work of the paparazzi photographers who emerged in 1950s Rome. Figures such as Geppetti and Tazio Secchiaroli developed an aggressive and confrontational photographic style, made famous by Federico Fellini in his satire of Roman high society, *La Dolce Vita*, from which the name "paparazzi" derives.[10] Photographing actors who came to Rome to shoot in the city's fabled film studios, the paparazzi were partly an effect of the decline of the Hollywood studios that guaranteed film stars protection from unwanted publicity. Critic Allan Sekula influentially argued that the paparazzi, "pose the theory of the higher truth of the stolen image," and act as "the antagonist and ethical better of the official portrait photographer."[11] In other words, the paparazzi assaulted the image of celebrity depicted in the Hollywood studio portrait.

Undoubtedly the most famous paparazzo to emerge in the 1960s and 1970s was Ron Galella—the self-styled "Paparazzo Extraordinaire." In what was by then a common photojournalistic refrain, Galella wrote, "I'm not interested in the packaged image, the sort of posed, retouched glossy favored by the official and unofficial corps of press agents . . . I am interested in printing onto film what is real . . . I want to reveal the [person's] essence."[12] For Galella, as with Salomon before him, and the Victorian hidden

camera photographers before him, a primary goal of successful photographic news reporting was to find new and challenging ways of witnessing the lives of others.

The tabloids and the stolen image

The tabloids are the most common form of the "scandal-mongering press" that Freund used to frame her discussion of the paparazzi, and are key to understanding the informational logic of the stolen celebrity photograph. Less a coherent genre of clearly identifiable periodicals than a set of discursive and representational practices, the tabloids are typically seen to include sensationalistic daily and Sunday newspapers as well as glossy weeklies featuring images of and stories about celebrities.[13]

The tabloids are central to the origins and history of photojournalism. Since the London *Daily Mirror* became the world's first newspaper to reproduce only photographic images in 1904—eschewing engraved illustrations as an inferior form of reportage—the tabloids have been at the forefront of adopting new photographic and image reproduction technologies. The *Daily Mirror*, and the many newspapers that it inspired in England such as the *Daily Sketch* and the *Daily Graphic* and later in America, the New York *Daily News*, helped consolidate a form of tabloid journalism that proved influential and durable. As scholars such as V. Penelope Pelizzon and Nancy M. West have shown, the tabloids' characteristic emphasis on crime, sex, and celebrity—mixed with a firm commitment to the photographic image—reached maturity by the interwar period on both sides of the Atlantic.[14] Through an editorial commitment to reproducing provocative images that could shock and titillate mass audiences, the tabloids would be one of the most fruitful sites for the development of a commitment to the stolen celebrity image.

Take, as a salient example, a photograph depicting a shirtless King Edward VIII and his married lover Wallis Simpson sitting, like Taylor and Burton so many years later, in a boat in a state of casual repose (Fig. 2.2b). Edward embodied the transformation of the British royals into celebrities in a modern

Figure 2.2b King Edward VIII and Wallis Simpson, *Sunday Graphic*, 6 December 1936.

sense, and nowhere was this more evident than in the press coverage of his affair with Simpson.[15] I will focus here on one photograph which crystallizes a particular form of stolen image-making that found fertile ground in the tabloid press, and would later be taken up and further popularized by the paparazzi.

The photograph was taken in the late summer of 1936, when the King invited Simpson and several close friends to join him on a holiday aboard the yacht *Nahlin*. Stanley Devon, the photographer responsible for the image, had been ordered by his editor at the *Daily Sketch* to stalk the couple and bring back any usable photographs of the two together. In his autobiography, Devon excitedly relayed the story of its acquisition. In a bold and inventive move, he circled the couple in a propeller plane that he had chartered, leaning out of an open side door with a magnifying camera lens. When the couple ventured from the yachting party for an intimate excursion, Devon engaged in what resembled a military assault: "We did three low-level attacks on the world's most powerful reigning monarch. I took a picture on each."[16] The tabloids, starting with the *Daily Sketch* and quickly followed by its competitors, liberally reproduced the results of this photographic "attack" once the news of the affair had broken.

Hurried and rough, the image shows signs of the stress of its making: blurry, distorted, and retouched to accentuate the hazy figures caught on camera. In its frantic lack of focus and compositional clarity, the image evinces a quality that would come to define tabloid photographs of celebrities in the next half century. Karin Becker has astutely argued that, "Technical 'flaws' like extreme graininess and underexposure have actually become conventions of the tabloids' style, visually stating the technical compromises the newspaper will accept in its commitment to presenting the 'real' story."[17] The most successful tabloid images, in other words, are not those with the most artful compositions, but rather, those that expressly eschew careful and mannered image-making. Precisely *because* they were so garbled, in other words, Devon's photographs of the King and Simpson express a firm commitment to seeing the "real" King—warts and all.

In what may appear now as a rather innocuous photographic cliché, the image was remarkably, even scandalously, novel when it was taken. It was the first photograph in history to exhibit the unclothed body of a British monarch for a mass audience. Going to great lengths—manning an air assault—was prurience, for sure, but it was also evidence of a dedication to eroding the defensive layers that had accumulated to protect the royal image.

In this way, the tabloids have long advocated a form of photojournalism that is powerfully iconoclastic. By capturing an unsolicited moment of physical intimacy and bodily proximity with his lover, the photograph proclaimed Edward's willful disregard for the Windsor tradition of respectable bourgeois rule, and its corresponding iconography. The photograph gives the lie to the King's image as an irreproachable demigod, wrapped in his ermines, robes, and regalia. To see the King engaging in a sensual act of mutual semi-nakedness with a married woman, is to see an aspect of royal life that is prohibited in traditional forms of royal portraiture, and in the sanctioned "photo-op" images that filled (and still fill) the tabloids. The royal body had never looked quite like this.

Such images would become part of a new iconography of fame: an iconography of the stolen image. Like the image of Taylor and Burton that began this essay, this photograph expresses a tendency that stretches deep into the history of photojournalism, especially in the "scandal-mongering press." Geppetti's stolen snapshots of a famous couple atop a boat in the Mediterranean are the successors— aesthetically and philosophically—of the practices pioneered by Devon and his contemporaries in pursuit of the King and Simpson atop their own boat in the Mediterranean thirty years before. While the technologies change and evolve, the underlying impulse is the same. Such images exemplify the tabloids'

commitment to a mode of photojournalism animated by an attempt to sabotage the face of celebrity in order to reveal the fallible, human, core beneath.

As scholars and practitioners of photojournalism have contended, the goal of photojournalism is to capture "things as they are."[18] The animating impulse behind news photography, according to this logic, is to offer a way of apprehending the undoctored truth. It is exactly this impulse that underlies the mode of celebrity photojournalism identified most closely with the tabloids and seen in the work of the paparazzi and their forerunners.

By assailing common standards of photographic etiquette, this form of celebrity photojournalism also assails the boundaries that keep the social elite at a remove from ordinary people. It is not only that such images show that celebrities are "just like us"—they also attempt to show that revered figures may indeed be much worse. While much of the history of photojournalism has focused on photographers who bring invisible social actors at the bottom of the social hierarchy into closer view for middle and upper class audiences, in an effort to ennoble and dignify their subjects, the paparazzi enact the opposite social transaction. This is a kind of seeing animated not by the desire to elevate the ordinary, but to depose the so-called extraordinary.

Focusing on instances of photographic "theft" helps to explain how celebrity functions as a social mechanism, and how celebrity culture's inherent contradictions are rooted in the qualities and capabilities of photojournalism. By definition, celebrity is an ambivalent social phenomenon, defined as much by opprobrium as by acclaim. If celebrity is "democratized fame," it is largely *because* of photojournalism. Photojournalism plays an inseparable role in making celebrities, but also works to drag them into a court of public opinion; it is at once a condition of celebrity and a consequence of it.

Notes

1 Gisèle Freund, *Photography and Society* (Boston: Godine Press, 1980): 181–2.

2 See Jacob A. Riis, *How the Other Half Lives: Studies among the Tenements of New York* (New York: C. Scribner's Sons, 1890).

3 See in particular Peter Howe, *Paparazzi and Our Obsession with Celebrity* (New York: Artisan, 2005).

4 For studies of the origins of celebrity culture, see Leo Braudy, *The Frenzy of Renown* (Oxford: Oxford University Press, 1986). See also Eva Giloi and Edward Berenson, eds., *Constructing Charisma: Celebrity, Fame, and Power in Nineteenth-Century Europe* (New York: Berghahn Books, 2010).

5 See, for example, John Plunkett, *Queen Victoria: First Media Monarch* (Oxford: Oxford University Press, 2003); Robert E. Mensel, " 'Kodakers Lying in Wait': Amateur Photography and the Right of Privacy in New York, 1885–1915," *American Quarterly* XLIII (March 1991): 24–45.

6 Tom Gunning, "Embarrassing Evidence: The Detective Camera and the Documentary Impulse," in J. Gaines and M. Renov, eds., *Collecting Visible Evidence* (Minneapolis: University of Minnesota Press, 1999).

7 See Nicholas Hiley, "The Candid Camera of the Edwardian Tabloids," *History Today* 43 (August 1993): 16.

8 *Sell's World's Press: The Handbook for the Fourth Estate* (London: H.W. Peet, 1914): 38–9.

9 See also Freund, *Photography and Society* (Boston: Godine Press, 1980): 115–40.

10 See Karen Pinkus, *The Montesi Scandal: The Death of Wilma Montesi and the Birth of the Paparazzi in Fellini's Rome* (Chicago and London: University of Chicago Press, 2003); Francesca Taroni, *Paparazzi: The Early Years* (Paris: Assouline, 1998): 5; Squiers, "Class Struggle: The Invention of Paparazzi Photography and the Death of Diana, Princess of Wales," in Squiers, ed., *Overexposed: Essays on Contemporary Photography* (New York:

The New Press, 1999). See also Vanessa Schwartz, "Wide Angle at the Beach: The Origins of the Paparazzi and the Cannes Film Festival," *Études photographiques* 26 (November 2010): 161.

11 Allan Sekula, "Paparazzi Notes," in *Photography against the Grain: Essays and Photo Works, 1973–1983* (Halifax: Nova Scotia College of Art and Design, 1984): 29.

12 Ron Galella, *Off-Guard: Beautiful People Unveiled before the Camera Lens* (New York: Greenwich House, 1983): 5.

13 See Colin Sparks and John Tulloch, eds., *Tabloid Tales* (Lanham, MD: Rowman & Littlefield Pub Inc, 2000).

14 V. Penelope Pelizzon and Nancy M. West, *Tabloid, Inc.: Crimes, Newspapers, and Narratives* (Columbus, OH: The Ohio State University Press, 2010). See also Ryan Linkof, "The Public Eye: Celebrity and Photojournalism in the Making of the British Tabloids, 1904–1938" (Doctoral Dissertation: University of Southern California, 2011).

15 See Laura E. Nym Mayhall, "Clark Gable *versus* the Prince of Wales: Anglophone Celebrity and Citizenship between the Wars," *Cultural and Social History* 4 (December 2007): 529–43. See also Ryan Linkof, " 'The photographic attack on His Royal Highness': The Prince of Wales, Wallis Simpson, and the Pre-History of the Paparazzi," *Photography and Culture* (November 2011): 277–92.

16 Stanley Devon, *Glorious: The Life-Story of Stanley Devon* (London: George C. Harrap & Co. Ltd., 1957): 102.

17 Karin Becker, "Photojournalism and the Tabloid Press," in Peter Dahlgren, ed., *Journalism and Popular Culture* (London: Sage Publications, 1992): 143.

18 See Christian Caujoulle and Mary Panzer, *Things as They Are: Photojournalism in Context since 1955* (New York: Aperture, 2007).

2.3

Pictorial Press Reportage and Censorship in the First World War

Ulrich Keller

Many accounts have been written about how press reportage was organized and controlled by the military authorities during World War I. Most of these accounts are limited to a single country; some attempt a larger overview; and almost all arrive at rather uniform results with only minor national variations. On all sides of the war, we gather, censorship was mercilessly applied and truth heavily distorted, with the Germans surprisingly said to have fostered a rather liberal regime of press management.[1] Some of this is true, but some is altogether mistaken, for the simple reason that all accounts are based on research into the bureaucratic rules and mechanisms set up in the various countries to control press reporting from the fronts. This has produced much useful information; however, with a couple of marginal and unhelpful exceptions,[2] it disregards *what was actually published* in the contemporary newspapers. Recently, the enormous legacy of pictorial world-war reportage has become systematically searchable through electronic scanning, with the result that bureaucratic rules and mechanisms prove to be poor predictors of the actual publication practices—not surprisingly so, because in human affairs, theory and practice, law and execution rarely coincide. For example, even though, in the first year of World War I, both the French and British authorities were in bureaucratic principle opposed to admitting any correspondents to the front—leading the existing scholarship to speak of a total initial news blackout save for quickly suppressed freelance activities—we only need to leaf through the *Illustrated London News* or *L'Illustration* to discover that, in point of fact, officially cultivated correspondents/war artists had produced significant amounts of approved reportage already by 1914. Similarly, while common wisdom has it that the official French "Section photographique de l'Armée" was founded in late spring 1915, it actually began in November 1914, to generate publicity for the Commander-in-Chief, as proven by numerous photo stories in *L'Illustration*.

German press reportage is the most misunderstood of all. While two British war photographers were active at the Western Front from spring 1915, and the French "Section photographique" comprised fifteen cameramen during its most active periods, the Germans admitted up to fifty photographers to their front-lines at any given time, in a remarkably permissive arrangement.[3] What ultimately mattered, though, was not how many cameramen were around, but what they were allowed to see, record, and publish. On this account, German censorship was marked by draconian severity and downright paranoia.

Consider this example: When Italy pursued a bloody colonial campaign in Libya in 1911–12, without any German involvement whatever, *Berliner Illustrirte* (circulation: one million) gave the episode several pages of pictorial coverage, only slightly less than appeared in the leading illustrated papers of France and Britain. When four years later the biggest battle in the history of the world raged around Verdun, costing German casualties in excess of 400,000 men, *Berliner Illustrirte* devoted only a few more pages to the 10-month struggle, and half of the images were "borrowed" from the enemy press, whereas the allied newspapers overflowed with Verdun imagery. In fact, for every Verdun picture in the German weeklies, their French competitors published ten (if not twenty, if we deduct from the German count the numerous pictures "borrowed" from the allied papers). In France and England, Verdun was big and absorbing news, while from the German picture press it was hard to divine that anything important was happening there. On the pictorial level, the German army leadership treated Verdun and other battles as its private affair that was nobody else's business; to put it in the words of contemporary pressmen, "the authorities handled the conduct of the war as the exclusive privilege of government and military leadership, instead of informing the people of the current dangers, treating it as a mature partner and permitting the press to carry the will to victory into every home."[4] As the generals saw it, the sacrifice of hecatombs of young men did not need to be explained to the nation, and the editors of the illustrated weeklies acquiesced to a degree unthinkable in France and England. Where the available research portrays German and allied picture coverage of the war as largely commensurate, the facts are drastically misrepresented.

The *qualitative* differences were even more pronounced. In those German weeklies that paid attention to Verdun at all, belated images of deserted French trenches and imperial troop reviews or prisoner transports far to the rear predominate (Fig. 2.3a); I have found only two photographs of combat situations, one of them fairly idyllic, whereas the French weeklies published scores of photographs of troops under stress and fire in front-line positions around Verdun (Fig. 2.3b), not to mention air reconnaissance pictures of contested trenches used to convince the public irrefutably of French progress in reclaiming lost territory.

French (and British) reportage pictures were usually published within a few days of the event, as timely visual proofs and arguments in a grand media effort to persuade the public of the seriousness of France's military situation, the glory of the French feat of arms, and the duty of every citizen to give fervent, unstinting support to the national struggle. The allied correspondents and photographers wore uniforms and enjoyed the respect of the officers and men. Quite in keeping, they had the right to interview generals, examine staff reports during battle, and send their reports by wire and telephone every evening, for publication in the morning papers.[5] News pictures traveled more slowly than these wired reports, but still as fast as technically possible. In short, verbal and pictorial press reportage became an *integral* component of the Allied conduct of war, with generals and journalists working hand in glove.[6] Restrictive censorship was only *one* tool used; the other was comprehensive, pro-active advertisement of military successes, without which the public support necessary to win a *total* war would have been hard to muster.

In Germany, by contrast, a few stale, belated photographs void of tangible news value served to hide the seriousness of the army's increasingly lopsided struggle against the rest of the world, with the troops mainly portrayed at peaceful pursuits far behind the front. This was not without reason, given that the German army was internationally seen as a horde of bloodthirsty barbarians; still, German censorship was unduly obsessed with suppressing any news that might conceivably raise civilian worries about husbands and sons stationed far away from home. Event and reportage were not rarely separated by months; only "short and disconnected accounts of individual battle phases and combat actions" were

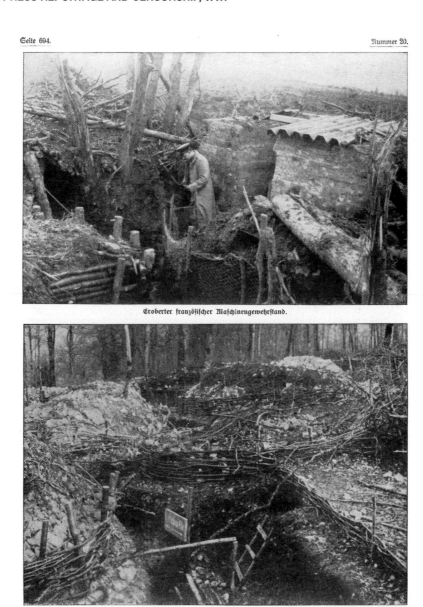

Seite 694. Nummer 20.

Eroberter französischer Maschinengewehrstand.

Eroberter französischer Schützengraben.
Von den Kämpfen um Verdun.

Figure 2.3a From fighting around Verdun, *Die Woche*, 13 May 1916.

permitted, "but never any continuous, gapless reportages across a larger period of time"—unless they were published "at least one year after the event." Most astonishingly, it was forbidden to say anything of substance that went beyond the brief, cryptic army communiqués.[7] The war correspondents were thus reduced to explanations such as that the villages of X and Y mentioned in the *Heeresbericht* (i.e. the daily army bulletin) were situated 3 kilometers apart, the altitude of the first being 40 meters below that

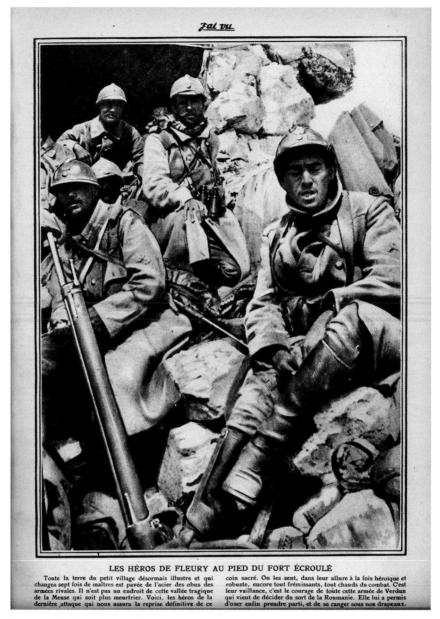

Figure 2.3b The heroes of Fleury at foot of ruined fort, *J'ai vu*, 9 September 1916.

of the second. Clearly, the German military was blissfully unaware of any benefit they could gain from timely and comprehensive press reportage. Matthias Erzberger, the government's unofficial, civilian and only moderately influential propaganda commissioner, observed that the Generals' attitude essentially was: we are victorious; everything else is immaterial.[8] Command centers thus remained impenetrable to press representatives; never allowed to wear uniform, they passed for a tribe of nosy, shameless, and unpatriotic civilians with whom self-respecting Prussian officers refused to have serious contact.

It is true that in France, a permanent contingent of reporters serving the broad spectrum of national newspapers was not admitted to the front until 1917. Yet, the public received ample information from the front—except it came from staff officers, rather than journalists. The French army had traditionally possessed an "historical section" which thoroughly documented all campaigns for use by military academies, historians, and even history painters. As a result, French (picture) newspapers were enabled to publish accounts of grand battles and individual heroism in abundant quantities. Each army employed an "officier informateur" to collect noteworthy episodes, give them literary form, and distribute them via pamphlets to the newspapers. The uniformed army photographers usually roamed the front in tandem with such officers, and they were given a far-sighted mandate to record subjects in three basic categories: (1) The entire range of weapons, munitions, supplies and military installations were to be photographed in order to give "a strong impression of the material and moral might of the army." (2) Systematic, repeated round trips were advised for "art-historical" purposes, to record the fate of heavily bombarded historical cities such as Reims and Arras. (3) The typical features of the war and its various phases were to be documented to aid future historians in reconstructing the war's "fundamental conditioning factors and gradual evolution." (German censorship, by contrast, strictly excluded from publication a long list of weapons, vehicles, and installations, except a few of small caliber and ancient manufacture. Since nearly all photos made near the front were bound to show one of these items, nearly all of them were banned.)[9]

Overall, France's "Section photographique de l'armée" produced no fewer than 150,000 regular and 20,000 stereoscopic exposures, which ensured a steady and diversified flow of topical military imagery to the newspapers (still preserved in thematically ordered albums at the Musée d'Histoire Contemporaine-BDIC, Paris).[10] But this was not all. Most low brow and several middle brow picture magazines also tapped the amateur market by offering high prices or regular weekly awards for the best pictures sent in by soldiers or bystanders. This material escaped control at the front and could be suppressed only by the Parisian censors—but even though *preventive* censorship had been adopted in France (meaning that offensive texts and pictures were marked for suppression on the galleys just before final printing, leaving white spots on the street edition because there was no time for substitution), lots of unusually revealing amateur imagery did get into print: seeing how far one could go in ignoring the censors' demands was a favorite sport of French editors—the radical *Bonnet Rouge*, for one, had 1,076 passages marked for suppression by the censors in 1916–17 but printed 316 of them anyway.[11] (In Germany, amateur imagery was strictly *verboten* as well: Advertisement for and editorial use of private photos and memorabilia was illegal, further compounding the dearth of topical picture reportage in the German press.)[12]

As to Great Britain (and America), by the 1890s verbal/pictorial war reportage had become a near-monopoly of an elite group of globe trotting Anglo-Saxon novelists, artists, and photographers earning princely sums for witnessing the many scenes of conflict during the heyday of imperialism: the bloodier the incident, the higher the street sales.[13] At the beginning of the world war, however, Lord Kitchener at the War Office tried to exclude the regular press from the battlefields, save for a few journalists of distinction and "influence." Respected as the "fourth estate" in a country of staunch liberal traditions, the British newspapers had high political standing, however, and were much involved in forming and toppling governments. The army treated correspondents such as E. Ashmead-Bartlett and Ph. Gibbs as gentlemen among gentlemen; top commanders and cabinet ministers took them into their confidence, and when a dinner was arranged to honor Gibbs in London, the Prime Minister made sure to attend and give a speech in praise of Gibbs' services. Kitchener had to relent, and through a series of constructively

resolved conflicts with the top brass, the British correspondents gradually acquired exceptionally far-reaching investigative privileges.[14]

The few accredited and uniformed British war photographers (only two were admitted to the Western Front) had lesser social standing but, from late spring 1915 on, were also given remarkably free access to the front and used it to great effect, accumulating the majority of the 40,000 images still extant and usable today at the Imperial War Museum, London. They focused, however, less on the stress and heroism of front-line combat, as their French colleagues did, than on spatially and materially easily readable scenes of typical army routines, front-line situations, supply lines and the like. Not only the British, but also the Canadian and Australian war photographs, were carefully archived and after the war transformed into publicly accessible museum collections. Like everything else, war was considered throughout the Commonwealth as a public undertaking for which a government was accountable to the people, including the sharing of all kinds of military records—a line of thought unavailable in contemporary, authoritarian Germany.[15]

Typically, as a matter of course and policy, William Robertson, chief of the British General Staff, kept his door open for reporters, editors, and publishers, dined with them and advanced privileged information where it served his purposes; other top commanders did likewise. A case in point is the British navy's attempt in April 1918 to destroy the harbor entrances of Zeebrügge and Ostend, in order to bottle up Germany's U-boat flotilla stationed there. The press received entire verbal/visual information packages *prior* to the event. The attack ended in failure and the German submarines continued to operate out of Zeebrügge, but with the Admiralty's generous help, the very daring (while also extremely costly) attack itself paid great publicity dividends to the navy—which probably was a major reason why it undertook and heavily publicized the raid in the first place, regardless of the uncertain chances of *military* success.[16]

By contrast, Hindenburg and Ludendorff, Robertson's German equivalents, cultivated low-profile contacts with right-wing newspaper publishers but largely considered press dealings as a restrictive and coercive business best left to the censors. By fall 1916, it had become apparent that this repressive approach could do nothing to shore up Germany's then slowly declining public morale. Upon taking over the army leadership, Ludendorff therefore decided to introduce a variant of the French "officier informateur" system, together with official, uniformed moving picture and still camera teams under the aegis of the newly founded *Bild-und Filmamt* (BUFA). In the 18 months of their active involvement, these teams produced numerous movies and upwards of 12,000 still images, which unfortunately were dispersed after the war.[17] Even during the war, the BUFA teams did not make a major difference because the generals remained standoffish and never took the now uniformed reporters into their confidence either; prior, generous information, for the press especially, was out of the question. Even Ludendorff's initially quite successful spring offensive of 1918 translated merely into a short-lived photo boom, not of tough combat scenes mirroring this massive *Materialschlacht*, but of traditional subjects like horse-drawn field artillery careening about muddy fields. BUFA films also remained unexciting and uncompetitive in comparison with the much superior French and British output.

Throughout, the principle was enforced that the German press *had no right* to investigate and report the war events. The army's chief censor, Walter Nicolai, was quite clear about this: "Reporting on the operational conduct of the war," he wrote in an apologetic treatise of 1920, "was the exclusive prerogative of the General Staff and was not permitted at all to be supplemented by any press organs." What rudimentary information services were then left to the newspapers? According to Nicolai, it was the duty of the accredited war correspondents to portray to the public at home "the life and emotional experiences"

(*Leben und Erleben*) of the troops abroad. In other words, German pressmen were obliged to forego news gathering properly speaking and to content themselves instead with innocuous sketching of mood and local color.[18] With remarkable docility, the correspondents indeed proceeded to share feelings with the troops rather than information with their readers. Where French and British battle accounts were rich with investigative detail and narrative excitement, the German reporters could only praise the *gemütlichkeit* of the soldiers' life behind the front, with occasional supplementary articles referring in portentous but vague language to fateful larger events in which the troops performed admirably, though of course no specifics could be shared with the readers at home—who had every right, nonetheless, to rest assured of the army leadership's ultimate wisdom and unstoppable drive towards final victory. The pictorial equivalent to such verbal reportage was an endless stream of "news" pictures showing German soldiers washing their laundry, or smoking pipes, or feeding French children, and so on—not that trivial genre subjects of this kind were missing on the Allied side, but they occupied a much smaller part of the overall, more topical spectrum.

Still, in September 1918, Ludendorff was besieged by the chairman of the German newspaper association to take the population into his confidence by informing it more fully, via the press, of the mounting military dangers. The General seemed to agree, but a few days later the German press was in an uproar when Ludendorff suddenly urged the government to sue for an armistice—that is, to concede defeat—without any prior warning to or coordination with the crestfallen press, which for years had received nothing but affirmations of certain final victory.[19] Though unwilling to the bitter end to lower the wall between conducting and reporting the war, that is, in spite of keeping the nation ignorant of the events at the front, Ludendorff's Intelligence Chief Nicolai left no doubt about who was to blame for the decline of civilian morale from 1916 on: It was the German press (together with an inept civilian government), he claimed, which failed to keep up public war enthusiasm. Paradoxically, in doing so, Nicolai conceded that the army had been content to win victories without bothering to accommodate the press. Nonetheless, in an early formulation of what blossomed into the notorious "stab-in-the back legend" of why Germany lost the war, despite remaining "undefeated" in the field, he held the press responsible for the faltering public war enthusiasm—which of course only the military leadership and its information services would have been in any position to maintain.[20] Left by the General Staff (and, to a lesser degree, by the Chancellor's and Foreign Offices) without substantive visual and verbal news to share, the German press remained a blunt publicity instrument in the world's first "total" war.

Notes

1 This article offers a condensed version of two larger essays on German and Allied picture reportage during World War I which appeared (in German) in the December 2013 issue of *Fotogeschichte* 33.130: 5–85 with 80 illustrations and many more bibliographic references than can find room here. To cite just two typical accounts of the nature of press reporting, 1914–18 (featuring factual details which will on the following pages not be referenced specifically): Phillip Knightley, *The First Casualty. The War Correspondent as Hero and Myth-Maker from the Crimea to Iraq* (Baltimore: Prion Books, 2004): 83 ff.; Almut Lindner-Wirsching, "Patrioten im Pool: Deutsche und französische Kriegsberichterstatter im Ersten Weltkrieg," in Ute Daniel, ed., *Augenzeugen. Kriegsberichterstattung vom 18. bis zum 21. Jahrhundert* (Göttingen: Vandenhoeck & Ruprecht, 2006): 113–40.

2 Gérard Canini, " 'L'Illustration' et la Bataille de Verdun," in *Verdun 1916. Actes du colloque international sur la bataille de Verdun* (Verdun: Association nationale du souvenir de la bataille de Verdun, 1976): 175–86; Thilo

Eisermann, *Pressefotografie und Informationskontrolle im Ersten Weltkrieg. Deutschland und Frankreich im Vergleich* (Hamburg: Kämpfer, 2000).

3 Ulrike Oppelt, *Film und Propaganda im Ersten Weltkrieg* (Stuttgart: Steiner, 2002): 203; Jane Carmichael, *First World War Photographers* (London: Routledge, 1989): 142.

4 Ludolf Gottschalk von dem Knesebeck, *Die Wahrheit über den Propagandafeldzug und Deutschlands Zusammenbruch. Der Kampf der Publizistik im Weltkrieg* (Wien: Selbstverlag Fortschrittliche Buchhandlung, 1927): 62.

5 Jean de Pierrefeu, *G.Q.G. secteur I*, 2 Bde. (Paris: Éd. Française Illustrée, 1920), Bd. 1: 169ff.; Jean-Claude Montant, *L'organisation centrale des services d'information et de propagande du Quai d'Orsay pendant la Grande Guerre . . .*: 135ff., here p. 138; Philip Gibbs, *Adventures in Journalism* (New York: Harper & Brothers, 1923): 246.

6 As the chief press officer at British Headquarters put it: "The Press has to be treated as an arm [of the army], like tanks or aeroplanes, suitable for defence or attack." Neville Lytton, *The Press and the General Staff* (London: W. Collins Sons & Co. Ltd, 1921): VII.

7 *Zensurbuch für die deutsche Presse*, ed. by Oberzensurstelle des Kriegspresseamts (Berlin: Gedruckt in der Reichsdruckerei, 1917), entry "Berichte."

8 Matthias Erzberger, *Meine Erlebnisse im Weltkrieg* (Berlin: Deutsche Verlags-Anstalt, 1920): 7f.

9 Pierrefeu, *G.Q.G. secteur I*: 169ff.; Dominique Pascal, "Les débuts du service photographique des armées," in *Prestige de la Photographie* 2, September 1977: 60ff., here p. 69; numerous entries in the German *Zensurbuch* (note 7) barred a broad range of weapons and military installations from reproduction in the press.

10 *Cf.* Thérèse Blondet-Bisch, "Vues de France," in *Voir ne pas voir la guerre. Histoire des réprésentations photographiques de la guerre* (Paris: Somogy, 2001): 54ff., here p.57; for the picture quantities produced see Dominique Pascal, "Les débuts du service photographique des armées," in: *Prestige de la Photographie* 2, September 1977: 60 ff., here p. 79.

11 *Cf.* Marcel Berger and Paul Allard, *Les secrets de la censure pendant la guerre* (Paris: Éditions des portiques, 1932): 206.

12 For the situation in France see Pascal, "Débuts": 73; Laurent Veray, "Montrer la guerre: la photographie et le cinématographe," in Jean-Jacques Becker, ed., *Guerre et cultures 1914–18* (Paris: Armand Colin, 1994): 229ff., here p. 233; the prohibition against private images: *Zensurbuch* (note 7), entry "Kriegserinnerungen."

13 *Cf.* Ulrich Keller, "Blut und Silber: Die Inszenierung der Kubainvasion von 1898 in der amerikanischen Bildpresse," in: *Fotogeschichte* 25.97, 2005: 25ff.

14 Gibbs, *Adventures*: 246, 249, 255, 270.

15 For the British war correspondents and war photographers see Lytton, *Press*, *passim*; Carmichael, *World War*, especially 16, 31, 34, 44 ff.; Martin J. Farrar, *News From the Front. War Correspondents on the Western Front 1914–18* (Stroud, Gloucestershire: Sutton Publishing, 1998).

16 *Cf.* David R. Woodward, *Field Marshal Sir William Robertson, Chief of the Imperial General Staff in the Great War* (Westport, CT: Praeger, 1998): 31; Paul Kendall, *The Zeebrugge Raid 1918: 'The Finest Feat of Arms'* (London: Spellmount, 2008): 147.

17 Oppelt, *Film*: 106ff.; Hans Barkhausen, *Filmpropaganda für Deutschland im Ersten und Zweiten Weltkrieg* (Hildesheim: Olms Presse, 1982): 97ff. BUFA's movie production is not at issue here but Oppelt's and Barkhausen's monographs provide excellent introductions to the subject.

18 Walter Nicolai, *Nachrichtendienst, Presse und Volksstimmung im Weltkrieg* (Berlin: E.S. Mittler und Sohn, 1920): 54, 58, 62.

19 Knesebeck, *Wahrheit*: 121f.

20 Nicolai, *Nachrichtendienst*: 86

2.4
Illustrating Sports, or the Invention of the Magazine*

Thierry Gervais

In the late nineteenth century, the rise of amateur photography and the development of halftone printing allowed newspaper publishers to imagine new weeklies centering on photography, among them *The Illustrated American* (1891) and *Collier's Weekly* (1895), in the United States, and *La Vie Illustrée* (1898) and *La Vie au grand air* (1898) in France. These periodicals inherited the format and length of their predecessors, but were more generously illustrated. This emphasis on quantity, closely tied to the realization of the halftone process and the new possibilities it generated, created its own set of constraints. Art directors were added to editorial teams to oversee image flow and layout, bringing with them visual strategies that would transform the structure of illustrated periodicals. All of these weeklies carried sports news, but only *La Vie au grand air* published nothing else, from 1898 to 1922, and under "art director" Lucien Faure it pioneered a graphic style that ushered in the age of the modern magazine.

During the nineteenth century, sport played a steadily expanding role in France, and in the early years of the twentieth century it became synonymous with the advent of leisure. As an "enjoyable break" from work for some, and a "pleasure that does you good" for others, sport, for the Belle Époque, was one result of progress.[1] Writing of the first Tour de France in 1903 and its handling by the media, historian Georges Vigarello comments, "The newspaper recounted the race to the reader, the race the roadside spectator only glimpsed: it gave meaning and unity to a spectacle, recreated duration, linked the episodes together and provided a dramatic structure. Whence the curiosity and the attraction. Whence the sales."[2] The association of the Tour de France with the magazine *L'Auto*, the Tour's initiator, testifies not only to reader interest in sporting events, but also to the inherent media-friendliness of sport for a press now more concerned with topical news than with informed, long-form articles.[3] More recreational in content than traditional newspapers, the sporting press developed a less restricted mode of presenting the news, and with the spread of photography and the advent of halftone illustration, sports weeklies enjoyed increasing visibility and independence on the press scene.

1 April 1898 saw the first issue of *La Vie au grand air* (1898–1914; 1916–22), an "Illustrated magazine of all sports"[4] devised and published by Pierre Lafitte (1872–1938), a major figure on the press and publishing scene in the pre-war years.[5] Under Lafitte's guidance, sports and "outdoor living" generally were addressed as social phenomena signifying progress and helping to shape a "young elite."[6] A surge of patriotism saw the editor-in-chief resolve to confront the Anglo-Saxon peoples and their reputation as

athletes with a France become "the land of muscle." As a "guarantee of growth,"[7] sports, offering a host of competitions and endlessly renewed feats, embodied the development of modern societies. France had its specialist press, but no "official, illustrated sports magazine" to make all of these activities accessible to the young, the "hope of our country."[8] *La Vie au grand air* was ready to take on the task, with news about cycling, cars, and athletics, and a program of the "popularization of sports," which Lafitte proposed to carry out by complementing official accounts and articles by specialists with "vibrantly interesting photogravures and lively compositions by our illustrators."

The amateur photography of the late nineteenth century showed a marked penchant for sports, and *La Vie au grand air* ensured amateur support from the time of its founding in 1898.[9] During the 1880s discerning photographers such as Albert Londe and Gaston Tissandier channeled the energy of amateurs by forming associations, both to promote the medium and its practice and to get the most out of the challenging new form of the snapshot. The gelatin silver technique offered hitherto unknown sensitivity to light and, what was more, a dry medium that freed hobbyists from their laboratories.[10] Their images not only embodied the medium's new possibilities, but also constituted an aesthetic and a strictly photographic genre that "came to resemble a kind of sporting competition dedicated to an ongoing quest for visual exploits."[11] It was hardly surprising, then, that "photography" should figure on Lafitte's list of sports, and that the outings of the Société d'Excursion des Amateurs de Photographie (SEAP) should include venues like the Le Vésinet Skating Circle, the racetrack, and the Joinville-le-Pont Military College,[12] where the great sports spectacle could be captured "on the spot." The fortuitous Belle Époque encounter of sports and photography generated a wealth of images which *La Vie au grand air* capitalized on and highlighted through sophisticated page design.

In its issue of 4 February 1899 the weekly carried sixty illustrations, all of them photographic.[13] A quick evaluation of standard issues of the magazine shows that photographs covered 10.5 to 14 pages, that is, around 70 percent of each issue. From cover to cover there were few pages of solid print. Furthermore, text typically took the form of captions, with the images structuring the space on the page. The quantity and type of images meant *La Vie au grand air* had to find graphic solutions for each issue; for this it appointed an "art director" whose job was not only to choose the pictures, but also to lay them out such that they supported the editorial line. Lucien Faure was in charge of giving visual shape to the sporting news and each page, beginning with the cover, was an exercise in graphic construction in which text and image were blended to meet topical requirements. On the cover of the issue of 16 March 1905, for example,[14] Hoffmann is shown on his motorcycle from a point of view that orients him towards the right-hand side of the page, eyes glued to the finishing line. The title of the magazine is laid out in four lines behind the motorcycle, whose front wheel is cropped by the bottom of a page insufficiently long to contain this vision of speed (Fig 2.4a).

This kind of presentation is aimed much more at a spectator than a reader: a spectator interested in things like the speed of motorcycles, and whose attention is likely to be drawn to the formal content of an image. Every possible technique has been utilized to produce an eye-catching cover: the snapshot freezes the movement, the frontality establishes the viewer's position, and the placement of the text underscores the construction of the page. Thus consumers are drawn toward *La Vie au grand air* first by its enticing cover, then by the carefully laid-out pages that structure the issue, and finally by its arguable high point, the central double-page spread, a horizontal rectangular space where all of the layout strategies used for the cover and full pages were put to work.[15]

In the issue of 29 February 1908 the magazine devoted its double page spread to the diabolo: "Is the diabolo a game or a sport?" (Fig. 2.4b).[16] The subject was addressed through a text-and-image layout

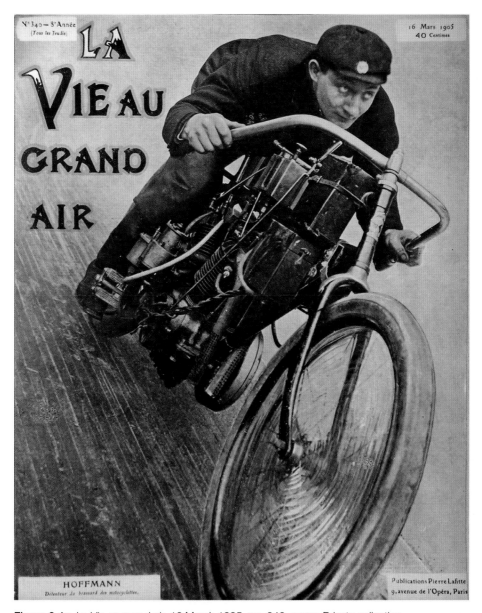

Figure 2.4a *La Vie au grand air*, 16 March 1905, no. 340, cover. Private collection.

that used the page to its fullest. A double border surrounds the composition, punctuated at several points by a diabolo or the arm of a player. A wide horizontal image unites the two pages, but is split down the middle by a player bent backwards in the act of throwing the diabolo. Arranged in a semi-circle around him are five other images: three silhouetted figures and two others set in circles. The text is not laid out with the same symmetrical exactness; rather, it fills out the remaining space, slipped in between

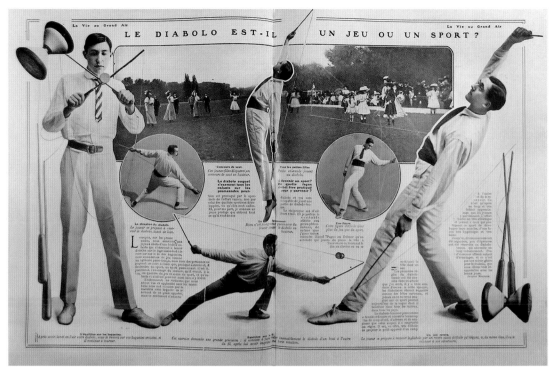

Figure 2.4b *La Vie au grand air*, 29 February 1908, no. 492, pp. 135–6. Private collection.

the images or the legs of one of the players. The author of the article struggles to convincingly present the game as a sport, but the layout certainly highlights the player's agility and dexterity. The figures are silhouetted in unusual but graceful poses; the circles echo the shape of the diabolo, accentuating its part in the general composition; and the scattering of the text mimics the speed of the movements demanded by the activity. The double page spread, then, presents its subject via a formal arrangement based on separate photographs. The layout employs a montage of distinct visual elements—text and images— aimed at an overall effect in which skill is conveyed through a formal display. The double-page spreads in *La Vie au grand air* systematically strove for this merging of form and content.

The spread in the issue of 1 August 1908 is further testimony to the narrative/display pairing (Fig. 2.4c).[17] Here the topic is that year's London Olympics. A montage with the title at the top, the images in the middle, and four lines of captions at the bottom includes nine snapshots in varied formats of, among other subjects, the finish line of the 100- and 200-meter races, the winner of the 1,500-meter, and the end of the marathon. The images are numbered from left to right and from top to bottom, with each number corresponding to a caption, but the narrative sequence is disrupted by the superposition of an image: that of the American Francis C. Irons, who had just broken the world long jump record and been photographed head on during one of his attempts. Occupying the full height of the page and stripped of its context by tight silhouetting, Irons' body partially masks some of the other photographs as it hurtles towards the reader/spectator. The montage transcends any mere account of the Games through its arrangement of a representative selection of snapshots of the events. Irons astonishes

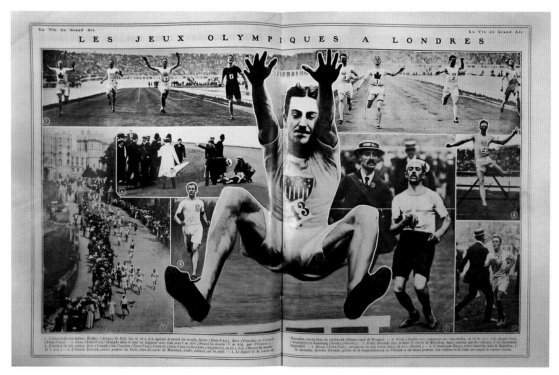

Figure 2.4c *La Vie au grand air*, 1 August 1908, no. 515, pp. 88–9. Private collection.

everyone by breaking the world record, but also by creating a spectacular visual effect. Number 2 in the sequence, the photograph of Irons, is the organizational linchpin for the spread. With this kind of montage, the *La Vie au grand air* double page became a magnet for readers in search of visual information modeled not on the academic dictates of the fine arts, but on modern forms. Incorporating photography and montage, the layouts of *La Vie* were, seductively, more suggestive of the newsreels being screened in Parisian cinemas than the teachings of the *académies*.

The modernity of those double pages in *La Vie au grand air* stemmed directly from the choice of photography as their mode of illustration, but also from a visual context marked by the advent of the cinema.[18] Both posed potential problems. Two examples attest to the illustrative constraints the weekly had to deal with in opting for photography. First, in February 1903, the journalist André Foucault recounted the rugby final in Paris.[19] Taking up four pages, his article was accompanied by nine illustrations: eight photographs and a drawing that covered the central double page. Derived by Tofani from a photograph, the drawing shows the Racing Club de France breaking through the Stade Français defense in a classical composition in which all lines of sight converge on the ball. The four-line caption gives equal emphasis to what is happening and to the reasons for using a drawing: "Our readers should not imagine that this is what old-style illustrated journalism called a 'composition.' This splendid plate is a faithful reproduction of a photograph. However, the snapshot's instantaneity makes it more suited to capturing situations than to indicating movement. This is why we called on skilled draftsman Tofani to come to the aid of photography by imbuing this scene with the liveliness the camera had robbed it of . . ." The choice of

photography and a commitment to the dynamics of modern journalism would eventually mean abandoning the illustrative mode of which this example is symptomatic, in which drawing had always helped to compensate for the shortcomings of the medium. Second, the different forms of photography, and in particular those permitted by the snapshot, were taken on by a magazine whose compositions were now based not on the image itself, but on the page and its sequence of pictures. Justification for this approach appealed more to the cinema than the fine arts. La Vie au grand air's issue of 21 June 1902 featured a six-photo double-page montage devoted to the Paris Grand Prix under the heading, "What our six photographers' cameras saw", together with captions declaring these snapshots of the race "a truly cinematic account of Kizil-Kourgan's victory."[20] This association of the cinema and the double-page format hinged on the use of silver gelatin images, the number and diversity of the shots and a montage forming a sequence from the race.

Even discounting the Lumière brothers' "topical subjects"[21] and Meliès's famous reconstructions of current events,[22] news continued to gain ground in the cinemas of Belle Époque Paris.[23] Pierre Lafitte was not unaware of the visual revolution taking place in media coverage of politics, society, and sports. It was probably too early for him to refer to the cinema when he wrote his 1899 article introducing La Vie au grand air in its new format, but in the inaugural issue of his daily, Excelsior, in 1910, he was adamant: "We are the first to take advantage, for the benefit and the pleasure of the public, of the enormous progress made over the last ten years in the industries of typography, photography and photogravure. The creation of Excelsior is the natural outcome of this progress . . . Thanks to these unparalleled developments Excelsior will be what it sets out to be: the cinema of the world's news."[24] In the words of René Jeanne and Charles Ford, "When the cinema became king, news was never the same again."[25] Here the historians are referring to content, but their observation could just as easily be applied to the forms the press was taking. Even so, it was not until the interwar period and the launch of such famous magazines as VU and LIFE that cinematic mise en scène and layout came face to face: "So the little paper cinema that is the magazine found itself . . . also involved in transforming its pages into mise en scène: something living, then something speaking, that is to say, something using a simple combination of photographic and typographic events to produce meanings sufficiently explosive for the reader to enjoy the magazine as a spectator: with no effort."[26]

From the beginning of the Belle Époque, La Vie au grand air invested each page with a dynamic that encouraged the reader to "flip through" the magazine rather than read. It could be felt in the visual narrative generated by sequences of photographs, but also in spectacular overlay effects. Speaking of early cinema, Tom Gunning reminds us that with the filmic construction of news, the mode of narration often went hand in hand with "attraction", and that the close-up was resorted to as a stage effect, "an attraction in its own right."[27] This definition of early cinema also presupposes that the spectator can become engrossed in a "fictional world" and let himself be seduced by the curiousness of a given effect. Is this not the same duality that the reader of La Vie au grand air consents to when browsing? Does not the London Olympics spread provide a double dose of narrative, with its numbered images, and spectacle, with its frontal, outlined view of the American athlete Irons?

The invention of the magazine sprang from its near-exclusive use of photography and halftone which, applied to the sporting scene, gave rise to a new mode of illustration in the late nineteenth and early twentieth centuries. The distinction between an illustrated weekly and a magazine hinged on new reading habits and the new way that readers encountered printed matter, owing to this use of photographs. In La Vie au grand air the draftsman and the engraver were replaced by the art director in a transmission of news no longer located in the image, but on the whole page. This shift was observable in many weeklies,

but it is in *La Vie au grand air* that it took on its most innovative form. Addressing a frankly frivolous subject—sports—with generous pictorial support, Lucien Faure selected, cropped, and organized his photographs to produce not only a visual narrative, but also spectacular effects. This graphic structuring of text and image enabled the pages and double pages to function independently of each other, freeing the reader/spectator from the hitherto mandatory first-to-last-page reading order. Each issue was designed to facilitate the random accumulation of information: the modern Belle Époque reader was no longer reading an illustrated newspaper. He was flipping through a magazine.

Notes

* This chapter translated from French by James Gussen.

1 Georges Vigarello, "Le temps du sport," in *L'Avènement des loisirs 1850–60*, ed. Alain Corbin (Paris: Flammarion, 1995): 193–221.

2 Georges Vigarello, "Le sport bouleversé par l'image," in Bernard Huchet and Emmanuèle Payen, eds., *Figures de l'événement. Médias et représentation du monde* (Paris: Centre Pompidou/BPI, 2000): 63.

3 Charles Giol, "La rubrique des sports," in Dominique Kalifa, Philippe Régnier, Marie-Ève Thérenty, and Alain Vaillant, eds., *La civilisation du journal. Une histoire de la presse française au XIXe siècle* (Paris: Nouveau Monde, 2011): 1077–86.

4 *La Vie au grand air. Revue illustrée de tous les sports*, 1, 1 April 1898.

5 In addition to *La Vie au grand air*, Lafitte was the man behind *Femina* (1901–39), *Musica* (1902–14), *Je sais tout* (1905–39) and *Fermes et Châteaux* (1905–14), all on coated paper and lavishly illustrated. Regarding his career, see Juliette Dugal, "Pierre Lafitte, 'Le César du papier couché,' " in *Le Rocambole*, spring 2000, 10: 12–38.

6 Pierre Lafitte, "La Vie au grand air," *La Vie au grand air*, 1, 1 April 1898: 4.

7 Georges Vigarello, "Le temps du sport," art. cit.: 208.

8 Pierre Lafitte, "La Vie au grand air," art. cit.

9 Regarding the amateur photographic output of this period, see André Gunthert, *La Conquête de l'instantané. Archéologie de l'imaginaire photographique en France (1841–95)* (Ph.D. dissertation, EHESS, Paris, 1999) and Clément Chéroux, *Une généalogie des formes récréatives en photographie (1890–1940)* (Ph.D. dissertation, Université Paris I, 2004).

10 Cf. Denis Bernard and André Gunthert, "Nouveaux mondes," in *L'Instant rêvé. Albert Londe* (Nîmes: Jacqueline Chambon, 1993).

11 André Gunthert, "Esthétique de l'occasion. Naissance de la photographie instanée comme genre," *Études photographiques,* 9, May 2001: 82.

12 Concerning the links between sports and photography in the late nineteenth century, and notably between the SEAP and the *La Vie au grand air* photographers, see André Gunthert, "Un laboratoire de communication de masse. Le spectacle du sport et l'illustration photographique," in Laurent Véray and Pierre Simonet, eds., *Montrer le sport. Photographie, cinéma, télévision* (symposium proceedings) (Paris: Cahiers de l'Insep 2000): 29–35.

13 *La Vie au grand air*, 21, 4 February 1899: 243–254. In no. 59 of 29 October 1899, the directors estimated the number of "photogravures" in each issue at sixty. See "À nos lecteurs" ("To our Readers"): 74.

14 *La Vie au grand air*, 340, 16 March 1905.

15 Tom Gretton, "Difference and Competition: the Imitation and Reproduction of Fine Art in a Nineteenth-century Illustrated Weekly News Magazine," in *Oxford Art Journal* 23: 2 (2000): 143–62.

16 Jacques Mortank, "Le diabolo est-il un jeu ou un sport?" (Is the Diabolo a Game or a Sport?), *La Vie au grand air*, 492, 29 February 1908: 135–6.

17 "Les jeux Olympiques à Londres" (The Olympic Games in London), *La Vie au grand air*, 515, 1 August 1908: 88–9.

18 On the context in which these new forms of entertainment appeared and the interplay between different media during the Belle Époque, see Vanessa Schwartz, "Cinematic Spectatorship before the Apparatus: The Public Taste for Reality in *Fin-de-siècle* Paris," in Leo Charney and Vanessa Schwartz, eds., *Cinema and the invention of Modern Life* (Berkeley/Los Angeles/London: University of California Press, 1995): 297–319, and Vanessa Schwartz, *Spectacular Realities: Early Mass Culture in Fin-de-Siècle Paris* (Berkeley/Los Angeles/London: University of California Press, 1998, 177–99.

19 André Foucault, "Le Racing champion de Paris" (Racing Club Parisian Champions), *La Vie au grand air*, 233, 28 February 1903: 135–8.

20 *La Vie au grand air*, 197, 21 June 1902: 408–9.

21 Marcel Huret, *Ciné Actualités: histoire de la presse filmée (1895–1980)* (Paris: Henri Veyrier, 1984).

22 *Méliès, magie et cinéma*, eds Jean Malthête and Laurent Manonni (Paris: Paris-Musées, 2002). See also Jean Mitry, "Le montage dans les films de Méliès," in Madeleine Malthète-Méliès, ed., *Mélies et la naissance du spectacle cinématographique* (Paris: Klincksieck, 1984): 149–55.

23 For all matters relating to the history of cinemas in Paris before World War I, see Jean-Jacques Meusy, *Paris-Palaces ou le temps des cinémas (1894–1918)* (Paris, CNRS, 1995): 108–10.

24 Pierre Lafitte, "Notre programme," *Excelsior. Journal illustré quotidien*, 1, 16 November 1910: 2.

25 René Jeanne, Charles Ford, *Le Cinéma et la Presse* (Paris: Armand Colin, 1961): 8.

26 Jean Selz, "Le cinéma et la mise en pages," *Presse-Publicité*, 3, 28 March 1937: 8. My emphasis.

27 Tom Gunning, "Cinéma des attractions et modernité," *Cinémathèque* (Spring 1994): 130–1.

2.5
After the Event: The Challenges of Crime Photography

Will Straw

The coverage of crime by photojournalists has often been imagined in relation to speed. Of the many legends concerning the US photojournalist Weegee (Arthur Fellig), one of the most repeated lauded his ability to reach crime scenes first, before competitors or the police had arrived to block or dilute his access to such scenes. This rush to the site of a crime has been central to the image of the crime-oriented photojournalist, from Hollywood newspaper films of the 1930s through documentaries on tabloid crime photographers working in present-day Mexico City.[1] Even as the speed of the photographer is celebrated, however, this celebration bumps up against one of the all-but-inescapable features of crime news photography. This is the fact that photographers are rarely present to witness and record the criminal act itself. The arrival of photojournalists at crime scenes is almost always belated. This belatedness has shaped the practices, conventions, and aesthetics of crime-oriented photojournalism. Its effects are to be found in the coverage of crime in daily newspapers (such as those which employed Weegee) and in those twentieth-century periodicals, usually of weekly or monthly frequency, which specialized in crime coverage.[2]

Arriving after the criminal act has been committed, photojournalists are normally limited to capturing the visible residues of crime, such as dead bodies or damaged buildings. Because of this, the photographic treatment of crime is unlike most other sorts of photojournalism, such as those involving sports, military battles, or political rituals. In the latter, even the unpredictable—a spectacular home run, an unexpected explosion, a resignation—typically unfolds in front of a camera which is already present in anticipation that something of journalistic value will occur. In these cases, photojournalism represents an activity of witnessing, and this status of witness has ennobled the profession and enshrined the status of photojournalists as custodians of collective memory. Crime photographers, in contrast, are rarely able to witness the criminal act itself and must represent that act using its after-effects and constituent parts. (In this, it might be argued, the photographic practice of photojournalistic crime coverage overlaps considerably with that of official forensic photographers engaged in the documentation of those aspects of a crime possessing evidentiary value.) In photojournalism, weapons, suspects, victims, locations, accomplices, and bloody crime sites are usually photographed separately, often at some remove in time and space from the crime itself. Crime-oriented photojournalism is thus marked by high levels of

fragmentation, which break the criminal act into disparate images. While the reporter's text may bind these fragments together within a coherent narrative, the visual components of crime coverage are usually characterized by multiplicity. This multiplicity works against the production of the single iconic image typical of other genres of photojournalism.

The fragmented character of crime coverage has had two principal effects on the visual aesthetics of the crime news story. One is that crime photography in the periodical press is marked by a high degree of sameness. Whatever the singularity of each criminal act itself, the images which form part of its coverage are usually conventional, even banal, because they are drawn from a relatively stable repertory. Images of guns and mug shot portraits of perpetrators convey information which is swiftly grasped, but this legibility is an effect of their restricted stylistic range and their repetition from one crime news story to another. A second effect of the fragmented visuality of the crime news story is that the journalistic status of different images—their documentary news value—is highly variable. The images used to illustrate crime news stories typically come from a range of sources—photojournalists, archives, judicial and family collections, and so on—and thus possess widely varying degrees of currency and journalistic legitimacy. Newspaper layouts may contain photographs of a crime scene taken immediately following the crime itself, but these often appear beside portraits (of perpetrators, victims, or officials) taken in the distant past, or are set amidst stock photographs of the streets, buildings, or cities in which a crime took place. The indexical status of the photographs employed within a single crime news story—the extent to which such photographs bear the imprint of a punctual place and time—is likely to fluctuate widely.

A two-page spread recounting a murder in 1930s Chicago will be used here to demonstrate many of the characteristic features of crime coverage in the periodical press. "Un gangster s'évade à l'Audience" ["A gangster escapes during his trial"] appeared in the 18 March 1934 issue of the French weekly *Police Magazine* (Fig.2.5).[3] Typical rather than exceptional, this layout exemplified the fragmented visuality of periodical crime coverage, with an assortment of images arranged around a lengthy text. With no images available of the criminal act itself, the magazine's editors assembled an array of partial views, of people and things involved in the crime. They supplemented these with group shots, which enhanced the dramatic, theatrical dimensions of the story. Together, these images gather up the key people and situations involved in this crime, though such images come from a variety of sources and points in time.

Police Magazine was launched in 1930, in an effort to mimic the runaway success of Gallimard's crime-oriented newspaper *Détective*. It presented itself, at least in part, as a weekly news periodical. Significant parts of each issue were devoted to coverage of recent and spectacular French crimes, such as the murder of financier and political figure Alexandre Stavisky or the sensational Violette Nozière affair of 1933, in which a working class woman killed her father. At the same time, *Police Magazine* sat alongside *VU* or *Voilà* (and equivalents in several other countries, like the Mexican *Todo*) as one of the new "picture magazines" of the early 1930s which transformed periodical publishing through the development of elaborate photojournalistic features and inventive layouts. These magazines were known for monochrome covers which simultaneously mobilized the power of the single photographic image and indulged in fanciful practices of superimposition or spatial distortion. Their interior layouts often involved extravagant interweavings of text and image and radical juxtapositions of scale (such as those which set group scenes alongside close-up portraits of equal size.)

Like these other picture magazines, *Police Magazine* partook of the vogue for lengthy reports on far-off spaces, with Orientalizing articles on vice capitals of the world or illustrated guides to the everyday customs of exotic populations. As Myriam Boucharenc has shown, the more ambitious of French magazines of the 1930s sent well-known authors to far-flung corners of the globe, to report back on

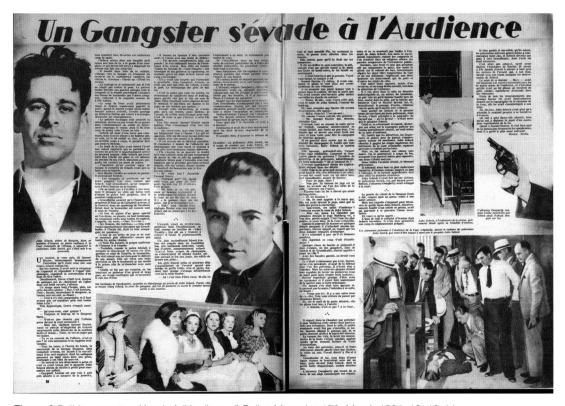

Figure 2.5 "Un gangster s'évade à l'Audience," *Police Magazine* 173, March 1934, 18: 10–11.

places or customs in lengthy articles and photojournalistic spreads deemed to possess artistic merit.[4] *Police Magazine* indulged in this practice on occasion, but its more limited resources meant that its feature articles were typically assembled in its Parisian offices, with materials reworked from other sources or acquired through international syndication services.

Police Magazine published its two-page spread on the murder of Chicago policeman John Sevick by bankrobber John Scheck nine months after the crime had occurred and one month before Scheck was executed for the act. The murder itself had made the front pages of newspapers across the United States, fitting neatly within that narrative of relentless Depression-era lawlessness which Brian Burrough has reconstructed in his recent book *Public Enemies*.[5] By March of 1934, when *Police Magazine* published its article, the events possessed little conventional journalistic interest. (The impending execution of Scheck, which might have served as a news hook, is not even mentioned.) Like so much of its coverage of crimes present and past, "Un gangster s'évade à l'Audience" permitted *Police Magazine* to revisit a place rich in narrative and visual materials. Throughout the 1930s, Chicago had served as one of the exotic locales covered most frequently in French picture magazines. Its status as a center of jazz-age nightlife and criminality prompted regular features filled with photographic imagery of its show girls, nightclubs, and celebrity criminals. The images assembled by *Police Magazine* in its coverage of the John Scheck crime are more limited in their variety and specialized in their content, but there is still the

observable effort to offer the familiar visual tokens of a broader gangland criminality: dead bodies lying amidst crowds of onlookers, murder weapons, institutional settings, and portraits of defiant criminals and virtuous victims.

While *Police Magazine* presented itself, at least in part, as a news magazine, closer examination of its reportage reveals a complex relationship to journalistic actuality. As noted, the murder of John Sevick was several months old, with little currency as news, and the appeal of the article apparently lay more in its exotic assemblage of places, people, and actions than in any informational function. Closer attention to the provenance of the various elements in this two-page spread confirms the suspicion that a punctual criminal act has been reconstructed from sources acquired over long distances and from very different moments in the unfolding of this criminal narrative.

The article "Un gangster s'évade à l'Audience" was credited to a Roger Nivès. The signatures of other articles in *Police Magazine* were sometimes prefaced by the words "enquête de", designating their authors as investigative reporters, but that is not the case for Nivès. Indeed, the name Roger Nivès turns out to have been one of several pseudonyms used by H.R. Woestyn, a prolific author of French-language crime novels and one of the translators of Edgar Allan Poe. Bibliographies of French crime fiction list one novel published under Roger Nivès' name—*La Fleur Fatale*, from 1921—and the style of the *Police Magazine* article is that of the quickly sketched short story as much as it is one of journalistic witnessing.[6] One can only assume that *Police Magazine*'s reconstruction of the events in Chicago was based on the reworking, by Nivès/Woestyn, of materials produced by others.

The photographs accompanying the article are of widely varying documentary value and suggest different relationships to the practices of photojournalism. The portrait of John Scheck in the upper left corner of the article was distributed by the International News Photo Inc. of Chicago (the agency of the Hearst newspaper chain), according to an eBay dealer's listing which offered the original print for sale in 2013 and reproduced the back of the photograph on which this provenance is confirmed.[7] At the same time, this photograph is similar in pose and dimensions to an official mug shot and may well have originated as such. It exemplifies, in any case, that defiant demeanour which, in the words of art historian Cuauhtémoc Medina, marks the "theatre of the battle of identities" in which the incarcerated criminal resists the dehumanizing operations of police photography.[8] The head-and-shoulders shot of policeman John Sevick, who was killed by Scheck in his attempted escape from the courtroom, may well be a slightly altered version of the official police force photo of Sevick, which is now reproduced on a website devoted to law enforcement officers killed in the line of duty in the United States.[9]

Two of the images within *Police Magazine*'s layout arouse immediate suspicion as to their documentary legitimacy. The image at the top of the second page, ostensibly of John Scheck being treated in a hospital ("gravely wounded after his escape attempt") reveals upon close examination that it may be a drawing or, at the very least, a photograph of low resolution touched-up for minimum legibility. There is good reason to doubt that photojournalists would have had access to a hospital room in which the killer of a Chicago policeman lay dying, and little reason to suppose that a French news magazine, reporting on the events a year later, would need to be scrupulously authentic in its use of images. Likewise, the image offered as that of Scheck's murder weapon, ostensibly held forth for examination by attorney Dougherty, may well fall within a long history of murder weapon imagery which employed posed or stock, archival photographs. What is of interest here, in any case, is less the photojournalistic authenticity of this image than the generic requirement that it fulfills, that of including, amidst the other features of this particular crime, a revolver held by an extended hand. Here, as in so many photojournalistic treatments

of crime, the isolated photograph of a pointed revolver stands metonymically for the inaccessible image of the actual shooting.

To these, the *Police Magazine* feature added a group shot of six women, identified in the story as the habitués (*belles de jour et de nuit*, in the reporter's words) of a speakeasy frequented by members of the gang which undertook the bank robbery. From American newspapers, which used this same photograph, we know that, like the head-and-shoulders portrait of Scheck, this image was distributed by the International News Photograph Service.[10] The women shown here figured in the narrative of John Sevick's murder in two ways. As witnesses for the defense of one of the accomplices of accused bank robber John Scheck, these women testified in court that said accomplice had been with them at the speakeasy Chez Nanette at the time of the robbery. More dramatically, one of the women, John Scheck's sister, had carried into the court the revolver with which Scheck killed the policeman as he attempted to escape during his trial. None of this information is conveyed by the photograph itself, of course, and the reasons for the choice of this picture clearly lie elsewhere. As an image of women over whom the suspicion of prostitution hangs, this picture joins dozens of others in *Police Magazine*, which throughout the 1930s documented, in almost anthropological fashion, the bands of women participants in night-time sexual commerce.

This image sits roughly opposite a picture at the bottom of the second page, in which men in a courtroom gather around the body of slain policeman John Sevick. The relationship between these groups is one of multiple kinds of contrast, of which the division between women and men is the most obvious. Other lines of distinction flow from this: between women returning the camera's stare and men gazing with concern at a murdered policemen, or between the former's clearly outsider status vis-à-vis the judicial setting and the latter's obvious sense of belonging there. Together, these two images capture the two dimensions of Chicago most prominent in coverage of the city in French picture magazines in the 1930s. The group of women stand in for "*le milieu*," "*la mondaine*", the aforementioned worlds of nightlife entertainment. In the range of their expressions they express the coquetry, solidarity, and hard-bitten defiance which form part of the inventory of stereotypical characterizations applied to women inhabiting this world. The men in the second photograph offer a more narrow range of expressions, but the impression collectively conveyed is of a distress held in check by the jaded professionalism of the Chicago justice system.

Images of dead bodies lying on streets or floors constitute the most cherished of crime photographs insofar as they are typically closest in time to the criminal act itself. Two additional, more formal features of such images are worth consideration. Both have been noted by Leonard Folgarait, in his study of Mexican photography. The dead body, Folgarait argues, is the perfect still object for the photographer's camera, because it is devoid of any of the movement which might render photography imperfect or call attention, through such imperfections (such as blurring) to its status as a technologically-based medium. Folgarait further explores the tendency, in photographs of those killed in acts of violence, for bodies to stretch in diagonal fashion across the space of the image. In the photographs of Revolutionary killings which Folgarait analyzes, this diagonality is said to underscore the "ultimately unknowable" character of political violence, through its difference from the grid-like, rectangular structure of those photographic genres (like the mug shot, perhaps) whose claims to truth are stronger.[11] Certainly, the diagonal arrangement of Sevick's body in the photograph analyzed here conveys a sense of disrupted institutional functioning, through the ways in which it forces the onlookers to position themselves in a disorderly, multi-plane arrangement.

For the inaccessible drama of the criminal act itself, photographs such as this one substitute the rich social theatre of the assembled crowd. Dead body scenes such as this one function as variants of that

tableau structure which cuts across several genres of photography, from images of families to group shots of sports teams, university classes, or military units. In press coverage of crime, these images of human gatherings strive to offer a dramatic energy appropriate to the criminal act itself, but the frozen immobility of the onlooking crowd almost always fails to convey a sense of urgency or alarm. Neither the totality of the photographs illustrating the *Police Magazine* article nor the sequence in which they are arranged provide information enabling us to reconstruct the narrative of the criminal act itself. That act comes to life only in the reporter's text, which offers a retrospective witnessing of murderous action and traces the interplay of people, settings, and behaviors in time. The photographs accompanying this text, which follow no sequence and show us people or settings as they existed before or after the criminal act, detached from the criminal act, are reduced to the status of illustrative ornaments.

Notes

1 See, for discussions of the myth of the photojournalist in US culture of the 1930s, Penelope Pelizzon and Nancy West, *Tabloid, Inc.: Crimes, Newspapers, Narratives* (Columbus, Ohio: Ohio State University Press, 2010). For treatment of contemporary photojournalism in Mexico City, see Vice Magazine, VBS.TV, "Alarma," Parts 1–3, http://www.vbs.tv/watch/vbs-news/alarma–1-of–3 (accessed 10 January 2010).

2 See Will Straw, *Cyanide and Sin: Visualizing Crime in 50s America* (New York: PPP Publications/Andrew Roth Gallery, 2006) and Will Straw, "Nota roja and journaux jaunes: Popular crime periodicals in Quebec and Mexico," in Graciela Martinez-Zalce, Will Straw, and Susana Vargas, eds. *Aprehendiendo al delincuente: Crimen y medios en América del norte* (Mexico City: CISAN/UNAM and Media@McGill, 2011).

3 R. Nivès, "Un gangster s'évade à l'Audience," *Police Magazine* 173, 18 March 1934: 10–11.

4 M. Boucharenc, *L'écrivain-reporter au cœur des années trente* (Villeneuve d'Acsq: Septentrion, 2004).

5 Brian Burrough, *Public Enemies: America's Greatest Crime Wave and the Birth of the FBI, 1933–34* (New York: Penguin, 2009).

6 See the website "A propos de littérature populaire." http://litteraturepopulaire.winnerbb.net/t667-woestyn-hr. (accessed 20 September 2013).

7 EBay listing. http://www.ebay.com/itm/Crime-Photo-Bank-Bandit-John-Scheck-Kills-Policeman-in-Chicago-Courtroom–1933-/301016863454?pt=Art_Photo_Images&hash=item461600d2de (accessed 15 November 2013).

8 J. Lerner, *El impacto de la modernidad: Fotografia criminalistica en la ciudad de México* (Mexico, DF: Editorial Turner de Mexico, 2009): 26.

9 Officer Down Memorial Page. http://www.odmp.org/officer/12046-patrolman-john-g-sevick (accessed 12 November 2013).

10 See, for example, the photographic spread entitled "Principals in Chicago Courtroom That Stirred Officials to Action," *Syracuse Journal*, 26 July 1933: 20.

11 Leonard Folgarait, *Seeing Mexico Photographed:The Work of Horne, Casasola, Modotti, and Alvarez Bravo* (New Haven: Yale, 2008): 12–14.

News Picture Media

2.6

News Pictures in the Early Years of Mass Visual Culture in New York: Lithographs and the Penny Press

Michael Leja

The construction and picturing of "news" was a key component in the development of a mass visual culture in the United States. The crucial formative years were the quarter century before the Civil War, when new print technologies and new divisions of labor allowed pictures to be circulated within days of an event; when industrialized production of prints began to provide numbers sufficient for a mass market; and when expanded transportation and mail networks enabled these images to reach across the nation and beyond. In these changed circumstances, events construed as news helped to shape a mass audience, and that inchoate mass audience helped determine what sorts of recent events could viably be marketed as news.[1] Some of the most successful early news images resulted from collaborations between print publishers and newspapers. This essay highlights some landmark examples demonstrating the different forms that collaboration could take. The process of aligning press accounts of news events with their pictorial counterparts calls attention to the surprising amount of incongruity between them that evidently was tolerable at this early moment in mass visual culture.

The great New York fire of 1835

In mid-December of 1835, a massive fire burned much of lower Manhattan, destroying thirteen acres in the city's growing commercial district. There were few deaths, but nearly 700 buildings were destroyed. Firefighters were hampered by freezing cold: when they managed to break through the ice on the frozen river, the water only froze in their hoses.

The fire's catastrophic destruction had far-reaching ramifications for city politics and infrastructure, but also for the circulation of information. It galvanized the new penny press—the aggressive, inexpensive newspapers seeking to profit from democratizing newspaper readership—and it provided a compelling subject for printers working with new image technologies capable of producing large editions.

Newspaper reports and extra editions dedicated to the fire led to new circulation records—more than 50,000 copies for the *New York Sun*.[2] The *Sun's* leading rival, the *New York Herald*, took the occasion of the fire to introduce illustrations for the first time. Just a few days after the fire, it published a crude wood-engraving showing the shell of the Merchant's Exchange, a recently built marble structure that had been thought to be fireproof. The paper signaled to readers the importance of the picture by advising them "to preserve this paper among the archives of their family. Fifty thousand copies only are printed."[3]

Several print publishers also capitalized on the opportunity to get quickly to press scenes of the conflagration and the ruins it left. Henry R. Robinson, a publisher of lithographic political cartoons and caricatures, collaborated with the artist Alfred Hoffy and the printer John Bowen to bring out in mid-January a picture of the Merchant's Exchange and the buildings adjacent to it engulfed in flames (Fig. 2.6a).

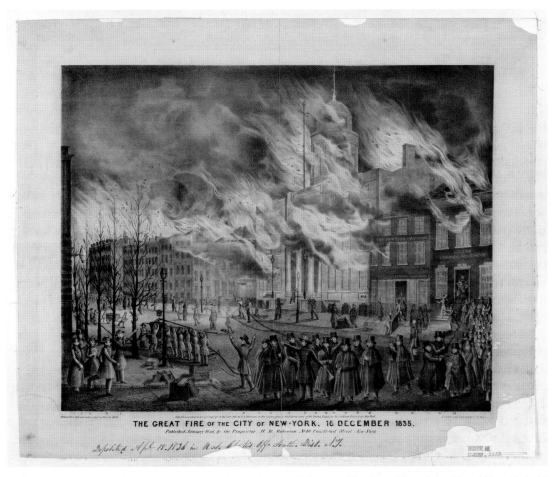

Figure 2.6a Henry R. Robinson, Alfred M. Hoffy, and John T. Bowen, *The Great Fire of the City of New York*, 16 December 1835, lithograph, 45 × 57 cm. From Library of Congress, Prints and Photographs Division, Washington, LC-DIG-pga–01587.

Although flames stream from windows and roofs, none of the buildings seem to be damaged yet, and fire hoses shoot water evidently without difficulty. The block of burning buildings serves as a backdrop for foreground activity: massed in the street, which recedes toward a vanishing point near the left edge of the picture, are fire-fighting companies, including various individuals facing outward—that is, looking away from the fire—as if posing for a group portrait. Numbers inscribed along the bottom edge of the picture correspond to a key identifying by name these figures "who rendered themselves conspicuous through their exertions in quelling the awful conflagration" and affirming that likenesses of all were taken from life. The foreground portraits make clear that acknowledging key individuals is as important here as recreating the sublime thrill of the spectacular flames, and both objectives overshadow conformity with the details of the story as told in the accompanying texts.

At least one job printer in lithographic publishing also saw the fire as an opportunity to add some original news images to his standard fare of commercial paperwork printed on commission. Nathaniel Currier had been operating his own printing shop for less than a year when he entered into a partnership in New York in 1834 and took over the business himself the next year. Of the eight original pictures he published in his first two years of business, three represented the 1835 fire. The first reportedly appeared for sale only four days after the fire—an astonishingly short time—and, like the *Herald's* illustration, which appeared simultaneously, it represented the shell of the Merchant's Exchange as the emblematic image of the devastation. The smoldering façade of the building, its side walls and cupola collapsed, was rendered by J. H. Bufford, printed by Currier, and published by John Disturnell. Undocumented legend holds that it sold thousands of copies and marked Currier as a rising force in the print world.[4]

By far the most dramatic scenes of the fire were two images done in a more traditional medium (aquatint), at larger scale, and more elaborately colored, and for these reasons likely more expensive, more limited in numbers, and slower to appear. Lewis P. Clover, a print publisher and owner of a framing and art supply shop in lower Manhattan, collaborated with painter Nicolino Calyo and engraver William James Bennett, a specialist in urban views, to produce a spectacular view of the fiery precinct as seen from the top of the Bank of America building and a dramatic view of the ruins receding into a great distance from Exchange Place. Hand-colored, like the lithographs produced by Currier and Robinson, these more lavish productions pose questions about the market appeal of these pictures. Would the audience for these more elegant prints of the devastating fire have framed and hung them as sublime spectacles of natural fury, akin to paintings such as J. M. W. Turner's recent *Burning of the Houses of Lords and Commons* (1834–5)? Would the cheaper, quicker, cruder prints that served primarily as visualizations of news have been considered disposable once the interest of the news had waned?

In mid-March a moving diorama of the fire opened at the American Museum and provided a spectacular visual narration of the fire from start to finish. The *Herald* published daily for a month an advertisement containing an illustration and a full description of the attraction.[5] It was already becoming clear that the symbiotic relationship between the penny press and most of the forms of mass visual culture was essential to the success of all parties.

The fire of 1835 was pictured in the full array of media that would form the first wave of mass-produced pictures in the period before mass reproducible photographs. The striking differences in materials, processes, physical textures, and overall impression of these early images—to say nothing of differences in quality of drawing and composition—may be obscured by the homogenizing classification "mass visual culture." While this classification is essential for marking the simultaneous emergence of diverse images and media seeking to appeal to a mass market, the differences among them reveal significantly varied pictorial strategies and different target audiences (i.e. different sectors of the population assumed to be central to the formation of a mass audience).

Picturing a sex murder

Just four months after the great fire, the murder in New York of a twenty-three-year-old courtesan named Helen Jewett filled the pages of the penny press. The coverage of this story is widely recognized as introducing the era of tabloid journalism in the United States, and the *Herald* in particular, under owner James Gordon Bennett, can claim much of the credit. It aggressively reported on the crime and the subsequent trial as part of a calculated strategy for selling papers.[6]

Jewett worked in an upscale brothel in the area now known as Tribeca. In the early morning hours of Sunday, 10 April, the proprietor of the brothel summoned some nearby watchmen to help her put out a fire in one of the rooms. When the smoke cleared, the body of Jewett was discovered in her bed, severely burned, and with her head bloody and battered. One of Jewett's preferred clients, Richard P. Robinson, was charged with the crime.

The *Herald* led the press coverage, describing the crime scene in lurid detail and eroticizing the grisly murder. It did not print illustrations, but once again publisher Henry R. Robinson (no relation to the murderer) teamed up with the artist Hoffy to seize the opportunity. For this event Robinson speeded up his production time to five days, publishing the first of three lithographs related to the crime on 15 April. All three lithographs by Robinson and two others by A. E. Baker (portraits of Jewett and Richard Robinson) were widely circulated—"put up at the windows of the print shops and hawked about the country by vagabond boys," in the angry words of the alleged murderer, who was interviewed following his acquittal. Asked if he had seen the lithographs, Robinson affirmed he had and volunteered that he resented the depictions of himself and Jewett. He was made to look idiotic and foolish, he said, and Jewett was unfairly portrayed as brazen.[7]

Henry Robinson's first and most important lithograph followed the Herald's coverage in eroticizing the victim (Fig. 2.6b). The print's caption claimed veracity: "a correct likeness and representation of this unfortunate female, taken on the spot very shortly after she had become the victim of a foul and barbarous murder and her bed clothes had been set fire to on the night of the 9th of April 1836, in New York." Although the bedclothes are decoratively tattered in what must be an attempt to reference the fire, they are not discolored, and Jewett's body, with legs and breasts exposed, is unmarred save for what may be a schematic linear gash in the hair above her ear. She appears to be peacefully sleeping, which may be what prompted the *Herald* to compare the print to the famous painting of *Ariadne Asleep on the Isle of Naxos* (1809–12, Pennsylvan Academy of Fine Arts [PAFA]) by John Vanderlyn. "An artist has taken a sketch of the beautiful form of Ellen Jewett, reposing in the embrace of death, like another Ariadne."[8] The salacious quality of the print was being tempered by comparison with an infamously risqué but categorically "fine art" nude. The *Sun* took a different view of the print: "It is sufficiently indecent to render it attractive to persons of depraved tastes, but as to being a likeness of Ellen Jewett, those who have seen her say that H. R. Robinson has murdered her far more barbarously than Richard P. Robinson did."[9]

The *Herald* demonstrated that mixing violence and salaciousness could be a potent strategy for marketing news, especially news pictures. But as the *Sun's* judgment suggests, this was a risky business. Robinson's lithograph of the dead Jewett tested the limits of what was acceptable at the time: it has been described as "one of the most suggestive popular prints of the early nineteenth century."[10] An influential early chronicler of American lithography, Harry T. Peters, described the Jewett print as pioneering—"the very first tabloid picture that I know of"—and he credited Robinson with revealing to Nathaniel Currier the great potential of lithography as a medium for popular art.[11]

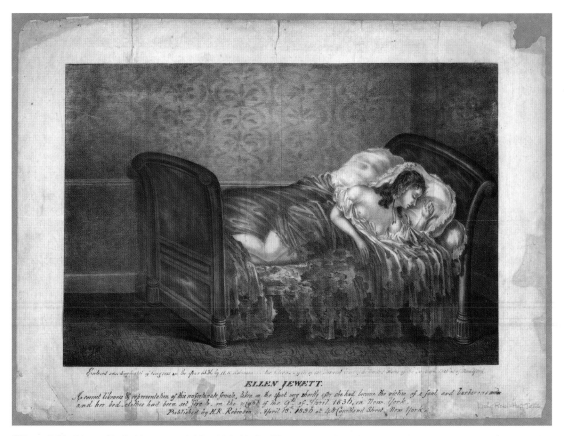

Figure 2.6b Henry R. Robinson and Alfred M. Hoffy, *Ellen Jewett*, hand-colored lithograph, 27 × 35 cm, 1836. Courtesy American Antiquarian Society.

Currier's awful conflagration

When another spectacular catastrophe occurred in New York in 1840, a lithographer and a penny press newspaper developed a new kind of collaboration to market pictures of it.

The paddlewheel steamship *Lexington* caught fire and sank in Long Island Sound on 13 January 1840. It had been built in 1835 by Cornelius Vanderbilt to be the finest and fastest vessel transporting passengers and cargo between New York and Boston. On 13 January it was en route from New York to Stonington, Connecticut, at night and in bad weather, carrying passengers and a load of cotton bales. When a fire broke out near the smokestack, the flammable cotton was quickly engulfed in flames. Lifeboats were launched prematurely and sank immediately in the wake of the ship. Many passengers were faced with the choice of burning to death on deck or jumping into the icy water. Of the roughly 150 people on board, only four survived, and they did so by clinging to flotsam or bales of cotton for hours until they were rescued or washed ashore.

The *New York Sun* broke the story with an extra edition published on 15 January. The next day it announced that it had commissioned an artist to produce "an accurate and elegantly executed

lithographic representation of the destruction of the steamer Lexington" that would be available by three o'clock that afternoon at the *Sun's* sales counter. Historians have long believed that the print produced so immediately was Nathaniel Currier's famous *Awful Conflagration of the Steam Boat Lexington*, but scrupulous research by James Brust and Wendy Shadwell has revealed a much more complicated story.[12] Although no copies of that first supplement to the extra edition have been located, a second state of that print survives in the collection of the New York Historical Society, and it differs considerably from the familiar Currier image. The composition is similar, but the scene is shown in daylight, is less dramatically presented, and is cruder. Authorship is not indicated, but captions state that the print is a *Sun* "extra" and that it was published at the *Sun* offices. This version was revised and republished three more times within a week, so we can infer it was selling briskly; the *Herald*, by contrast, published no pictures of the flaming, sinking ship. Nonetheless, on 23 January, the *Sun* offered an improved illustration: it announced that a new lithograph was being published that day "which will far surpass any thing of the kind yet presented. The plate represents the calamity as a night scene . . . and is executed with much more accuracy and finish than any others." This version added a map of Long Island Sound marking precisely the place where the tragedy occurred; and while it too bore the heading "The Extra Sun," the draftsman and printer, W. K. Hewitt and N. Currier, were credited explicitly. This version too was republished with revisions frequently over the next few days (Fig. 2.6c).

Five days after this second version's appearance, the *Sun* announced that between 12,000 and 13,000 copies of its lithographs had been sold and that the paper would be suspending sales in a few days. At that point, Currier's own shop evidently took over the distribution and marketing; he issued at least three more states of the print, indicating that its commercial success continued well after the *Sun's* involvement.

Whether Currier was responsible for the crude first version of the print is impossible to know, but he had collaborated with the *Sun* on another shipwreck image three years earlier.[13] The careful chronology assembled by Brust and Shadwell verifies the commercial success of the *Sun's* direct involvement in lithographic production, which represented a significant departure from its prior practice of merely criticizing, promoting, and commenting on the work of independent lithographers. At least eleven other lithographic portrayals of the Lexington disaster were published, but none achieved anything like the success of the collaboration between Currier and the *Sun*.

This collaboration did not point the way toward the future. Newspapers and lithographers would go separate ways when picturing news, even as the appetite for spectacle and sensation in news reporting grew. The *Herald's* strategy of including a wood engraving in the front page of its coverage of the 1835 New York fire forecast the coming of the illustrated newspaper, although the *Herald* itself never published enough images to be so classified. The revolutionary publication in this regard was English—the *Illustrated London News*, which included a wood-engraving of the city of Hamburg in flames on the cover of its first issue. Although the picture was copied from a print of Hamburg borrowed from the British Museum and overlayed with signs of a fire—smoke, flames, and onlookers—it initiated a form that would become dominant in illustrated news for decades.[14]

This brief survey of early picturings of news events for the mass market raises questions about their functions, their relations to textual accounts of the event, and the features that made them successful. The Merchant's Exchange as a burned-out shell was a salient visual fact of the 1835 fire, while the disfunction of firehoses in the cold apparently was not. A schematic rendering of a burned bedspread stood in for the violence suffered by a murdered prostitute, whose death was primarily an occasion for

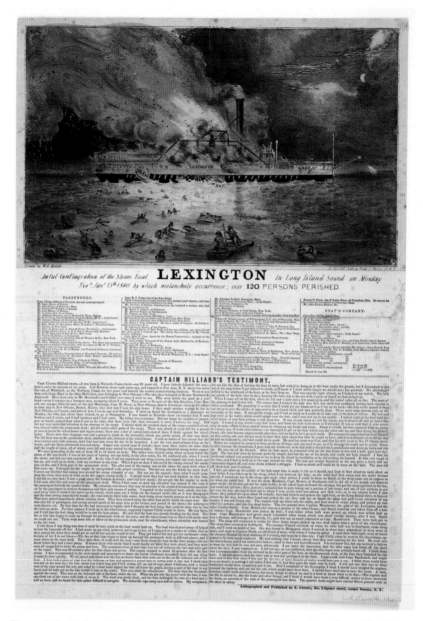

Figure 2.6c Nathaniel Currier and W. K. Hewitt, *The Awful Conflagration of the Steam Boat Lexington*, hand-colored lithograph, 36 × 47 cm, 1840. Courtesy American Antiquarian Society.

displaying an eroticized female body. A simplified imagining of the Lexington's demise as a daylight event (in the first highly popular visualization) was marketable even when accompanying text reports emphasized the darkness of night and the illumination from the flames. Early news pictures evidently were granted plenty of latitude in portraying recent events. They provided crude but concrete armatures fostering

desirable imaginary visualizations. In so doing, they helped order the disorderly stream of information generated in urban experience.

Notes

1 For earlier news images, see Peter Marzio, "Illustrated News in Early American Prints," in *American Printmaking Before 1876: Fact, Fiction, and Fantasy* (Washington, DC: Library of Congress, 1975): 53–60.

2 Frank M. O'Brien, *The Story of the Sun, New York, 1833–1928* (New York: Appleton, 1928): 60.

3 "The Merchant's Exchange," *New York Herald*, 21 December 1835: 1.

4 Russel Crouse, *Mr. Currier and Mr. Ives, A Note on Their Lives and Times* (Garden City, NY: Garden City Publishing, 1936): 5.

5 "New Grand Moving Diorama," *New York Herald*, 18 March 1836: 4.

6 Oliver Carlson, *The Man Who Made News: James Gordon Bennett* (New York: Duell, Sloan, Pearce, 1942): 143–67. John D. Stevens, *Sensationalism in the New York Press* (NY: Columbia University Press, 1991): 42–53.

7 The pamphlet containing the interview is quoted in Patricia Cine Cohen, *The Murder of Helen Jewett: The Life and Death of a Prostitute in Nineteenth-Century New York* (New York: Alfred A. Knopf, 1998): 273.

8 "A View of the Scene of Murder," *New York Herald*, 14 April 1836: 1; quoted in Cohen, *The Murder of Helen Jewett*: 269. The *Herald's* review of Robinson's other prints pertinent to the Jewett case, portraits of Jewett and R. Robinson, criticized them as "colored and lithographed with a good deal of impudence and pretension." See *Herald*, 1 June 1836: 1.

9 *New York Sun*, 21 April 1836: 1; quoted in Cohen, *The Murder of Helen Jewett*: 272.

10 Nancy R. Davison, "E. W. Clay: American Political Caricaturist of the Jacksonian Era," (Dissertation, University of Michigan, 1980): 168–9.

11 Harry T. Peters, *America On Stone* (Garden City, NY: Doubleday, Doran, 1931): 341.

12 James Brust and Wendy Shadwell, "The Many Versions and States of *The Awful Conflagration of the Steam Boat Lexington*," *Imprint* 15.2 (1990): 2–13.

13 Currier's *Dreadful Wreck of the Mexico* (1837) was not designated a news extra, but it was published by the *Sun* office under the paper's previous owner, Benjamin Day.

14 Leonard de Vries, *Panorama 1842–1865* (London: Murray, 1967): 9.

2.7
Beautiful Contradictions: News Pictures and Modern Magazines

Jordana Mendelson

Magazines tell their own stories. They are designed to do so. From their covers to their tables of contents, from their editorials to their staff, magazines are privileged objects within the history of modernism in that they display, as part of their appeal, the history of their manufacture. Magazines, like other serialized publications, reflect upon their own origin, purpose, distribution, and reception. It is often within (and through) a magazine itself that one garners the most information about its publication history. For magazines with limited print run, specialized content, or that originate in locations or at times that have not yet caught the attention of historians, it is too often only from within the magazine itself that scholars can reconstruct information about its history, including the work and lives of the writers or artists involved with its production. Most importantly, and perhaps counterintuitive to working with ephemeral mass culture, a close and sustained analysis of magazines brings forward issues that are both media-specific and of broad cultural interest. Since magazines are both self-referential and inter-textual objects, our knowledge about them depends on looking deeply within and across the archives in which they are conserved, as well as studying the cultural histories located beyond their binding. Thus, as a nexus for period-specific knowledge, magazines both illuminate and confound expectations, often within the same page and frequently across the same publication.

Recent scholarship about magazines has paid special attention to the undeniable and complex relationship between paginated content and advertising sections.[1] Publicity on billboards and posters, and advertisements on postcards and in magazines, forcefully occupied the public sphere. Especially in the early twentieth century, and with growing impact during the interwar period, artists and intellectuals were coming to recognize the insistent role that photography played in making the rhetoric of fantasy and persuasion visible.[2] From the turn-of-the century forward, there are examples aplenty of the productive dialog, manifest in print culture, between various serial forms of publication and the work of artists, both independent and commercial.[3] As numerous scholars have shown, the precincts of fine art and commercial design were inextricably bound during the early twentieth century.[4] The result of this particularly modernist synergy was loudly displayed in illustrated magazines.

What has been explored significantly less is the relationship within single magazines between two sides of the high modernist coin: the photographic advertisement and the news photograph. I want to

focus on the complex issues that arise when high gloss advertisement and cutting-edge photojournalism exist side-by-side. In this regard, it isn't a matter of merely considering advertising sections that were cordoned off from a magazine's intentional, editorial content, but rather taking into consideration those magazines in which the aesthetic that developed around advertising, and formed part of the early twentieth century's golden age of publicity, permeated publications to such a degree that the seemingly serious work of journalism and the capricious display of luxury were conflated.

During times of war, the juxtaposition of news photograph and advertisement gains troubling poignancy, as magazines then become platforms for the exhibition of war and commerce, photograph as testimony and fantasy. Magazines published during wartime face an additional challenge: to operate within established conventions while also providing an account of life at war and in the rear guard. How do magazines both feature and provide a context for the news photograph during war? How do magazines, with their heterogeneous content, frame news photographs so that they are legible to readers, normalized as an expected part of its content, yet at the same time exceptional in the information or emotion they seek to convey? One of the most startling examples of the incursion of the atrocities of war into the realm of the high glamour illustrated magazine was the publication of Lee Miller's experience as a front-line journalist and her accompanying photographs of war, and especially the Dachau concentration camp, in *Vogue*.

But, what of juxtapositions that are less startling, wartime content that is less shocking, and lesser known magazines and photographers? What do these examples tell us about the place of the news photograph in the illustrated magazine? And, what constitutes a news photograph when the definition of both "news" and "photograph" are themselves made the subject of a magazine's wartime content? Without the benefit of reader response or editorials published at the time on specific wartime content, how are scholars to understand the contamination of commerce with the news, and news with advertising? How are we to make sense of these aesthetic (and ethical) trespasses? These are troubling questions because they bracket off a discussion of the news photograph as unintelligible shock—a topic meditated upon by Roland Barthes and Susan Sontag most notably—and reintroduce issues around the potential beauty and consumption of banality during times of war, as framed and delivered within the pages of the illustrated press.[5]

A key arena in which to study the blurred lines distinguishing the news photograph as documentation or fabrication, and the relationship between news photograph and advertising, is the Spanish Civil War, in which hundreds of magazines and other serialized publications were available in the rear guard and the front. Of the many magazines representing trade unions, political parties, military units, women's organizations, and government agencies,[6] the three issues of the large-format illustrated magazine called *Nova Iberia* (New Iberia), published in multiple languages by the Comissariat de Propaganda of the Generalitat de Catalunya in Barcelona, provide an exceptional opportunity to study the different ways in which what constituted news was communicated through a range of photographic styles and subject matter that were solicited from a variety of international and Spanish authors. Most notable, and what sets *Nova Iberia* apart, are the ways the magazine modeled its presentation of wartime content after earlier large format illustrated magazines that were emblematic of the conspicuous modernity of graphic and industrial design in Spain, prior to the outbreak of the war. It is not that other wartime magazines did not evolve out of the rich design environment of the 1930s, or that there were not other popular magazines that featured both wartime news photographs and material from everyday life and culture, but, as a whole, *Nova Iberia* was the most declarative in setting itself up as a magazine-object, one that converted design, layout, and photographic content into a form of propaganda.

Nova Iberia inverted the hierarchy of importance given to different forms of photographic representation, and ultimately absorbed wartime news into a neutralized, safe environment of design and consumption

that, in defending progressive ideas about art, literature, and culture, became a powerful instrument of Republican propaganda as pictured through a decidedly Catalan lens. Before attending to the magazine itself, and one specific photographic image, let us consider the cultural history of the magazine's place within a broader framework of propaganda efforts in Barcelona during the Civil War, which will help illuminate how it became a nexus for the joining together of news and publicity, and explain, at least in part, its prominent position among wartime magazines.

The government agency that published *Nova Iberia*, the Comissariat de Propaganda of the Generalitat de Catalunya, was formed in October 1936 and led by a charismatic intellectual and political agitator named Jaume Miravitlles, who had been a childhood friend of Salvador Dalí, made an appearance in Dalí and Luis Buñuel's *Un chien andalou* (1929), and was in exile in France during the dictatorship of General Miguel Primo de Rivera (1923–30).[7] During the Second Republic, Miravitlles was a prominent organizer within Communist circles in Barcelona. When the military coup erupted in July 1936, he was on the executive committee for the People's Olympiad, which was to be held in Barcelona as a protest to Hitler's Olympics in Germany. During a short time span, Miravitlles transitioned from being a leader within the Leftist militias that emerged in Barcelona to defend the city against the coup to being appointed director of the Comissariat de Propaganda. Through his adroit leadership, Miravitlles put into place an efficient, well-organized propaganda agency that produced some of the most strident and visually arresting imagery of the war. Miravitlles was well connected with intellectuals and artists in Spain and abroad and he leveraged these contacts to assemble the city's most progressive designers in the fabrication of the Commissariat's propaganda.

Most relevant to a discussion of the place of the news photograph and publicity in *Nova Iberia* were the photographers who Miravitlles brought into the Comissariat's fold. While there may have been variability with regard to their political affiliations or their support of Miravitlles's political objectives, all of the photographers whose work appeared in the Comissariat's publications appear to have supported the same belief in photography as a necessary tool for the promotion of Catalonia as a symbol of modernity. Through the adoption of a photographic style that embraced close-ups, experimental angles, visual narratives, and front-line reporting, Miravitlles's publications showed the world (and Barcelona's own inhabitants) evidence of the city's progressive reforms, which ranged from the education and health of its children and elderly to the protection of its artistic, literary, and cultural patrimony. The photographers who contributed to the Comissariat's publications bear witness to the Comissariat's ability to fuse together the work of different photographers seamlessly into the government's wide array of illustrated books, periodicals, postcards, and posters. Whether from Barcelona (like Gabriel Casas and Agustí Centelles), or part of the international cohort (like Margaret Michaelis, Robert Capa, and David Seymour), all seemed to concur with a belief that photography was a necessary and instrumental part of the success of the Comissariat's propaganda campaign, a sentiment that was strongly, if paradoxically, expressed in what would become *Nova Iberia*'s final issue: "The quality of the photographs provides assurances that *Nova Iberia* will continue to surpass itself, just as it has been doing up till now with every number."[8]

One of the guiding forces behind the prominence of photography within the Comissariat's materials was undoubtedly its director of publications, Pere Català-Pic, who was one of the most widely published voices on photography in Spain prior to the war. His 1933 declaration in defense of new technologies and practices such as photomontage and research-based ideas about publicity was made with polemical force when it appeared as the lead article in the city's dominant amateur photography magazine *L'art de la llum*. In the years that followed, and throughout the Civil War, Català-Pic published numerous articles about his own photographic practice, innovations in the use of applied psychology in advertising, and

reviews of the work of various other European artists and photographers, including Man Ray and Henri Cartier-Bresson.[9] Though he only authored one poster during the war, it has become one of the most widely recognized and iconic, featuring a single foot, wearing an *alpargata* (a sandal worn in Catalonia) above a broken swastika and featuring, in some editions, the phrase in Catalan "Aixafem el feixisme," "Let's smash fascism" (Fig. 2.7a).[10]

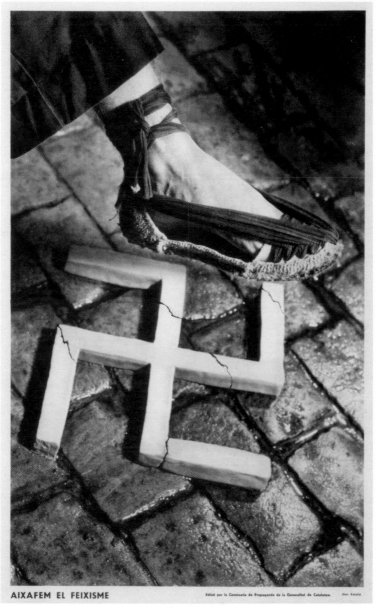

Figure 2.7a Pere Català-Pic, *Aixafem el feixisme*, 1936–7 (poster). Courtesy of the Tamiment Library and Wagner Labor Archives.

The poster epitomized Català-Pic's ideas about the power and efficiency of visual images to communicate complex ideas simply, across public space, and with great impact. If we understand this poster as representational of the Comissariat's goals in creating buzz-worthy propaganda, we begin to see how the agency was able to leverage the instability of photographs to communicate a direct wartime image (realistic, believable, and compelling) that was, at the same time, based on high modernist principles of design and publicity.

While reviewing the whole of the Comissariat's publications is valuable for gaining an overview of the importance of news photographs as propaganda, to understand the intentional force that came of bringing together the news photograph with the aesthetics of publicity during the war, one needs only to flip through the pages of *Nova Iberia*. The magazine prominently displays the wartime investment the Comissariat made in photography, offering a kind of micro-tribute to its prominence in Barcelona during the decade before the outbreak of the war. Even more, the issue transfers into a wartime context Català-Pic's high praise of Barcelona's ability to reach its peer cities in the production of well-designed illustrated magazines with exceptional photographic content. In "La fotografia i els bells magazines" (Photography and beautiful magazines) from 1935, Català-Pic highlights the importance of good photography as a mark of modernity and success for an illustrated magazine (and its originating city). After commenting upon a recent issue of the French review *Photographie*, he turns his attention to the Barcelona-based magazine *D'ací i d'allà*, "The publication of this trimester magazine, as much for its publicity as for its literary and artistic content, represents a joyful motif for us, given that it is the first of its kind in value and modernity to be edited in the Peninsula."[11] Throughout the remainder of his reflections on this magazine, Català-Pic returns over and over again to the importance of good photography, as both the foundation for a high quality magazine and as the stimulus for a receptive audience. Indeed, because *Nova Iberia* modeled itself after the highest profile popular interest magazine to be published in Barcelona prior to the war (*D'ací i d'allà*), it differentiated itself from other wartime propaganda magazines, which tended to use their visual content more prescriptively. By announcing itself as a quality magazine, with richly integrated photographs, typography, and articles written by leading intellectuals, *Nova Iberia* leveraged its similitude to other high profile international magazines to demonstrate that revolutionary Barcelona and the Leftist reforms of the Second Republic should not be feared as a threat to international order, but rather embraced as a defender of civilized culture. In this equation, photography and the aesthetics of publicity become the proof.

That *Nova Iberia* might be viewed as a wartime homage to *D'ací i d'allà*, and by association a monument in print to Barcelona's pre-war prestige as a haven for modernity in design, is abundantly clear after reviewing its photographic content, especially that of its second issue of February 1937. The issue deftly brings together some of the Comissariat's leading photographic contributors as well as key moments from the reforms in arts and letters during the Second Republic. But, what stands out, much more than the front-line photographs of bombed out buildings or the features on the treatment of the civilian population, is the final image of the issue: A photogram featuring diaphanous materials, pills spilled out from a glass tube, a perfume bottle, and cotton balls slightly pulled apart, appears with the caption (printed directly over the bottom left corner of the photogram) "War Gases and Peaceful Industries" (Fig. 2.7b).

It is this single image that serves as the issue's exclamation point, by turning a photographic technique used as a benchmark for avant-garde experimentation by Man Ray and Laszlo Moholy-Nagy, and later usurped by graphic designers in high-end publicity, into a public service announcement about the dangers of everyday materials in the confection of chemical warfare. More important still to the ways

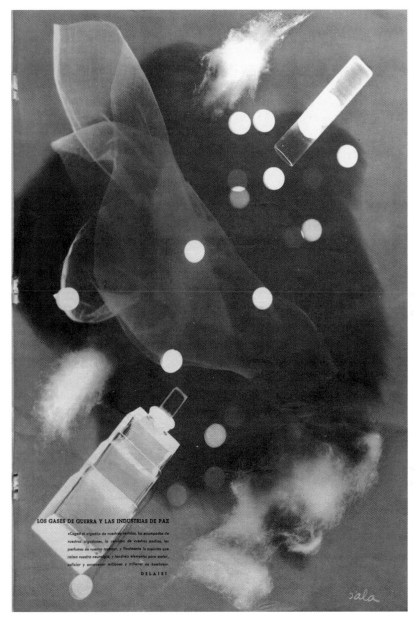

Figure 2.7b Josep Sala, photogram published in *Nova Iberia*, no. 2, 1937. Courtesy of the Tamiment Library and Wagner Labor Archives.

Nova Iberia inverted the relationship between news photograph and publicity is the fact that the author of the photogram was Josep Sala, one of the artistic directors for *D'ací i d'allà* and one of Barcelona's leading commercial photographers during the 1930s. Shocking at first, and seemingly out of place, Sala's elegant photogram is nonetheless both news photograph, because it announces the horrific use of chemical warfare, and retrospective homage, because it points back to Barcelona's heyday as a producer of luxury goods and high-end illustrated magazines.

The lesson learned about news photographs in magazines from this singular example is that, during the 1930s, as illustrated magazines were reaching a golden age and photojournalists were emerging as a new kind of professional image maker, there was still a great deal of productive instability. What may strike today's reader as anomalous or out of place, may instead be the photographic key to unlock the meaning and potential of photographic creativity during war, a creativity that relied upon intelligent (and sometimes irreverent) image makers like Pere Català-Pic, the photographers he employed, and the director of the propaganda agency they worked for.

Notes

1 Sean Latham and Robert Scholes, "The Rise of Periodical Studies," *PMLA* 121:2 (March 2006): 521.

2 On graphic design and advertising in the twentieth century see, Michele Bogart, *Artists, Advertising, and the Borders of Art* (Chicago: University of Chicago Press, 1997).

3 Kirk Varnedoe, *High and Low: Modern Art and Popular Culture* (New York: Museum of Modern Art, 1990) and Janine Mileaf, Christine Poggi, Matthew Mitkovsky, and Judith Brodie with Sarah Boxer, *Shock of the News* (Washington, DC: National Gallery of Art/Lund Humphries, 2012).

4 Elaine Lustig Cohen and Ellen Lupton, *Letters from the Avant-Garde: Modern Graphic Design* (Princeton, NJ: Princeton Architectural Press, 1996); Deborah Rothschild, Ellen Lupton, and Darra Goldstein, *Graphic Design in the Mechanical Age: Selections from the Merrill C. Berman Collection* (New Haven and London: Yale University Press, 1998).

5 Roland Barthes, "The Photographic Message (1961)," *Image Music Text*, transl. Stephen Heath (New York: The Noonday Press, 1988): 15–31; Susan Sontag, *Regarding the Pain of Others* (New York: Farrar, Straus and Giroux, 2003).

6 For a much more extensive treatment of the role of artists in Spanish civil war magazines, see Jordana Mendelson, *Revistas y Guerra 1936–1939/Magazines and War 1936–1939*, exh. cat. (Madrid: Museo Nacional Centro de Arte Reina Sofía, 2007); Jordana Mendelson, ed., *Magazines, Modernity and War* (Madrid: Museo Nacional Centro de Arte Reina Sofía, 2008); http://www.revistasyguerra.com.

7 For an excellent overview of Miravitlles' political writings and evolution, see: Enric Pujol, "Jaume Miravitlles and Marxism: a Twentieth-Century Voyage," *Journal of Catalan Intellectual History* 3 (2012): 29–45. On Miravitlles and the Commissariat, see: Rafael Pascuet and Enric Pujol, dir., *La Revolució del Bon Gust. Jaume Miravitlles i el Comissariat de Propaganda de la Generalitat de Catalunya (1936–1939)* (Barcelona: Viena Edicions, 2006).

8 Translations by the author unless otherwise indicated.

9 Jordana Mendelson, "Desire at the Kiosk: Publicity in Barcelona during the 1930s," *Catalan Review* (special issue on Barcelona and Modernity) XVIII: 1–2 (2004) [Pub. 2006]: 191–208.

10 Miriam Basilio, "Catalans! Catalonia! Catalan Nationalism and Spanish Civil War Propaganda Posters," in *Barcelona and Modernity: Picasso, Gaudí, Miró, Dalí* (New Haven: Yale University Press, 2006): 436–449.

11 Pere Catalá-Pic, "La fotografia i els bells magazines," *Mirador* (14 February 1935): 7.

2.8

"Public Forum of the Screen": Modernity, Mobility, and Debate at the Newsreel Cinema

Joseph Clark

In 1936, the *New Yorker* featured a cartoon by renowned illustrator Peter Arno depicting two well-heeled couples calling to their friends through the open window of a New York townhouse. The caption read: "Come along. We're going to the Trans-Lux to hiss Roosevelt."[1] The Trans-Lux was one of approximately thirty theaters in the United States exclusively dedicated to showing newsreels and other short films in the 1930s and 1940s.[2] These theaters were relatively small—usually fewer than 500 seats and sometimes as few as 100—and they offered a continuous program that allowed patrons to enter at any time. Typical programs ran for an hour or 90 minutes and included a selection of the "best of" the week's newsreels, as well as travelogues, comedy shorts, and cartoons. Introduced as a way of capitalizing on the burgeoning popularity of news films, these cinemas often featured architecture and interior design that emphasized the global reach of the news camera as well as the audience's shared modernity and common American identity. But as Arno's cartoon suggests, audiences regularly ruptured any apparent consensus: they hissed, booed, cheered, and applauded the newsreel. Despite—or perhaps because of—its emphasis on modernity and mobility, the newsreel cinema created a forum where audiences could engage with both the news and one another. Theaters such as the Trans-Lux were shared spaces in which audiences did not simply consume the news as an image on screen, but instead reveled in the collective experience of seeing and debating the news in public.

By the early 1930s, the Hollywood studio system had transformed the newsreel business and the experience of newsreel spectatorship. Once a patchwork of short-lived producers, independent companies, and local reels, by 1931 most cinemas in the United States screened newsreels from one of Pathé, Fox, Paramount, Universal, or MGM/Hearst.[3] Although punctuated by dramatic and sensational news stories, the studio newsreel system's efficiency was premised on centralization and standardization—a Fordist model of production that turned to human-interest stories, sports, and public ceremonies such as parades, to provide predictable and visually compelling content. This mode of production was reflected in the format of the newsreel itself. Unrelated items followed one another without narrative or logical connection, organized instead as a continuous procession of the news, stressing predictability and regularity.[4] It is no coincidence that both Hollywood studios and the trade

press referred to the newsreel as a news parade.[5] The processional mode of the news parade addressed its spectator as part of a virtual crowd watching as the world passed by on the screen. Moreover, the newsreel's frequent portrayal of real crowds attending parades, rallies, and sporting events, linked the spectator in the theater to the masses represented in the films. By encouraging audiences to identify with these onscreen crowds, the newsreel offered them a sense of shared identity as well as a privileged vantage point from which to watch the world. The crowd, once identified with the visual spectacles of the street, now became a global and technologically enhanced spectator position mediated through the screen.[6] The newsreel brought exotic images from distant places to the local theater. Close-ups and multiple camera angles allowed audiences to get closer and to see more of the news than ever before, while still holding it at a safe distance. In doing so, the newsreel elevated the pleasure and privilege of watching the news over the news itself.

The newsreel cinemas of the 1930s offer unique insight into how audiences took up the privileges of looking on offer in the news parade. Much of the scholarship on the newsreel in the United States and elsewhere has emphasized its consensus-building role and even its uses in propaganda before and during World War II.[7] No doubt the news parade and its focus on the crowd helped build a shared sense of identity for spectators, but vocal newsreel audiences show that viewers refused to sit and watch passively. Like the newsreels themselves, news theaters framed the viewing experience within discourses of technology, transportation, and globalized vision, using architecture and design to highlight the audience's power to see the world in new ways. Moreover, while unruly audiences alarmed the studios and others, the newsreel cinemas embraced audience debate and controversy as part of the show. For these cinemas and their audiences, the theatrical space was not just a place to see the newsreel but served as a public forum where viewers could engage with the world and each other. The well-to-do New Yorkers of Arno's cartoon didn't go to the Trans-Lux to see Roosevelt, they went to hiss him.

Primarily located in the busy downtown areas of major cities, usually close to entertainment, shopping, and transit hubs, newsreel theaters were the product of modern urban life as well as symbols of modernity itself. Unlike the elaborate grandeur of movie palaces, Trans-Lux theaters offered an efficient movie-going experience, designed for the pace of the modern city and to be easily accommodated between appointments. Minimal staff, small theaters, and the continuous newsreel program created a sense that the Trans-Lux was a kind of automatic cinema; one observer called it a "coin-in-the-slot newsreel theatre."[8] Trans-Lux adopted architectural elements in each of its cinemas that spoke to the newsreel's place in the technologically advanced city. Designed by Thomas W. Lamb, the chain's theaters were a distinctive blend of Art Deco and the more populist Streamline Moderne aesthetic. By incorporating machine-age materials such as aluminum and black vitrolite (a type of opaque glass) into signage and exterior facades, Lamb created a "Trans-Lux look" that made the company's theaters instantly recognizable (Fig. 2.8a).[9] Together, streamlined design, technological innovation, and a new kind of movie experience reinforced Trans-Lux's slogan and reputation as "The Modern Theatre."[10]

Along with the discourse of modernity, strong associations with speed and travel offered audiences at the Trans-Lux and other newsreel cinemas a privileged view of the news. For many newsreel audiences, the trip to the newsreel theater started in a train station. Newsreel cinemas opened in Cincinnati's Union Station in 1933, Boston's South Station in 1936, New York's Grand Central Station in 1937, and across the street from Pennsylvania Station in 1938. News film exhibitors also drew on long-standing associations between film and transportation to stress the mobility as well as the modernity of the newsreel spectator.[11]

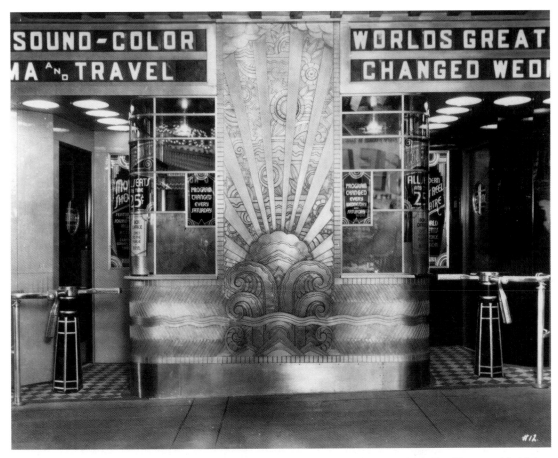

Figure 2.8a Façade of Trans-Lux Twin Cinema at Broadway and 49th Street, New York City. Photographic History Collection, National Museum of American History, Smithsonian Institution, catalog number 88.74.4.

The regular addition of travelogues to newsreel theater programs as well as the global reach of the newsreel itself gave audiences a chance to travel the world virtually. While the newsreels ostensibly focused on current events, they also included frankly ethnographic stories on exotic festivals and customs in addition to more timely news items from its cameraman around the world. Images of globes, maps, zeppelins, airplanes, and trains dominated the promotional materials for the newsreel and were regularly incorporated into murals and other design elements within newsreel theaters. California architect S. Charles Lee's proposed Town Theatre took these motifs to new heights with a massive globe dominating the building's exterior (Fig. 2.8b).

Echoing the monumentality of the *Perisphere* of the 1939 World's Fair in New York—itself a machine for looking—Lee's design simultaneously emphasized the enormity of the world, the power of the newsreel to represent it, and the privileged position of the American spectator to see it all. This imagery, along with slogans like the Newsreel Theatre's "World around, in sight and sound," helped to reinforce the link between modern technologies of transportation and a new privileged mode of vision.[12]

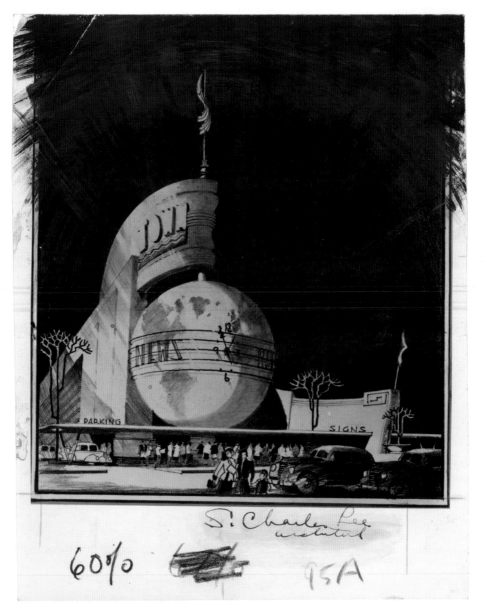

Figure 2.8b Sketch for proposed newsreel theater, by architect S. Charles Lee. S. Charles Lee Papers, Collection 1384, *Library Special Collections*, Charles E. Young Research Library, University of California, Los Angeles.

While the architecture and design of newsreel cinemas served to emphasize the modernity and global vision of newsreel spectatorship, it is only by looking at what Miriam Hansen calls the "public dimension of cinematic reception" that we can understand the ways in which audiences took up this privileged position.[13] When audiences booed or cheered the images on screen, they demonstrated that the shared experience of newsreel spectatorship was not simply an occasion to watch the world from their seats.

The technologically enhanced global spectatorship on offer in the newsreel may have invited audiences to join a virtual crowd, but the responses of viewers in the theater remind us that real crowds saw the newsreel, and that their experience was local and particular. These vocal audiences transformed the theatrical space into a kind of public forum where audiences could respond to the news. Lively audiences were by no means unique to the newsreel theater, but they took on special meaning in this context; both because of the newsreel's reference to real world events and politics, but also because audiences used the newsreel as an opportunity to engage with one another as well as the film.[14] Moreover, while film studios and conventional theater managers worried about such responses, the newsreel theaters embraced controversy and debate.

Booing and jeering at the newsreel in the 1930s was frequent enough to warrant comment in the press. Foreign leaders such as Mussolini and Hitler were by far the most popular targets for the so-called boo birds, but they voiced their displeasure with various American politicians as well. Unsurprisingly, election campaigns sparked particularly partisan expressions.[15] Such was the frequency of this opinionated interjection that journalists sometimes turned to the newsreel audience as a kind of microcosm of public opinion. *Washington Post* columnist Alice Hughes described going to the newsreel theater "whenever in doubt as to how the public [felt] about this or that."[16] Noting how responses to politicians changed over time or by neighborhood, Hughes drives home the specificity of newsreel reactions. While Roosevelt was hissed on the Upper East Side, he was cheered across town.[17] The newsreel may have offered the spectator a privileged position from which to view the news, but this by no means created consensus.

A 1941 audio recording of a Radio City Music Hall audience watching *The March of Time* short news film "Peace by Hitler" testifies to the ways in which audiences used the shared space of the theater to engage with one another as well as the news itself.[18] The film, which detailed the various broken promises of Hitler in the run-up to the war in Europe, elicited ironic laughter at the transparency of German propaganda and applause as it highlighted British defense efforts and the arrival of American aid. The audience's reaction was more complicated when the film turned to the issue of American war preparations and the isolationist stance of people such as Charles Lindbergh. At this point, boos and applause competed with one another, as the audience apparently divided over the question of US participation in the war. Crucially, the timing of the responses suggests that people were not just reacting to the images on screen, but to one another. It was not Lindbergh who was jeered, but the other patrons who had applauded him. The recording reveals factions of the audience clearly engaging with each other. While the newsreel invited its audience to join the virtual crowd of the news parade, audiences like this one were apparently just as interested in the real crowd in the theater with them.

Not everyone embraced these lively newsreel audiences. As early as 1931, Fox sent an order to managers of its theaters instructing them to censor controversial subject matter in the newsreels, insisting that it was their "business to show entertainment—and nothing else but entertainment" and that managers should ensure "nothing is presented to [their] audiences that [could] in any manner cause demonstrations or irritation inside of [their] theatres."[19] The memo specifically mentioned instances where various personalities had been both booed and applauded by audiences, arguing vehemently against encouraging such behavior. Others questioned the propriety of audience dissent. Theater managers, newspaper columnists, and letter writers complained about the booing of presidential candidates in particular, calling it disrespectful and in one case "un-American."[20]

In stark contrast to these denunciations, the managers and owners of several newsreel theaters embraced debate. Courtland Smith, head of the Trans-Lux theater chain, and one-time newsreel editor

for both Fox and Pathé, told reporters he believed the American public was interested in controversy and he regularly visited theaters to gauge the audience's reactions to specific stories and personalities.[21] French Githens, president of the Newsreel Theatres chain, was emphatic about the policy of his theaters:

> We will show without fear or favor news which comes to us from any recognized American producer, no matter how controversial the subject matter may be. We show all the news impartially, take no sides and play no favorites. In short, our embassy newsreel theatres are the public forums of the screen.[22]

Unlike traditional movie theaters, where the newsreel was a footnote to the main program, newsreel houses relied on the news—and on the controversies it could ignite—to attract their audience. While Fox managers worried newsreel subjects might be "too interesting," Githens understood that controversy and debate were central to the newsreel's appeal and, invoking Adolph S. Ochs, aligned the newsreel cinema with the putative impartiality of the *New York Times*. Conventional exhibitors saw their theaters as offering an escape from the world and naturally worried that when audiences reacted negatively to controversial subjects, they adulterated that fantasy with the real world of politics. Githens recognized that the newsreel theater was different. Rather than offering an escape from the world, the newsreel theater constituted a "public forum of the screen."

As a public forum, the newsreel theater did not simply package the news for its audience to consume passively. Audiences consumed and contested their position as spectators by interacting with the images on screen as well as other theater-goers. The newsreel was neither a simple instrument of propaganda nor a manufacturer of consensus. Instead, newsreel audiences felt fully able to watch the news and voice their opinions about it. These responses remind us that, despite the global vision and shared identity of the virtual crowd on offer in the newsreel, the shared public dimension of newsreel reception was distinctly local and transpired in actual spaces. As a public forum of the screen, the newsreel cinema reflected a tension between competing notions of news consumption, between the mass-mediated crowd of the news parade and the vocal debates of the actual crowd in the theater.

Notes

1 Peter Arno, "Come Along, We're Going to the Trans-Lux to Hiss Roosevelt," *New Yorker*, 19 September 1936: 16.

2 "War News Brings Boom to Newsreel Theatres," *Motion Picture Herald*, 24 January 1942: 21.

3 Raymond Fielding, *The American Newsreel, 1911–1967* (Norman: University of Oklahoma Press, 1972): 132.

4 In this respect, the newsreel resembled less the "disorganization" of the printed newspaper described by Richard Terdiman and more the variety of Tom Gunning's "cinema of attractions" and the "flow" of television broadcast described by Raymond Williams. Cf. Tom Gunning, "The Cinema of Attractions: Early Film, Its Spectator and the Avant-Garde," in Thomas Elsaesser, ed., *Early Cinema: Space, Frame, Narrative* (London: BFI, 1990); Raymond Williams, *Television: Technology and Cultural Form*, Routledge Classics (New York: Routledge, 2003); Richard Terdiman, *Discourse/counter-Discourse: The Theory and Practice of Symbolic Resistance in Nineteenth-Century France* (Ithaca, NY: Cornell University Press, 1985).

5 "The Newsreel Parade," *Motion Picture Daily*, 15 September 1937: 3. *Hearst Metrotone News*, Synopsis sheet, 6.226, 1934, in Hearst Metrotone News Collection, UCLA Film and Television Archive, Los Angeles, CA.

6 On the crowd, visual culture, and the street see Vanessa Schwartz, *Spectacular Realities: Early Mass Culture in Fin-de-Siècle Paris* (Berkeley: University of California Press, 1998); Lauren Rabinovitz, *For the Love of Pleasure:*

Women, Movies and Culture in Turn-of-the-Century Chicago (New Brunswick, NJ: Rutgers University Press, 1998).

7 Richard M. Barsam, *Nonfiction Film: A Critical History*, vol. revised edn (Bloomington: Indiana University Press, 1992); Raymond Fielding, *The American Newsreel, 1911–1967* (Norman: University of Oklahoma Press, 1972); Sumiko Higashi, "Melodrama, Realism, and Race: World War II Newsreels and Propaganda Film," *Cinema Journal* 37, 3 (1998): 38–61; Luke McKernan, *Yesterday's News: The British Cinema Newsreel Reader* (British Universities Film & Video Council, 2002).

8 Terry Ramsaye, "The Short Picture—Cocktail of the Program," *Motion Picture Herald*, 14 March 1931: 59.

9 James L. Holton, "Trans-Lux to Move Its Theatre Block North on Madison Ave.," *New York World-Telegram*, 7 September 1933.

10 Trans-Lux Movies Corporation, "The Modern Theatre," Promotional brochure in clipping file, Theatres: US: NY: Trans-Lux, Billy Rose Theater Collection, New York Public Library.

11 See Jennifer Lynn Peterson, *Education in the School of Dreams: Travelogues and Early Nonfiction Film* (Durham, NC: Duke University Press, 2013); Lauren Rabinovitz, *For the Love of Pleasure: Women, Movies and Culture in Turn-of-the-Century Chicago* (New Brunswick, NJ: Rutgers University Press, 1998); Wolfgang Schivelbusch, *The Railway Journey: Trains and Travel in the 19th Century* (Oxford: Basil Blackwell, 1979).

12 Promotional Pamphlet in clipping file, Theatres: US: NY: Newsreel Theatres Inc, Billy Rose Theater Collection, New York Public Library.

13 Miriam Hansen, *Babel and Babylon: Spectatorship in American Silent Film* (Cambridge, MA: Harvard University Press, 1991): 7.

14 On the lively film audience see Janet Staiger, *Perverse Spectators: The Practices of Film Reception* (New York: NYU Press, 2000); Melvyn Stokes and Richard Maltby, *Hollywood Spectatorship: Changing Perceptions of Cinema Audiences* (London: British Film Institute, 2001); Richard Maltby, Melvyn Stokes, and Robert C. Allen, *Going to the Movies: Hollywood and the Social Experience of Cinema* (Exeter: University of Exeter Press, 2007); Kathryn H. Fuller-Seeley, *Hollywood in the Neighborhood: Historical Case Studies of Local Moviegoing* (Berkeley: University of California Press, 2008).

15 "Fox Warns Mgrs to Keep an Eagle Eye on Newsreels," *Motion Picture Herald*, 7 March 1931: 54; "Movie Audiences Cool to Walker," *New York Times*, 12 September 1932: 2; "War News Films Stir No Demonstrations, But Applause and Hisses Greet Some Pictures," *New York Times*, 4 September 1939: 12; Jimmy Fiddler, "On Hollywood: 10 Best in Newsreels," *The Washington Post*, 3 February 1937:11; Alice Hughes, "A Woman's New York," *Washington Post*, 10 July 1937: 12; Arthur Krock, "The Paramount Issue: Roosevelt," *New York Times*, 4 October 1936, SM1; H. I. Phillips, "The Once Over: Interview with a Hisser," *Washington Post*, 29 August 1936, X7 15.

16 Hughes, "A Woman's New York," *Washington Post*, 10 July 1937: 12.

17 Hughes, "A Woman's New York," *Washington Post*, 10 July 1937: 12.

18 Audience Reaction to "Peace by Hitler," *March of Time*, 7.13, recorded at Radio City Music Hall, 13 August 1941. In Jack Glenn Papers, Collection 9059, American Heritage Center, University of Wyoming.

19 "Fox Warns Mgrs to Keep an Eagle Eye on Newsreels," *Motion Picture Herald*, 7 March 1931: 54.

20 Fiddler, "In Hollywood: 10 Best in Newsreels," *Washington Post*, 3 February 1937: 11.

21 Lucius Beebe, "The Man Who Edits the News Reels," *New York Herald Tribune*, 24 June 1934; Creighton Peet, "Trans-Lux," *Outlook and Independent*, 25 March 1931.

22 "Githens Takes Charge of Newsreel Theatres," *Motion Picture Herald*, 31 August 1935: 41.

2.9

"See it Now": Television News

Mike Conway

University of Miami Radio and Television Professor Sidney Head issued a harsh warning in a study of local television news in 1950. In a year when television set ownership in the United States would jump from 9 to 23 percent, Head could see lack of advertiser interest stifling television news: "Unless the industry itself can anticipate and forestall this kind of thing, television may end up in a degree of sterility and pussy-footing juvenility that will make the motion pictures and radio seem like dynamic, challenging media of adult communication in comparison."[1]

The potential of television as a news and information medium had been trumpeted for decades before the public started watching. Broadcasting enthusiast Orrin Dunlap echoed a common prediction: "television promises to put the globe in the palm of everyone's hand, so that the eye may look around the sphere as if it were an orange. Nations shall look in upon nations . . . the world enters the home as an animated panorama."[2] But, as with the promise of all new media and technologies, television (and television news) turned out to be more complicated and contested. The potential and reality of the use of news pictures in television news can be best illuminated by concentrating on the "early history,"[3] the period in the development of a technology that is critical for understanding its eventual use, a period when patterns of existing technology and media are "reexamined, challenged, and defended."[4] Technological limitation is often offered as the villain for the absence of effective television news pictures in the early years, given the cost and complexities of providing live pictures or motion picture film of events in the 1940s and 1950s.[5] But the stronger constraints on television news in the United States stemmed from the twin shackles of television's economic model and the print culture that dominated journalism.[6] In most cases, programs and efforts that effectively used visuals for news and public affairs were freed from at least one of these entanglements by securing a budget beyond what advertisers would pay or entrusting a program to people with visual acumen.

Television's fate was determined well before the public started watching. Commercial interests in radio beat back any attempts at media reform in the 1920s and 1930s, equating commercial media with democracy itself. Then, those same companies defined television as a logical extension of radio, once again quashing any hope for a different economic model for the medium. Using the basic argument of capitalism, competition for listeners and viewers would result in quality programing, in a much more effective way than by relying on the government or a tax (such as the system used to fund the British Broadcasting Company) to fund news coverage.[7]

The government nevertheless played a major role in broadcasting, mainly because of the limited number of broadcast licenses. The Federal Communication Commission expected radio and television

stations to provide news and public affairs programing in exchange for the profitable broadcast licenses. In general though, the government only considered the amount of news and public affairs programming, not its quality. In theory, competition should reward the higher quality news programs with a larger audience, drawing more advertising money. Decades later, John McManus systematically took apart that idea in his book *Market-Driven Journalism*, positing that, instead of higher quality, television news departments presented "the least expensive mix of content that protects the interests of sponsors and investors while garnering the largest audience advertisers will pay to reach."[8]

Journalism's quest for professional status, and newspapers' response to competition, also hampered the effective use of news pictures. In the first half of the twentieth century, many print journalists and publishers tried to stifle radio competition by insisting that real news was words on paper and not voices in the air. The written word was positioned as fact, while a radio newscast was ephemera. In the area of images, still photography was slowly accepted to a degree in print journalism, but moving pictures were equated with show business. During World War II, print journalists began slowly to acknowledge some radio news people, especially the famous war correspondents including Edward R. Murrow. But in the era before recorded interviews and sounds became standard, the practice, if not writing style, of radio news was quite similar to print journalism, with the written document simply read into a microphone instead of printed on paper. Radio journalists tended to identify with their print brethren and shun those working in television.[9]

Television news emerged with funding issues and few staff members equipped with an understanding of visual communication. As National Broadcasting Company (NBC) television news pioneer Reuven Frank put it simply, television news brought together some "picture people" who understood images, but mostly "word people" who came out of print journalism or radio. "Word people always win," insisted Frank, "because word people are always in charge."[10]

The visualization of news on television also had to overcome the comparison to the oft-criticized Hollywood newsreels. Journalists and media critics had long complained about these staples of the movie-going experience, kept bland and non-controversial on purpose by the movie studios that believed their audiences did not pay to see depressing news. The newsreel format itself was also constraining, a series of edited films of various events with an unseen announcer adding information and commentary, allowing no room for stories not easily captured on film (Fig. 2.9a).[11]

One of the most inventive approaches to visualizing the news in early television had little in common with newsreels, mainly because the staff did not have access to timely news film. The Columbia Broadcasting System, CBS, launched a daily news effort at the start of commercial television in 1941 at its New York City station. For the first years, the station had few sponsors and the radio journalists were either covering World War II or not interested in television. So the news was produced and presented by a small group of people with disparate backgrounds, including several with still or moving picture experience.

For the CBS television crew, the lack of resources and oversight sparked creativity. They did not have access to a live remote camera and did not even have a dedicated field cameraperson or reporter. Instead, the staff concentrated on visualizing the news through maps, cartoons, artwork, animated graphics, props, in-studio interviews, and occasional timely news film. Since they had limited staff and resources, they considered their niche as presenting a visual guide to the top stories, providing another way for the audience to learn about important issues. Unlike the newsreels or a radio newscast, the CBS television crew considered each story as a separate communication opportunity. Their work resulted in the television newscast format that survives to this day, with each story considered for its unique visual, and auditory, characteristics (Fig. 2.9a).[12]

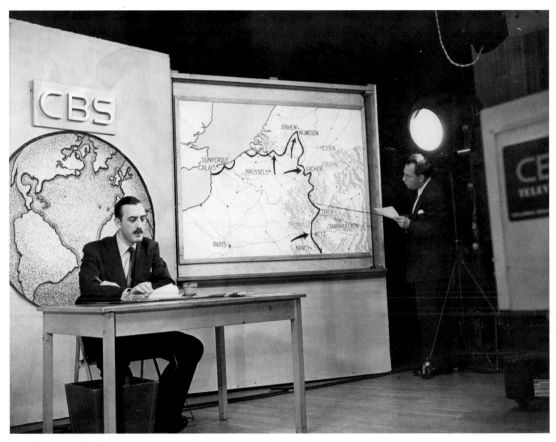

Figure 2.9a CBS television newscast on WCBW in New York City 1944. Newscaster Everett Holles reads latest World War II news while camera focuses on map of a battle front. Producer Henry Cassirer stands off camera, using pointer to help viewers follow the action. The Dolph Briscoe Center for American History, The University of Texas at Austin.

Few members of the early CBS television news staff considered themselves journalists. The person in charge of the CBS television newscast for a few years in the 1940s was documentary filmmaker Leo Hurwitz. Hurwitz had embraced documentary film in the 1930s as a way to communicate the struggles of the working class in the United States, a group ignored in American newsreels because of what he called "rigid censorship" and "malicious distortion."[13] While Hurwitz did not push his revolutionary film ideas during his years at CBS television, he certainly did not fit the role of journalism professional. Chester Burger said one of his first assignments at CBS from Hurwitz was to work with a cameraman on a photo essay on a New York subway line. Hurwitz expected Burger to have an understanding of how to communicate a story visually.[14] The CBS news staff did not shy away from topics that were difficult to present as television stories. In fact, Chester Burger's first job title was "Visualizer," and it was his responsibility each day to figure out how to visually communicate top stories from around the world. In his resignation letter to the staff in 1946, Hurwitz's expressed aspiration for CBS television news was not

to match print or radio journalism icons such as the *New York Times, LIFE* magazine, or even CBS radio news. Instead, he hoped the newscast would one day be comparable to Roberto Rossellini's 1945 Italian neo-realism movie, *The Open City*.[15] In the case of CBS television news in the mid-1940s, the lack of resources sparked creativity and the absence of a manager constrained by a print journalism background allowed the staff to explore television's communication potential (Fig. 2.9b).

The CBS television news crew began to lose its autonomy in the late 1940s when advertisers became interested in the medium and network managers took control of the news effort. The crew had created incredibly complicated visual strategies to cover the news, but CBS at that time would not invest in the film crews necessary to cover national and international stories. At NBC, Camel cigarettes made a major investment in television news by sponsoring the nightly newscast, *The Camel News Caravan*. Camel's money allowed NBC to set up a network of film crews as well as agreements with newsreels around the world. But by the mid-1950s, NBC began to scale back its operation because the advertising revenue did not match the expenditures.[16]

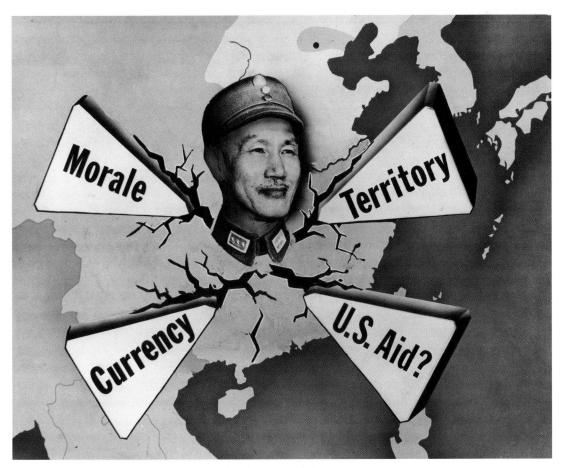

Figure 2.9b 1940s-era CBS television news artwork for story on Chiang Kai-shek during Chinese civil war. The Dolph Briscoe Center for American History, The University of Texas at Austin.

A handful of local stations in the late 1940s believed in the visual potential of television news. Those stations attempted to recreate the national newsreels in their own communities, using the format of a series of filmed events guided by an unseen narrator. The most impressive local news effort happened in New York City, where the tabloid New York *Daily News* launched a station in 1948. The paper with the masthead slogan "New York's Picture Newspaper" took the same approach to television, from the call letters, WPIX, to its news investment. The company spent a half-million dollars on news in the first year, more than many stations spent on entire operations. WPIX boasted ten cameramen in New York and Washington, two planes, remote cameras for live shots, and film processing equipment to quickly get images on the air. The station produced two daily newsreels, *The TelePIX Newsreel*, and promised its viewers it would be "First on Scene, First on Screen." The station is even credited with starting a television cliché when it enticed viewers to stay up for the late news by repeatedly promising "film at eleven."[17]

WPIX was one of the first true local television news efforts in the United States. Advertising dollars alone could not support this highly visualized news effort so the station syndicated its newsreels to other stations for extra money. Only eight months after *TelePIX Newsreel* debuted, WPIX canceled its syndicated effort and laid off twenty-eight of the thirty-seven people working in the newsreel operations, citing a lack of stations willing to pay for the newsreel service.[18]

WPIX was the exception in early television news. As the 1950 local news study revealed, 75 percent of the stations did not assign anyone solely to television news, and roughly that same percentage said local coverage was lacking at their station. The cheapest and most popular format included a person sitting behind the desk reading stories into a camera with still photographs supplied by a wire service. Stations also fulfilled their news obligation with syndicated national newsreels. The study made it clear that, by 1950, the key to effective television news was obvious, but not realized: "Pictorialization of news events instantaneously or within a few hours after they occur seems to be the solution to the problem. Because most stations do not consider the value of a good news show worth the cost of production, the programs will continue to suffer."[19]

Given the economic realities, it is not surprising that one of the most honored and respected news programs from the 1950s did not have to worry about budgetary constraints. In 1951, a decade after the start of commercial television in the United States, CBS finally convinced famous radio journalist Edward R. Murrow to move into television, a medium he had often criticized over the previous decade. Along with co-producer Fred Friendly, Murrow created *See It Now*, a weekly television public affairs programs based on their radio program, *Hear It Now*.[20] Because of Murrow's stature, *See It Now* had an unlimited budget and little management oversight. The Aluminum Company of America (Alcoa) sponsored *See It Now* in the early years, but CBS still had to fund up to "several thousand" dollars each week to supplement the advertiser money.[21] That one weekly public affairs program regularly spent more money per week than the rest of the CBS television news department.

See it Now also succeeded as a visual news program because Murrow and Friendly had the humility to admit they did not understand pictures. Instead, they turned to veterans from Hearst's *News of the Day* newsreel operation to film and edit their stories. In addition, they hired a documentary veteran, Palmer Williams, for guidance on how to visualize their stories. Bringing together experienced media professionals from all of the main formats of the era and eliminating budget constraints, Murrow's *See It Now* program was able to experiment with new ways to visualize the news, including heavy use of live cameras, filmed interviews, and sound and image sequences from around the world.

Murrow and Friendly insisted their crews record synchronous sound on all of their filmed stories, which forced the staff to drag the mostly immobile 35mm cameras and audio equipment around the

world, including to the mountains of Korea. The *See It Now* insistence on on-location sound instead of music or sound effects came years before the lighter, more mobile camera equipment ushered in the direct cinema movement. The newsreel and documentary film veterans contributed the idea of pictorial continuity, a style perfected by the Hollywood studios for fiction films, which included shooting stories in a series of individual shots that could be edited together to tell a visual story. Pictorial continuity worked well for the "people" and "little picture" stories that Murrow and Friendly preferred, especially when covering war. But this style of reporting was expensive. For one hour-long holiday program, *See It Now* sent 15 people to cover Christmas with the American troops during the Korean War.[22]

Only six months into *See It Now*, Murrow realized the advertiser-funded model would not provide quality television news: "To assume that the total sum expended should be precisely what sponsors are willing to pay is not sound operation. The broadcasters who will obtain circulation with their television news programs will be those who are willing to invest over and above the income derived from sponsors."[23]

Journalism's distrust of visuals, as well as the advertiser-funded model of news, continued to have a heavy influence on television news well past the medium's "early history." As late as 1963, when more than nine out of ten American homes had a television and the public had already pushed aside newspapers for television as their most popular format for news, NBC's Reuven Frank, who ran *The Huntley Brinkley Report*, wrote a memo, which became known as "the bible" and was a touchstone for a generation of television journalists, explaining how television was best as a transmitter of experience by taking the viewer to the scene of the important stories.[24]

Later that year, television transmitted an experience so traumatic and cathartic in the United States that even those who had dismissed the medium had to admit its influence. In November 1963, American television reported on the assassination and funeral of President John F. Kennedy. For four days, the networks canceled commercials and regular programing, presenting hours of live pictures, film, still photographs, interviews, dramatic readings, and religious services. People watching NBC that Sunday saw the first live televised murder, as Jack Ruby shot Kennedy murder suspect Lee Harvey Oswald. Ninety-three percent of the people who owned televisions watched the coverage, more than half for over 13 hours straight.[25] Government pressure and network television profitability reached their peaks in the 1960s and 1970s, but deregulation and competition resulted in cutbacks in network television news budgets in the last two decades of the twentieth century. In general, local television news suffered from limited resources until stations, prompted by audience research and news consultants, realized their viewers were ready to watch, and advertisers were ready to pay for, a hyper-local news effort with heavy use of live coverage and filmed reports. By the 1970s, newscasts became the most popular and profitable local programs on television, prompting stations to expand and add to their news programing.

Meanwhile on the national level, as the government reduced the pressure for news programing and the three main networks merged into larger corporations, network news divisions had their budgets slashed, a reduction that continues to this day. Technological limitations of the early years turned into expanded opportunities as satellites allowed for world-wide live coverage, cable expansion encouraged niche news channels, and the progression through videotape, online, digital, and mobile technology has democratized the capturing of news images.

The cutbacks at American network news, especially in the costly areas of international coverage, contrasted sharply with countries that had chosen a different funding model for television (and radio) news. Taxpayer funded services, including the British Broadcasting Company (BBC) in Great Britain and the ARD and ZDF networks in Germany, and more recently *Al Jazeera*, funded by the Qatari government, have been able to retain or build on their national and international coverage.

As journalism in the twenty-first century, in both pictures and words, struggles with major funding issues across all platforms, McManus's market-driven journalism model becomes even more prescient: "advertising's 'subsidy' makes a definition of quality based on popularity more profitable than one based on less widely shared professional or craft standards."[26] As Edward R. Murrow warned back in 1951, "[i]t would be unfortunate if television's swaddling clothes turned into a dollar-lined strait-jacket."[27]

Notes

1 Sidney Head, Foreword to "News on Television" by Ralph A. Renick, Miami, FL, May 1950, 2, Pamphlet 3637, Library of American Broadcasting, University of Maryland, College Park, MD (P-LAB).

2 Orrin E. Dunlap, Jr., *Understanding Television: What It Is and How It Works* (New York: Greenburg, 1948): 8.

3 Carolyn Marvin, *When Old Technologies Were New: Thinking About Electric Communication in the Late Nineteenth Century* (New York: Oxford University Press, 1988): 4.

4 Marvin, *When Old Technologies Were New: Thinking About Electric Communication in the Late Nineteenth Century* (New York: Oxford University Press, 1988): 4.

5 Erik Barnouw, *Tube of Plenty: The Evolution of American Television*, 2nd rev. edn (New York: Oxford University Press, 1990); Edward Bliss, Jr., *Now the News: The Story of Broadcast Journalism* (New York: Columbia University Press, 1991).

6 The United States had the most advanced television news efforts in the 1940s and 1950s because World War II slowed down or stopped television experimentation and programing in Europe and the Soviet Union. Mike Conway, *The Origins of Television News in America: The Visualizers of CBS in the 1940s* (New York: Peter Lang, 2009).

7 Robert W. McChesney, *Telecommunications, Mass Media, & Democracy: The Battle for the Control of U.S. Broadcasting, 1928–1935* (New York: Oxford University Press, 1993).

8 John H. McManus, *Market-Driven Journalism: Let the Citizen Beware?* (Thousand Oaks, CA: Sage, 1994): 85. Italics in original.

9 Gwenyth L. Jackaway, *Media At War: Radio's Challenge to the Newspapers, 1924–1939* (Westport, CT: Praeger, 1995); Michael Stamm, *Sound Business: Newspapers, Radio, and the Politics of New Media* (Philadelphia: University of Pennsylvania Press, 2011); Stanley Cloud and Lynne Olson, *The Murrow Boys: Pioneers on the Front Lines of Broadcast Journalism* (Boston: Mariner, 1996); Kevin G. Barnhurst and John Nerone, *The Form of News: A History* (New York: Guilford Press, 2001).

10 Reuven Frank, interview by author, 14 August 2003, Tenafly, NJ, videotape recording, Briscoe Center for American History, University of Texas at Austin.

11 Raymond Fielding, *The American Newsreel 1911–1967* (Norman, OK: University of Oklahoma Press, 1972); Gilbert Seldes, "The Unreal Newsreel," *Today*, 13 April 1935: 6–7, 18; Joseph E. J. Clark, " 'Canned History': American Newsreels and the Commodification of Reality, 1927–1945" (Ph.D. dissertation, Brown University, 2011) and this volume.

12 Conway, *The Origins of Television News in America: The Visualizers of CBS in the 1940s* (New York: Peter Lang, 2009).

13 Leo Hurwitz, "The Revolutionary Film—Next Step," *New Theatre*, May 1934: 14–15.

14 Chester Burger, interview with author, 11 August 2003, New York City, videotape recording, (BCAH).

15 Leo Hurwitz to CBS News staff, CBS Memo, 3 August 1946, Chester Burger Papers, Box 3E20 #2, (BCAH).

16 Conway, *The Origins of Television News in America: The Visualizers of CBS in the 1940s* (New York: Peter Lang, 2009).

17 Craig Allen, *News is People: The Rise of Local TV News and the Fall of News from New York* (Ames, IA: Iowa State University Press, 2001); "WPIX Newsreels," *Broadcasting*, 24 May 1947: 39.

18 Allen, *News is People;* "WPIX Drops Film Syndicate," *Broadcasting*, 7 February 1949: 86.

19 Renick, *News on Television*, Ralph A. Renick, Miami, FL, May 1950, 2, Pamphlet 3637, Library of American Broadcasting, University of Maryland, College Park, MD (P-LAB) 4.

20 Ralph Engelman, *Friendlyvision: Fred Friendly & the Rise and Fall of Television Journalism* (New York: Columbia University Press, 2009); A. M. Sperber, *Murrow: his Life and Times* (New York: Freundlich, 1986).

21 Val Adams, "Ed Murrow Offers Case for TV News," *New York Times*, 4 May 1952: X11.

22 Mike Conway, "Murrow and Friendly's Multimedia Maturation: How Two Non-Visual Communicators Created a Groundbreaking Television Program," Paper presented at the annual meeting of the Association of Educators in Journalism & Mass Communication, Washington, DC, August 2013; Edward R. Murrow & Fred W. Friendly, *See it Now* (New York: Simon & Schuster, 1955).

23 Val Adams, "Ed Murrow Offers Case for TV News," *New York Times*, 4 May 1952: X11.

24 Reuven Frank, "the bible," NBC News staff memo, 1963, Box 13107551, Personal Speeches-Written Works, 1963–71, Reuven Frank Archives, Tufts University, Boston, MA, (RF-T).

25 Edward Bliss, Jr., *Now the News: The Story of Broadcast Journalism* (New York: Columbia University Press, 1991); Erik Barnouw, *The Image Empire: A History of the Broadcasting in the United States from 1953* (New York: Oxford University Press, 1970).

26 John H. McManus, *Market-Driven Journalism: Let the Citizen Beware?* (Thousand Oaks, CA: Sage, 1994): 62.

27 Val Adams, "Ed Murrow Offers Case for TV News," *New York Times*, 4 May 1952: X11.

2.10
Collective Self-Representation and the News: Torture at Abu Ghraib

Abigail Solomon-Godeau

Torture is not new, but its detailed photographic representation is shockingly, stunningly new.[1] The Abu Ghraib visual archive is a collective portrait of a group of American reservists, Military Police, enlisted soldiers, CIA personnel, and civilian contractors who, almost overnight, become jailors of Iraqis. In the span of a few months, one group of [mostly] white and [mostly] working class men and women were given life and death power over dark, mostly male foreigners, the majority of whom, needless to say, did not speak English and whose culture was altogether alien to the occupying Americans.[2] The unprecedented aspect of this phenomenon—I refer to the participants' act of collective self-representation as they tortured their prisoners—should not be underemphasized. [3]

Certainly it is of some significance that, despite the ready availability of the camera, routinely practiced tortures such as waterboarding, beating, or electrical shock have rarely if ever been photographically documented as part of the torture process itself. Whether officially sanctioned, as in the dirty wars in Chile, Argentina, Guatemala, El Salvador, or further back, the Algerian War of Independence, as far as is known, neither the torturers nor the observers thought to visually record, circulate, and indeed, publicize their activities.

Where some writers have made reference to photographic precedents (e.g., the lynching photographs published and exhibited in New York City at the New York Historical Society in 2004)[4] or to the concentration camp photographs that are for many the benchmark for atrocity imagery, others have looked back historically to the representation of torture in the visual arts, as represented in the prints of Jacques Callot, Francisco Goya, as well as to certain paintings by Leon Golub.[5] But this evocation of an art historical genealogy, if that is what it is, misses one of the central features of the Abu Ghraib archive; namely, its carnivalesque atmosphere, its eroticism, and its s/m trappings and staging. In this sense, the photographic record is less a "documentary" than an "entertainment," a spectacle, a kind of aggregate movie, comprising both still and moving pictures (i.e. videos) whose participants function as both directors and actors who perform their roles for one another as well as for an implied spectator. These feature particular forms of torture, imply certain forms of viewing, and involve circuits of transmission and reception that distinguish much of the imagery from Abu Ghraib from, say, the nightmarish depictions of rape, mutilation,

and carnage that Goya depicted in his *Disasters of War*, or for that matter, the photographs of lynching that have been cited as photographic precedents. But the central problem with the reference to examples taken from the visual arts is the elision of the distinction between the imaginative rendering of torture in graphic or painterly forms and the indexical properties of the photographic—even if digital—record. Which is merely to say that a photographic record is categorically different from a graphic one, even if the torture represented in graphic form "really" happened, or was "really" observed by the artist.[6]

The photographs and videos made in Abu Ghraib, from the moment of their recording, became an archive, an image repertoire. As an archive, the collective representation of the torture at Abu Ghraib circulates in the world with newly acquired meanings and significance. In the ether of cyberspace, the pictures were exchanged and circulated initially between a few dozen of the Americans posted in Iraq and, since 2004, they have circulated internationally. Interestingly, although these images were made with digital media, they prompted no challenge to their authenticity. (They have, however, remained censored; much of the image archive has never been released). But as a digital archive now available to anyone with access to the web, the archive is located nowhere in particular and everywhere that it comes into use. It is, moreover, a constantly expanding archive. These include, but are not limited to, the use of the photographs in the international media, the conscription of the imagery to political posters, art works, street theater, political cartoons, demonstrations, and other various oppositional uses.

One of the uses of the archive in the US that sparked controversy was the exhibition of certain of the images, downloaded from various websites in art venues. I refer specifically to exhibitions held at the International Center of Photography in New York City and the Andy Warhol Museum in Pittsburgh in 2004.[7] In this regard, the presentation of manifestly non-artistic pictures whose significance lay only in *what* they depicted (as well as the form of digital media itself and its modes of dissemination) sparked comment on the risks of the "aestheticization" of the imagery, or alternatively, the argument that the space of a museum (a priori defined as a space for aesthetic contemplation) had no business trafficking in such pictures in the first place. These were arguments that were made previously around the exhibition of the James Allen archive of lynching photographs, although in that instance, its first venue was the New York Historical Society, not an art museum. Putting aside the merit of either argument, the more important point here is how archives—especially digital archives—lend themselves to these plural applications, addressing different audiences, becoming variously re-signified in the process, and, in turn, generating new discourses.

Another element in the discursively generative capacity of an archive is the phenomenon of "iconization." By this term, I refer to the process by which certain images, for a variety of reasons, become generally symbolic not only of the particular event depicted, but of a larger entity or situation. In other words, the "iconic" image, such as that of the hooded detainee, precariously poised on a box, wires dangling from his limbs, became for many a synecdoche of the evil of the war itself as well as an evidentiary rebuttal to President Bush's claim that "the US does not torture." For certain commentators, such as W.J.T. Mitchell, the symbolic as well as the discursive power of this single image lay in its evocation of the crucifixion.[8] Whether such an association is what made this particular picture *the* iconic representation of torture at Abu Ghraib is less important that the scale of its diffusion. "As famous as advertising logos and brand icons like the Nike Swoosh or the Golden Arches, the image rapidly mutated into a global icon, that 'had legs,' to use the Madison Avenue expression."[9] In this particular respect, almost as soon as the Abu Ghraib pictures were released to the American media, this harrowing picture became such an icon.[10] In fact, the hooded man was reproduced on political posters in Baghdad and Teheran within days of its release, and has since become ubiquitous as an indictment of the war and the policies that accompany it.

In its various appropriations, the original meaning of the hooded detainee thus became re-signified, transformed from the American jailors' orchestration of one man's victimization to a signifier of defiance, a call for revenge, a rallying point for opposition. And because the images, however abstracted (as in many of the anti-war posters and other graphic media) were drawn originally from the photographic archive, the hooded man retains the shock of the indexical; a living, terrorized body, precariously tottering forever on its box.

The history of the public exposure of this archive is a story in itself, beginning with a single soldier's forwarding of some of the pictures to his superiors. In the following months, selections from the archive were leaked to Seymour Hersh, reporting for the *New Yorker*, and to CNN in 2004. In the wake of the efforts of the White House and the military to block the further public release of the images, the American Civil Liberties Union and the Center for Constitutional Rights initiated ultimately successful lawsuits in 2003.[11] Subsequently, several hundred more of previously censored images and videos were leaked to the Australian television news program "Dateline" and, almost immediately after, were acquired and reproduced by *Salon.com*.[12]

The pictures from Abu Ghraib will never go away. While it is possible to destroy "original" physical pictures, electronic media is forever. Like other visual evidence of American atrocities (for example, the massacre at My Lai) the proof of what went on in this war is having its effects, metastasizing globally, functioning to rally opposition, to foment hatred of the US and its policies, to give the lie to America's stories about itself and its moral and ethical exceptionalism. Although what the Abu Ghraib archive depicts is hateful, shameful, sadistic, insofar as it documents one vicious aspect of a conflict that has been subject to unprecedented visual censorship, it is finally better—necessary—to have these records of the horrors, than not.

The central question raised by the Abu Ghraib visual archive has been raised before. Has the capacity for shock or outrage that might be conceivably provoked by the photographic imagery of torture been irrevocably diminished as a consequence of repetition and familiarity? Has the almost quotidian exposure to the photographic record of carnage, cruelty, and victimization operated to numb the affective capacities of viewers? Has the mass media exploitation of simulated violence in TV, or especially film, neutralized the perception of real violence? These are among the central questions raised by Susan Sontag and several other writers addressing the meaning and significance of the Abu Ghraib archive.

In her 1977 book *On Photography* Sontag argued that it was one of the consequences of our immersion in the image world of photographic representation that we become inoculated to the horrors that photographs enable us to see.[13] In certain of the essays, Sontag continually referred to the deadening attributes of photographic imagery at least in its collective manifestations.[14] "To suffer is one thing; another thing is living with the photographed images of suffering, which does not necessarily strengthen conscience and the ability to be compassionate. It can corrupt them. Once one has seen such images, one has started down the road of seeing more—and more. Images transfix. Images anesthetize."[15]

In her last book, *Regarding the Pain of Others* (2003), Sontag returned to the problem of photographic imagery in relation to war. The problem, as she then saw it, was that the photographic revelation of carnage, destruction, and death, brought daily into the domestic space of readers and viewers, could only be descriptive, like any other photographic document.[16] The photographic evidence of any war's destruction and human suffering, she argued, could neither analyze, explain, narrate, nor contextualize. It could not, in and of itself, prompt action, effect political beliefs, shift perceptions. "To an Israeli Jew, a photograph of a child torn apart in the attack on the Sbarro pizzeria in downtown Jerusalem is first of all a photograph of a Jewish child killed by Palestinian suicide-bomber. To a Palestinian, a photograph of a

child torn apart by a tank round in Gaza is first of all a photograph of a Palestinian child killed by Israeli ordnance."[17] But even more pointedly, Sontag observed that a century of unbearable, previously unrepresentable photographic pictures of the casualties of war, increasingly civilian, has done nothing to make warfare less frequent.

Sontag's last published essay, "Regarding the Torture of Others," remains unsurpassed in its scenographic analysis of what happened at Abu Ghraib prison.[18] As a canny anatomist of camera culture, Sontag was especially attentive to the staging of particular kinds of torture. The essay, whose tag line in the original *New York Times Magazine* format was "The Photos Are Us," stressed the generic categories to which Abu Ghraib belonged: tourist snapshot, home-made pornography. In the former instance, the perpetuators' desire to document their activities were likened to vacation snapshots, recording the subject's temporary occupancy of a foreign place, sometimes with the natives, sometimes in picturesque or recognizable settings. As such, the torture photo, like the touristic souvenir snapshot, is a kind of visual trophy. In this respect, those Abu Ghraib pictures depicting the perpetrator posed, often smiling, with the victims—corpses included—are uncannily similar to the more anodyne pictures made by (in some cases) the same individuals, such as those featuring Pfc Sabrina Hartman playing with an Iraqi child and those depicting her mugging over the battered corpse of a prisoner. As such, the torture photo, like the touristic souvenir snapshot, is a visual trophy of a part of one's life that one wishes to be made visible, preserved, and remembered.

The photos from Abu Ghraib, as Sontag concluded, far from being the productions of a deviant fringe, or as government apologists had it, "a few bad apples," were fully in keeping with a pornographic imaginary that constituted the underside of the United States' official values and ideologies and further shaped by a global camera culture based on fantasies of imaginary possession and appropriation. Although it is equally germane to note, as she did, that the actions and their documentation are equally shaped by the ideologies of militarism, and (although she did not stress this) racism and anti-Arab prejudice. If I am correct in viewing the archive as both a kind of collective home movie, and as a self-representation of a certain strata of American society—the lower functionaries of the American imperium in its militaristic incarnation—there are many reasons to reflect on Sontag's succinct analysis of the imbrication of both aspects of the events: the photographs are "representative of the fundamental corruptions of any foreign occupation and its distinctive policies which serve as a perfect recipe for the cruelties and crimes in American run prisons."[19] "The photos," as the *New York Times* glossed her essay "are us."

Notes

1 I refer to the photographs and videos made in Abu Ghraib prison and released by the media on 27 April 2004. The present essay is excerpted from a text originally published in French as "Torture à Abou Ghraib: les medias et leur dehors." *Multitudes* 1/2007 (n. 28): 211–23. Online at http://www.cairn.info/revue-multitudes–2007–1–page–211.htm#citation (accessed 2 January 2013).

2 There is a substantial bibliography on the psychology and sociology of torture. But with respect to the "ordinariness" of those who abused or tortured detainees in Abu Ghraib prison, see especially John Conroy, *Unspeakable Acts, Ordinary People: The Dynamics of Torture*, 1st edn. (New York: Knopf, 2000).

3 There are, of course, numerous precedents for these collective photographic portraits; soldiers, communards, and concentration camp personnel—all have produced visual documentation of their activities. But as I will argue, the pictures from Abu Ghraib are fundamentally different from their predecessors.

4 The photographs exhibited at the New York Historical Society were drawn from the collection of James Allen and were later published in James Allen, *Without Sanctuary: Lynching Photography in America* (Santa Fe, NM: Twin Palms, 2000). See, for example, Dora Apel, "Torture Culture: Lynching Photographs and the Images of Abu Ghraib," *Art Journal* 54 (2005).

5 Stephen F. Eisenman, *The Abu Ghraib Effect* (London and New York: Reaktion Books, 2007).

6 And, I would add, made by digital rather than analog cameras. For while, in theory, the digital cameras used in Abu Ghraib are by definition technically distinct from the indexical properties of analog representation, the cameras and videos were used in no way differently than analog cameras, nor, apparently, were they manipulated.

7 A selection of the Abu Ghraib pictures was exhibited at the International Center of Photography in New York City (17 September—28 November 2004). See the thoughtful review by Eleanor Heartney, "A War and Its Images," *Art in America* 92.9 (2004): 51–53.

8 W.J.T. Mitchell has discussed the symbolic resonance of the hooded Iraqi tricked out with wires and the reasons for its iconic status. See Mitchell, "Sacred Gestures: Images from our Holy War," *Afterimage* 34.3 (November/December 2006): 18–23.

9 See W.J.T. Mitchell, *Cloning Terror: The War of Images, 9/11 to the Present* (Chicago: University of Chicago Press, 2011).

10 Debate continues about the actual identity of the hooded man. See in this respect Kate Zernicke, "Cited as Symbol of Abu Ghraib, Man Admits He Is Not in Photo," *New York Times*, 18 March 2006.

11 These Freedom of Information Act lawsuits were first filed in October 2003, for the purpose of documenting the abuse of detainees held in US custody abroad, well before the release of the first set of images from the prison nearly seven months later. These lawsuits resulted in the release of more than 90,000 pages of government documents on issues of detainee treatment in Iraq, Afghanistan, and at the US military prison in Guantanamo Bay, Cuba.

12 *Salon* obtained the files and other electronic documents from one of the investigators involved with (or close to) the Army's Criminal Investigation Command (CID). The material, which includes more than 1,000 photographs, videos, and supporting documents from the CID may not represent all of the photographic and video evidence that pertained to that investigation. According to the Army's own accounting, the review of all the computer media submitted to this office revealed a total of 1,325 images of suspected detainee abuse, 93 video files of suspected detainee abuse, 660 images of adult pornography, 546 images of suspected dead Iraqi detainees, 29 images of soldiers in simulated sexual acts, 20 images of a soldier with a swastika drawn between his eyes, 37 images of military working dogs being used in abuse of detainees, and 125 images of questionable acts. Based on time signatures of the digital cameras used, all the photographs and videos were taken between 18 October 2003, and December 2003.

13 Susan Sontag, *On Photography* (New York: Farrar Straus Giroux, 1977).

14 This argument was one of the central themes in the Situationist critique of mass media in capitalist society. See Guy Debord, *The Society of the Spectacle* (Detroit: Black and Red, 1983).

15 Sontag, *On Photography* (New York: Farrar Straus Giroux, 1977): 20.

16 The war that provided the immediate context for her discussion of recent war photography was the war in Bosnia.

17 Susan Sontag, *Regarding the Pain of Others* (New York: Picador, 2003): 10.

18 Susan Sontag, "Regarding the Torture of Others," *New York Times*, 23 May 2004.

19 Sontag, *Regarding the Pain of Others*: 17.

News Picture Time

Adrift: The Time and Space of the News in Géricault's *Le Radeau de La Méduse*

Jordan Bear

Théodore Géricault's *Le Radeau de La Méduse* has always been an untimely representation. It famously dispenses with the traditional temporal distance with which history painting ennobled its subjects, instead fixing on a recent, and hardly morally instructive, event. Unlike the sword-and-sandal essays of the young David and his followers, this work employs no ancient costume to veil its critique or elevate its figures. The gruesome scene of the survivors of a shipwreck caused by the ineptitude of a captain appointed by a corrupt government is a striking departure from the aesthetic and moral idiom of much painting of the time. Despite this strident contemporaneity, however, Géricault's picture was also a notably belated image, for by the time that the painting was presented at the Salon in August 1819, the painful topicality of the disaster it depicts had undoubtedly been diminished.[1] More than three years had elapsed between the grounding of the *Méduse* on the Banks of Arguin in July 1816 and the appearance of the painting, and in the interim the public had been furnished with two editions of the eyewitness account published by a pair of the tragedy's survivors, as well as two other books on the subject, and a number of prints. Curiously, the painting transgressed the temporal conventions of history painting, even as it emulated the painstaking, elongated process by which such a large-scale oil painting could be realized. Géricault's diligent investment in the minutiae of the event, and the immediacy of the reality effects that they would achieve, stretched the picture's temporal distance from its stimulus in reality. While he was busy breaking with the past, Géricault ran out of the present long before his work was complete.

Nevertheless, *Le Radeau de La Méduse* is a news picture, but not because it took particular advantage of or replicated the instantaneity, or even the great rapidity, of the transit of information. To the contrary, the painting is a milestone of this genre because it takes as its subject the challenges and shortcomings of the transmission of visual information, even in an historical moment of its quickening pace. When the most important eyewitness version of the catastrophe was published in book form fifteen months later, in October 1817, the entire expedition was presented as a series of failures of visual communication, foreshadowing the almost unbearable tension of the moment of the painting. These smaller, premonitory fiascos are attributed, in the narrative, to the incompetence of the captain, a man of high birth and low aptitude who, after the purge of the military of Bonapartists, was unwisely given his commission. Barely

out of French waters, a young sailor is accidentally thrown overboard; the *Méduse* discharges a flag buoy into the sea so that he may be picked up by the trailing ships in the party. These vessels, however, glide obliviously by, condemning the first of the journey's victims to his watery end. A few nights later, an indolent master of the watch cannot be bothered to hang the lantern with which the craft in the convoy kept sight of one another, causing the *Méduse* to lose her sister ships by morning. Soon after, the easily deceived captain of the ship is persuaded that a cloud is in fact a snow-covered mountain peak, sending the frigate further off course.

Géricault's picture commits itself to the problem of visual communication with its very existence, for the canvas makes the particular visual transmission that is its condition of possibility—the successful signaling of the castaways to the rescue ship *Argus*—the center of its narrative conflict. Géricault's image depends, after all, upon the survival of the shipwrecked men to transmit their story, and so their valiant struggle to signal visually their distress to their saviors is an existential matter for the painting. It is this commensurability of the dramatic charge of the painting with the system of information transmission upon which its existence relies that provides Géricault's image with its very particular kind of immediacy.

The communication of visual information is the source of *Le Radeau de La Méduse*'s conflict, as the emaciated survivors desperately seek to muster their own visibility, fashioning signals from their tattered clothes and from their vitiated bodies. As Jonathan Crary has noted, "the painting incarnates a vision all but cut off from the possibility of a reciprocal exchange of gazes. For reprieve and deliverance in this image would consist in a mutual exchange of gazes, in being acknowledged by the ship, which is here tragically denied or at least deferred."[2] The impossibility of that reciprocity, of the fundamental visual disconnection of the producers and intended recipients of signals, needs to be understood within the broader context of communication at the beginning of the Restoration. This non-reciprocity of gazes, as well as the formal signaling posture in which Géricault configures his protagonists, are historically specific, reflecting the technological and political dynamic of the news in these consequential years in French history.

When the Méduse convoy departed Rochefort in June 1816 with the assignment of receiving the handover from the British of the African colony of Senegal, it had been less than a year since the final banishment of Napoleon from Europe. Any closure that the Emperor's exile provided would have been extraordinarily tenuous, for this was not the first time that he had been sent far away, out of sight. The British iconography of Napoleon in exile on St. Helena—his final port of call—is strikingly consistent. Benjamin Robert Haydon's Napoleon Bonaparte Musing at St. Helena (Fig. 2.11a) is representative: the diminished Emperor, who once had the entirety of Europe within his grasp, stares into an oceanic abyss, master not even of the wind-swept rock to which he has been relegated.

This image seems designed to ward off the return of the tyrant, to prevent another debacle like the Hundred Days, when the seeming remoteness of the isle of Elba proved no match for Napoleon's ability to bridge great distances. The power of this imagery comes from imposing upon Napoleon a physical disconnectedness that he had spent his career successfully surmounting. Now he scans the void, waiting, in vain, for his loyal subjects to restore him once again, but unlike at Elba, there are no signs or signals on the horizon, just the relentlessly blank indifference of a sea that stretches forever. Here, amidst the vast vacuum of sea and sky, Napoleon is expelled from the coordinates of space and time, impotent, shipwrecked.

Long-distance communication—rapid and unimpeded—was of course a critical component of Napoleon's military successes and the expansion of his empire.[3] More than that, though, a network over

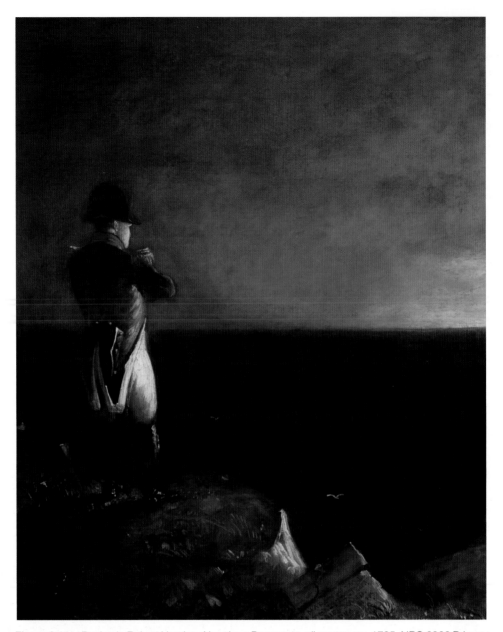

Figure 2.11a Benjamin Robert Haydon, *Napoleon Bonaparte*, oil on canvas, 1795. NPG 6266 Primary Collection. © National Portrait Gallery, London.

which information could flow from the metropole to its far-flung colonial outposts served as a conceptual model for the entire imperial enterprise. As one recent study has aptly put it, "the Empire was nothing but a mirror of [a] perfect system of communication," in which successfully delivering dispatches became "the defining imperial act."[4] The particular system upon which this expansive empire relied was a pre-eminently visual one: the optical telegraph or, as its inventor Claude Chappe would christen it, the

semaphore. A network of signal towers were placed at what was, with the aid of a telescope, the maximum visible distance from one another, near the highest point of the terrain. Atop each sat the semaphore, made of moveable wooden arms and operated by two men with a simple system of counterweights. The well-trained operator could signal and discern more than 8,000 distinct words and phrases, and under the right conditions complete messages could travel from Paris to, for instance, the northern border at Lille, in just half an hour.[5] So potent was the semaphore as a symbol of Napoleonic expansionism that the caricaturist James Gillray nervously expressed the widespread fear of a French invasion in a remarkable print, in which the semaphore is anthropomorphized, signaling the fleet with a lantern in one arm, and pointing menacingly towards the dome of St. Paul's with the other (Fig. 2.11b).

But after Waterloo, the Restoration government virtually shut down the network, severing all the links that went beyond France's historical borders. It was an unsurprising symbolic and strategic maneuver, renouncing Napoleon's expansionist vision and occluding its lines of sight.

<p style="text-align:center">* *</p>

The communication—and contestation—of the news of the *Méduse* disaster helps us to see the contours of the information network in the first years of the Restoration clearly, something like a radioactive dye

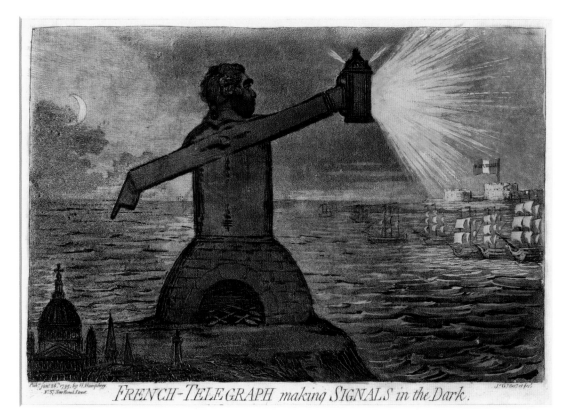

Figure 2.11b James Gillray, *French-telegraph making signals in the dark*, hand-colored etching, 1795. 1868,0808.6406. © Trustees of the British Museum.

moving through the circulatory system. The news initially made its way into the public sphere when an anti-Royalist Prefect of Police leaked the story to a sympathetic paper. The government of Louis XVIII mustered its considerable resources to suppress the story entirely. The authorities ransacked the rooms of the naval engineer Corréard, co-author with his fellow survivor, the surgeon Savigny, of the definitive contemporary chronicle of the raft. The functionaries came in search of manuscripts which they deemed "seditious," a scene that was immortalized in a lithograph, possibly based upon a watercolor by Géricault himself, which illustrated the later editions of the text. Worried not only about outright suppression, but also by the potential publication of scurrilous accounts of the wreck under their names, Corréard and Savigny took to hand-signing an *avis* at the beginning of their book.

Such measures seem justified, given the astounding brazenness with which the government, having failed miserably to suppress the narrative, sought to discredit its veracity. A prefatory note to the second edition warned of the imminent appearance of an alternative version of the events penned by a "pretended sea-officer who was partly the cause of our misfortunes." The authors inform us that this ultra-Royalist and inept sailor, having abandoned the raft for the safety of the governor's boat, "remained a stranger to the disasters which he had partly caused, and consequently, knew nothing of what passed."[6] This bit of hackery was to be published by a Mr. Sevigny, whose surname conveniently resembled that of one of the genuine authors. The warning further notes that this Sevigny had achieved some financial success in similar larcenies against the public when, having acted as the front man for the disgraced governor, he founded a company called the "Colonial Philanthropic Society of Senegambia," and bilked Napoleonic military pensioners with promises of parcels in an exotic African paradise.

Yet the uncertainty of the guarantees of the survivors' recollections, and particularly their visual dimensions, are built into the expository prose of the text. After the grounding of the *Méduse* and the haphazard creation of the raft, they report, the pitiful passengers are tormented by a series of mirages. Some of these condemned souls:

> pictured delicious fountains, at which they sought to quench their burning thirst. Others, more sensible perhaps to the loss of their friends than to their own sufferings, dreamed they again clasped them in their arms.[7]

But the cruelest of these hallucinations involved the spectres of salvation: appearance of distant fires in the darkness of night, and sightings of land and rescue vessels. These phantasms were ones that Géricault's own preparatory studies seem to have internalized, for throughout his sketches the *Argus* is continually repositioned, moving from the middle ground to the farthest horizon and then vanishing altogether.[8] Clearly, these exercises allowed Géricault to modulate the affective potency of the image, experimenting with the impact of a salvational nearness, an unresolved distance, and a despondent disappearance. Indeed, Géricault began with a scene of the rescue underway, the dinghy of the *Argus* just feet away from the raft.[9] But closure was not to be the aim of the painting, and so the final version shows the *Argus* at its most minute, at the moment of its most tenuous visual linkage to the signals of the survivors.

When the painting traveled to London and Dublin, an accompanying pamphlet announced the moment of the disaster that Géricault had selected: the survivors are "just descrying the vessel that rescued them from their dreadful situation," a slightly, but crucially, misleading summation.[10] The *Concise Description* goes on to inform the viewer that this instant is in fact *not* the moment of deliverance itself, for the *Argus* does not spot the waterlogged pile of bodies; it is only some time later when, by happy

coincidence, their trajectories cross again. The men have hoisted one of their party atop a barrel, and he strains to attract the eyes of the *Argus* with the red and white scraps he holds twisted in his hand. Those survivors who still harbor hope struggle to aid in the signaling, grasping plaintively at the air as the current pushes them back, away from the direction of redemption. From the tender nearness of the signaling arm of a survivor, Géricault plunges us into a chasm of choppy waters, and then to glimpse the faintest cruciform outline of the *Argus*. This is the final moment of visibility, for in an instant that ship will be gone from sight, the already-weak signal of the survivors fully extinguished by her distance.

The spatial elasticity of France in the years after the fall of Napoleon was the result, in diplomatic terms, of an oddity of the Treaty of Paris. While France was stripped of the European holdings it had acquired after 1792, it was restored a group of colonial territories that had been lost to the superior British navy during the intervening decades.[11] The ironies of this reordering are embodied in the fact that, even as Napoleon was banished to St. Helena, Britain's most remote colony, the Royal Navy restored to the French the island of Réunion which, at the time of its capture, bore the name "Île Bonaparte." If the semaphore and its network of visual communication had shrunk the strategic terrain of Europe to the benefit of Napoleonic expansion, the newly restored portfolio of colonial bases remained astonishingly distant. The transmission of information from these colonies to the metropole still relied upon oceanic navigation, a realm in which speeds had remained relatively stagnant for decades.[12] The signature accomplishment of the semaphore network—to liberate communication from transportation—was largely irrelevant to the new, circumscribed map upon which France's expansion could now unfold.[13] It was on the return from one such outpost—Senegal—that the survivor Savigny would pen the first brief manuscript of the harrowing history of the *Méduse*, carrying with him the news of the disaster.[14] Lodged together below deck, the news, its author, and its material embodiment as a manuscript, sailed slowly for home. The drama of transmission is a double one, for even if the castaways' signal is glimpsed by the *Argus*, the story of the wreck must overcome its own distances to reach the public. And this distance was, in a very marked way, the defining metaphorical feature of a newly royal France and its global position.

* * *

If the "moment" of *Le Radeau de La Méduse* locates its inhabitants at the absolute outer marker of the visibility of signals, the completion of the canvas itself also occupied an extreme position in the historical development of visual modes of telegraphic communication. The many experimenters across Europe who had been working feverishly towards faster and more reliable telegraphy announced a series of major breakthroughs, the first just a year after the arrival of Géricault's painting. In 1820 the Danish physicist Hans Christian Oersted published the principles of electromagnetism, the conceptual foundation upon which the electrical telegraph would be constructed. The impact on the time and space of the news of this emerging mode of transmission would be truly epochal. The electrical telegraph excelled in precisely those dimensions that had hamstrung its optical predecessors. Chappe's system could operate only during daylight hours and under favorable climatic conditions, which in wintry France might be as little as three hours per day. By contrast, the electrical telegraph could transmit messages regardless of the conditions of visibility.[15] The crucial function of visually discerning the meaning of a communication was rendered obsolete, and a variety of ingenious mechanisms for receiving and translating messages sent electrically quickly assumed this responsibility. In Munich, incoming communications passed through a clockwork apparatus that maneuvered a paper ribbon under a needle that punched dots in the shape

of the letters of the alphabet; in New York, the job was taken up by a modified piano-forte keyboard.[16] In these and other centers of communication around the globe, the new registration devices did not simply extend human sensory capacities, as a telescope might; rather, they helped to decode messages transmitted along channels that had ceased to have any direct relationship to the abilities or experience of the human perceiver. The visual pathway of communication, which Chappe had created and Napoleon had harnessed, was, in short order, supplanted by the fundamentally non-visual signals of the new electrical telegraph. Within two decades, this variety of telegraphy would become indispensable to the world's news agencies, restructuring radically the temporal implications of the news.[17]

If, as Norton Wise has argued, "much of the history of science could be written in terms of making new things visible—or familiar things visible in a new way," then Géricault's painting stands at the threshold of a new chapter in this history.[18] The frailties of the human capacity to discern visual signals—embodied in the unaware searchers of the *Argus* failing to see their marooned comrades' contorted signs—was the source of the picture's drama. This was a mode of communication already on the verge of obsolescence, whose feebleness is memorably condemned by the momentary abandonment of the poor souls, who cling to their wooden raft and to quickly-vanishing hope. *Le Radeau de La Méduse* is as much a picture about the particular spatio-temporality of the news in 1819 as it is a representation of a newsworthy event. It is this narrative and conceptual accord that imbued *Le Radeau de La Méduse* with its peculiarly untimely timeliness.

Notes

1 Paul Joannides, "The Raft of the Medusa." Review of *Géricault's Raft of the Medusa*, by Lorenz Eitner. *Burlington Magazine* 117.864 (1975): 171.

2 Jonathan Crary, "Géricault, the Panorama, and Sites of Reality in the Early Nineteenth Century," *Grey Room* 9 (2002): 16.

3 Frank Hellemans, "Napoleon and Internet. A Historical and Anthropological View on the Culture of Punctuality and Instantaneity," *Telematics and Informatics* 15.3 (1998): 127–33.

4 Andy Martin, "Mentioned in Dispatches: Napoleon, Chappe and Chateaubriand," *Modern & Contemporary France* 8.4 (2000): 446.

5 Patrice Flichy, "The Birth of Long Distance Communication. Semaphore Telegraphs in Europe (1790–1840)," *Réseaux. The French Journal of Communication* 1.1 (1993): 81–101.

6 Jean Baptiste Henri Savigny, and Alexandre Corréard, *Narrative of a Voyage to Senegal in 1816: Undertaken by Order of the French Government, Comprising an Account of the Shipwreck of the Medusa, the Sufferings of the Crew, and the Various Occurrences on Board the Raft, in the Desert of Zaara, at St. Louis, and at the Camp of Daccard. To which are Subjoined Observations Respecting the Agriculture of the Western Coast of Africa, from Cape Blanco to the Mouth of the Gambia*. (London: H. Colburn, 1818): v, vi.

7 *A Concise Description of Monsieur Jerricault's Great picture . . . representing the surviving crew of the Medusa French frigate, open for public inspection at The Roman Gallery, Egyptian hall, Piccadilly* (London: W. Smith, 1820): 11.

8 These preparatory endeavors are conveniently collected in Bruno Chenique, *Géricault, au coeur de la création romantique: études pour le Radeau de la Méduse* (Clermont-Ferrand: Musée d'art Roger-Quilliot, 2012).

9 Lorenz Eitner, *Géricault's Raft of the Medusa* (London: Phaidon, 1972).

10 *A Concise Description of Monsieur Jerricault's Great picture . . . representing the surviving crew of the Medusa French frigate, open for public inspection at The Roman Gallery, Egyptian hall, Piccadilly* (London: W. Smith, 1820).

11 Guillaume Bertier de Sauvigny, *La Restauration* (Paris: Flammarion, 1963). For an impressive art historical study of France's colonial ventures in this period, see Darcy Grimaldo Grigsby, *Extremities: Painting Empire in Post-Revolutionary France* (New Haven: Yale University Press, 2002).

12 Yrjö Kaukiainen, "Shrinking the World: Improvements in the Speed of Information Transmission, c. 1820–1870," *European Review of Economic History* 5.1 (2001): 1–28.

13 On this separation and its consequences, see James W. Carey, "Technology and Ideology: The Case of the Telegraph," *Prospects* 8.1 (1983): 303–25.

14 A short version of the account was initially published 13 September 1816 in the anti-Bourbon *Journal des Débats*, and in English translation very soon thereafter. The full narrative was published the following year in Alexandre Corréard and Jean B. H. Savigny, *Naufrage De La Frégate La Méduse: Faisant Partie De L'expédition Du Sénégal En 1816*. (Paris: Eymery, 1817).

15 Daniel Headrick, "Electricity Creates the Wired World," in David Crowley and Paul Heyer, eds, *Communication in History* (Boston: Allyn and Bacon, 2010): 127.

16 Charles F. Briggs and Augustus Maverick, *The Story of the Telegraph and a History of the Great Atlantic Cable* (New York: Rudd and Carleton, 1858): 24–6.

17 Roland Wenzlhuemer, *Connecting the Nineteenth-Century World: The Telegraph and Globalization* (Cambridge, UK: Cambridge University Press, 2013): 90.

18 M. Norton Wise, "Making Visible," *Isis* 97, 1 (2006): 75–82.

2.12
Snap-Shot:
After Bullet Hit Gaynor

Jason E. Hill

When, on Monday, 15 August 1910, the *Seattle Star* topped its front page with William Warnecke's photograph of "the scene on board the Kaiser Wilhelm der Grosse a moment after [New York City Mayor William] Gaynor had been shot," the information contained in that photograph was no longer news—the paper had printed the United Press service's same-day wire account the previous Tuesday and had closely covered the story ever since (Fig. 2.12).[1]

But if the shooting itself was no longer breaking news, the "remarkable picture taken by a newspaper photographer who happened to be aboard [the Hoboken-docked ship]" still was. For as quick as Warnecke and his camera had been, and for as efficient as the technologies of halftone and wire-news already were, until the institution of wire-photo services beginning in 1935, the wide geographic distribution of news photographs was still a relatively slow business.[2] The news and its images necessarily traveled on different schedules. Published in the New York *World*—its offices just across the Hudson River from the shooting—just hours after the incident and on the Pacific Coast six days later, Warnecke's speedy and on-the-spot "Snap-Shot After Bullet Hit Gaynor" would suffer a substantially longer delay before entering into its fuller cultural currency as an emblem of newspaper photography's essential program of subtracting any temporal gap between an event and its mediated public knowability.

At its second annual exhibition at Rockefeller Center in December 1936, the New York Press Photographers Association (NYPPA) awarded top prize in the "spot news" category to Warnecke's then twenty-six years old news photograph. The picture prevailed over some 440 other photographs included in the exhibition (among them hundreds more contemporary, of which several were comparably well-timed). In making such a selection in what was its well-publicized contest's second year, the NYPPA could be said to have been assigning the criteria of value in "spot news" photography's still nascent field on the basis of a picture that substantially preceded it.[3] But then such was Warnecke's fortune that long-past August morning to have been pointing his 4x5 ICA camera in the direction of New York City's mayor at the very moment that the mayor himself became alert to the bad news that he had been shot. Value in "spot" news photography is and always has been measured in the first place by the degree to which it is punctual. As a category of daily newspaper production, "spot news is the specifically *unforeseen-event-as-news*," journalism scholar Gaye Tuchman explains, and it is news only insofar as it is delivered promptly: "spot news events are unscheduled; they appear suddenly and must be

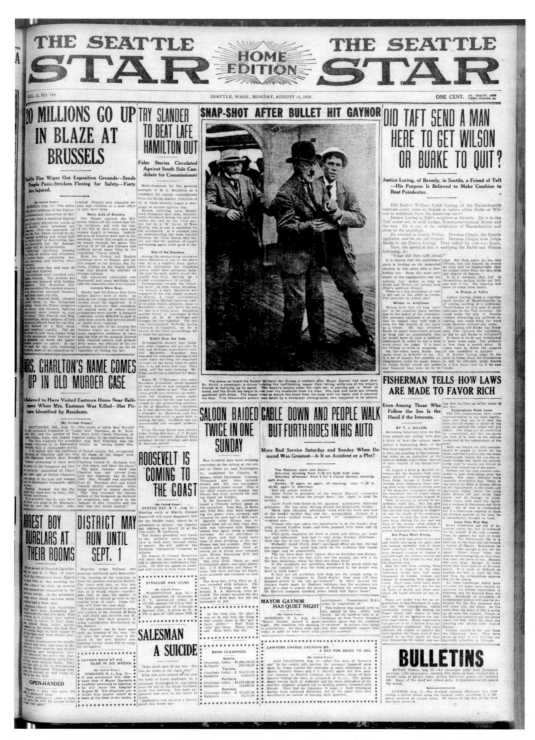

Figure 2.12 *Seattle Star*, 15 August 1910, page 1. Courtesy of Library of Congress and Office of Washington Secretary of State.

processed quickly."[4] Essential in its very immediacy to the modern concept of the newspaper whose burden is as temporal as it is thematic, the good spot news photograph then is the timeliest of all pictures and the hardest kind to capture. It strives toward near-total simultaneity, collapsing any perceived temporal, spatial, or interpretive boundary between the unpredicted event and its circulated description.[5]

In its topical and urgent captured subject matter, as much as in its internal meditation on the quick but not instant time of news, and its accretion of telling details concerning the newsmaking culture of its day, Warnecke's picture functions almost perfectly as an allegory of the spot news photograph. Incident and its only-just-delayed understanding radiate as if in waves from the center of the picture. The curve of Gaynor's lapel seems almost to trace the arc of his hand's path from his bloodied neck to the point before him where he himself could inspect it and so become his own shooting's witness; the blood on his palm providing visual confirmation of the confusing event that he himself had only just experienced but could not yet fully understand. Two men, having heard the gun's report, have been propelled to his aid. One braces the collapsing mayor while engaging Warnecke visually, perhaps in search of external confirmation of the truth of the circumstance he suddenly inhabits, perhaps in condemnation of the photographer's seemingly passive role in providing that same confirmation. The other man rushes forward along the ship's floorboards as if through the portal behind him, his own intervention delayed by his distance from the event. Beyond that portal we find in silhouette the forms of four men who stand behind a wall and so at a substantial experiential remove from the episode that would be the news here. Soon they are likely to become actors in this story, but they, like this picture's subsequent public, will depend on the mediation of those nearer to the scene for any full understanding of what has occurred.

The picture is further distinguished as a member of its class by the distinctly journalistic conditions of its subject, production, and distribution. Gaynor, who was shot (gravely but not mortally) by a disgruntled constituent, had just the year before prevailed over New York *Journal* publisher William Randolph Hearst in the contest for his seat. The assassin, one J.J. Gallagher, was made alert to the opportunity—just as Warnecke's editor had been—by the pre-publicized fact of the Mayor's planned departure for Europe that morning. For his part, Warnecke, one of only five photographic staffers on Joseph Pulitzer's New York *World* (Hearst's great yellow-journalistic adversary), had arrived late to the scene but on time for his picture on account of his humdrum newsman's obligation to photograph, earlier that morning, a horse set to be retired by the New York City Fire Department in favor of its new motorized fire truck.[6] Indeed, what celebration this picture enjoyed in 1910 was not unconnected to that moment's shifting technological negotiation with the problem of speedy conveyance: much of its value to its initial public lay in its almost unprecedented same-day speed to local press at a time when telegraphy allowed big stories to be reported almost instantly while no adequate mechanism was in place (too few photographers, too little infrastructure) to ensure such stories their appropriate photographic counterparts.[7]

For all this, the NYPPA jury left no record of its collective reasoning in electing Warnecke's old news picture the best in its category. But the Museum of Modern Art's then librarian and future first curator of photography Beaumont Newhall, whose West 53rd Street office was just four blocks from the exhibition, was receptive to the result of that jury's appraisal, and in his own landmark spring 1937 exhibition surveying the photographic arts, he offered some limited accounting of the picture's distinction. Exhibiting the photograph as the very ideal of press photography, Newhall gave the once merely and variously captioned picture a proper title, "The Shooting of Mayor Gaynor," and, in that exhibition's influential and frequently reprinted catalog, he flagged the picture's distinctly temporal achievement, articulating its special bearing on our evaluation of press photography's singularity:

> Sensing the exact instant to release the shutter is the most important factor in the making of any photograph. With press photographers, this sense becomes so acute as to seem instinctive . . . A fraction of a second's delay, and the remarkable picture of the shooting of Mayor Gaynor would have lost its terrific force; it seems as if William Warnecke must have released the shutter at the same moment that the assassin fired the gun.[8]

Newhall's enthusiasm for the picture and his assessment of it, whose rhetoric and title situate Warnecke's exposure within the almost impossibly quick temporal span of the gun's discharge, gained real traction within a museum whose early commitment to photography was marked less by a concern for press photographic value as such than by an obsession with the camera's distinctive temporal competence as a machine.[9] In 1943, Newhall's spouse, and then acting curator, Nancy Newhall, exhibited Warnecke's picture in her exhibition "Action Photography," where it hung alongside such precise exemplars of the camera's wider entanglement with instantaneousness as Harold Edgerton's 1939 *Firing a Mauser Automatic (Exposure 1/1,000,000 second)*.[10] But such invited comparison with Edgerton's extraordinary achievement points to the fundamental inappropriateness of Newhall's evaluative criteria, for indeed nothing could be more apparent in Warnecke's picture, once measured against Newhall's hyperbole (and Edgerton's more perfect suitability to it), as the fact that Warnecke had exactly *not* made his exposure "at the same moment that the assassin fired the gun," but only a moment later.

Beaumont Newhall's and the Museum of Modern Art's investment in photography's technological capability to isolate a precisely chosen instant led him to see in Warnecke's photograph a kind of instantaneousness that was simply not there. Newhall's concept of medium isolated the deftly wielded camera and its unique claim to the instantaneousness of the quick and timely exposure. This led him to miss what most matters in Warnecke's photograph *as a press photograph*, capturing, as it does, not the instant of Gaynor's shooting but instead the moment of that event's coming into being as a matter of concern—as news.

Newhall's blinkered description of the picture is not entirely misplaced, however, and some bridging of the ideals of medium specificity and instantaneousness will productively set Warnecke's picture into its proper context. Where in Newhall's and the Museum of Modern Art's reckoning with press-photographic possibility, instantaneousness had one meaning, in the world of journalism and of the NYPPA it had another valence altogether.

The instantaneousness of the photograph as the prompt expression of well-managed machines had long been held by journalists to be the medium's chief virtue. But the photographic medium to which journalism's instantaneousness was conceived to adhere was not so much that trapped within a press photographer's camera (such as Newhall would have it), but rather that of the camera and its captured image as they functioned within photographic journalism's full operational structure. Within this wider complex the camera was privileged only insofar as it operated in consort with an evolving set of technologies and professional protocols, ensuring both the timely picture's initial production and the speediest translation of that image into the widest possible newsprint circulation. Such an understanding of press photographic instantaneousness was already being articulated at the dawn of the enterprise. In an essay promoting photography's advantage over handmade engravings for newspaper publishers in the still medium-transitional year 1906, Stephen Horgan, an early innovator in the development of halftone process who was responsible for the first mechanical reproduction of a photograph in a daily newspaper in 1880, drew little distinction between the camera-in-the-field and its photomechanical engraving process:

The public demand[s] sensational news pictures with as few minutes elapsing between the occurrences and the sale of the papers containing the pictures. This necessary haste . . . prevents artistic illustrations . . . The most important consideration [is that] the printed product must be cheap in price. It is with knowledge of these latter requirements that the modern illustrated daily newspaper must be judged.[11]

Racing past the typewriter and sketchbook in their hobbled dash to the deadline, the camera offered reporters the fastest way to record the news. And it was the halftone screen—a secondary photographic application translating the press photographer's primary, tonally gradient images into the discontinuous grids of dots suitable for the cylinder relief printing compatible with newspapers' high-speed rotary presses—that offered the fastest way to print and circulate that record, as the news. For Horgan, the photographic technologies of the camera and the halftone aligned as one photographic apparatus serving mechanical objectivity and procedural efficiency (and so economy) in equal measure.[12]

Three years earlier the photographer and critic C.H. Claudy had already insisted upon the photographer's new operational burden in the face of the increasingly ubiquitous convergence of news-camera and halftone screen, as the latter technology came to be embraced by ever more newspaper publishers in the decades following its perfection in the 1880s:

The papers *must* have photographs of events or places as soon as possible after the orders are given the photographer. No matter what . . . difficulties . . . you must secure your negative, make your print and deliver it to the editor in time for him to have a plate made which will be finished before the hour of going to press. This one item of speed is frequently worth more than all the rest of a make-up of a picture put together.[13]

For Claudy the timeliest exposure by even the fastest camera is of value to the press photographic enterprise only insofar as its image is promptly inserted into the network of human and mechanical practices which cohere in the institutional conduct of newspaper production. So far so good on the local stage, but in the absence of the wire-photo services and their virtually simultaneous far-flung transmission of copy *and* its attending picture, "spot" newspaper illustration, even where a good and timely picture existed, was still very much a hybrid affair including both halftones and artists' illustrations (wanting for a photograph, the Seattle *Star* illustrated its first report of Gaynor's shooting with a handy but unrelated wood-engraving).

A nascent discourse when Warnecke took his well-timed picture, then, press photographic instantaneousness was, by the late 1930s when Newhall encountered Warnecke's picture, an idea whose time had come, now fully institutionalized into emerging textbook pedagogy. Introducing their popular manual, *Pictorial Journalism*, Laura Vitray, John Mills Jr., and Roscoe Ellard isolated "instantaneousness"—understood precisely as the successful and prompt alignment of event, cameraman, camera, press, and public—as photography's signal contribution to modern communication and "modern thought" more generally, and argued its central importance to the newspaper's survival in the competitive face of the newsreel and the radio:

The development of modern photographic and engraving processes might not have been so rapid and so amazing if what they had to offer had not so well answered the demand of the modern mind for a quality best described as "instantaneousness." As . . . the boundaries of communication have been pushed farther and farther out . . . [m]odern thought . . . insists on arriving . . . at knowledge by

the shortest route. That is the surest reason why picture reporting, the "instantaneous" route to realization of the world's events, has succeeded column after column of mere words out of the daily paper.[14]

Here, photographic instantaneousness refers not to Newhall's privileged photographic capacity to freeze an instant but to the press photographic enterprise's hard won and ever improving ability to reduce the delay between an event and its newspaper public. The value of this subtractive competency was well-recognized by 1910 but only realized as a professional norm by the late 1930s with the convergence of technological and cultural conditions reaching far beyond the introduction of lightweight cameras, compact flash equipment, and the intrepid photographers who increasingly used them. Vitray and her co-authors reckon press photography to include, in addition to these, a mature production complex consisting of high-speed presses, halftone reproduction, and wire photography services; the wholesale escalation by thoughtful newspaper editors and production staff of photography from a novel means of illustrating a story to a legitimate technology for reporting one; and the attendant proliferation of cameras and technicians working on the production end, all ready to distribute the timely picture when it came.

What had been an aspirational ideal in William Warnecke's 1910 was, by Newhall's and the NYPPA's 1936–7, an operational certainty, one even bearing a name, "spot news photography," whose more spectacular achievements might garner a prize. Warnecke's picture's quick four city-block hop from Rockefeller Center and the New York Press Photographers' values, to the Museum of Modern Art and Newhall's values, suggests how well it functioned in the interstice of these two discursive fields as they were being independently elaborated, belatedly, in the 1930s.

Notes

1 "Snap-shot after Bullet Hit Gaynor," *Seattle Star*, 15 August 1910: 1; "Mayor Gaynor of New York Shot Down by Assassin is between Life and Death," *Seattle Star*, 9 August 1910: 1.

2 See Zeynep Devrim Gürsel, "A Short History of Wire Service Photography," this volume. On the procedures of early twentieth-century newspaper photography, see Ulrich Keller, "Early Photojournalism," in David Crowley and Paul Heyer, eds., *Communication in History: Technology, Culture, Society* (New York: Pearson, 2002): 170–8.

3 "1910 Photo of Attack on Gaynor Wins Prize at News Men's Show," *New York Times*, 5 December 1936, 21. Google's Ngram application does not yield a result for the phrase "spot news photo" before 1934.

4 Gaye Tuchman, "Making News by Doing Work: Routinizing the Unexpected," *American Journal of Sociology* 79.1 (July 1973): 120. Italics in original.

5 On the centrality of timeliness to any definition of the news, see Bernard Roshco, "Newsmaking," in Howard Tumber, ed., *News: A Reader* (New York: Oxford University Press, 1999): 34.

6 John Faber, *Great News Photos and the Stories Behind Them* (New York: Dover, 1978): 24.

7 The picture was published as an "Extra" in the *World* on the evening of 10 August. For one contemporary account of this picture's temporal achievement (which neglects to mention the name of the photographer), see "Unusual Snapshots Taken at Thrilling Moments," *New York Times*, 14 August 1910: 7.

8 Beaumont Newhall, *Photography: A Short Critical History* (New York: Museum of Modern Art, 1938): 79.

9 On Newhall's technological commitments, see Sophie Hackett, "Beaumont Newhall and a Machine: Exhibiting Photography at the Museum of Modern Art," *Études Photographiques* 23 (May 2009): 177–91. His successor Edward Steichen would include the picture in his 1949 "Exact Instant," an exhibition of press photography whose very title appears to have been drawn from Newhall's treatment of the Gaynor picture.

10 See "Checklist B," "Action Photography," Exh. 240, 1943, Museum of Modern Art, New York.

11 Stephen H. Horgan, "The Evolution of Daily Newspaper Illustrating," *Graphic Arts and Crafts Yearbook* 1906: 223.

12 On the history of the halftone, see Jacob Kainen, "The Development of the Halftone Screen," *Annual Report of the Smithsonian Institution 1951* (Washington, DC: Smithsonian, 1952): 409–25.

13 C.H. Claudy, "Press Photography," *The Photo-Miniature* 5.51 (June 1903): 107. Emphasis in original.

14 Laura Vitray, John Mills, Jr., and Roscoe Ellard, *Pictorial Journalism* (New York: McGraw-Hill, 1939): 4.

2.13

Rotogravure and the Modern Aesthetic of News Reporting

Andrés Mario Zervigón

Two months after the Wall Street Crash that ushered in America's Great Depression, a politically radical German magazine summarized the events with a remarkable amalgam of news photographs, drawing, and text (Fig. 2.13a). Atop galloping towers rendered by hand, cartoon-like moneybags bear the photographed heads of J. P. Morgan and John Rockefeller. Their stubby arms extending from the overstuffed sacks that are their bodies pull the reins of finance, keeping European stock exchanges under tight control. Behind these plutocrats, the photographed façade of New York's stock exchange towers upward toward a view that opens onto its hectic trading floor. At the other end of the taut reins lie similar circular views of other exchanges, each bearing the same top hat sported by the stern-looking oil magnate "on" his skyscraper perch. Faintly undergirding this scene, a curving globe situates Europe's financial capitals geographically, and signals the world domination of American plutocracy in this moment of crisis.

What this double-spread in the communist-affiliated *Arbeiter-Illustrierte Zeitung* (*AIZ* hereafter) demonstrates is that the news photograph and the rotogravure printed page, on which the former increasingly met its audience, often worked in dynamic tandem, nourished by notions of instantaneity, mobility, and wonder. It was through this conjunction that the full potential of photojournalism as a multi-layered and specifically aesthetic practice was best realized, particularly between the two world wars. This had been a prospect pushed along by advances in halftone printing around the turn of the last century and the release of handheld cameras in the mid-1920s. Rotogravure conclusively capped this progression by improving the pictorial quality of photography in mass print and significantly reducing the price of this sort of mass publication. But it did something else as well. The new technology made the most inventive designs of halftone printing a commonplace. Beautifully reproduced photographs now regularly flew, crashed, and overlapped in a kaleidoscopic sequencing that mirrored the hectic and politically-charged instants caught by the camera. Operating in close tandem, the rotogravure's affordability, visual fidelity, and its openness to free-form design fostered a cutting-edge visual culture for mass audiences, an aesthetic development that rivaled the achievements of avant-garde artists.

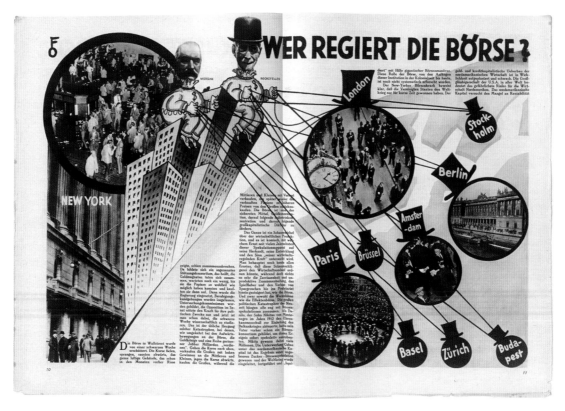

Figure 2.13a Designer signing as "FO," "Wer regiert die Börse?" ["Who Controls the Exchanges?"], *Die Arbeiter-Illustrierte Zeitung [AIZ]*, Vol. 8, No. 49 (1929) pp. 10–11. The Museum of Fine Arts, Houston, Museum purchase funded by Max and Isabell Herzstein.

Photography and photogravure

Ever since the first triumphs in fixing the camera obscura's projected image, photography's home has been as much on the printed page as on light-sensitized copper or photographic paper. Inventor Joseph Nicéphore Niépce achieved his earliest success on the road to the medium's discovery when he incised a sensitized plate of bitumen by exposing it to the sun under a translucent image.[1] The prints he drew from this plate and others like it from 1822 and 1825 were at once among the first photomechanical images and the first photogravures. What qualified them specifically as gravure was that the image plate used to print them was etched rather than rendered in relief. His printer's ink filled recessions incised on a flat surface rather than coating forms protruding from that plane. Rotogravure would be a similar sort of etching but made on a copper drum fitted to a rotary press. Although gravure accompanied photography's discovery, it would take nearly a century of further refinements before it could affordably work on these room-size machines that printed in mass volumes.

Chief among the hazards facing those who sought to expand on Niépce's early precedent was the difficulty in obtaining the same pictorial quality from a printing plate as from a negative. Most press technologies worked in simple black and white, impressing their text and pictures with solid pigment stamped onto a uniform ground. Text appeared in solid blocks and pictures arose through a network of solid—often minuscule—lines varying in width. The printer's limitation to undifferentiated pigment and ground made it exceedingly difficult to duplicate the photograph's subtle gray tones. As a consequence, there long remained a boundary separating mechanical and photographic printing.

An important casualty of this prolonged separation was the full integration of word and photograph on one plate and, thus, on the same printed page. One of photography's inventors, William Henry Fox Talbot, patented an early photogravure process he called photoglyphic engraving in 1858, and this held the potential of combining the mechanically impressed photograph and type in the same periodical issue or book, if not on the same page. But its quality was low. In the case of his own book, which he published as the multi-volume *Pencil of Nature* a decade earlier (1844–6), Talbot produced his photographs separately as negative–positive contact prints and tipped them in by hand at substantial cost. The great breakthrough came in the early 1880s with the invention of halftone printing. Finally photographs and text could be set into the same plate and, a few decades later, spun from rotating presses at great speed. But this relief process only mimicked the gray tones of photography by reducing an image to a small network of dots of varying size. Its quality of reproduction was correspondingly often quite low. More advanced forms of halftone printing developed in the 1890s offered far more detail and even a surprising degree of design liberty, effectively softening this division and inaugurating exciting image-text spreads by inventive editors. But the cost of composing these plates and the limited number of prints they could spin before wearing down meant that design experimentation was generally the exception rather than the rule.[2]

Modern photogravure made complicated text-image-graphic compositions of the sort printed by the *AIZ* easily available. Thus was born the age of the "typophoto," as German typographer Jan Tschichold termed this amalgam in 1928.[3] Like Niépce's early intaglio (or engraving) process, this newer technology is a photoengraving process that uses the action of light to etch an image on a flat tablet. Unlike other photomechanical print techniques, such as halftone relief, it is not limited to the printing of solid pigment on undifferentiated ground. Instead, it can stamp a great variation of tones and fine details that approximate the quality of the traditional photograph produced from a negative. It works by engraving innumerable intaglio cells on a copper plate. These vary in depth depending on the tones of the original photographic negative to which the plate is exposed. The darker the tone, the less light hits the sensitized copper plate, and the shallower the cell. The infinite variation of this depth duplicates the photograph's detail and subtle tonal gradations for mechanical printing. It also allows for the appearance of layered images, text, and graphics, as in the *AIZ* composition where round photo fragments bordered by black appear over the faint design of a globe.

Another key improvement in photogravure, and its partner technology rotogravure, is that the same plate is engraved with text, graphics, and photographs, all at once. No longer was it necessary to prepare halftone or woodblock reliefs in advance, and then slot these into matrices of set type. This development meant that all the typographic and design work took place on the same surface before the printing plate was even prepared. Photograph and text therefore met much earlier on the apparatus that spelled one of the photogravure's greatest technical differences over its predecessors: the light table.

Designing for the rotating copper cylinder

Between the mid-1920s and the advent of computer-assisted publishing around 1967, the mounting of an illustrated magazine page took place not on the plate itself, as with earlier technologies, but on page-sized sheets of glass illuminated from below by a light table. First, a layout grid was devised that roughly determined the placement and dimensions of the images, texts, and graphic elements. The original photographs were then duplicated at the appropriate size and printed directly on positive film.

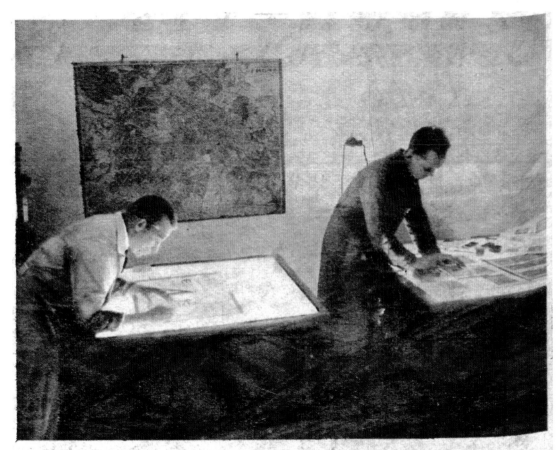

Auf Tischen mit von unten beleuchteten Glasplatten wird das Material der einzelnen Seiten fertiggestellt, die Diapositive und Bronzeabzüge des Textes auf seitengroßen Glasscheiben zusammenmontiert

Figure 2.13b From *"Wie eine Zeitung entsteht"* ("How a Magazine Arises"), double-spread centerfold composition with the embedded feature *"Kupfertiefdruck. Herstellung der A.I.Z."* ("Rotogravure: Production of the AIZ"), in *AIZ* 6, no. 31, 1927, p. 8. Staatsbibliothek zu Berlin – PK/Abteilung Historische Drucke/Signatur: 2″ Ue 526/12: R.

The text was typeset and then similarly rendered on transparent cellophane. The two were then cut and pasted onto the backlit glass sheet roughly following the original layout grid. One can see the layout staff of Berlin's *Arbeiter-Illustrierte Zeitung* leaning over their light tables to arrange these celluloid and cellophane pieces into a unified amalgam (Fig. 2.13b). The result would be a maquette on glass.

Through a series of photomechanical processes, these plates would be printed onto a copper drum leaving the signature intaglio cells of infinitely varied depth. Because the rotogravure's glass plate was literally a blank sheet, the process naturally allowed for a great deal of creativity in how photographs, text, captions, and headlines could be positioned. Captions or headlines, for example, could be hand-drawn on film rather than typeset, and then pasted under, above, or even over the other translucent components. Moreover, because the film and cellophane were so easy to cut, rows and columns of text could be shaped like putty as they filled gaps between pictures and captions, or the photos could be fragmented, made to overlap one other, or otherwise set at unusual angles.

The extraordinary possibilities of this photo-typo-graphic alchemy can be seen on the pages of *Mahnruf* (1923–33), the monthly magazine of the radical-left *Internationale Arbeiterhilfe* (*IAH*, or Workers International Relief), an organization based in Berlin and generously (but secretly) funded by Moscow. In a 1931 double-spread titled "No Work—No Bread" (Fig. 2.13c), circular photo fragments cluster and overlap toward the middle of the composition while another fragment above-right shows a hand outstretched toward a woman tipped toward the left, her face aghast at the meager sum of coins carried by the hand's palm. Most of the article's text flows around the circles, like water filling empty volume, while other texts and the title itself run over these photos.

In a particular flourish, the magazine read by a woman at the bottom-left features slogans that spring from her periodical's pages and declare "WOMEN MUST READ . . . AND LEARN!" Although not always realized to this extreme, the rotogravure's process encouraged the creation of eye-catching photomontages. This could make every page or double-spread a complete design unit, blurring the distinction between picture, word, and graphic when best realized.

Once transferred to copper cylinders and fitted on a rotary press, these amalgams could print high volumes on cheaper, lighter paper than was otherwise possible with the halftone. Unique to the rotogravure process as well was its use of thinner inks of various colors. These liquids had to flow rapidly in order to fill the gravure cells, a technical specificity demanding nearly the opposite consistency of halftone printing, which was made in relief. In the older technology, denser gooey inks had to stick tightly to protruding forms, which were usually small dots, rather than rush to fill recessed spaces. These thinner inks could be far less opaque and were available in many colors. Some magazines chose a sepia-toned dye that better favored the subtle tonal gradations of photography. Periodicals could also opt for red, blue, or any other color depending on the desired effect. Generally, an entire issue would be printed in one color, although the occasional translucence of these inks could create the illusion of multiple colors. If desired, a publisher could send pages through two or more printing cycles, thereby producing multi-chromatic arrays that caught the eye with even greater allure.

The news photograph and rotogravure

The affordability at high runs, visual fidelity, and design liberty of this process made the most exciting design work of halftone printing a regular eye-catching affair. Leafing through the more creative of these

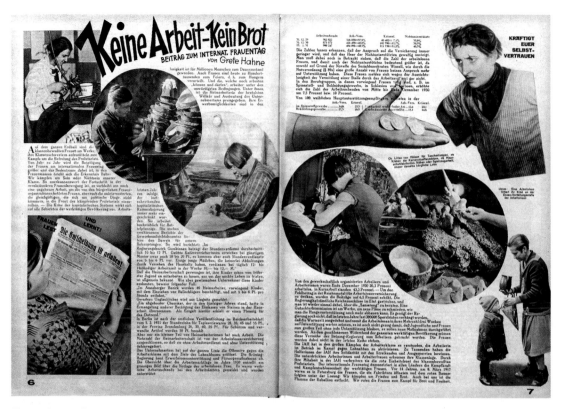

Figure 2.13c Grete Hahne, "*Keine Arbeit—Kein Brot. Beitrag zum Internat. Frauentag*" ("No Work–No Bread: An Article on the Occasion of International Women's Day"), in *Mahnruf*, no. 3, 1932, pp. 6–7. Stiftung Archiv der Parteien und Massenorganisationen der DDR im Bundesarchiv (SAPMO), Berlin.

rotogravure periodicals, such as the Berlin-based *Arbeiter-Illustrierte Zeitung (Worker's Illustrated Magazine*, 1921–38), the French *VU* (1928–40) and the Soviet *USSR in Construction* (1930–41), was like peering into a pictorial whirlwind. As a reader turned an issue's pages, multiple pictorial shards slid against each other, arrows pointed, graphs indicated, and free-flowing text divulged the week's news. But even though each page or double-spread could function as a deeply integrated graphic unit, the photograph nevertheless provided the greatest allure and frisson in an increasingly common frenetic assembly. Essentially, the picture, or a number of them stacked in interesting ways, almost always provided the pole around which the larger assembly spun.

Under these typo-pictorial conditions, the news photograph thrived. It reached larger audiences than ever before and struck with a clarity that often stunned or—alternately—repulsed its audiences, depending on the beauty or ghoulishness of its highly legible content. But its flash isolation of an important moment and place, a characteristic that increasingly defined its pictorial style, also helped determine the often frenetic-looking layout of the pages on which it appeared. Duration had retracted into tighter units, as the cameras snapping before cataclysmic events now made manifest. Simultaneously, time began moving so quickly that its frames seemed to overlap, as illustrated periodicals had increasingly revealed

across their flipping pages. This perfect fit of the news picture with the printed page had already begun to unfold to great effect in the 1890s with halftone printing. But rotogravure's openness to design liberty encouraged editors and print technicians to devise these sorts of complex graphic systems on a far more regular basis, generating compositions that signaled the ever more hectic pace of modern life. The experience of consuming an illustrated weekly by the late 1920s became as vertiginous as the rapidly unfolding events reported by the photographs within their typographic units, a perceptual encounter that approximated the newest fashions in modern cinema.

VU emphasized this development in its 1928 inaugural issue. "Produced through the latest technology and based on an entirely new concept," it proclaimed, *VU* was to be an "ILLUSTRATED MAGAZINE that reflects the brisk rhythm of modern life, a magazine that reports and documents every aspect of contemporary life," including political events, disasters, and sporting achievements. On its pages, the newest photo, print, and transport technologies would cohere in a blend that, through its content and look, reflected the harried pace of interwar modernity. As the magazine's statement further emphasized:

> From every place on the globe where an event of any significance occurs, photographs, dispatches and articles will find their way into the pages of *VU*, with columns and special reports and illustrations serving as links that connect its readers with the rest of the world, giving them a bird's-eye view of life as it is lived in far-flung parts.[4]

Enhanced by the affordability and design liberty of rotogravure, the illustrated periodical could now regularly offer a cutting-edge look, if the editorial and design team possessed the initiative. Availing themselves of this potential, they could define page after page by the fast-paced reporting of the news photograph, which was increasingly taken in the thick of key events. Typographic elements could easily be made to swirl from and around the mass-reproduced image. Signals of action flashed by the modern news photograph, such as vertiginous vantage points, close proximity, and the blur of half-stopped action, could easily be coordinated with the similarly vertiginous designs of accompanying graphic and textual work, to conjure a complete unit based on spontaneity and mobility. What once lay at the extreme of halftone design possibilities now became an everyday performance in print.

The astringently political staff of *Mahnruf* was particularly well-disposed to realize the design possibilities of rotogravure on a regular basis (Fig. 2.13d). Its later issues were printed in rotogravure and took great advantage of the process' design liberty. Another double-page spread from February 1933 shows a proudly-standing worker from a dramatic worm's-eye view at its center. As he rises to near page height, photos of worker misery cluster to the left, and shots of radical "solidarity"—realized in strikes and protest—overlap each other to the right. This second array floats on a field of red that matches the thick line on which the Paul Bunyan-like worker stands. In this bar that runs the double-spread's length, a quote by Marx famously intones that philosophers have only interpreted the world, whereas the necessity is to change it. The arrangement of word and image suggest that the agent of this transformation is the hammer-bearing worker who pounds misery into solidarity with spectacular and dynamic success. Here was the perfect pictorial realization of the agitational charge of the Workers International Relief, realized on a monthly basis through rotogravure's ready openness to extreme design.

This new technology helped realize German artist Johannes Molzahn's 1928 prophesy that the photograph in mass print would become "the pacesetter for the tempo of time and development." As he

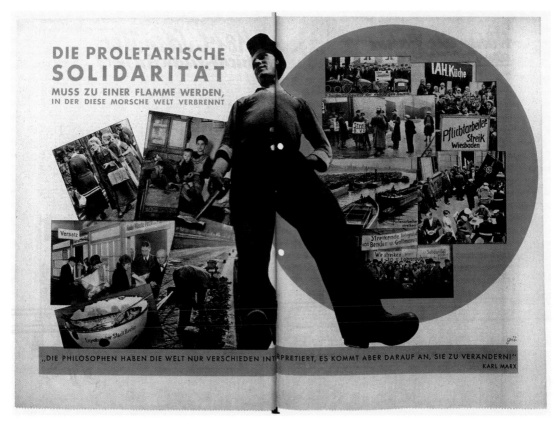

Figure 2.13d Designer signing as "gü," "*Die proletarische Solidarität muss zu einer Flamme werden, in der diese morsche Welt verbrennt*" ("Proletarian Solidarity Must Become a Flame That Burns This Rotten World") in *Mahnruf*, no. 2, 1933, pp. 8–9. Stiftung Archiv der Parteien und Massenorganisationen der DDR im Bundesarchiv (SAPMO), Berlin.

explained, "the multitude and arrangement of visual sensations forces the uninterrupted work of assimilation on the eye and the psyche." With photo, type, and graphic regularly and fully integrated on the rotogravure page, this visual sensation was indeed accelerated and the modern urban citizen now had to follow Molzahn's imperative: "Stop Reading! Look!"[5]

Notes

1 More specifically, he prepared the plate for etching; the bitumen hardened in relationship to the light striking its surface. He then washed the plate with lavender oil, which diluted and washed away the unexposed portions much as acid would in a traditional copper engraving. For a classic review of this process, see Beaumont Newhall, *The History of Photography* (New York: Modern Museum of Art, 1988): 13–16.

2 For more on this lack of picture-text correspondence in halftone printing, see "Before *VU*," in Michel Frizot and Cédric de Veigy, eds, VU: *The Story of a Magazine* (London: Thames and Hudson, 2009): 288–95. My account of the rotogravure process is heavily indebted to this book and Frizot's essay "Photo/graphismes de magazines:

Les possibles de la rotogravure, 1926–35," in *Photo/Graphisme* (Paris: Jeu de Paume, 2008): 5–12. For the spectacular possibilities of halftone printing that defined the exception rather than rule, see Thierry Gervais, "L'invetion du magazine. La photographie mise en page dans 'La Vie au grand air' (1898–1914)," in *Etudes Photographiques* No. 20 (2007): 50–67.

3 Jan Tschihold, *Die neue Typographie. Ein Handbuch für zeitgemäss Schaffende* (Berlin: Bildungsverband der deutschen Buckdrucker, 1928).

4 "Reflections on a New Magazine," in Frizot and de Veigy, *VU*: 300–1.

5 Johannes Molzahn, "Stop Reading! Look!" in *Das Kunstblatt* Vol. 12.3 (March 1928): 78–82. Translated and reprinted in Anton Kaes, Martin Jay, and Edward Dimendberg, eds, *The Weimar Republic Sourcebook* (Berkeley: University of California Press, 1994): 648–9.

2.14
A Short History of Wire Service Photography

Zeynep Devrim Gürsel

Behind every iconic photograph is a rarely told story of circulation.[1] Much has been written about images that move us and how they have such affective powers.[2] Yet the question of how photographs themselves move, the means by which they circulate, has received much less attention. For news images to have the tremendous affective and political impact scholars often highlight and analyze, they needed initially to get to one or several publications. This chapter focuses on the physical movement of images, and specifically on wire services as institutions that move most of the photographs that accompany daily news stories worldwide.

The story of transportation is central to photojournalism, for it is only by circulating in particular networks and appearing in certain types of publications that a photograph becomes a news image. There are two important stories here: the well-known one about the rise of photojournalism and the less-known one about the rise of distribution networks for journalistic photographs. Both are entangled histories of events deemed newsworthy in distant places, of technological developments, commercial interests, and new roles for old infrastructures.

News agencies (also called news services) were initially formed in the mid-nineteenth century to share the cost of gathering news.[3] News services became "wire services" as they turned to the latest invention— the electric telegraph—to send news farther and faster. The Associated Press for example, was formed in 1846 by six New York City newspapers to share the costs of getting news of the Mexican War via boat, pony express, and telegraph, rather than by relying on the US Post Office. Today, wire services are news organizations responsible for gathering news, both text and visuals (still and moving imagery). The three largest are Associated Press (AP), Agence France-Presse (AFP), and Reuters. They disseminate the majority of the international information broadcast in the world every day by serving as wholesalers of news for their subscriber base of worldwide news publications.

Initially news services were designed to dispatch text. If photographs were to be used to illustrate the news, there needed to be a transportation network to get them to the publications. Moreover, these distribution networks would develop according to the commercial value of news images and the costs of the means of transportation and eventually transmission available. There was a sort of feedback loop; the more publications believed that news images moved publics, the more necessary it became to move photographs quickly. Already by 1894 a photographic agency, the Illustrated Journals Photographic Supply Company of Ludgate Hill, guaranteed images from any part of

the United Kingdom in twenty-four hours, thus tying the visual news cycle to the means of transportation available.[4]

Communication networks were substituted for transportation networks when it became possible to transmit images over telegraph wires, eliminating the need to wait for carriages, trains, and ships. By 1913 pictures were being transmitted across the Atlantic by cable, though prohibitively high costs made very few photographs worthy of cable transmission. The 1920s saw experiments with telephotography—the transmission of photographs over dedicated telephone lines—but again costs were considerable. The technology that transmitted images by cable is the same as common fax technology.[5] Patented in 1843, it was not put to commercial use until the 1860s. More importantly, it did not take off in the general consumer market until over a century later in the mid-1980s when the Japanese economy boomed: fax technologies were useful for languages whose characters did not adapt easily to Western telegraph and telex systems.[6] In other words, it took the rise of the Japanese economy near the end of the twentieth century to produce sufficient commercial interest to justify the production of machines that would enable individuals to transmit images via telephone lines.

But even in the early twentieth century when costs were prohibitive for most individual consumers, institutions were nevertheless interested in the technology's potential. When telecommunications giant AT&T was unable to generate sufficient profit from individual users, it sold its picture telegraphy service to the Associated Press in 1933, and AP Wirephoto was launched in 1935.[7] With the introduction of Wirephoto, images could travel as quickly and as far as text. By 1938 pictures constituted almost 40 percent of the content in American dailies.[8] Given the scale of the conflict on several fronts and across four continents, the mobility of photographs became particularly important in covering World War II.

It made sense that wire services were the ones pursuing costly photographic transmission technologies. Whether corporations, government subsidized agencies, or not-for-profit cooperatives, these institutions understood the commercial value of information and had decades of expertise in distributing news stories to ever widening geographies. Take, for instance, Agence Havas, which later became Agence France-Presse. In 1835, more than a decade before the founding of AP, Charles-Louis Havas had established an international news service comprised of correspondents and translators. Paul Reuter and Bernhard Wolff set up rival news agencies in London and Berlin respectively. In 1859 the three agencies—Havas, Reuters and Wolff—divided Europe up into exclusive zones of reporting, essentially three non-competitive markets for news. This agreement lasted until the invention of shortwave wireless in the 1930s significantly reduced communication costs and enabled far greater reach for each of the wire services, making it profitable for them to compete once again.

Until the widespread use of digital photography in the late 1990s, wire services were one of three main sources of news photographs for news publications. The others were photo agencies and historical archives. The aim of a wire service was to have a photograph available on the wire as soon as possible after an event. These were "fast" photographs.[9] In contrast, news magazines would send freelance, staff, or contract photographers on assignment to cover the event. Smaller photo agencies representing freelancers catered mostly to the needs of news magazines, many of which distinguished themselves from daily newspapers through their photographic feature stories. Freelance photographers shipped their undeveloped rolls of film via airplane back to their agency or the publication that had assigned them. These images were often published some time after the event had been in the dailies but might accompany more in-depth reporting on the event. These were considered "good" photographs.

This is not to say that wire service photos—"fast" photos—were necessarily "bad," but that they were perceived as less complex images.[10] Their value was their speed, and speed also determined their

content. Because the transmission of a single image took anywhere from four to fifteen minutes, wire photographers were trained to take shots that summed up the event in a single image—getting *the* picture—rather than in a series of images that collectively told a story or constituted a photo essay. Eventually when more news publications printed in color, color photographs were sent via wires as well. Each CMY (cyan, magenta, yellow) required seven minutes and several additional minutes for the photo to be written to tape, hence a single image could take up to half an hour. There was rarely any point to transmitting a series of photographs over the wire because daily newspapers, wire services' main clients, did not have space for photo stories in their pages. Thus, a wire service photographer excelled in getting a single summary image. In 2004, the senior manager of the AFP photo department at the Paris headquarters defined a wire service in a single word: "Speed."[11]

Another senior photo department official also emphasized speed as he led new bureau chiefs through orientation one day: "The most important thing for us is speed. We must not leave room for AP, Reuters, or Getty." Indeed the highest level daily planning meetings would begin with reports about which wire service had been the first to report each major story, and the history of journalism is full of stories about a wire service having a critical lead on its rivals. One of the visiting new bureau chiefs that day asked if publications had any sense of loyalty to a particular wire service, since many of the major publications subscribe to multiple wire services and use photographs from all of them. The photo official replied emphatically, "Yes, I believe speed creates loyalty." Speed—being the first with a photograph—allows publications to pay attention to the content of an image. The director of photography confirmed what the others had been saying by highlighting that speed was paramount in an environment where publications subscribed to all the major wire services, each competing for the same spots on front pages, "On the other end [of the wire] there is always someone waiting for the images no matter what the quality and therefore if you wait on your images they'll never get played [published.]"

Perhaps the best way to tell the story of digitization in photography is to suggest that it was just the latest innovation by wire services to get their photographs to subscribers faster. AP introduced the first digital camera for photojournalists in 1994. Their photographers shot the 1996 Super Bowl entirely without film, confirming that digital technologies could be relied upon for coverage of the largest news stories even in sports where speed is at a premium. The advent of digital photography and transmission led to the rise of large corporate "visual content" providers.[12] The two most often credited (or cursed, depending on the speaker) with changing the landscape of the image industry—Corbis and Getty Images—were founded by men whose expertise was not in journalism but rather corporate finance and technology. Both Corbis and Getty grew by acquiring the major news photography agencies of the day and historical archives to form large online image banks with millions of instantly available digitized photographs for anyone seeking visual content. Suddenly the established wire services were no longer the only ones who could instantly transmit images, and all distributors were in competition with one another. All photographs had to be "good" because they were all "fast."

Wire services, like all visual content providers, now use the Internet to transmit images. Yet, wire services have thus far survived the obsolescence of the wire. They still disseminate a majority of the international information broadcast every day. This is because of the continued pertinence of the wire's infrastructure, understood not only as the physical wire but also as the totality of organizational structures, protocols, practices, and conditions that allow for and direct the circulation of news by a wire service. Today it is the wire in this sense, rather than the speed enabled by wire transmission, that is valued. Historically, getting to an event or its aftermath first, and finding a timely way to transmit an image back to headquarters and then to the appropriate publications, was the primary challenge for wire service

photo departments. In the early years of digital photography when few freelance photographers could afford digital cameras or satellite phones required for remote transmission, the AP website bragged, "There is no place on earth too remote for same-day news picture transmission."[13] Today the challenge is no longer simply to offer a representation but to offer a validated representation chosen from the overwhelming number available. Speed alone no longer guarantees success for a wire service; new challenges arise from the abundance of images. Wire services function as gatekeeeepers and sort through this abundance for the critical and credible images.

Moreover, today millions of people have access to the means of production and circulation of visual representations and are regularly promised opportunities to broker information, especially images, by being "i-witnesses" or citizen journalists. The Internet enables many new kinds of image brokers to put photographs into potentially global circulation: governments, military personnel, activists, amateur photographers, and terrorists all have networks through which they can circulate images extensively online.[14] Editors repeatedly noted that, although getting to the news site first remains important, it is now critical to be the source that has professional image brokers, both photographers who can take images and editors to evaluate and validate them, close to events so that they can understand images in context and gather citizen-produced images, if necessary.[15] "First to bring you the news" comes after "reliable" and "impartial" in a 2012 AFP video about its visual services.

Today major wire services all underscore the scale of their services both in terms of global coverage and in terms of sheer numbers of images transmitted every day, the size of their archives, and the number of photographers working for them. Reuters Pictures' website boasts that its "global network of 600 photographers distributes 1,600 pictures each day, added to a growing archive of over 6 million. Images are transmitted within minutes to the world's media providing a constant window on the world."[16] Whereas being in multiple locations served to transmit images faster than anyone else, today wire services underscore that they are global networks with regional expertise, languages, topical breadth of coverage and reach ("Reaching a billion people everyday" reads Reuters' tagline) on multiple platforms in multiple media.

After more than a century of visual journalism, significant events are rarely reported without images. The demise of physical newspapers at the beginning of the twenty-first century led to significant reductions in staff, and in some cases shutting down photography departments altogether, yet the demand for news images remains.[17] Furthermore, whereas limited physical space in a print publication meant that not every article would be accompanied by an image, online versions of publications allegedly had no space concerns and, so, every news story could be accompanied by images—photo essays as well as single shots. Wire services now feature their editing function by prominently displaying slideshows on various topics—not just single shots. In short, despite rendering the physical wire obsolete, digital transmission has only revalidated the function of wire services.

As the uncertainty in the world of journalism continues, the specific role for photo departments in wire services may be unclear. What seems more certain, for now at least, is that they will continue to play a significant role. Wire service' websites and news aggregator websites that automatically publish "wire feed" now provide multiple publics access to the wire—a constant window on the world—without the intermediary of publications. At the same time their business models fluctuate as journalism is restructured, and subscription models alone seem inadequate. Many historic publications have folded and "the world's media" looks very different than it did just a few decades ago, but there are also new types of clients, from individual bloggers to corporations that some wire services now seem open to serving. Today many press images go beyond illustration and are often factors in causing these

events, often playing a critical and highly controversial part in political and military action. Paying attention to how images circulate and the institutions that validate their circulation has become ever more critical.

Notes

1 See Robert Hariman and John Louis Lucaites, *No Caption Needed: Iconic Photographs, Public Culture, and Liberal Democracy* (Chicago: University of Chicago, 2007) for accounts of how images gained significance through their circulation after publication.

2 Some examples include Ariella Azoulay, *The Civil Contract of Photography* (Cambridge, MA: MIT Press, 2008), Amahl Bishara, "Covering the Barrier in Bethlehem: The Production of Sympathy and the Reproduction of Difference," in *The Anthropology of News and Journalism: Global Perspectives*, S. Elizabeth Bird, ed. (Bloomington: Indiana University Press, 2010), Susan Sontag, *On Photography* (New York: Noonday Press, [1989] 1977). Susan Sontag, *Regarding the Pain of Others* (New York: Picador, 2003), Barbie Zelizer, *About to Die: How News Images Move the Public* (New York: Oxford University Press, 2010), and David Levi Strauss, *Between the Eyes: Essays on Photography and Politics* (New York: Aperture Foundation, 2003).

3 Oliver Boyd-Barrett's *The International News Agencies* (London: Sage, 1980) and his introduction to *News Agencies in the Turbulent Era of the Internet* (Government of Catalonia, 2010) provide extensive histories of international news agencies.

4 Ken Baynes Hopkinson, Allen Hutt, and Derrick Knight, *Scoop Scandal and Strife: A Study of Photography in Newspapers* (London: Lund Humphries Publishers, 1971).

5 See *Spot News 1937*, Jam Handy Organization, Detroit http://internetarchive.org

6 Jonathan Coopersmith, "Facsimilie's False Starts," *IEEE Spectrum* (1993): 46–9.

7 Jonathan Coopersmith "The Failure of Fax: When a Vision is not Enough," *Business and Economic History* 23, (1994): 272–82.

8 Barbie Zelizer, "Journalism's 'Last' Stand: Wirephoto and the Discourse of Resistance," *Journal of Communication* 45:2 (1995): 78–93.

9 "Fast photographs" and "good photographs" regularly came up in conversations about wire service photography with professionals in the image industry.

10 For example, the work of wire service photographers was always present but rarely showcased at the prestigious annual photojournalism festival, *Visa Pour L'Image*.

11 See Zeynep D. Gürsel, "The Politics of Wire Service Photography: Infrastructures of Representation in a Digital Newsroom," *American Ethnologist* 39.1 (2012): 71–89 for an extended ethnography of the AFP photo service. All quotes are from fieldwork conducted by the author in 2003–2005 at nodal points in the international photojournalism industry.

12 Paul Frosh, *The Image Factory: Consumer Culture, Photography and the Visual Content Industry* (London: Berg, 2003). David Machin, "Building the World's Visual Language: The Increasing Global Importance of Image Banks in Corporate Media," *Visual Communication* 3.3 (2004): 316–36.

13 http://www.ap.org (accessed 28 September 2002).

14 Zeynep D. Gürsel, "The Politics of Wire Service Photography: Infrastructures of Representation in a Digital Newsroom," *American Ethnologist* 39.1.

15 Many wire photographers transmit from the event or a nearby location and, while exceptionally fast, many industry professionals expressed concern that these images may not be appropriately contextualized until they reach an editor with a little more distance and information about relevant events.

16 http://www.reuters.com (accessed 20 December 2013).

17 Pablo I. Boczkowski, *Digitizing the News: Innovation in Online Newspaper*s (Cambridge, MA: MIT Press, 2004). Zeynep D. Gürsel, "A Challenge for Visual Journalism: Rendering the Labor Behind News Images Visible," *Anthropology Now*, 17 July 2013. Neil Henry, *American Carnival: Journalism under Siege in an Age of New Media*. (Berkeley: University of California Press, 2007). Philip Meyer, *The Vanishing Newspaper: Saving Journalism in the Information Age* (Columbia: University of Missouri Press, 2004).

Speaking of News Pictures

"Famished for News Pictures": Mason Jackson, The *Illustrated London News* and the Pictorial Spirit

Jennifer Tucker

The origins of pictorial journalism are frequently traced to the 1880s and 1890s, years of fundamental photographic and printing innovations and the rise of "New Journalism." But for contemporary observers, the late nineteenth century was not the beginning of the era, but, instead, the high watermark of three hundred years of progress in the art of news pictures: a process that began with illustrated broadsheets and culminated with the birth, in 1842, of the world's first illustrated weekly newspaper, the *Illustrated London News*.[1]

The founder of the *Illustrated London News*, Herbert Ingram (1811–60), was a news vendor in the East Midlands who, after noticing that more copies of the *Observer* and *Weekly Chronicle* sold when they contained engravings, decided to start a paper whose "chief attraction" was "its *pictures*."[2] The *Illustrated London News* rapidly gained a large mass readership relative to many other British papers but, perhaps even more significantly, altered the way news was defined and consumed. By the 1890s illustrated newspapers were established in many countries: at least five in Paris, one in St. Petersburg, six in New York, three in Australia, two in Warsaw, one in Mexico, one in Rio de Janeiro, and two in Montreal.

Few participants in the forces rapidly transforming the late-Victorian news picture business spoke with more knowledge about the changes of "pictorial journalism" in England than the engraver whose ideas are the subject of this essay: the artist, editor, and journalist, Mason Jackson (1819–1903). From 1860 to 1890, Jackson, a wood engraver by training, held the prestigious position of second art editor of the *Illustrated London News*.[3]

In 1885 Jackson wrote and published a book, *The Pictorial Press: Its Origin and Progress*, an illustrated history of the intellectual origins and development of modern pictorial journalism from the English Civil War to the *Illustrated London News*. Contained within its pages were reproductions of more than 150 historical news pictures from private libraries and print collections. *The Pictorial Press* remains a unique historical source about the practice and theories of news pictures in the nineteenth century. This essay considers Jackson's ideas in the light of historical understandings about the complex relations

between fine art, popular journalism, historical narrative, and visual display in the world that the Victorians made, showing how Jackson believed that illustrated news was about activating a meaningful history: not just delivering news pictures to the public to satisfy their transient curiosity, but, instead, catering to a primal impulse that Jackson referred to frequently in his writings as a "Pictorial Taste Universal."[4]

By the time his book was published, Jackson had served as art editor of the *ILN* for nearly a quarter century, having participated—both as a contributing artist and as an editor—in its rapid rise to the position of the world's leading purveyor of news pictures.[5] "When the history of our own age comes to be written," Jackson predicted, "the pictorial newspapers will form an inexhaustible storehouse for the historian." As Jackson noted, the preface to the first volume of the *Illustrated London News* spoke to the value and interest of the work to future historians: "What would Sir Walter Scott or any of the great writers of modern times have given—whether for the purposes of fiction or history, or political example of disquisition—for any museum-preserved volume such as we have here enshrined?"

> The life of the times—the signs of its taste and intelligence—its public monuments and public men— its festivals—institutions—amusements—discoveries . . . what *must* be all these but treasures of truth, that would have lain hidden in Time's tomb . . . but for the enduring and resuscitating powers of art.[6]

Jackson traced a historical passage from the era of rough woodcuts to the sophistication of wood engraved news images. Long before the initiation of regular newspapers in England, there existed small tracts, irregularly published—some adorned with engravings on the title pages. Although drawings sometimes were made depicting battles and sieges, these early news illustrations tended, he noted, to be either "works of pure imagination" or woodcuts that were re-used multiple times to depict different events.[7] An exception to the general practice of using woodcuts was a pamphlet containing eight pages of illustrations, all etched on copper, representing the execution for treason of the Earl of Stafford in 1641.[8] Revising the widespread contemporary dating of the time that the first caricatures had appeared to the eighteenth century, he retorted that caricatures were of "frequent occurrence" during the English Civil War, adding that graphic satire rose dramatically around this time, especially in relation to religious matters.[9] *Mercurius Civicus*, founded in 1643, and "therefore entitled to be ranked as the first illustrated newspaper," frequently reproduced illustrations: mostly wood engraved portraits although, he noted that, reflecting contemporary artistic practice, "sometimes the same woodcut is used to represent more than one person."[10]

Miscellany characterized the emerging news picture genre. Popular topics included shipwrecks, murders, a "great fire—a remarkable murder—a fatal balloon ascent"—events that were "unusual or interesting: these were the subjects seized upon at the moment" to gratify the appetite for visual immediacy in journalism. Wars continued to be a staple subject: "the food on which picture newspapers thrive best has been abundantly supplied."[11]

Yet, despite the evident powerful "public craving" or "appetite" for news pictures, Jackson noted that illustrated journalism took a long time to manifest itself in the early seventeenth century.[12] It was sixteen years after the founding of the *Weekly News* in 1622, for example, that it published its first copper engraving in 1638 (of a fire on an island). During the Restoration, several illustrated broadsides of news were published, including a copper-plate engraving purported to be the appearance of the Old Bailey Court at the trial of the Regicides in 1660, which paired two images, the execution of Charles I and of the regicides.[13] But despite such examples, Jackson noted that very little pictorial journalism was done, even

less of which was regarded as "news." Interested in how categories of genre were starting to evolve and be defined, he suggested that the pictorial content of early newspapers was more of a satirical and humorous kind, making it hard to tell whether what was reported was "truth or fiction."[14]

Jackson's history of pictorial journalism described how, while the numbers of periodical papers published in England rose rapidly after official censorship of newspapers ceased in 1695, the art of news pictures lagged: "The art of wood-engraving, the readiest and least expensive method of illustration, was now in the lowest possible condition." For that reason, primarily, he said, "the newspapers at the end of the seventeenth century contain scarcely any illustrations."[15] Visible in a myriad of small visual acts—the insertion into a newspaper of a map of a place where a war was raged or of a diagram of a city plan, or of the use of copper engravings for "enlivening the pages of the early newspapers"—the idea of illustrating current events had "already taken root" long before the establishment of regular newspapers.[16]

According to Jackson, the *Grub Street Journal*, published during the 1730s, was the first historical example of a newspaper employing the expensive process of copper-plate engraving for semi-regular illustrations, and for printing the plate in the body of its pages.[17] Subsequently, *The Daily Post*, launched in 1740, provided a further example of a *daily* paper attempting to illustrate current events. Jackson cited it as an example of "the tendency of newspapers, in times of excitement, to call on the artist's pencil to aid the writer's pen."[18] Inventorying famous firsts in the history of illustrated journalism (and drawing perhaps upon the motifs of chronologically organized picture albums), he then gave the example of "The view of Fort Fouras" [1758], published in *Owen's Weekly Chronicle*, as "the earliest attempt I have seen in a newspaper to give a pictorial representation of a place in connexion with news."[19] "Naval and military officers in all parts of the world" were among the most valued correspondents of the modern illustrated newspapers," he added, because they sometimes supplied newspapers (as they did their family and friends) with their eyewitness sketches.[20]

Novel values were being crafted, along with the new images. Jackson especially credited the *Observer, Bell's Life in London*, and the *Weekly Chronicle* as the first newspapers "to direct attention as being the main supporters of the pictorial spirit until it culminated in the *Illustrated London News*."[21] The *Observer* (which, in 1885, was the oldest existing weekly newspaper) was the first newspaper to use the restored art of wood engraving—"reawakening," like a fairy tale, a "dormant idea."[22] Jackson especially credited the pioneering wood engraver and famous illustrator of natural history books, Thomas Bewick, for teaching the restored art to a new generation of engravers. This was especially true at the *Observer*. Already a model for other newspapers, with its rough woodcuts of the Cato Street Conspiracy (1820), and its lush engravings on a large scale of the 1821 coronation of King George IV, the *Observer* was "the pioneer of modern illustrated journalism."[23] With its published engravings of balloon ascents, views of the new Houses of Parliament, and "repulsive" criminal records (a favorite subject), moreover, the *Weekly Chronicle*, first published in September 1836, established news pictures as a visual genre of tremendous miscellany.[24]

All of this prepared the ground for the debut of the *ILN*. The *Illustrated London News* was recognized immediately as a "bold undertaking." On 14 May 1842, in the first issue of the newspaper, readers were treated to the picture, "View of the Conflagration of the City of Hamburg," a picture that was "historically significant," stated Jackson, as "marking an epoch in the history of the Pictorial Press."[25] The picture shows spectators watching the fire from the safety of the opposite shores, witnessing events from a safe distance—much in fact like news readers, who were positioned to view the prints of topical news in far away places. The attempted assassination of Queen Victoria was the most important "news of the hour" covered by the *ILN* that summer.[26]

The *ILN* differed from previous publications that had featured illustrations. With sixteen pages covered with thirty-two woodcuts, large and small, accompanying forty-eight columns of news, it was unlike anything readers had ever encountered before. As historian Brian Maidment has noted, the *ILN* introduced many innovations in periodical illustration, making the wood engraving "larger, more highly finished, and more profuse than any previous publication."[27] Noting how the images "writhe" about the page ("shape shifting" and "bullying" the text), Maidment calls attention to the centrality of the pictures *as news*. Expensive, but priced at a point that many among the wealthier middle classes could still afford, by 1863 the magazine was selling 300,000 per week. (For the marriage of Prince of Wales, an unprecedented 930,000 copies of the paper were sold.)[28] The character of subjects depicted was multifarious: illustrations of police reports mingled with images of the ballet, a public dinner, a horserace, a boat launch, sketches of Chartist riots, and a new series of "Parliamentary Portraits," of Disraeli and other politicians.[29] As Julia Munro shows, from the outset there were ties between the *ILN* and the development of photography. In just the third issue of the periodical, 28 May 1842, for example, the *Illustrated London News* published reactions from other periodicals to *ILN*'s large-scale engraving of the London cityscape, based on a series of daguerreotypes by Antoine Claudet.[30]

Jackson remarked that the "London citizen" might drink coffee and read about "what is happening on every side of the inhabited earth."[31] However, this rapid gathering of information from around the globe, made possible by the telegraph, put the pictorial press at a disadvantage, because by the time a picture was made, the subject was no longer fresh. The pictorial press, Jackson noted, would suffer from this disadvantage until some method was invented of sending pictures by electricity—for "by the time it can publish sketches of interesting events in far distant countries the freshness of the news is gone, and the public mind is occupied with later occurrences." "Until some method is invented of sending sketches by electricity," he added, "the pictorial press must endure this disadvantage, but in the meantime it spares no pains to overtake the march of events."[32]

This production of "a modern pictorial newspaper," as it came to be described, was accomplished by a reorganization of labor and capital on a large scale.[33] The *ILN's* headquarters at 198 Strand was a large, open space where literary and artistic aspirants came to test their ideas before the editor.[34] The large and diverse staff of the *ILN* included, for example, paper makers, ink makers, wood draughtsmen, engravers, electrotypers, roller makers, machine men, and warehousemen.

An invention that, for excitement, rivaled other innovations in periodical illustration was that of the "special artist", who was depicted in several engravings published in the *ILN* over the years, shown risking life and limb in order to "overtake the march of events."[35] Fulfilling a role said to have commenced with the Crimean War, the special artists had a rapid way of working to make the sketch, using what Jackson described as a kind of "pictorial shorthand."[36] Special artists were active: "Now he is up in a balloon, now down in a coal-mine; now shooting tigers in India, now deer-stalking in the Highlands."[37] One artist wrote a letter to Jackson detailing how he had rolled his sketches into pills to disguise them. Jackson told the story of a French correspondent of the *ILN* who supplied sketches to the *ILN* during the Prussian siege of Paris by photographing sketches and sending them by balloon outside the city to London.[38]

With the next two figures, Jackson gave the example of the adaptation of a rapid sketch in the engraving of the surrender of Sedan, published in the *ILN* on 17 September 1870. While both sketches depict the surrender, they reveal characteristically different stages and values of visual documentation in the field: the sketch and the finished engraving. The sketch, reproduced in Fig. 2.15a, was probably taken "under fire."[39] The dynamism of the scene—cannonball projectiles, explosions, a soldier waving a

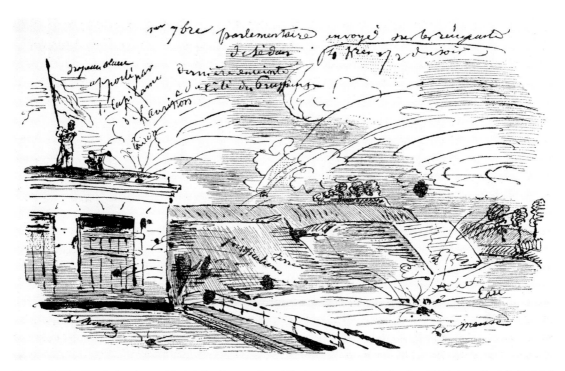

Figure 2.15a Facsimile of a rapid sketch of surrender of Sedan, around 2 September 1870, by a French "special artist" during the Franco-Prussian War when French emperor, Napoleon III, was taken prisoner with 100,000 of his troops. The sketch, Jackson noted, was probably "taken under fire." From Mason Jackson, *The Pictorial Press: Its Origin and Progress* (London: Hurst and Blackett, 1885), p. 320.

flag of surrender atop a building, a trumpeter—is captured in the rapid rough sketch, as field notes annotate the physical and human landscape. Like the copy of the engraving beside it, the sketch appears to have been signed, though the name is illegible. For the engraving based on the artist's sketch (Fig. 2.15b), the engraver took as the "cream or heart of the sketch" an officer waving a white flag over the gate of Sedan attended by a trumpeter, while the rest of the sketch ("comparatively unimportant") was left out. Unlike in the sketch, the engraving focuses the energy of the scene in the figure of the soldier in the center, waving a flag whose motion and color reinforces transit of white clouds in the background.

Jackson wrote, of this image, that he published it in order to "show the reader the way in which hurried sketches are sometimes adapted to the purposes of a newspaper without at all impairing their original truth"—in this case, presumably, the documentation of defeat.[40] But the example is more interesting in showing Jackson's efforts to demonstrate how visual *evidence* was constructed. Despite the prevalence of war as a subject for news pictures, Jackson noted that unprecedented sales of the newspaper throughout the "peaceful display" of the Great Exhibition of 1851 at Crystal Palace showed the world that the "arts of peace" were "more attractive than the excitement of war."[41] But whatever the subject, for Jackson and many of his peers in the illustrated news business, news pictures had become "as necessary to our daily life as bread itself."[42]

* * *

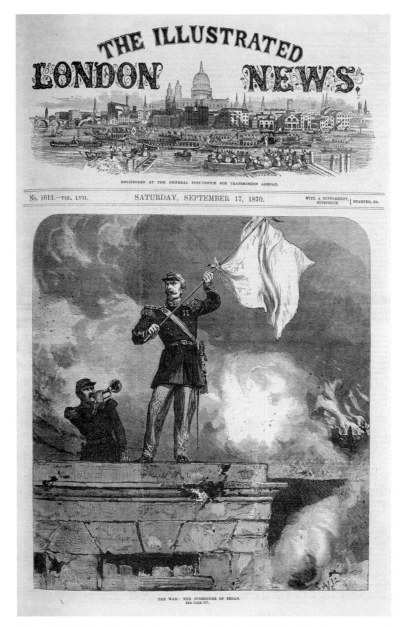

Figure 2.15b "The War: The Surrender of Sedan," published on front cover of *Illustrated London News*, 17 September 1870, p. 285, for story entitled, "Illustrations of the War." The fact that the sketch had been "rapidly engraved," wrote Jackson, did not impair its "original truth." From Mason Jackson, *The Pictorial Press: Its Origin and Progress* (London: Hurst and Blackett, 1885), p. 320.

In *The Structural Transformation of the Public Sphere*, Jürgen Habermas was "severely negative" about the type of discourse enabled by modern capitalism and media, and argued that the expanded public sphere lost its critical quality as "[t]he techniques of the cartoon, news picture, and human-interest story" developed and rendered citizens as spectators and consumers.[43] Today, the value of news images as knowledge is often called in question. For Jackson and many of his contemporaries during the nineteenth century, however, a different theory of news picture prevailed. For him, the illustrated news was the product of the "working of an impulse or instinct which existed even before the days of newspapers."[44] This "pictorial spirit" was an independent, active force or agent, operating through but also outside of history. His claim was that "the pictures speak a universal language," and that no teaching was necessary.[45] He described "pictorial spirit" as a trans-historical force that he argued was seen both in prehistoric times, and in childhood experience of delight in picture-books. For Jackson and other news picture artists and editors, the "love of pictures" was an important and widely overlooked agent not only of historical change, but also "as an exponent of public opinion." The printing press, on this reading, did not usher in the love of pictures; it gave it a "wide field for development."[46] His story about the "public appetite" for news, particularly illustrated news, helps us understand how, through news pictures, papers became the "food of conversation."[47]

Notes

1 For history of the *Illustrated London News*, see esp. Christopher Hibbert, *The Illustrated London News' Social History of Victorian Britain* (Sydney: Angus & Robertson, 1975); Graham Law, *Indexes to Fiction in* The Illustrated London News *(1842–1901) and the* Graphic, *(1869–1901)*, Victorian Fiction Research Unit, University of Queensland, 2001; Peter Sinnema, *Dynamics of the Pictured Page: Representing the Nation in The Illustrated London News* (Aldershot: Ashgate, 1998); and Patrick Leary, "A Brief History of the *Illustrated London News*," http://gale.cengage.co.uk/images/PatrickLeary.pdf.

2 Mason Jackson, *The Pictorial Press: Its Origin and Progress* (London: Hurst and Blackett, 1885): 284.

3 By 1836, Jackson was well enough trained that he helped with the engraving of Richard Seymour's design for the monthly parts of *Pickwick Papers*. For more on Jackson and the *Illustrated London News*, see esp. Tim Barringer, *Men at Work: Art and Labour in Victorian Britain* (Paul Mellon Centre for Studies in British Art, 2005)

4 Mason Jackson, *The Pictorial Press*: 1

5 Mason Jackson, *The Pictorial Press*: 302.

6 Mason Jackson, *The Pictorial Press*: 296–7.

7 Mason Jackson, *The Pictorial Press*: 43.

8 Mason Jackson, *The Pictorial Press*: 53.

9 Mason Jackson, *The Pictorial Press*: 64–9.

10 Mason Jackson, *The Pictorial Press*: 121.

11 Quoted in Mason Jackson, *The Pictorial Press*: 176, 304. For more on the emergent genre of news pictures, see Brian Maidment, *Reading Popular Prints, 1790–1870* (Manchester: Manchester University Press, 1996).

12 Mason Jackson, *The Pictorial Press*: 7.

13 Mason Jackson, *The Pictorial Press*: 165.

14 Mason Jackson, *The Pictorial Press*: 173.

15 Mason Jackson, *The Pictorial Press*: 179.

16 Mason Jackson, *The Pictorial Press*: 6.

17 Mason Jackson, *The Pictorial Press*: 194.

18 Mason Jackson, *The Pictorial Press*: 196.

19 Mason Jackson, *The Pictorial Press*: 205.

20 Mason Jackson, *The Pictorial Press*: 205. An example of a penny paper doing the same thing at the same time was the *Penny London Post*, which in 1748–9 gave an engraving about a fireworks display.

21 Mason Jackson, *The Pictorial Press*: 225.

22 Mason Jackson, *The Pictorial Press*: 220.

23 Mason Jackson, *The Pictorial Press*: 219.

24 "Certainly nothing more repulsive ever figured in the pages of an illustrated newspaper than some of the woodcuts published by the *Weekly Chronicle*." Quoted in Mason Jackson, *The Pictorial Press*: 264.

25 Mason Jackson, *The Pictorial Press*: 286.

26 Mason Jackson, *The Pictorial Press*: 293.

27 Brian Maidment, "Representing the Victorians—Illustration and the *ILN*." http://gale.cengage.co.uk/images/BrianMaidment1.pdf (accessed 7 January 2014).

28 Mason Jackson, *The Pictorial Press*: 305.

29 A few illustrated police reports were to have formed "part of the attractions of the paper," but evidently selected with a "view to provoke merriment rather than to indulge a morbid taste for criminal records" (287–8).

30 Julia F. Munro, "The *ILN* and Photography." http://www.gale.cengage.co.uk/iln

31 Mason Jackson, *The Pictorial Press*: 326.

32 Mason Jackson, *The Pictorial Press*: 327–8.

33 Mason Jackson, *The Pictorial Press*: 315.

34 Mason Jackson, *The Pictorial Press*: 305.

35 Mason Jackson, *The Pictorial Press*: 354.

36 Mason Jackson, *The Pictorial Press*: 317, 330–8.

37 Mason Jackson, *The Pictorial Press*: 328.

38 Mason Jackson, *The Pictorial Press*: 338.

39 Mason Jackson, *The Pictorial Press*: 320.

40 Mason Jackson, *The Pictorial Press*: 320.

41 Mason Jackson, *The Pictorial Press*: 303.

42 Mason Jackson, *The Pictorial Press*: 2.

43 David Lemmings, ed. *Crime, Courtrooms and the Public Sphere in Britain, 1700–1850* (Farnham, UK: Ashgate, 2012): 18.

44 Mason Jackson, *The Pictorial Press*: 5.

45 Mason Jackson, *The Pictorial Press*: 1.

46 Mason Jackson, *The Pictorial Press*: 1.

47 Mason Jackson, *The Pictorial Press*: 5.

2.16
Capturing Scandal: Picturing the Sultan's Harem in Turn-of-the-Century Morocco

Patricia Goldsworthy-Bishop

In 1905, a series of European illustrated newspapers reported on the activities of the ruler of one of the last independent nations in Africa, Sultan Abd al-Aziz of Morocco. These journals, including *L'Illustration*, the *Illustrated London News, Sketch: A Journal of Art and Actuality*, as well as stories reproduced a few years later in *Harper's Weekly* in the United States, foretold the decline of the Sultan's relationship with his subjects and his gradual loss of political control to external forces. Rather than describe his failure to collect taxes, tensions with local leaders, or the encroachment of European authority, the stories focused on the activity that seemingly encapsulated the fall of the regime: the Sultan's photographic practice. Articles such as "In spite of the Prophet: A Moslem Ruler as a photographer," and "Photographs: How the Emperor of Morocco defies the Prophet"[1] highlight the dichotomy between the Sultan's activities and his religion. Even more shocking than these headlines, however, were the accompanying photographs of the "amusements" in the Sultan's court and the photographs taken by Abd al-Aziz himself. These photographs circulated images of that which had been impossible for Moroccans or Europeans to see in person: the Sultan's harem.

While the accompanying stories list the number of gadgets and activities that allegedly "distracted" the Sultan from effectively running the country, the Harem photographs caused the greatest stir. Rather than acting as mere illustration or accompaniment to the articles, these images *were* the news and deserve to be examined as such. These photographs came to define the Sultan's relationship to Europeans, his view of Islam and Euro-Moroccan relations. Furthermore, they shaped the tumultuous relationship between Abd al-Aziz and Moroccans, and established the perception of the Sultan's photography as a revolutionary practice that symbolized a complete break with his beliefs and his country. Abd al-Aziz's appropriation of the camera and his staging of harem photographs could be viewed as a challenge to the predominately European representations of the Maghreb circulating in the early twentieth century, or as a counterpoint to the European perceptions of Arabs as backwards and devoid of modern expertise. The circulation of these images in a European context, however, controlled their distribution, manipulated their interpretation, and sensationalized both their form and their content.

The path from the Sultan photographing his harem to their publication in European journals remains unclear. While the Sultan enjoyed photography and employed European photography instructors with ties to illustrated news journals, he did not appear to have been an active agent in the articles that accompanied the photographs. The author of the *l'Illustration* article in which the photographs first appeared is anonymous and does not relate any first-hand encounters with the Sultan, and the *London Illustrated News* and *Sketch: A Journal of Art and Actuality* both reproduce the images from *l'Illustration*. As sultan, Abd al-Aziz did attempt to reconcile certain elements of European and Moroccan technologies and cultures, by dictating European dress and determining what could be photographed outside the palace walls in the early years of his reign, but the articles in European illustrated journals frame his activities as a complete rejection of Moroccan faith and traditions. Given the emphasis in the articles on the un-Islamic nature of the Sultan's photography, and the attacks on the Sultan's character and ability to govern, it is doubtful that Abd al-Aziz would have knowingly participated in an activity that would further injure his already damaged reputation. Even if Abd al-Aziz had contributed these images, his motives for doing so were lost in the overwhelmingly negative portrayal of the Sultan in the press. By controlling the distribution of these photographs, the European illustrated press determined their meaning and crafted a narrative of Abd al-Aziz's disregard for his traditions and his subjects. In doing so, they delegitimized Abd al-Aziz's reign and questioned his ability to faithfully rule his nation, in order to justify the need for European intervention.

While the Sultan's harem photography circulated freely in Europe and the United States, most Moroccans never saw these images. This uneven distribution of visual cultural materials shaped and reflected the uneven power relations between European imperial nations and Moroccans.[2] Moroccans adopted the printing press later than much of the Muslim world because Moroccans believed that "the acceptance of printing . . . signified the modification and sometimes the abandonment of traditional Islamic principles," which were more strictly enforced in Morocco than elsewhere in the Muslim world.[3] Pre-Protectorate Morocco had limited newspaper circulation, which predominately targeted the foreign population, and a Moroccan illustrated press did not exist until after the establishment of the protectorate in 1912. While the European press emphasized the uproar in Morocco resulting from the publication of the harem photographs, the unequal access to these images, and the question of the Sultan's participation in their publication, demonstrates the ways by which Europeans created and manipulated news through photographs.

Abd al-Aziz took control of the Moroccan sultanate upon the death of his father, Hassan I, in 1894. Until 1900, the young Sultan relied upon the regent Ba Ahmad to fulfill the majority of his duties as sultan and to quell the rebellions that questioned his legitimacy. Upon Ba Ahmad's death, Abd al-Aziz was faced with the difficulties of governing against a series of internal and external challenges marked by increasing pressure from the religious *ulama* as well as from encroaching European powers. Faced with a growing European presence in Moroccan political and economic interests, Abd al-Aziz embraced certain European technologies, such as the camera, and incorporated them into his activities as sultan. Critics in Morocco and abroad lambasted Abd al-Aziz's interest in European technologies and used this to demonstrate that he was an unfit ruler.

European journals alluded to the Sultan's religious affront to Islam through both the public display of the forbidden site of the harem as well as the Sultan's participation in the act of image making, which is restricted in Islam. The inclusion of these restrictions in an article on the Sultan's photographic activities highlights the extent to which Abd al-Aziz's photography—through the act, the subject matter, and its subsequent publication—effectively distanced him from his subjects. It was precisely this distance as

epitomized by these news photographs, the journals later implied, which would lead to his dethronement in 1908.

The oppositions to figurative imagery in Islam are nebulous, as aniconism is not specifically addressed in the Qur'an, and the sayings and actions attributed to Muhammad compiled in the hadith that oppose figurative representation have been interpreted in different manners throughout Islamic history. Limitations upon image making were codified only in the late Umayyad or early 'Abbāsid eras, and both Salafist and Orientalist interpretations of sacred texts in the modern era reinforced these restrictions.[4] Beginning in the early nineteenth century, Moroccan sultans showed growing support for Salafist interpretations of Islam, which rejected foreign influence in any aspect of Muslim society, religion, and culture. The camera represented these very forces that Salafism attempted to eliminate in a region that had some of the strictest restrictions against figurative representation in the Islamic world. In Europe, Orientalist study of Islamic sacred texts reinforced the notion of hostility to figurative representation, and European presses drew from these Orientalist and Salafist studies to denounce the Sultan's activities.[5]

Abd al-Aziz turned away from such restrictions upon his first exposure to photography in 1901, after which he decided to hire a photography instructor and summoned both the Lumière cinematographer Gabriel Veyre and an English photographer, John Henry Avery, to Marrakesh. While Avery only stayed in the Sultan's court through 1901, Veyre remained in his employ for several years, and also worked as a correspondent for *l'Illustration*. Abd al-Aziz's interest in photography and alleged religious transgressions quickly gained attention at home. Al-Kattani, an influential member of the *ulama*, blamed European technology for the downfall of Abd al-Aziz and Morocco: "How could they not defeat us when we have forsaken the practices of our Prophet and filled our time with their practices, their goods, their trinkets, and their novelties?"[6]

Abd al-Aziz's decision to take photographs of his household, and British and French newspapers' desire to publish these images, adds a new layer to the European obsession with the harem and demonstrates the Sultan's attempts to navigate the path between Moroccan isolation and colonization by European powers. By photographing the women in his household participating in non-traditional activities, Abd al-Aziz challenged both the European trope of the harem and the Moroccan tradition of isolation of the Sultan's household, and created a new vision of the harem, one in which women actively participated in the introduction of European technology in Morocco.

The Sultan regularly incorporated members of his harem into his activities, teaching them to take photographs and ride bicycles, and taking them for drives in his automobiles. Gabriel Veyre also staged cinematography screenings for the harem, with a curtain divider separating him from the women. In addition to cinematography shows and photography lessons, Abd al-Aziz often used these women as his models. According to Veyre, the Sultan enjoyed taking portraits of women in his harem (Figs. 2.16a and 2.16b):

When he had mastered the camera, his greatest joy was to photograph his favorite wives in countless copies. He had them dress themselves in their most beautiful attire, embroidered, multicolored; he took charge of their jewels, pearls and herons, and thus adorned, he posed them in front of backdrops scattered with flowering patterns, close to tables draped with carpets.[7]

Abd al-Aziz's participation in their publication beyond his role as photographer is unclear. The photographs can be seen, but his voice, as well as those of the women captured within the images, is unheard. As opposed to other harem photographs that circulated in Europe in this era, which had been

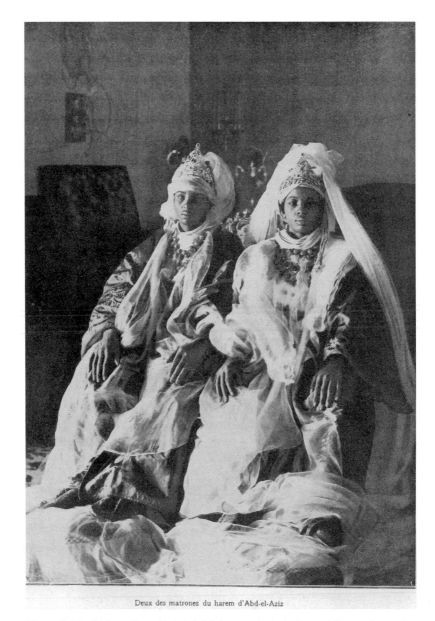

Deux des matrones du harem d'Abd-el-Aziz

Figure 2.16a Matrons from Abd al-Aziz's Harem, *L'Illustration*, 23 September 1905.

designed as strictly European fantasies of the harem, Abd al-Aziz's photographs shattered the European myth of an exotic, sexualized harem by showing women in the harem in the course of their daily lives.

While the Sultan's unpublished harem photographs cannot be found, the surviving images in journals allow for a unique vision of the women living in Abd al-Aziz's harem. Whereas other prominent Middle Eastern leaders who photographed in the late nineteenth and early twentieth centuries seem to have "self-orientalized," or internalized and re-presented European notions of the Orient in their images, Abd

al-Aziz instead presented viewers with his own vision of the harem, one devoid of the exoticism that marked harem photography in the nineteenth and twentieth centuries.[8] In one undated photograph, probably from 1901 or early 1902 and reproduced in *L'Illustration* in September 1905, two young women, the *matronnes* of the harem, sit staring at the camera (Fig. 2.16a).

The women, slaves responsible for managing the women of the harem, are dressed in long, covering material that spills from their bodies to cover the floor in front of them.[9] Both women are posed, looking straight at the camera with their hands on their knees. A telegraph, which Veyre most likely installed for the Sultan when he installed similar devices throughout the palace, is visible in the background. This telegraph, and the electric sign marking the year underneath, denotes a deviation between this image and Orientalist images that circulated in Europe in the nineteenth century. Whereas Orientalist images highlight the "traditional" nature of Middle East and North African societies, and erase any trace of modernization in an attempt to present these societies as timeless, Abd al-Aziz's photographs instead show the methods by which his household embraced both the modern and the traditional. The accompanying text, however, does not comment upon this representation of the women, but focuses solely upon the scandal of seeing the interior of the harem.

In lieu of the naked, lounging odalisques found in European photography, other photographs by the Sultan published in *l'Illustration*, the *Illustrated London News* and *Sketch: A Journal of Art and Actuality* in 1905, present the harem fully clothed in the palace's *Cour des Amusements* (Fig. 2.16b).

These images of the women, on bicycles and gazing at pictures, dressed in their normal daily wear and paying little attention to the man behind the camera, offer a non-sexualized, non-Orientalized account of the Harem. Such images are not intended for ethnographic purposes, nor to support European theories of Muslim women, but are rather designed as a type of family portrait or a documentation of his court. Abd al-Aziz attempted to use the camera to transform the dominant perceptions of the Orient and its inhabitants.

In 1905, these images were first published in the mass-produced popular French weekly *l'Illustration*. The article described the Sultan as photographer and incorporated images from a film he had taken of his wives riding bicycles in the courtyard. *l'Illustration* remarked upon the photographic act as at least as significant as their content. For *l'Illustration*, the fact that he took these images indicates his break with the Moroccan tradition of restricting European access to Moroccan interiors as well as the limitations on figurative imagery in Islam. The article does not address Abd al-Aziz's incorporation of the harem into his activities, nor the departure from previous forms of harem imagery. The *Illustrated London News* also reproduced the photographs a week later, providing credit to *l'Illustration* for the images, alongside captions reproaching the Sultan for "defying" the Prophet by taking up photography: "In spite of the Prophet: A Moslem ruler as a photographer"; "Photographs: How the Emperor of Morocco defies the Prophet."[10] A few days later, John Avery published an article in the *Sketch* on their controversial status and reproduced the images from the *Illustrated London News*. While these photographs in many ways counter the existing stereotypes and predominant representations of the harem, the accompanying stories do not speak to this opposition, focusing instead on the act of photographing itself. The photographs mark a striking departure from Orientalist photographs through their incorporation of signifiers of modernity—the bicycle, a telegraph—but the language of the accompanying articles expunges any meaning of the photograph that strays from scandal. By focusing on the images as a marker of the Sultan's transgression, the periodicals reinforced the transformation of these images from "mere" photographs into news.

The genre of the photographs published by European journals reinforced their status as "news." Gabriel Veyre emphasized in his autobiography and letters that he took images for the Sultan enacting

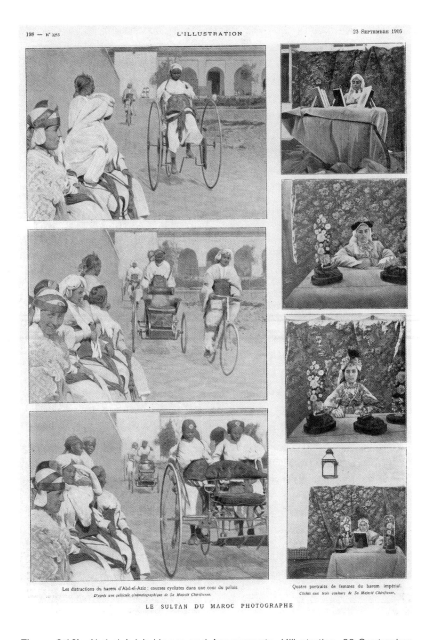

Figure 2.16b Abd al-Aziz's Harem and Amusements, *L'Illustration*, 23 September 1905.

his religious and political duties as head of state, as well as the Sultan's accomplishments as a photographer, however, the only images the illustrated press focused on were those of the harem. *L'Illustration*, the *Illustrated London News*, and *Sketch: A Journal of Art and Actuality* framed the Sultan's modernity as cause for scandal, and fixed the meanings of these photographs as such. While the staging

of the images counters many European stereotypes, and in a non-European setting could have been used to contest the Sultan and his harem, the appropriation of the Sultan's photographs in the context of European authority instead served to justify European intervention in the region. Transforming these images from the Sultan's personal and documentary photographs into press images reinforced European stereotypes about Morocco and reasserted European power. Observers drew a direct correlation between the Moroccan Revolution that dethroned Abd al-Aziz and his interest in European technologies. However responsible for his downfall the photographs were, becoming an unwitting "photojournalist" for the European press did not help Abd al-Aziz maintain the support of his subjects or independence from European colonial powers.

Notes

1 The *Illustrated London News*, 30 September 1905: 466–7.

2 Nicholas Mirzoeff, *The Right to Look: A Counterhistory of Visuality* (Durham: Duke University Press, 2011).

3 Fawzi Abdulrazak, "The Kingdom of the Book: The History of Printing as an Agency of Change in Morocco between 1865 and 1912" (Ph.D. dissertation, Boston University, 1990): x.

4 On image-making and Islam, see Oleg Grabar, *Early Islamic Art, 650–1100: Constructing the Study of Islamic Art, Volume I* (Burlington, VT: Ashgate/Variorum, 2005), Sylvia Naef *Y a-t-il une "Question de l'Image" en Islam?* (Paris: Téraèdre, 2004), Priscilla P. Soucek and Silvia Naef, "Taswir" *Encyclopaedia of Islam Online*. http:// referenceworks.brillonline.com/entries/encyclopaedia-of-islam–2/taswir-COM_1195.
Retrieved 20 July 2009, Stephen Vernoit, "The Visual Arts in Nineteenth-Century Muslim Thought," in Doris Behrens-Abouseif and Stephen Vernoit, eds, *Islamic Art in the Nineteenth Century: Tradition, Innovation, and Eclecticism* (Boston: Brill, 2006).

5 Naef, *Y a-t-il une "Question de l'Image" en Islam?* (Paris: Téraèdre, 2004): 10.

6 Muhammad al-Baqir al-Kattani, *al-Shaykh Muhammad al-Kattani al-shahid* (Rabat: Maktabat al-Talib): 37. Cited in Henry Munson, *Religion and Power in Morocco* (New Haven: Yale University Press, 1993): 63.

7 Cited in Philippe Jacquier Farid Abdelouahab and Marion Pranal, *Le Maroc de Gabriel Veyre 1901–1936* (Paris: Kubik editions, 2005): 20.

8 This term is borrowed from Ali Behdad, "The Power-ful Art of Qajar Photography: Orientalism and (Self)-Orientalizing in Nineteenth-century Iran," *Iranian Studies* 34 (2001): 141–51. Behdad analyzes the way in which Nasir al-Din Shah's private photographs of his wife "depicts himself and his wives in the same stereotypical way as European artists represented Middle Eastern women and the oriental despot. While women are portrayed as objects of male voyeuristic pleasure and symbols of exotic sexuality, the Shah is represented as a solemn figure of cruelty and despotic power." Behdad: 148.

9 See Mohammed Ennaji, *Serving the Master: Slavery and Society in Nineteenth-Century Morocco* (New York: St Martin's Press, 1999) for a full discussion of slavery within the harem and the Makhzen.

10 The *Illustrated London News*, 30 September 1905: 466–7.

2.17

Never Alone:
Photo Editing and Collaboration

Nadya Bair

On 3 December 1938, Gerda Taro's portrait of Robert Capa appeared on the cover of *Picture Post* with the caption: "The Greatest War Photographer in the World" (Fig. 2.17a). This widely reproduced image focuses on the journalist, whose pose suggests near total absorption in the act of reportage on the front of the Spanish Civil War. The magazine's coverage of Capa in the field solidified his fame as a major war photographer of the period. But this page was a calculated editorial choice made to promote *Picture Post* itself.[1] As the illustrated press proliferated in the 1920s and 1930s, editors knew that one way to grow their readership was to turn photographers into celebrities, making their names and faces known to the public who would follow their exclusively published work in the pages of the magazine.[2] Photographers were invested in making their names known because this increased their earning potential and their chances for getting more assignments.

This clever business strategy did more than sell magazines and bring photographers fame; it also shaped how histories of photography would subsequently be written. On the one hand, monographic studies dedicated to individual artist-photographers have proliferated, associating Capa with war photography; Eugene Smith with the photo essay; Henri Cartier-Bresson with street photography. A substantial and enlightening body of work about how illustrated publications—especially *Picture Post, VU* and *LIFE*—represented and therefore shaped our understanding of iconic moments in history has drawn as much attention to the history of the press as to photographers.[3] What these two predominant approaches underemphasize, however, is the centrality of editorial collaboration in the fabrication of news pictures. Away from the news front, story production—the planning before a photo shoot, its editing and subsequent layout as a picture story—was as important as taking pictures. To understand the history of the photographic press requires that we look beyond the singular image and celebrated names that appeared in print, to consider instead the stages of collective thinking and decision-making that produced each issue, and each page, of a news publication. Shifting attention towards collaboration also means writing pivotal but forgotten figures—such as the photo editors who shaped the content and form of photojournalism—back into the history of news production.

Compared to the iconic cover of *Picture Post*, a page from the January 1953 issue of *Holiday* magazine offers a less memorable and more complicated representation of the collective practice of photojournalism (Fig. 2.17b).

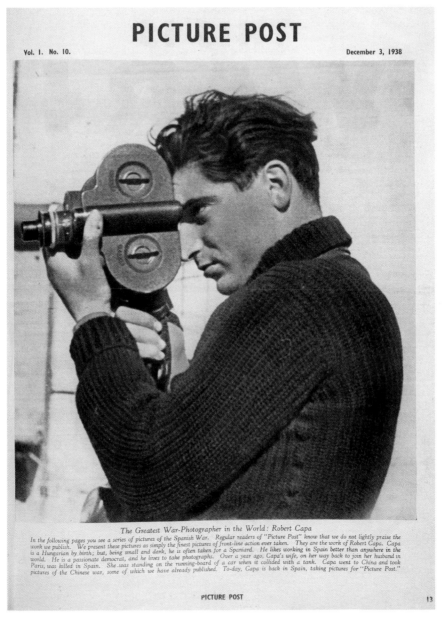

PICTURE POST

Vol. 1. No. 10. December 3, 1938

The Greatest War-Photographer in the World: Robert Capa

In the following pages you see a series of pictures of the Spanish War. Regular readers of "Picture Post" know that we do not lightly praise the work we publish. We present these pictures as simply the finest pictures of front-line action ever taken. They are the work of Robert Capa. Capa is a Hungarian by birth; but, being small and dark, he is often taken for a Spaniard. He likes working in Spain better than anywhere in the world. He is a passionate democrat, and he lives to take photographs. Over a year ago, Capa's wife, on her way back to join her husband in Paris, was killed in Spain. She was standing on the running-board of a car when it collided with a tank. Capa went to China and took pictures of the Chinese war, some of which we have already published. To-day, Capa is back in Spain, taking pictures for "Picture Post."

PICTURE POST 13

Figure 2.17a *Picture Post*, 3 December 1938, p. 13. Collection International Center of Photography.

Capa appears once again, now gazing not into a camera but seemingly into the magazine's own editing room. The walls are covered in mock-ups and its leading editors are huddled around an image, deliberating where it should go. At this moment, Capa had already founded *Magnum Photos*, the cooperative that provided *Holiday* magazine with an exclusive, three-part photo story called *Youth and*

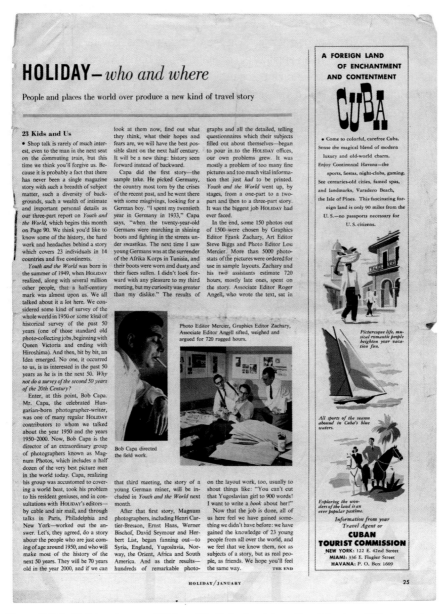

Figure 2.17b *Holiday*, January 1953, p. 25. Collection International Center of Photography.

the World. If, in 1938, Capa was shown in the midst of filming battle, in 1953 no camera is in sight. Instead, he trains his gaze toward the production of a story that required the coordinated efforts of over a dozen Magnum photographers in fourteen countries around the world.[4] The editors acknowledged their partnership with Capa, but what they really wanted readers to consider was the 720 hours of writing, layout, and editing that its staff had invested in the project—"the biggest job *Holiday*

had ever faced."[5] Indeed, this impressive statistic could never have been gleaned from looking at the published photographs, whose neat arrangement was meant to engross the reader in the content, rather than the construction, of the picture essay.[6] By revealing the process of photo editing, *Holiday* demonstrated that its expertise and commitment to delivering the most thoughtful and visually captivating coverage of the world depended on a team of editors rather than one star photographer.

The rise of photographic magazines required the coordinated efforts of many kinds of professionals in addition to the photographer, who played a limited role in both story conception and in its final presentation. By the interwar period, picture supply rested on a three-way relationship between photographers, publications, and photo agencies. Photo agencies such as Dephot (founded in 1928), Rapho (1933), Alliance Photo (1934), and Black Star (1935) sold images to magazines and kept 35–50 percent of the profit, with the rest going to the photographers.[7] Photographers not only allowed agencies to negotiate prices; they also ceded control both over their negatives and over the final layout, which remained the property of the magazine.[8] In return, agency photographers had the freedom to take on a range of assignments and story angles—unlike staff photographers, who always worked for the same editors and shot stories for a single publication.

As photographers professionalized and agencies proliferated, magazines became inundated with solicited and unsolicited photographs, of which only a small fraction could be published. Picture editing, therefore, became as important as picture supply to the development of pictorial reporting. The images that magazines received—or commissioned—were editorially divided into two kinds of picture stories. Feature stories examined relevant issues but could take weeks or months to produce, while news stories examined time-sensitive materials. At editorial meetings, staff selected feature stories. There, writers and researchers presented their ideas to the managing editors who oversaw multiple magazine departments and were responsible for the magazine's editorial content.[9] News stories were allotted blank pages in the magazine dummy and were the last to be submitted before the magazine was sent to the printer. As news stories increasingly became a priority, their dramatic content could frequently overshadow the pre-assigned features that had taken months to prepare. *Photo Technique*, a magazine that advised amateur photographers on how to break into publishing, warned: "One of the oldest and most established . . . prerogatives of editors is to change their minds and decisions. What may seem to the editors an excellent picture story today, may by next week have lost all interest for them."[10]

Just as planning each magazine issue required the collaboration of many professionals, story execution also depended on balancing multiple priorities beyond the photographer's vision. Once the managing editors finalized the contents, a photo editor assigned photographers to stories, taking into account the skills and personal interests of the photographers with whom he worked.[11] Photo editors had to communicate the magazine's vision for an article, explain the reasoning behind a shooting script if there was one, and assist the photographer with making the necessary connections in the field. Magazines could request that photographers use specific camera equipment and frequently indicated the preferred percentage of color versus black and white images. To please editors, photographers also needed to overshoot their assignments, making many more exposures than could ever be used in order to give editors—and writers—an exhaustive pictorial account of the story, from which a small number of images would be chosen.[12]

When photographers completed shooting an assigned story, a range of personnel handled the photographs. Darkroom staff initiated the editing process, printing contact sheets from the negatives and

identifying the better images for enlargement which would be shown to the editors. Depending on the publication's workflow, personalities, and deadlines, managing editors could be involved in weeding out the best images from a large sample of photographs and putting them into a rough mock-up, often with the input of the writers, researchers, reporters and, in rarer cases, photographers.[13] A magazine's art director, responsible for the overall design of each issue including typography choices, illustrations, and the placement of pictures, could also be involved in the process of picture selection and would finalize the layout of the picture story, leaving room for text, headlines, captions, and advertisements.

The extent to which a photographer was involved in laying out a picture story varied from publication to publication. *LIFE* photo editor Wilson Hicks believed that photographers were too emotionally attached to their work to make sound editorial decisions and he limited most photographers' involvement in the editing process. *Holiday's* art director and managing editor Frank Zachary argued for the "dominant editor," responsible for shaping each magazine issue to his personal vision. *Look*, on the other hand, encouraged close collaboration between the photographer, editor, writer, and art director.[14] Nevertheless, photographers could rarely prescribe how their images would be seen in print. Henri Cartier-Bresson admitted that magazines gave photographers the opportunity to reach a wide audience but regretted that it was only within the magazine's confines: "The words are the words of the photographer," he wrote in 1955, "but the phrasing is that of the magazine."[15] The few photographers who attempted to control a magazine's editing process—as Eugene Smith did while working as a staff photographer at *LIFE*—were eventually fired or quit. Some photographers had more luck in controlling image layout and presentation by authoring photo books, but even in these cases, the role of the book publisher (and project financier) could trump the photographer's vision.[16] Capa's heroic portrait in *Picture Post* and the image of photojournalism that it promotes, we can now see, occludes far more than it reveals.

For photojournalists, submitting one's work to the collective editing and layout of magazine staff—especially one with a strong editorial direction such as *LIFE*—was a routine aspect of the profession, but was often seen as a sacrifice that stultified their individual creativity and expression. In 1947, four successful and independently spirited photographers—Robert Capa, Henri Cartier-Bresson, George Rodger, and David Seymour—challenged the business standards of photojournalism by founding a cooperative organization called Magnum Photos, which would be owned by the photographers and which would coordinate the sale and distribution of picture stories to magazines around the world.[17] Studying Magnum as a supplier of press pictures underscores the collective process by which photographs ended up on the printed page—even in an organization that was set up to represent and defend the interests of individual photographers.

Magnum transformed the industry of photojournalism by establishing the photographic copyright, enabling Magnum photographers to retain the rights to their negatives, to choose where to publish them, and to charge magazines, books, or other publications for reprints. But what is equally important and unique about the organization is that Magnum wanted to escape the control of magazine photo editors who determined which images would be seen and in what context.[18] To further their individual careers, Magnum photographers had to learn to work collaboratively, to critique and edit each other's work and, as an organization, to anticipate the demands and interests of magazine editors. Looking at Magnum's early operations allows us to see how its members challenged themselves to succeed in the business of photojournalism not just by being better photographers, but also by thinking like photo editors: documenting stories rather than producing singular, iconic images; learning to let others into the

process of editing; and knowing when to stop shooting and begin the equally important stage of post-production.

Robert Capa was not just "the greatest war photographer," as history has it; he was also, as president of Magnum, acutely aware of the importance of producing picture stories for the magazine market. After World War II and until his death while on assignment for *LIFE* in Indochina in 1954, Capa regularly generated story ideas for his colleagues and invested much time into courting magazine editors. Addressing the photographers in an annual stockholder report five years after the organization's founding, Capa criticized the other Magnum photographers' weak sense of journalism and their preference to shoot pretty pictures rather than document stories.[19] Capa recognized that Magnum's lagging sales were the result of the product that Magnum offered, rather than their sales strategy. His proposition was unequivocal: "What Magnum and the Magnumites need most is not a business man, but an editor."[20] The commitment to editing and distributing high-quality material, rather than just selling more photographs, was what in Capa's mind distinguished Magnum from an agency such as Black Star, which had represented him in the 1930s and whose photographers regularly complained that they felt exploited by Black Star agents willing to sell their work cheaply for the sake of maintaining good relations with *LIFE*.[21]

To further emphasize the role of editors, Magnum hired John Godfrey Morris in 1953. Morris was responsible for generating story ideas and helping photographers execute them, as well as for selling those stories to publications for the highest possible price. First as an assistant to Wilson Hicks at *LIFE* and then as the photo editor of *Ladies' Home Journal*, Morris had gained ample experience in producing picture stories and working closely with photographers.[22] Critiquing the work of photographers would become an integral part of Morris' activities, as he helped them better understand what it took to succeed as photojournalists. It was not uncommon for photo editors to accompany photographers into the field, and Morris did this on a number of occasions when working on stories that he considered particularly challenging or innovative, and which he predicted would be difficult to sell if shot incorrectly.[23] Morris wanted the photographers to understand that, while the market for "great pictures" was limited, the market for "great stories" was infinite, and that to turn the former into the latter, thinking about a final layout needed to be enforced when shooting a story.[24] In his weekly correspondence with photographers, Morris constantly shared his impressions of their contact sheets and their published work. In the introduction to *The Decisive Moment*, Cartier-Bresson—who frequently clashed over picture editing decisions with magazine editors as well as with Morris himself—acknowledged, ". . . it was only in the process of working for [magazines] that I eventually learned—bit by bit—how to make reportage with a camera, how to make a picture-story."[25]

Magnum's collective structure also created an environment in which photographers saw each other's work, edited pictures jointly, and gave each other feedback on the craft of photography itself. Thus while Magnum photographer Werner Bischof worked in India in 1951, Robert Capa and the photographer Ernst Haas jointly edited his work for distribution. It was Capa who encouraged Bischof to keep traveling to other countries, observing that Bischof had exhausted the possibilities of photographing in India for that year, and that he needed to generate new stories.[26] Bischof listened to Capa's advice, but complained regularly about the pace at which he had to work: "I must rush onward under the pressure of editors," he wrote in 1952, referring not only to the magazines but also to the pressure of his own colleagues to see him produce timely material.[27]

The Magnum documentation reveals more than a series of exchanges about picture quality and story content; it also shows an organization-wide struggle to make time for editing. From the beginning of its operations, the New York and Paris headquarters were inundated with images, the majority of which never entered into circulation because of the photographers' pace of work. In the 1955 annual report,

Morris asked Magnum photographers to recognize that there was no quick, standard formula for editing a picture story, just as there was no single way to shoot it: "A story which has taken days or weeks to shoot is often edited in a few hours . . . we must recognize that picture editing is just as creative a task as photography, and that a person may be a good editor for one story but not for another."[28] Magnum pioneered an unprecedented system of distribution that placed collaborative work at the center of their enterprise, which allowed Magnum photographers to circumvent the collective editing process at magazines. The cooperative's "distros," as they were called, consisted of approximately thirty images selected with the consent of the photographer, as well as captions and a general story text written either by the photographer or a member of the staff. Circulated to potential magazine clients on a regular basis, these distros diminished a magazine's influence over picture editing by presenting it with a pre-selected set of pictures. They also obliged magazines to write a story that adhered to the spirit of the Magnum text, and to caption the pictures similarly, if not verbatim. While photography curator and historian Alison Nordstrom notes that Magnum's distribution system "constituted a major shift in establishing the creative authority of the photographer," that innovation was also the product of collaboration and collective learning about picture editing that happened behind the scenes at Magnum, and which has heretofore been absent from histories of the agency and its members.[29]

To understand the production of news pictures, it is essential to look beyond the photographer and his or her picture taking. A more comprehensive understanding of photojournalism takes into account that no single individual can be credited for the great moments of photographic history. In a 1960 letter to his colleagues at Magnum, Henri Cartier-Bresson acknowledged that while he frequently edited his own pictures, "it is most helpful for me to have a confrontation with the Magnum editor next to me, or another photographer."[30] His statement beckons us to look at those moments of confrontation and at the range of people—from photo editors and art directors to writers—who shaped the work of photographers, and to acknowledge the integral stage of photo editing in the making of news pictures. When we affirm that photojournalists were never alone, we can begin to ask new questions about the group efforts of press photography.

Notes

1 Michael Hallett, *Stefan Lorant: Godfather of Photojournalism* (Lanham: The Scarecrow Press, Inc., 2006).

2 Earlier precedents include the war photographers Jimmy Hare and Roger Fenton, who became famous for their images of the Crimean War and the Russo-Japanese War. See Thierry Gervais, "Witness to War: The Uses of Photography in the Illustrated Press, 1855–1904," *Journal of Visual Culture* 9 (3), (2010): 1–15. Before the proliferation of illustrated journalism, the adventures of reporters such as Henry Morton Stanley occupied the reading public's imagination. See Tim Jeal, *Stanley: The Impossible Life of Africa's Greatest Explorer* (New Haven: Yale University Press, 2008).

3 Michel Frizot, *VU: The Story of a Magazine* (London: Thames and Hudson, 2009); Wendy Kozol, *Life's America: Family and Nation in Postwar Photojournalism* (Philadelphia: Temple University Press, 1994); Erika Doss, ed., *Looking at LIFE Magazine* (Washington, DC: Smithsonian Institution Press, 2001); and Carolyn Quirke, *Eyes on Labor: News Photography and America's Working Class* (New York: Oxford University Press, 2012).

4 "Youth and the World" published in *Holiday* magazine in January, February, and March 1953.

5 "Holiday: who and where," *Holiday* (January 1953): 25.

6 Stanely E. Kalish and Clifton C. Edom, *Picture Editing* (New York: Rinehart and Company, 1951): 135.

7 Patricia Vettel-Becker, *Shooting from the Hip: Photography, Masculinity, and Postwar America* (Minneapolis: University of Minnesota Press, 2005): 6.

8 Peter Galassi, "Old Worlds, Modern Times," in *Henri Cartier-Bresson: The Modern Century* (New York: The Museum of Modern Art, 2009): note 158.

9 Wilson Hicks, *Words and Pictures* (New York: Harper & Brothers, 1952), especially chapters 1–2.

10 Dawson Powell, "The Facts of LIFE," *Photo Technique* (April 1941): 31, 66.

11 Photo editors were also charged with looking through the hundreds of unsolicited photographs. See "Speaking of Pictures . . . These Show *LIFE* in Process," *Rockefeller Center Magazine* (April 1938): 18–19.

12 *Holiday's* editors informed their readers that they had selected 150 out of 1500 photographs for the "Youth and the World" series.

13 Glenn G. Willumson, *W. Eugene Smith and the Photographic Essay* (Cambridge, UK: Cambridge University Press, 1992): 13–20.

14 R. Smith Schuneman, ed., *Photographic Communication: Principles, Problems, and Challenges of Photojournalism* (New York: Hastings House, 1972): 91.

15 Henri Cartier-Bresson's text for his one-man exhibit at the Louvre in 1955, in the archive of the Foundation Henri Cartier-Bresson.

16 Michael Jennings, "Agriculture, Industry and the Birth of the Photo Essay in the Late Weimar Republic," *October* 93 (Summer, 2000): 23–56 and Joshua Chuang, "When the Medium is the Message: The Making of Walker Evans' 'American Photographs' and Robert Frank's 'The Americans,' " *Yale University Art Gallery Bulletin* (2006): 108–23.

17 On the origins and history of Magnum, see Jean Lacouture, "The Founders" and Fred Ritchin, "What is Magnum?" in William Manchester, American Federation of Arts, Eastman Kodak Company, Minneapolis Institute of Artsm Jean Lacouture, and Fred Ritchin, *In Our Time: The World As Seen by Magnum Photographers* (New York: The American Federation of Arts in association with WW Norton & Co, 1989): 47–61 and 417–44.

18 Rudolf Janssens and Gertjan Kalff, "Time Incorporated Stink Club: The Influence of *Life* on the Founding of Magnum Photos," in Mick Gidley, ed., *American Photographs in Europe* (Amsterdam: VU University Press, 1995): 223–6.

19 Magnum Stockholder Report, 15 February 1952, in the archive of John Godfrey Morris (henceforth AJGM).

20 Letter from Robert Capa to John Godfrey Morris, 23 July 1951, AJGM.

21 Hendrik Neubauer, *Black Star: 60 Years of Photojournalism* (Köln: Könemann, 1998):19–21.

22 John Morris, *Get the Picture: A Personal History of Photojournalism* (Chicago: University of Chicago Press, 1998): 11–112.

23 Morris went to Idaho with Robert Capa to shoot the first set of pictures for the Magnum series "People are People the World Over" for *Ladies' Home Journal* in 1947. Morris: 113–22.

24 "Magnum and Its Markets," 21 June 1954, AJGM.

25 Henri Cartier-Bresson, *The Decisive Moment* (New York: Simon & Schuster, 1952).

26 Robert Capa to Werner Bischof, 7 May 1951, in the archive of Werner Bischof (henceforth AWB).

27 Bischof diary entry, July 1952, AWB.

28 Report on the State of Magnum, 1 July 1955, AJGM.

29 Alison Nordstrom, "On Becoming an Archive," in Steven Hoelscher, ed., *Reading Magnum: A Visual Archive of the Modern World* (Austin: University of Texas Press, 2013): 21.

30 Henri Cartier-Bresson, "Magnum in General," 13 January 1960, AJGM.

2.18

Look at those Lollipops! Integrating Color into News Pictures

Kim Timby

When and where did the news start being in color on a regular basis? The answer is: in magazines, and Sunday newspaper magazine supplements, before anywhere else. This coloring of the news was closely tied to changes in the photographically illustrated press in the interwar years, when editors of certain high-circulation periodicals, especially in the United States, started routinely banking on chromatic content to seduce advertisers and readers. Color's gradual integration into news magazines was most intense in the 1940s and 1950s. The mid-twentieth century crystallizes the issues at stake in color's adoption, demonstrating that it in no way constituted an obvious or undiscussed development. Motivations behind bringing it to news media had as much to do with appearing up-to-date and attracting revenue as they did with providing more complete information.

The coloring of news photographs was contingent on developments in color photography and polychromatic printing techniques, but just as crucially required the motivation of different professions to see both technologies converge around current events magazines. Color illustrations or design elements had started to enliven weekly supplements of major European and American newspapers in the 1890s.[1] Select large-circulation illustrateds, including pioneer *Ladies' Home Journal*, also ran color regularly before World War I. This necessitated the adoption of new rotary presses designed to print color—an investment favored by magazines' longer preparation times, higher price, longer life, and wider advertising base compared to newspapers. The chromatic trend strengthened between the wars in response to growing consumer interest in color. Goods from cars to housewares were produced in an ever-greater range and intensity of hues, and periodicals and advertising media that could reflect this were increasingly valuable.[2] It is indicative of motives driving color printing that American women's and lifestyle magazines were early adopters of it, and used it more in advertising than in editorial pages at first.[3] In the *Saturday Evening Post*, for example, polychromatic ad pages went from 5 to 50 percent of the total between 1907 and 1930.[4] In *House and Garden, American Home*, and *Better Homes and Gardens*, the balance of four-color ads would approach 30 percent in the 1930s, and 60 percent in the 1940s, whereas editorial color was still extremely rare.[5] Color drew the eye, in everyday life as in the press (see volume cover image).

Only a small part of this color was photographic at first. In the early 1930s, however, a new wave of colorful content based on photography swept lifestyle magazines and advertising, where the use of

photography itself was an emerging innovation. Condé Nast, via *Vogue, Vanity Fair*, and *House and Garden*, invested lavishly in this direction in 1932–4, running 195 color editorial pages and 479 color photographs in advertisements, with the help of photographer Anton Bruehl and engraver Fernand Bourges. It then showcased this work in a book titled *Color Sells*.[6] In the early 1930s, color photography was a complex affair best carried out in the studio. The first easy-to-use color process had been the glass-plate Autochrome (1907).[7] Although it freed photographers from the cumbersome recording of three images through separate filters, and wealthy amateurs and travelers dabbled in the expensive process, Autochromes only rarely found a wider circulation in magazines of the 1910s and 1920s—most consistently in *National Geographic* in the United States, or sporadically *L'Illustration* in France, for example.[8] The plates were fragile and slow, and their natural grain made producing color separations from them tricky[9]—leading Condé Nast specialists to prefer three-color studio cameras. The goods portrayed in lifestyle magazines were particularly conducive to studio photography, however. These periodicals were thus well placed both to feel and respond to commercial demands for color photography. They contributed to the establishment of the technological structures supporting its use in magazines, and of cultural expectations that would soon favor its apparition in news-oriented titles.

Whatever a publication's thematic content, technical issues framed the adoption of color and how it was presented to readers. Full-color printing was more complicated than the monochrome variety. Color presses printed three or four different inks (cyan, magenta, and yellow, plus black), and represented a significant enough investment to still be a rarity in 1950.[10] Color separations had to be made for each ink by photographing images to be reproduced through different filters. Manual color correction was almost systematic, commonly requiring several days' work in the 1930s and 1940s. Publishers pioneering in color rightly insisted on the process as collaborative, necessitating talented engravers and finishers.[11] All of this meant longer preparation times: for example, it took at least six weeks for color editorial photographs to reach readers of *LIFE* in 1936, and three weeks in 1953; new technologies reduced color lead time for advertisers to twenty-two days at the end of 1959—versus seven for black and white.[12] Accordingly, color was expensive, and publishers billed advertisers more for it: opting for full-color typically raised ad prices by 50–60 percent.[13] Magazines were printed with pages grouped on wide rolls of paper, then folded, cut, and bound. Editors grouped color images on certain pages and limited color to a set number of sheets to lower printing costs. Multihued pages (editorial or advertising) therefore often appeared in positions mirroring each other in the final layout.

New, faster, grain-free, easy-to-use color films like Kodachrome and Agfacolor, introduced in 1935–6, would be vital in making it feasible to establish a practice of photographing current events in color and of circulating those images in the press. The effect wasn't immediate, however. The cinema industry was behind the expensive and painstaking invention of this new technology and for quite some time movies were *the* place, along with lifestyle magazines, where people experienced the magic of photographic color. Use of color film for news pictures may have been discouraged at first by polychromy's association with commercialism. In the interwar years, avant-garde European magazines based on photographic reporting, like *VU* in France, had been faithful to monochrome photography, even in ad pages. Experiments with printing color photographs, as in the French Draeger 301 process, were reserved for still-life-based ad inserts in older-style periodicals like *L'Illustration* and promotional brochures.[14] A similar chromatic divide between advertising and social documentary photography was also present in the United States. Sally Stein has demonstrated that, as a new generation of picture magazines like *LIFE* (1936) and *Look* (1937) was established there, color photography was associated with modern commodities and the superficial, Madison Avenue and Hollywood—reinforcing perception of black and white as pure and

unmediated. When FSA photographers tried to use color, they found themselves unable to create images with the same "symbolic resonance" as their monochrome ones, involved as they were in portraying a world "bound to pre-modern traditions." These pictures didn't find a place in magazines.[15] Even in the cinema, color was largely limited to spectacular feature films, while more "realistic" genres— including newsreels—remained in black and white.[16] Verisimilitude was one of color's major selling points for representing goods in advertisements, but apparently much less so when it came to picturing the news.

Color in the news

Publication of Kodachrome views of the 6 May 1937 Hindenburg disaster in the Sunday magazine of the New York *Mirror* is indicative of color's situation at the time.[17] The tabloid had recently started printing color photographs in its weekly supplement. They sometimes related to the news, but the regular features were described as "the natural-color photographic portrait of a Hollywood screen star and the reproduction of famous paintings." The photographer sent to cover the Hindenburg's arrival had color film in his camera because his paper had a venue to publish it. Given the unexpected disaster's newsworthiness, editors exceptionally flew the film to Kodak and back for rushed development, two weeks later publishing pictures of red burning wreckage on the ground and billowing dark smoke. The drama of the scene is underlined by the redness of the fire, still raging in the pile of debris. The *Mirror* vaunted the exploit of these images, claiming that it had been "first among newspapers to reproduce natural-color photos successfully and first to 'cover' spot-news assignments with the color camera." It informed readers that regular color art and cinema features would resume the following week. These subjects were much more common color fare than breaking news in the late 1930s, when polychromatic news photos in one paper could still draw mention in another.[18]

During and after World War II, certain prominent picture magazines dedicated to current events increasingly combined the possibility of photographing the world in color with color's tested attraction in magazines. A multihued reading experience strengthened a periodical's circulation, making it an attractive venue for advertisers with important budgets who wished to reach large audiences with the most current tools. The strategy of *LIFE* (1936), although conservative, is revealing of these affinities and of color's wider connotations. *LIFE* rarely broke with monochromatic photography before the war, but half its ads were full-color by 1945. Black and white editorial content was part of what one editor called "daring to look dull" for *LIFE*, which associated itself with austerity and the seriousness of newspapers as opposed to the frivolity of lifestyle magazines.[19] In addition, monochromatic editorial pages helped financially vital color advertisements stand out. After 1939, *LIFE* used more color in articles, including those related to the war, running a first isolated color cover in a special "Defense issue" on 7 July 1941.[20] After 1945, one or two color photos appeared in an article in many issues, with color reaching an estimated quarter of editorial images by 1955.[21] In the United States, other current events magazines publishing color in the post-war era included large-circulation or upscale publications such as *Look, Fortune*, and *Collier's*. The number of color photographs fluctuated from issue to issue, and they were surrounded by a predominantly monochromatic editorial content.

After the war, color news photography developed in European periodicals as well. In France, color blossomed in select magazines dedicated to contemporary life created during the post-war renewal of the press. One expert observed, for example, that press magnate Hélène Lazareff had passed the war

in the United States (working at *Harper's Bazaar* among other publications) and returned to France in 1945 with a mastery of color previously unknown there.[22] *Réalités* (1946), an early adopter of color, was an upper-end monthly with lengthy articles on current social, political, and artistic issues. It timidly introduced color over its first years, with a color photograph adorning the cover from January 1949 and an average of ten to twenty examples per issue throughout the 1950s.[23] Polychromy was associated with a variety of subjects, with no obvious thematic pigeonholing—although art reproductions were frequent, elevating color photography.

Magazine editors developed specific strategies regarding color, motivated and constructed according to their own positioning and economic situations.[24] Differences between the use of color in *Réalités* and *Paris-Match*, a French weekly launched in 1949, are similar to those identified by Sally Stein as distinguishing *LIFE* and *Look*. Color was sensationalistic in *Paris-Match*. One early ad for the magazine defined it as "The big color-photo weekly," providing "All the news photographed in color."[25] After a festival of a dozen or so full-color pages in the first issues, a typical *Paris-Match* of the early 1950s included four pages in color plus the covers. Copy often presented color photographs as exciting feats or spotlighted chromatic interest with headlines or captions like "In a split-second flash, the sea reveals its colors [. . .] never before seen by man," "Maurice Chevalier lives in blue and pink," "For this close-up of Stromboli an explorer risked his life," or "The first color photographs of Elizabeth's coronation."[26] Local and national situations clearly influenced the establishment of color in magazines. For example, in 1950s Britain, color's adoption was slowed by the scarcity of the necessary printing specialists; it remained relatively rare, even in advertising, and was associated with luscious American publications.[27] Color in magazines—and therefore in news pictures—was intimately tied to the economics of publishing, and to the equipment and practical know-how on which it depended.

Picturing the news in color

The demand for color in current-events magazines around the time of World War II was the driving force behind the use of color film by news photographers. Robert Capa's intermittent employment of color is enlightening: his first examples were taken in China in 1938 on Kodachrome film and appeared in *LIFE*; he then set color aside because the magazines for which he was working didn't publish it; in 1942, for *Collier's*, he took up the new film again—depending on the market for it.[28] Walker Evans started creating color photo essays in 1945, when he became picture editor at up-scale color-publishing *Fortune*.[29] By 1954, Henri Cartier-Bresson, who would later denigrate color, discussed his recent exploration of it as resulting from modern commercial demands for such coverage.[30]

What did working in color mean for photographers? Answers were shaped by both technical constraints of the medium and the expressive and communicative potential of color itself, just as when editors worked it into magazine pages. Color film of the mid-twentieth century brought complications compared to black and white. French reporter Jean-Philippe Charbonnier vividly recalled his first color assignment for *Réalités* in 1950, when the slow medium-format film used meant arriving on location with tripods, flashbulbs, and reflectors, like "a pioneer from the days of collodion plates."[31] Even with 35 mm film, reporters working with color generally carried two cameras so as to always be ready with black and white—considered more suitable to most subjects—or to shoot with both.[32] The lower sensitivity of color film supposed still or brightly lit subjects, or working with motion blur or a narrower depth of field. These effects are more common in color photography, constituting an important marker of its aesthetic exploration.

A photograph by *Réalités* reporter Édouard Boubat closely framing two girls with lollipops against an indefinite background is illustrative (Fig. 2.18). It is the only color element in an eighteen-image picture story about a large family.[33] The black and white views build context, presenting wider scenes as if captured from the constant flow of everyday life. In contrast, the color image, near the end, has very limited depth of field and conveys the warmth and stillness of an intimate moment; the two children, dressed in blue, appear absorbed in their own world as they enjoy red and yellow candies in what reads as late-afternoon sunlight. Photographers chose whether to use color based on the nature of the specific subjects encountered and on what they thought would make both strong pictures and ones adapted to magazines' demands. Cartier-Bresson underlined to what degree it took time to make the new technical requirements of color second nature and mentally adjust to looking for different kinds of compositional relationships. In addition, he avoided effects that he felt translated poorly from transparency to print, like out-of-focus backgrounds.[34]

While color was used sparsely, it was essential that photographers select subjects with obvious chromatic interest so as not to waste color, in an economic sense, but also to make photographs legible for readers. Luc Boltanski has described how images in *Paris-Match* circa 1960 were often composed so as to concentrate elements symbolically summing up a story as narrativized by the magazine. At the same time the magazine's photographers privileged visual strategies that deflected attention away from the synthetic nature of the image. Markers of spontaneity, such as slight technical imperfections,

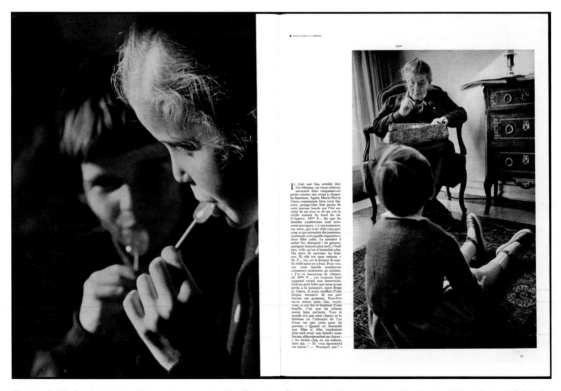

Figure 2.18 Double page from a photo-essay by Edouard Boubat, in "La vie d'une famille de huit enfants," *Réalités*, April 1959, p. 54–55.

increased the appearance of objectivity and favored the perception of documentary intention. Similarly, color deflected attention from subjective choices, focusing it on the beauty of the image.[35] As Pierre Bourdieu demonstrated, color possessed a unique capacity to make viewers "suspend the rejection of photographs of trivial things."[36] In this visual system, color interest had to be evident. Boubat's image described above, for example—possessing a powerful chromatic structure with bright spots of warm primaries in a complementary wash of deep blues and greens—clearly presents itself as beautiful rather than a document of an essential event. Other color pictures were less composed, but contained at least one impressive chromatic element or dominant hue (red embers of the Hindenburg, sea of brownish muck of the Korean war, etc.). Like lollipops for Boubat's children, color was a treat for the reader. Color in news photography was about spectacle—impressive tints, sensual beauty—just as much as it was about realism, with individual images and magazines layering these qualities differently according to subject matter, photographers' styles, and editorial positions.

In the 1930s, color photography had possessed markedly commercial connotations. By 1948, a Kodachrome ad could believably mirror its changing status by picturing a woman looking at color art reproductions in a magazine.[37] In 1957, color's associations had decidedly tipped toward the excitement of photojournalism when Kodak advertised its latest color products showing a man climbing to high places to take pictures, with the headline "You are a reporter at heart" and copy urging him to be the reporter of his family.[38] A quarter-century witnessed this shift. Color went on to become ubiquitous in news magazines of all sorts in the 1960s. Mid-decade it reached the editorial content of text-based publications like *Time* and *Newsweek*,[39] and *Réalités* abandoned black and white altogether, as color photography became the norm in amateur snapshots and movie theaters. By then, however, the decisive medium for current events was television. In the United States the evening news transitioned to color circa 1965 as well (and a little later elsewhere), definitively making color, in the words of Richard Misek, "a format of the present—of *current* affairs."[40] When color became commonplace, it lost the power to attract attention through its presence alone. However, when the appearance of the world as we perceive it, of our own photographs and of professional photography-based imagery all converged more closely around the question of color, the mediated news arguably gained an unprecedented aura of proximity.

Notes

1 *Annuaire de la presse française et du monde politique* (1893): 84–9, 976–5; Michael Emery, Edwin Emery, and Nancy L. Roberts, *The Press and America. An Interpretive History of the Mass Media*, 9th edn (Boston: Allyn and Bacon, 2000): 188, 195.

2 On color goods, see Regina Lee Blaszczyk, *The Color Revolution* (Cambridge, MA: MIT Press, 2012).

3 Sally Ann Stein, "The Rhetoric of the Colorful and the Colorless: American Photography and Material Culture between the Wars" (Ph.D. dissertation, Yale University, 1991): 1–183, 268–9.

4 Patricia Johnston, *Real Fantasies. Edward Steichen's Advertising Photography* (Berkeley: University of California Press, 1997): 239–40.

5 Stephen R. Milanowski, "Factors Influencing the Neglect of Color Photography, 1860 to 1970" (Master's Thesis, MIT, 1982): 57–8.

6 *Color Sells* (New York: Condé Nast, 1935). See also Katherine A. Bussard and Lisa Hostetler, eds., *Color Rush. American Color Photography from Stieglitz to Sherman* (New York: Aperture, 2013): vi, 3, 58–62.

7 On the early history of color photography: Brian Coe, *Colour Photography. The First Hundred Years 1840–1940* (London: Ash & Grant, 1978).

8 On *National Geographic*: C. D. B. Bryan, *The National Geographic Society. 100 Years of Adventure and Discovery* (New York: Harry N. Abrams, 1987): 124–8, 133, 167–74, 213; and Katherine A. Bussard and Lisa Hostetler, eds., *Color Rush. American Color Photography from Stieglitz to Sherman* (New York: Aperture, 2013): vi, 3, 38–43. On *L'Illustration: Léon Gimpel, les audaces d'un photographe (1873–1948)* (Paris: Musée d'Orsay/5 Continents, 2008): 62–6, 115–21.

9 Louis Walton Sipley, *A Half Century of Color* (New York: Macmillan, 1951): 123.

10 Sipley, *A Half Century*: 122–7. The inevitable paper waste of about 5 percent as presses were adjusted was multiplied by as many colors (F. de Laborderie and J. Boisseau, *Toute l'imprimerie* [Paris: Dunod, 1964]: 224–5).

11 *Color Sells*; Alexander Liberman, *The Art and Technique of Color Photography. A Treasury of Color Photographs by the Staff Photographers of Vogue, House & Garden, Glamour* (New York: Simon and Schuster, 1951): x–xi. A lack of skillful specialized engravers limited use of color in British publications (Ernest Biggs, *Colour in Advertising* [London: The Studio, 1956]: 67, 140).

12 Stein, "The Rhetoric": 275; "News of the Advertising and Marketing Fields," *New York Times*, 12 June 1953; Clay Buckhout, "Fast-Close," *LIFE*, 14 December 1959 (insert).

13 Loudon Wainwright, *The Great American Magazine. An Inside History of LIFE* (New York: Alfred A. Knopf, 1986): 41; rates at *Plaisir de France* and *France Illustration*, in *Annuaire de la presse française et étrangère*, 1947, 1948, 1954, and 1959.

14 For a Draeger example: Michel Frizot, ed., *A New History of Photography* (Köln: Könemann, 1998): 582–3.

15 Stein, "The Rhetoric": in particular xviii, 204–7, 308–9, 348.

16 Richard Misek, *Chromatic Cinema. A History of Screen Color* (Oxford: John Wiley & Sons, 2010): 38, 41.

17 *New York Sunday Mirror*, 23 May 1937. The spread reproduced in *Color Rush*: 77, 79, is the source of the information and quotes that follow on the *Mirror*.

18 For example: "Spot News Shown in Color," *New York Times*, 6 June 1939.

19 Stein, "The Rhetoric": 271–2, for this and the following remark.

20 On *LIFE* and war pictures, see Stein, "The Rhetoric": 277–8. War didn't preclude use of expensive color technologies, although it restricted who had access to them. An exception to monochrome newsreels in the 1940s were military-sponsored combat reports filmed on Kodachrome and released in Technicolor. See Thomas Schatz, *Boom and Bust: American Cinema in the 1940s* (Berkeley: University of California Press, 1997): 411.

21 Milanowski, "Factors": 56–7.

22 Françoise Giroud, *Leçons particulières* (Paris: Fayard, 1990): 142.

23 Observations on French magazines based on my study "La photographie en couleurs dans *Réalités* et *Paris-Match*," 2012, financed by the Agence nationale de la Recherche Scientifique as part of the "PhotoCréation" program, directed by Michel Frizot. For an overview of *Réalités*: Anne de Mondenard and Michel Guerrin, *Réalités. Un mensuel français illustré* (Arles: Actes Sud, 2008).

24 Stein, "The Rhetoric": 238–40, 269–77.

25 "Le grand hebdomadaire de Photo-Couleur," "Toute l'actualité photographiée en couleurs" (*Annuaire de la presse*, 1949: 227, 230; and 1950: 256, 258).

26 *Paris-Match*, respectively 11 August 1949; 10 December 1949; 3 June 1950; 13–20 June 1953.

27 Biggs, *Colour in Advertising*: 55–67; Anne Massey, *The Independent Group: Modernism and Mass Culture in Britain, 1945–1959* (Manchester: Manchester University Press, 1995): 84.

28 Richard Whelan, *This is War! Robert Capa at Work* (New York: Steidl/International Center of Photography, 2007): 124–9; and Cynthia Young and Sally Stein, *Capa in Color* (New York: Prestel, 2014).

29 Jeff L. Rosenheim, *Unclassified. A Walker Evans Anthology* (New York: Scalo/MoMA, 2000): 192.

30 John Ross, "Cartier-Bresson Finds the Decisive Moment in Color," *Modern Photography* February 1954: 50–5, 111–14.

31 Jean-Philippe Charbonnier, *Un photographe vous parle* (Paris: Bernard Grasset, 1961): 21.

32 See for example Whelan, *This is War!*: 129; Peter Galassi, *Henri Cartier-Bresson. The Modern Century* (New York: MoMA, 2010): 15, 47; Stein, "The Rhetoric": 292.

33 "La vie d'une famille de huit enfants," *Réalités* 159, April 1959: 44–55.

34 Ross, "Cartier-Bresson,"; Henri Cartier-Bresson, *The Decisive Moment* (New York: Simon and Schuster, 1952), section "Color."

35 Luc Boltanski, "La rhétorique de la figure," in Pierre Bourdieu, ed., *Un art moyen. Essai sur les usages sociaux de la photographie* (Paris: Éditions de Minuit, 1965): 178–94 [text omitted in translation of this book cited below].

36 Pierre Bourdieu in P. Bourdieu, ed., *Photography. A Middle-brow Art* (Cambridge, UK: Polity Press, 1990): 57–9, 92.

37 Reproduced in *Color Rush*, 93.

38 "Vous avez l'âme d'un reporteur . . . Kodak vous le prouve! [. . .] Vous pouvez [. . .] être le reporteur de votre vie familiale," in *Réalités*, July and August 1957.

39 Milanowski, "Factors": 56.

40 Richard Misek, *Chromatic Cinema*, 84. Color TV reached France in 1967 (Jean-Pierre Rioux and Jean-François Sirinelli, eds., *Histoire culturelle de la France. Le temps des masses, le vingtième siècle* [Paris: Seuil, 1998: 266–71]).

News Picture
Connoisseurship

2.19

Horace Vernet's *Capture of the Smalah*: Reportage and Actuality in the Early French Illustrated Press

Katie Hornstein

The pages of the 15 March 1845 edition of the illustrated newspaper *L'Illustration* featured a novel visual form of the newspaper picture. Instead of the standard *vignettes* that were confined within the borders of a single newspaper page, this particular edition featured an image that spanned the entire width of two newspaper pages (Fig. 2.19b).

The subject of these unprecedented honors of horizontality concerned a contemporary armed encounter that had taken place in the Algerian desert in May of 1843: the capture of the itinerant military encampment, or *smalah*, of the Algerian commander Abd-el-Kader, the spiritual and military leader of the resistance against France's military, which was at the time engaged in a bloody struggle to bring Algeria under its complete control. Newspaper accounts celebrated the proliferation of objects captured by the French military: "four flags, one canon, two gun carriages, [Abd-el-Kader's] correspondence, the family members of his most important lieutenants, an immense booty: such are the trophies of this memorable day."[1] Conspicuously absent from this list was Abd-el-Kader himself, who had fled to Morocco during the scuffle with the French army and would not be captured until 1847. The capture of Abd-el-Kader's *smalah* merited a lengthy article in the 17 June 1843 edition of *L'Illustration* (Fig. 2.19a) as well as a large illustration that took up nearly one half of a page.

The image of this event that appeared in the newspaper two years later was not in fact connected to a story about France's ongoing struggle to colonize Algeria. Rather, this representation of the capture of Abd-el-Kader's *smalah* accompanied an article devoted to works of art on display at the Salon exhibition of 1845, and was a reproduction of the most important battle painting on view that year, Horace Vernet's (1789–1863) *Capture of the Smalah of Abd-el-Kader*. The publication of Vernet's battle painting as a woodblock engraving within the pages of an illustrated newspaper is an example of what Walter Benjamin calls a "mighty recasting" and a process of "melting down" between cultural forms that have been conceptualized as opposites.[2] For Benjamin, it was the newspaper in particular that challenged traditional

Figure 2.19a "The Capture of the Smalah of Abd-el Kader, after Horace Vernet," *L'Illustration*, 15 March 1845. Courtesy of Dartmouth College Library.

boundaries between genres, audiences, and cultural forms. The appearance of Vernet's *Capture of the Smalah* in the pages of *L'Illustration* constituted one instance of this melting down. It revealed the contours of a distinctly mid-nineteenth-century phenomenon that emerged when the illustrated mass press brought fine art and journalism together as never before, blurring the relationship between the production of information and the production of art.

The expansive format of the newspaper illustration of Vernet's *Smalah* mimicked the unusual (and indeed, unprecedented) format of Horace Vernet's monumental painting: a staggering 66 feet wide × 16 feet tall. Its bombastic scale was a function of the work's importance for the July Monarchy government, and for the legitimacy of the Algerian campaign in the eyes of the French public. Since its inception in 1830, the French effort to colonize Algeria had been dogged by an active resistance movement that the French countered with brutal tactics against civilians and soldiers alike. The conquest faced lukewarm support among certain sectors of the French public, including the Republican and Bonapartist opposition, who regarded it as "a box at the Opera," — less illustrious than Napoleon's wars of European conquest waged decades earlier.[3] King Louis-Philippe, who inherited the conflict from his predecessors, viewed Algeria as a means of restoring the prestige of France's military without disturbing the peace that had existed among the European powers since Waterloo. Official battle paintings were

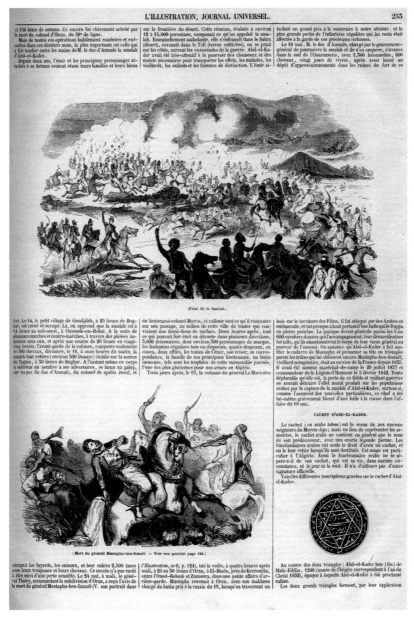

Figure 2.19b "The Capture of the Smalah of Abd-el Kader," *L'Illustration*, 17 June 1843. Courtesy of Dartmouth College Library.

therefore tasked with convincing the French public that Algeria was a worthy object of French colonial ambition.

Horace Vernet's status as the most important battle painter of the period (1789–1863) was confirmed by King Louis-Philippe's decision to award him with a series of important government commissions for battle

paintings to hang in the galleries of the *Musée historique de Versailles*—a massive arts project personally overseen by Louis-Philippe that transformed the dilapidated chateau into a didactic museum of French history narrated by paintings of France's past and present.[4] The *Smalah* was installed in a specially designed section of the museum that honored the Algerian campaign, the *Salles d'Afrique*. After being painted in a remarkably quick eight months, the painting was exhibited at the Salon of 1845—the longest, most horizontally expansive, battle painting to ever appear.

Vernet's *Smalah* provoked an immediate sensation in the press. "In front of the infinite canvas of M. Horace Vernet," wrote one critic, "everything else is erased, everything disappears . . . You are seized on your approach by a group of cavalry who stop you. Impossible to escape them! M. Vernet thrusts them, at a gallop, upon you, and there you are, captured."[5] The *Smalah* reportedly attracted huge crowds, causing another critic to note that "no painting has ever been the object of such enthusiasm."[6] While such effusive reactions dominated the critical reception of the painting, there was nevertheless a vocal minority who objected to what they saw as Vernet's overreliance on a descriptive rhetoric, which they negatively associated with newspapers, official military bulletins, and published eyewitness accounts of battles. This particular criticism had been routinely leveled at Vernet's battle paintings since the Bourbon Restoration and proposes that Vernet's artistic practice was unto itself a form of Benjamin's "melting down" process. Critics took him to task for his apparent rejection of the aggrandizing rhetoric associated with French classical tradition of history painting.[7] In the early nineteenth century, battle painting had grown in scale and importance under the exigencies of Napoleonic propaganda. The so-called *grandes machines* of Jacques-Louis David and his students, including Antoine-Jean Gros and François Gérard, were intended to edify and instruct using metaphor, idealization, and a focus on a single, culminating action—what the academic theorist Quatremère de Quincy called "transposition."[8] Though Vernet's *Smalah* is also an ambitious, large-scale history painting in the tradition of these *grandes machines*, it could not be more different than the kind of battle painting practiced by David and his contemporaries during the First Empire.

Instead of focusing on a singular heroic action, Vernet's painting spreads dozens of different, yet interrelated, groups of figures across a horizontal expanse and places these figures and their actions within a precise moment in time (as opposed to the transcendent timelessness that Napoleonic military painting sought to depict). The title of the painting is somewhat misleading, since it does not actually represent the capture of the 15,000 person encampment, but rather depicts a scene of flight, right after the French army commenced its surprise attack, or *razzia*—a brutal, scorched-Earth raid that had become a standard tactic in the French army by 1841.[9] Across the entire composition, the inhabitants of the *smalah* run out toward the space of the viewer; some of Abd-el-Kader's soldiers hold their ground to fire at the French cavalry, who are depicted by Vernet in mid-gallop, the horses with nostrils flared, advancing toward the foreground. A group of charging oxen in the middle-right foreground similarly threatens to run out of the picture. Steam wafts off a bowl of couscous in the middle foreground; a baby tumbles out of a mother's arms as she falls to the ground. Next to her, one of many racist caricatures in a painting replete with them, depicts a fleeing man, who nineteenth-century audiences would have identified as Jewish, clinching a bag of money as he retreats.

In their reviews of the painting, critics focused on the way that Vernet organized his painting around a proliferation of different episodic details without a central focal point, similar to the way that a panorama painter would compose a round canvas in order to keep customers interested in viewing the entire work. The fact that there was no single heroic focus made it difficult for many critics to discern any higher meaning in the work; this led to charges that Vernet had not sufficiently elevated the importance of his

subject. The sight of the cavalry charge, far from suggesting an important encounter in the desert, suggested a minor skirmish and the idea that "this war is nothing more than the *little war*."[10] Other critics called attention to the appearance of a disproportionate amount of French military force against the enemy, which "diminishes the merit of the victory" and "results in an involuntary pity for these poor Arabs."[11] This rather extraordinary evocation of sympathy for the victims of French colonial intervention underscores the instability of the painting's intended propagandistic function in support of the colonization of Algeria. Beyond the possibility that Vernet had depicted the fleeing inhabitants of the *smalah* as innocent victims, many critics perceived a troubling incongruity between the subject and its gigantic proportion. Why, asked one critic, did Vernet use such a large canvas "for an armed encounter that certainly does not rival the battles of Alexander, of Cesar, of Charlemagne or Napoleon?" He then sardonically remarked that the canvas could be rolled up and taken back to North Africa "to make a good tent."[12]

Horace Vernet had long been accused of painting journalistically, that is to say, in a descriptive mode, without elevating or idealizing his subjects. This is precisely how Charles Baudelaire, one of Vernet's most scathing critics, classified his manner of composing the *Smalah*—according to the "method of a *feuilletoniste*," or serial-novelist, an author whose works were disseminated piecemeal in the bottom section of nineteenth-century newspaper pages. In addition to serial novels, the *feuilleton* also featured art criticism, theater reviews, and other non-political items of interest. Baudelaire's disdain for the newspaper is well known. As he wrote in *Mon coeur mis à nu*, "it is this disgusting aperitif that civilized man takes with breakfast every morning. I do not understand how a pure hand could touch a newspaper without a convulsion of disgust."[13] This condemnation notwithstanding, Baudelaire could not pursue a literary career in the mid-nineteenth century without relying on newspapers to publish his work. *The Painter of Modern Life*, for example, first appeared in installments in the *feuilleton* of the newspaper *Le Figaro* in 1863. In this seminal text in which Baudelaire articulates his theory of *modernité*, he focused on the work of Constantin Guys, who worked as an illustrator for the *Illustrated London News*, the illustrated newspaper after which L'*Illustration* was modeled. In a section devoted to Guys' Crimean War drawings that were published as woodblock engravings in the *Illustrated London News*, Baudelaire had the privilege of examining the original drawings (likely owned by Nadar) and could therefore bypass their unsavory mode of mass diffusion.[14] Despite the fact that Guys worked as an actual newspaper illustrator, it is Vernet who Baudelaire calls in *the Painter of Modern Life* a "veritable journalist (*gazetier*), more than a real painter."[15] At a time when newspaper readership was rapidly expanding due to falling prices, Baudelaire's identification of a history painter as a journalist, and a newspaper illustrator as the visual poet of actuality, marks a surprising inversion of the categories of fine art and journalism. While Baudelaire may have objected to the newspaper as a vapid commodification of the written word, he nevertheless recognized that it was an indispensible component of lived experience, and took full advantage of it to formulate his ideas of what a truly modern form of artistic engagement might look like.

The first issue of *L'Illustration* appeared in February 1843, thirteen years after the French conquest of Algeria had commenced. Several articles, under the title of "Revue Algérienne," were published to catch readers up with these past events. On 17 June 1843, *L'Illustration* introduced the contemporary events of the campaign to readers with a lengthy description of the capture of the *smalah*, accompanied by a large illustration of it. In contrast to the bright clarity of Vernet's painting, the black and white newspaper image of the raid depicts French and Algerian forces charging in multiple directions within a landscape that is almost completely obscured by clouds of smoke. This illustration, which was not based on visual reportage but likely on the official dispatches of the event, focuses on the swirling chaos of the scene. Though the schematic character of the image prevents a focus on any individual soldiers, there is a clear

demarcation between Algerian and French forces in terms of the differences between their uniforms. A separate image, located below this central image of the capture of the *smalah*, provides reader/viewers with an image of a dramatic hand-to-hand combat lacking in the central image: in this case, it is the death of the Mustapha-ben-Ismaël, an Arab chieftain who fought for the French army. The image's caption states that it is his death that is represented; the column of text informs reader/viewers that Ben-Ismaël's tragic end occurred one day after the capture of the *smalah*. To the right, the smallest image on the page appears: the seal of Abd-el-Kader, ostensibly seized during the capture of the *smalah*. Spread out asymmetrically over the newspaper page, these three images offer different perspectives on the event—an overview, a close-up detail of combat, and a glimpse of the material culture of the encampment. As a group, they depict a series of shifting temporal and spatial perspectives, making reader/viewers aware of the expansiveness of the campaign and the allure of some of its details.

Two years later, the reproduction of Vernet's *Smalah* appeared in the pages of *L'Illustration*. While it had become routine by 1845 for the newspaper to publish reproductions of works of art that were on view at Salon exhibitions, the publication of this particular reproduction constituted a formal intervention, expanding, as no image previously had in the newspaper's two-year history, across the entire space of two pages. The paper made no mention of this unprecedented decision and claimed that the image appeared in order "to satisfy the curiosity of readers" who were eager to glimpse the year's most discussed work. After marveling at the size of the painting and describing its manifold episodes, *L'Illustration*'s art critic took Vernet to task for "exciting and satisfying curiosity" without "stirring the soul." At the very end of the section devoted to Vernet, the critic launched into a more severe, and exceptional, critique that revolved around the problem of illustration: "With these exaggerated proportions, painting is threatened by being no more than picturesque and animated topography; battle painters transform into illustrated bulletin authors, and Versailles, if this should continue, will cease to be a museum in order to become an annex of the [French] War Depot."[16] Illustration, claimed this critic, was best left for the newspapers: Vernet's *Smalah* problematically blurred the boundaries between history painting and the production of visual actuality by the illustrated press.

The reproduction of Vernet's *Smalah* appears on the top portion of two pages and is interrupted by the center fold, which cleaves the image into two discrete halves. This has the effect of focusing attention upon the center of the image in a way that the painting, whose sprawling horizontality and lack of a single narrative focus, does not. The dramatic imposition of a central focus also creates a rupture in the frieze-like horizontal flow of the image and proposes an alternative mode of apprehending it: from the center out toward the edges of the page. The material conjunction between the center of the newspaper page and the center of the composition bestowed upon *the Capture of the Smalah* what many critics felt that it had lacked as a large-scale oil painting. While a heroic center of focus had long been the most important criterion for grand-manner history painting, it was the emergent visual form of the illustrated newspaper and the exigencies of page layout that provided it for Vernet's painting. This striking interaction between the illustrated newspaper page, woodblock engraving, and oil painting portended a new frontier of cultural leveling between media, at a time when the identity of nascent mass cultural forms like the illustrated newspaper were still very much up for negotiation. Human perception, as Walter Benjamin argued, is "conditioned not only by nature but by history."[17] The fact that the illustrated newspaper could, for example, disrupt and readjust the visual codes of history painting, and at the same time generate its own particular systems for representing contemporary actuality, is one example of the ways in which the "medium" of mid-nineteenth century perception was undergoing constant redefinition through the circulation of new visual forms.

Notes

1 "Revue Algérienne," *L'Illustration, Journal Universel* (17 juin 1843): 255.

2 Walter Benjamin, "The Author as Producer," in *The Work of Art in the Age of Its Technological Reproducibility, and Other Writings on Media* (Cambridge, MA: Harvard University Press, 2008): 82.

3 Jean-Joseph Louis Blanc, *La révolution française, l'histoire de dix ans*, v. II (Bruxelles: Société typographique Belge, 1844): 127. For more on the French conquest of Algeria, see Jennifer Sessions, *By Sword and Plow: France and the Conquest of Algeria* (Ithaca and London: Cornell University Press, 2011).

4 See Marie-Claude Chaudonneret, *L'état et les artistes: de la restauration à la monarchie de juillet (1815–1830)* (Paris: Flammarion, 1999): 102–5; and Daniel Harkett, "Exhibition Culture in Restoration Paris" (Ph.D. Dissertation, Brown University, 2005): 72–119.

5 "Salon de 1845; les Batailles," *L'Artiste* (23 mars 1845): 177.

6 Edouard Bergounioux, "Peinture religieuse et historique; Salon de 1845," *Revue de Paris* (1 avril 1845): 479.

7 Susan Siegfried has identified a de-hierarchizing narrative tendency among post-revolutionary history painters, including Vernet. Susan Siegfried, "Alternative Narratives," *Art History* 36 (February, 2013): 100–27.

8 Antoine Quatremère de Quincy, "Notice historique sur la vie et les ouvrages de M. Gros," in *Recueil des notices historiques lues dans les séances de l'Académie royale des beaux-arts à l'Institut* (Paris: A. Leclere, 1837): 161.

9 Jennifer Sessions, *By Sword and Plow: France and the Conquest of Algeria* (Ithaca and London: Cornell University Press, 2011): 163–5.

10 Edouard Bergounioux, "Peinture religieuse et historique; Salon de 1845," *Revue de Paris* (1 avril 1845): 478.

11 "Lettre sur le Salon de 1845," *Bulletin des amis des arts* 3.

12 Théophile Thoré, *Les Salons de Théophile Thoré* (Paris: Librairie international, 1868): 111.

13 Charles Baudelaire, *Œuvres posthumes et correspondances inédites* (Paris: Maison Quantin, 1887): 117.

14 Baudelaire, *Critique d'art*, ed. Claude Pichois (Paris: Gallimard, 1992): 652.

15 Baudelaire, *Critique d'art*, ed. Claude Pichois (Paris: Gallimard, 1992): 361.

16 "Beaux-Arts—Salon de 1845," *L'Illustration, Journal Universel* (15 mars 1845): 39.

17 Walter Benjamin, "The Work of Art in the Age of Its Technological Reproducibility," in *The Work of Art in the Age of Its Technological Reproducibility, and Other Writings on Media* (Cambridge, MA: Harvard University Press, 2008): 104.

2.20
Hindenburg Disaster Pictures: Awarding a Multifaceted Icon

Vincent Lavoie

Prizes and distinctions awarded in the field of photojournalism confer symbolic and economic value on press photography through the celebration of news pictures epitomizing recent newsworthy events. Photojournalism competitions such as the Pulitzer, the World Press Photo, and the Pictures of the Year serve to recognize the excellence of pictures taken or published during the previous year. Pictures of the crash of the dirigible the *Hindenburg* in Lakehurst, New Jersey, on 6 May 1937 are emblematic of such photographs. In 1948, the National Press Photographers Association (NPPA) instituted a contest called "The Best Picture of My Life!" which was to "be one of the knockouts of the year—holding to photography the position of the Kentucky Derby has in horse racing."[1] The first prize went to Murray Becker's shot of the *Hindenburg*, a photograph taken, however, eleven years earlier (Fig. 2.20a).

The photograph chosen by the NPPA jury shows the burning German airship touching the ground as people run from the landing site. The NPPA contest was not the only competition to pay such a late tribute to a photograph showing the *Hindenburg* disaster. In 1958, the University of Missouri School of Journalism organized a photographic selection of the "Fifty Memorable Pictures of the Last Half-Century." This group of famous pictures of course included a photograph of the dirigible, but this one was taken by Sam Shere, an International News Photos photographer.

These tributes to Becker's and Shere's pictures correspond to a post-war need to enhance the professional recognition of press photographers through contests and institutional acknowledgments. Picking historical gems on which to build current legitimacy was part of this recognition process—which was a complex one, as the pictures receiving retroactive awards had to fulfill photojournalism's new expectations. In the case of the Hindenburg disaster, the honor went to several photographers, including amateurs, and the winning pictures were the outcome of a fluctuating recognition process irreducible to the praising of a single shot. Although various in terms of authorship and news value, images such as those of the *Hindenburg* disaster soon became invaluable benchmarks of the evolving history of photojournalism. What exemplary merits are they said to be epitomizing? Because the *Hindenburg* crash occurred at a time when the normative precepts of the press picture were in the process of being formalized, we must consider the use of these pictures by those who were establishing the canons at the time.

Guides and manuals for amateur and professional photographers, biographies, and volumes on methods of picture editing published in the 1930s and 1940s are invaluable for studying embryonic

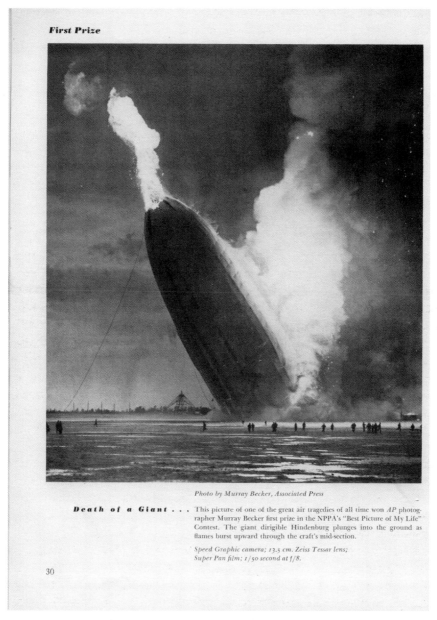

First Prize

Photo by Murray Becker, Associated Press

Death of a Giant . . . This picture of one of the great air tragedies of all time won *AP* photographer Murray Becker first prize in the NPPA's "Best Picture of My Life" Contest. The giant dirigible Hindenburg plunges into the ground as flames burst upward through the craft's mid-section.

Speed Graphic camera; 13.5 cm. Zeiss Tessar lens; Super Pan film; 1/50 second at f/8.

30

Figure 2.20a Murray Becker, *Death of a Giant*, 6 May 1937, as reproduced in *The Complete Book of Photography* (New York: National Press Photographers Association, 1950), p. 30. Getty Images.

criteria for the "good" picture. The considerable growth in the number of photographers and the constant flow of pictures sent to editors of illustrated dailies and weeklies required the institution of an evaluation criterion to identify the best images. Three volumes in particular, Jack Price's *News Pictures* (1937), Aaron Jacob Ezickson's *Get That Picture: The Story of the News Cameraman* (1938), and *Pictorial*

Journalism (1939), by Laura Vitray et al., all recognized the *Hindenburg* pictures as emblematic of the highest standards of photojournalism, and all played an instrumental role in endowing such pictures with a lasting paradigmatic value.[2]

Getting the big picture

A former student of the Columbia University School of Journalism in New York and a staff member of the Wide World Photos agency, Aaron Jacob Ezickson devoted almost an entire chapter of his book to the *Hindenburg* pictures. In his account of the forty-nine seconds that "turned a glistening monarch of the air into a fiery mass of twisted aluminum ribs," he focuses particularly on how fast and clever the photographers, agency staff, and editors were in bringing the pictures to the eyes of readers. Before discussing how people at Lakehurst managed to rush out the pictures, Ezickson first praises modern photographic transmission techniques for having dramatically reduced the delay from production of the pictures to their distribution in the media. From planes chartered to carry negatives to trains equipped with darkrooms for processing pictures, mobile newsrooms for captioning the images, and motorcycles racing to shuttle editorial staff and photographers from offices to newsworthy sites, Ezickson reviews all the means used since the 1920s for winning the race against time—and, more important, against rival media outlets.[3] A frantic quest for scoops and profit seems to have motivated this ingenuity in speeding up the manufacturing of visual journalism. This hymn to speed and time-reducing methods provides the framework within which Ezickson assesses the media coverage of the *Hindenburg* pictures, which were rushed to editors' offices by all available means. International News Photos, for instance, chartered two planes for the purpose of producing and dispatching the pictures taken. A first plane was used for taking photographs from the air when the *Hindenburg* flew over New York, and a second one sent to Lakehurst was still on the landing field when the explosion occurred and was used to get the pictures out of the site. International News Photos took substantial advantage of this logistical asset. "Their [Charles Hoff's and Robert Seelig's] first plates were handed to the pilot who flew them back to North Beach, Long Island, and then rushed by car to the News office. As a result, the News was the first on the streets in New York with the pictures of the disaster."[4] Similarly, a representative of American Airlines "raced from cameraman to cameraman, collecting their holders," and had them flown to Newark Airport, where motorcycle drivers were waiting to bring the plates to their syndicates' offices in New York. "An outstanding example of speed in picture reproduction," Ezickson writes, "was the ability of the *New York Times* to place the pictures of the disaster in its first edition, a little more than an hour and a half after the first flames were sighted on the Hindenburg's tail."[5] Ezickson's narrative of the *Hindenburg* crash is a statement about the intertwining of modern transportation and transmission systems and visual journalism in a context of fierce competition among photographers and editors. His colorful story draws a portrait of intense visual economy fueled by the pictures taken at Lakehurst. In his view, the media coverage of this catastrophe was an invaluable case study for assessing efficient dissemination of press pictures. Very little is said about the pictures themselves, whose value, in his account, relied mainly on their ability to trigger a media frenzy.

In the introduction to Jack Price's book *News Pictures*, Roy W. Howard, president and editor of the *New York World-Telegram*, wrote, "No writer, had he written with the pen of a genius, could have portrayed the horror of that holocaust with anything approximating the realism of the pictures taken at the very instant when the probable death-knell of lighter-than-air aviation was being rung above Lakehurst field."[6] Published

a short time after the event occurred, *News Pictures* covers a series of topics—assignments, the market for pictures, news coverage, use of miniature cameras, and so on—all considered through the prism of the pictures taken at Lakehurst. Price discusses pictures of the tragedy taken by amateur photographers in greater depth. These photographs were widely and immediately disseminated and published in major newspapers and magazines whose editors were already praising the value of miniature cameras used by non-professional photographers.[7] Price reminds the reader that the New York *Daily News* published two pages of photographs taken by a Chinese-born amateur, Foo Chu, who was at Lakehurst for the landing of the zeppelin.[8] Showing the disaster from beginning to end with a camera loaded with multiple-exposure film rolls, this double-page spread sets out the course of the catastrophe. The editors were not alone in looking for pictures made by amateurs; officers from the Board of Inquiry investigating the disaster were also looking for such images. Price quoted from the New York *Herald Tribune*, "Lieutenant Watson appealed to amateur motion-picture photographers or still camera enthusiasts who may have been at Lakehurst last Thursday and filmed the tragedy from beginning to end to send in their pictures to him to assist in the current investigation."[9] Investigators requested these filmstrips made by amateurs because they allowed them to visually re-enact the scene, something impossible with single shots, even those as sensational as those made by Becker and Shere. According to Price, this appeal for photographic evidence "is high endorsement of the value of chance shots made by amateurs." Using amateur pictures of the *Hindenburg* disaster as forensic evidence is not only a way to acknowledge their evidentiary value, but is also a plea for a visual economy whose standing relies also on unqualified press photographers.

Reproduced on the back of Hoff's picture, next to the title page (Fig. 2.20b), this epigraph opens *Pictorial Journalism* (1939), a book that provided readers with a broad base of knowledge regarding changes occurring in visual journalism: "The prize photo of the Hindenburg explosion on the following page is by Charles Hoff, of the New York *Daily News*." Throughout the book, the authors address topics related to newspaper planning and production—picture editing, photo equipment, layout, types, front-page issues, captioning, ethics, and other issues—as did similar guides published at the time. Most of the themes covered pertain to practical matters. There is, however, a chapter ("Judging Newsphotos") that deals with more critical and interpretive issues. In this section of the book, the authors are trying to establish news value criteria and photograph-rating methods. Here Charles Hoff's *Hindenburg* is used as a template for judging the newsworthiness of press pictures. Laura Vitray and her colleagues are attempting to determine quantifiable criteria for helping editors in the picture-selection process. They developed a rating system according to which, in regard to a given picture, "33 1/3 percent is given for the importance of the personality involved; 33 1/3 for the news it reports; and 33 1/3 percent of the amount of action portrayed."[10] As Hoff's picture had no "personality involved"—or, indeed, any visible human presence—it seemed to fall short in terms of human-interest content and thus received the moderate score of 66 2/3. Nevertheless, this "amazing frontispiece shot of the explosion of the dirigible *Hindenburg*" was outstanding enough a picture to be the introductory icon of the book.

The human-interest value has to be found elsewhere than in the visual content of the picture, something that Vitray and her colleagues' evaluation method was unable to take into account. As mentioned above, the *Hindenburg* pictures were praised not for their aesthetic value but for the performative conditions of their making. The recording of the landing was supposed to be a routine assignment. Twenty-two photographers and cameramen were there that day to cover the arrival of a zeppelin that had already made seventeen successful round trips between the United States and Europe.

Figure 2.20b Charles Hoff, *Hindenburg Explosion*, 6 May 1937, as reproduced in Laura Vitray, John Mills, Jr., and Roscoe Ellard, *Pictorial Journalism* (New York: McGraw-Hill, 1939). Corbis Images.

The explosion was the unexpected outcome of a presumed controlled situation. This is where the human factor comes forward and worms its way into the photographic act. Ezickson intuited better than the authors of *Pictorial Journalism* how this event reconfigured the hierarchy of merits by highlighting ethical qualities rather than aesthetic skills. Indeed, according to Ezickson, "nerve-shattering" events offered an

opportunity for the photographer to show his ethical stature. "The Hindenburg crash, the Panay bombing—no other stories have ever tested the cameraman's courage more. Amid two outstanding trials of peace and war, the newspaper photographer has proven that he will never flinch in the line of duty. He does not have to be told: 'Get that picture!' He gets it!"[11] Ezickson admired these photographers, who "steeled themselves to rigid control of hands and eyes" when facing the tragedy. He interpreted this behavior as a sign of moral elevation, a self-denial reaction inherent to dedicated photographers. Ezickson's account suggested that the moral qualities of the photojournalist had become a criterion of excellence, whatever the aesthetic value of the image.

This seems particularly true when the event occurs unexpectedly in front of an untrained photographer who happens to be there. In its 17 May issue, LIFE's coverage of the event underlines photographer Arthur Cofod's behavior when the first flames burst out, and how that reaction is translated into one of the picture taken: "The effect on him, as on others, was so nerve-shattering that his hands shook. You can see the resultant blurring in the second picture below." A representative of a firm specializing in speeding parcels to US Customs, Cofod, was actually there that day "to get a package of photographs arriving from the Hindenburg to LIFE."[12] Cofod, using a Leica, took a series of pictures showing the unfolding of the catastrophe, from the Hindenburg preparing to land to the horrified spectators reaching the photographer's position. LIFE reproduced a spread of nine of these pictures taken by this amateur photographer. It is worth mentioning that, in addition to Cofod's pictures, LIFE published shots by Murray Becker and Sam Shere, the photographers who later received awards from the National Press Photographers Associated and the University of Missouri School of Journalism. It was not unusual to reproduce within a single photographic essay pictures taken by both amateurs and syndicated photographers. However, this essay can be viewed as a visual statement on the newsworthiness of pictures taken by chance, regardless of the skill or professional status of the photographers featured.

In 1950, following the awarding of Murray Becker's Hindenburg picture, a debate occurred at the NPPA about whether or not shots taken by chance by amateur or professional photographers should receive an award. Judges wondered whether "spot-news photos taken, because a photographer happened to be at the right place at the right time, should get the lion's share of the recognition."[13] The debate around the recording of an unforeseen event was fueled by an editorial by the American Society of Magazine Photographers that criticized the 1950 Pulitzer Prize[14] because "once again the highest honor in journalism goes to a man who got his picture by accident."[15] On the other hand, Bernard Hoffman, a society trustee, wrote in the January 1951 issue of National Press Photographer that Bill Crouch, a photographer from The Tribune (Oakland) who had just received a contested Pulitzer Prize for a picture of two planes colliding at an air show, "obviously recognized a good picture when he saw one. That was no accident."[16] At about the same time, Wilson Hicks, picture editor of LIFE, addressed this issue in his book Words and Pictures: An Introduction to Photojournalism, taking as an example Sam Shere's shot of the Hindenburg explosion. "Frequently the event, not the photographer, makes the picture,"[17] he wrote regarding this picture, which was reproduced alongside another one made by an amateur, showing a falling man seen from the terrace of the Empire State Building in New York. Both images show the outcome of a presumed controlled situation, he argues in support of his assertion that "good pictures are taken accidentally every day . . . But it is the event that is good or great, not the photograph."[18]

Globally reproduced in the media, and instrumental in the formation of a nascent historiography of photojournalism, the Hindenburg pictures were the subject of public discourses, corporate assertions, professional speeches, and collective remembering. Whether for discussion of the circulation of press

pictures, appraisal of the newsworthiness of amateur photographs, or assessment of the news value of a photographic shot, they were unanimously seen as authoritative benchmarks and unprecedented accomplishments for visual journalism. Both the May 1937 issue of *LIFE* and books published in the following years acknowledged this through a set of new requirements: the shortest time between the making of an event-related image and its distribution; the acquisition of pictures from a variety of sources, amateur or professional; and standard appraisal of news pictures through charts and quantitative methods. Picture-press magazines and books published before World War II, as well as later contests and commemorative exhibitions, instituted and recalled how the *Hindenburg* pictures played a seminal role in shaping the newsworthiness of press photographs. Not assignable to any single photographer or any specific moment, the *Hindenburg* pictures work as a multifaceted icon praised by a global system of excellence.

Notes

1 Claude H. Cookman, *A Voice is Born: The Founding and Early Years of the National Press Photographers Association* (Durham, NC: National Press Photographers Association, 1985): 142.

2 Jack Price, *News Pictures* (New York: Round Table Press, 1937); Aaron Jacob Ezickson, *Get That Picture! The Story of the News Cameraman* (New York: National Library Press, 1938); Laura Vitray, John Mills, Jr., and Roscoe Ellard, *Pictorial Journalism* (New York: McGraw-Hill, 1939).

3 See Aaron Jacob Ezickson, "Charter III: The Train, Plane, Pigeon, Wire and Radio Carry the Picture," in Ezickson, *Get That Picture!*: 33–48.

4 Ezickson, *Get That Picture!* (New York: National Library Press, 1938): 195.

5 Ezickson, *Get That Picture!* (New York: National Library Press, 1938): 196.

6 Price, *News Pictures*: xii.

7 For a discussion about the use of the miniature camera in the news at the time of the *Hindenburg* disaster, see Duane Featherstonhaugh, *Press Photography with the Miniature Camera* (Boston: American Photographica Publishing, 1939).

8 Price, *News Pictures*: 118.

9 Price, *News Pictures*: 13.

10 Vitray et al., *Pictorial Journalism*: 30.

11 Ezickson, *Get That Picture!*: 200.

12 "Life on the American Newsfront," *LIFE*, 17 May 1937, 28. For many years, the *Hindenburg* had been used as a picture carrier, a means on the verge of being outdated by new transmission technologies such as the wire. Its destruction on 6 May was an allegory for its obsolescence. The pictures taken at the time were evidence of this.

13 Cookman, *A Voice is Born*: 145.

14 The award went to Bill Crouch's picture, "Near Collision at Air Show."

15 Cookman, *A Voice is Born*: 145. The "once again" may refer to Arnold Hardy, an amateur photographer from Atlanta, who won a Pulitzer Prize in 1947 for a picture showing a woman falling out of a window.

16 Cookman, *A Voice is Born*: 146.

17 Wilson Hicks, *Words and Pictures: An Introduction to Photojournalism* (New York: Harper, 1952), 74.

18 Wilson Hicks, *Words and Pictures*: 88.

An Era of Photographic Controversy: Edward Steichen at the MoMA

Kristen Gresh

Edward Steichen's tenure as Director of the Photography Department at New York's Museum of Modern Art (MoMA) from 1947 to 1962 was a transformative time for photojournalism and photographic exhibitions. As Christopher Phillips wrote, "At a time when most American art museums still considered photography well beyond the pale of the fine arts, a peculiar set of circumstances allowed Steichen effectively to establish MoMA as the ultimate institutional arbiter of the entire range of photographic practice."[1] These years at MoMA merit further attention and analysis because Steichen's controversial use of the medium, as well as his tendency to act as picture editor while curator, revealed opposing forces at the MoMA and in the world of photography. As a result of Steichen's mass-media oriented exhibitions, advocates of "creative" photography, including those who had once been open to news photography in the Museum, openly resisted Steichen's use of photojournalism at the MoMA. The controversy surrounding Steichen's press-inspired exhibition style contributed to defining the polarity between art and news photography, and permanently changed the way news pictures are displayed in a museum setting. The effects of this historical crisis under Steichen reveal significant questions about photography and the art and artifice of print journalism and museum display.

In his acceptance speech as Director of Photography in 1947, Steichen said he wanted to legitimize under-recognized news photographers, and that one of his first exhibitions, "Great News Photographers," would trace the history of press photography.[2] This first exhibition was "The Exact Instant," and comprised 300 news photographs, displayed in different thematic groups (Fig. 2.21a).[3]

Some groups were mounted as bold wall size murals, others were in traditional cases, and there were even groups of actual pages from the newspaper tacked onto the walls. Exhibiting (unmounted and unframed) newspaper clippings from the popular press on the exhibition walls of the MoMA was unprecedented and marked a radical departure from Steichen's predecessor Beaumont Newhall's method of display which typically included matted, glass-protected, framed photographs. "The Exact Instant" checklist included the photographer's name, publication, and date. This recognition mirrored the way the photographs were originally viewed in the press. "The Exact Instant" presented news pictures as news pictures, anchored by reference to their original context, a milestone for the presence of press photography in the museum.

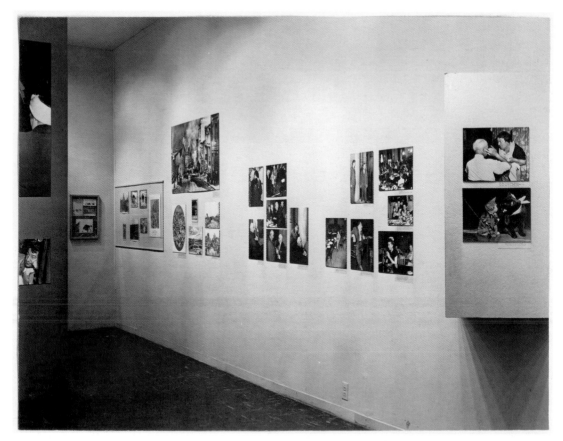

Figure 2.21a "The Exact Instant 100 Years of News Photography," exhibition installation view, 1949. Courtesy of The Museum of Modern Art, New York. Digital Image © The Museum of Modern Art/Licensed by SCALA/Art Resource, NY.

In 1951, Steichen mounted a second major press photography exhibition, "Memorable *LIFE* Photographs" simulating magazine pages on the walls of a museum (Fig. 2.21b). The exhibition comprised a selection of photoessays from the fifteen years since the founding of *LIFE* magazine. In the foreword to the exhibition catalog, Steichen wrote:

> Photographic journalism is generally accepted as an authoritative visual source of visual information about our times . . . Many of the pictures have an intrinsic value beyond the immediate purpose they have fulfilled. They often manifest new achievements in photography. On occasion they create images that reach into the nebulous and controversial realm of the fine arts.[4]

Influenced by his experience as a working commercial photographer, Steichen expresses his awareness of the tensions between art and press photography, and argues for a shift in the consideration of "photographic journalism" and the photographs traditionally valued in a museum.

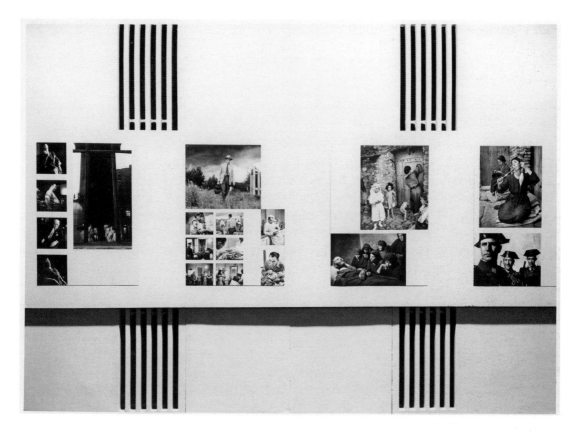

Figure 2.21b "Memorable LIFE Photographs," exhibition installation view, 1951, Courtesy of The Museum of Modern Art, New York. Digital Image © The Museum of Modern Art/Licensed by SCALA/Art Resource, NY.

Steichen's professional trajectory parallels the evolving medium of photography in the twentieth century. Early on in his career, Steichen argued for photography to be considered as fine art, and was later involved in portrait, commercial, advertising, and war photography, straying from his earlier convictions. Steichen's professional orientation allowed him to understand the medium and its capacities in a way that distinguished his approach from that of his predecessor Beaumont Newhall, whose training was a formal art history education.

MoMA did exhibit news pictures before Steichen's arrival, such as in Newhall's ground-breaking exhibition "Photography 1839–1937" or Nancy Newhall's "Action Photography" (1943). Newhall's survey of the medium's history included sections dedicated to press, color, and scientific photographs. However, the overall exhibition promoted the inclusion of "masterpieces" of the nineteenth and twentieth century to "demonstrate the particular characteristics of different techniques, the artistic qualities of each process, and the relation of technical and esthetic developments of photography to the taste and social needs of the time."[5] Despite recent scholarship that challenges the view that the Newhalls were seeking to promote largely fine art photography, the conceptual framing of the 1937 exhibition and the idea of "masterpieces" conforms to traditional museum presentation of a unique object of art, and does not explicitly seek to validate news photography as news photography.[6]

In 1940, the year MoMA created the Department of Photography, the Museum's overall exhibition strategy began to shift to reflect contemporary visual culture and politics.[7] The rise of the picture press in the United States, and particularly the growing popularity of *LIFE* magazine, founded in 1936, had a direct impact on MoMA's exhibition strategy, as did the imminent war in Europe.

In 1941, Steichen was invited to organize the first of several didactic, propaganda photography exhibitions at MoMA. Through his ability to capture the imagination of popular culture through mass media, Steichen met with immediate success with the Museum administration and general public. The "Road to Victory: A Procession of Photographs of the Nation at War" (1942) exhibition presented a large-scale patriotic collage of the power of the United States, seeking to defend its entry into World War II, while displaying military and press photography at MoMA in a new way.

The news picture, generally destined for the printed page, was still new to the walls of the MoMA or any other museum, where its potential for iconicity and influence increased dramatically.[8] Not only were the actual photographs being used in a new context, beyond information or news, but the experience of the news photograph was magnified by its larger than life (and *LIFE*) presentation. In Steichen's complete control of the size, format, and placement of the images, as well as their captions throughout the exhibition, he acted as a picture editor, capitalizing on the power of museum display and potential to evoke emotions. Steichen revised the display of news photographs at MoMA through his monumental design and creation of a specific spatial experience for the viewer.

"Road to Victory" was followed by "Airways to Peace: An Exhibition of Geography for the Future" (1943), organized by Monroe Wheeler and Herbert Bayer, and "Power in the Pacific" (1945), organized by Steichen upon his return as Head of the Naval Aviation Photographic Unit (1942–5). This series of propagandistic exhibitions paved the road for Steichen's nomination as Director of Photography and for the monumental Cold War era exhibitions such as "The Family of Man."[9]

These spectacular mass media exhibitions, and photography's new status as a museum object, provoked vibrant discussions within the museum. Among the voices of dissent against this form of exhibition was Ansel Adams who wrote to the Head of the MoMA Trustees, raising questions about the museum setting for war exhibitions. Implying that such "objective and illustrative" photography should not have a place in the museum, Adams suggested Grand Central Station as a more appropriate alternative.[10]

These propagandistic exhibitions at MoMA solidified the belief of Adams, Beaumont, and his wife Nancy Newhall that MoMA's mission for photography should be limited to expressive photography and to displaying photographs as art objects. Steichen's nomination and exhibition style pushed them to create a stricter divide between fine art and press photography. Newhall describes the tensions, "While my interests were *increasingly* in photography as a fine art, [Steichen's] were increasingly in the illustrative use of photography, particularly in swaying large masses of people . . . he was a populist in taste."[11] Newhall's all-inclusive approach progressively shifted to exhibiting photography uniquely within an art historical framework, undoubtedly as a reaction to Steichen's radical approach to displaying photographs.

Steichen viewed the exhibition as another form of mass distribution for photography, on the same level as a magazine or movie theater, in which the exhibition gallery provided a new platform. In 1963, he wrote:

Photography, including cinema and television as well as the printed page, is a great and forceful medium of mass communication. To this medium the exhibition gallery adds still another dimension. In the creation of [a thematic] exhibition, resources are brought into play that are not available elsewhere.[12]

This great potential described by Steichen exploits all of the intrinsic qualities of the photographic medium, making the exhibition a product of mass media itself.[13]

Key players in the shift of vision for photography inside the museum were Steichen himself, Willard Morgan, and Thomas J. Maloney, all of whom had close ties with the picture press, and Nelson D. Rockefeller.[14] The symbolic nomination of Steichen as Director of the Department of Photography was promising for the future of photojournalism at MoMA and in the museums in general, and it immediately provoked the departure of Beaumont Newhall. The confrontation between Steichen and Newhall's distinct points of view at MoMA resulted in an historic time for photographic exhibitions and for the status and recognition of the news photograph.

Adams wrote in protest to the Head of the Board of Trustees at the time, "To supplant Beaumont Newhall, who has made such a great contribution to the art through his vast knowledge and sympathy for the medium, with a regime which is inevitably favorable to the spectacular and 'popular' is indeed a body blow to the progress of creative photography."[15] Adams was prescient on this score: the change of "regime" succeeded in changing the focus of photography at the museum.

The crisis highlighted a larger divide of those committed to the fine art and creative aspects of the medium versus those affiliated with the illustrated press. One notable instance of the debate about the future of photography was the historic ten-day Photography Conference in Aspen in 1951 which assembled important members of both worlds (Berenice Abbott, Ansel Adams, Dorothea Lange, Wayne Miller, John G. Morris, Beaumont and Nancy Newhall, and Minor White).[16] The meeting itself and its outcome, the founding of the influential publication *Aperture*, were a direct response to the rise of the picture press and the need for a platform to exchange ideas about photography. The conference was also a response to the urgency for discussion about the authority and future of the medium and the changing nature of its display in the press and in exhibitions such as those under Steichen at MoMA.

In Steichen's exhibitions at MoMA, a photograph is not seen as a unique object but rather as a device that has multiple uses, from the printed page ("The Exact Instant") to an exhibition tool ("The Family of Man"). Steichen's method transcends the Museum's discourse of rarity.

Steichen's successor, John Szarkowski described him as an "auteur" of exhibitions, as opposed to a curator.[17] Steichen indeed remained faithful to his artistic and photographic personality, breaking with traditional ideas of a curator as someone who organizes exhibitions of art objects within an art historical context. Steichen was however the first curator of photography to regularly exhibit news pictures, promoting them as news pictures, as well as using them as illustrations, without systematically seeking to emphasize their artistic qualities, which created new narratives at the museum and a new vehicle for news photography.

Steichen's tradition of press photography exhibitions persisted to some extent after his departure. Szarkowski created a few press exhibitions, although he distanced himself from Steichen's close alignment with press photography. The 1965 exhibition "The Photo Essay" displayed forty years of "experiment in a new medium" featuring forty-five picture stories, highlighting the roles of both the news reporter and a publication's art director.[18] The exhibition featured different layouts of the same picture story in different publications. By drawing attention to the array of different contextual possibilities for a photoessay, Szarkowski also highlighted the variety in style of news photographic practice as one of the exhibition's points. This exercise reinforced the idea that press photography is a reproducible medium, destined for the printed page, and not a unique or rare object.

Szarkowski also presented "From the Picture Press," which included 225 press photographs from the previous five decades, highlighting photographs mainly from the New York *Daily News*, and some

photographs from the *New York Times*.[19] Peter Galassi followed as Director of Photography and was more of the Newhall than the Steichen cast of mind. However, he too presented a significant press exhibition "Pictures of the Times: A Century of Photography from *The New York Times*" (1996).

The presence of the news picture at MoMA at mid-century and beyond speaks to the truly contemporary and innovative curatorial practice of the institution. Steichen's photographic style of exhibitions and revision of the display of press photographs reflected the importance of news photography at the height of the influence of the picture press. The initial battle between Steichen and Newhall, enables us to understand the roots of contemporary debates regarding "creative" photography versus photojournalism. The results of this critical debate helped photojournalism gain its foothold in museums, resulting in capturing the imagination of popular culture and mass media on a different scale than the printed page. MoMA provided a platform for the convergence of photography in print and museum display, still a subject of vibrant debate within museums today, many still upholding Newhall's ideas of the photographic "masterpiece." Steichen's legacy paved the way nevertheless for the role of news pictures as important components of major museum exhibitions that continues as we journey through the second decade of the twenty-first century.

Notes

1 Christopher Phillips' seminal text "The Judgment Seat of Photography" analyzes the status of a photograph evoking its "cult value" versus "exhibition value" under the first three curators of photography at MoMA: Beaumont Newhall, Edward Steichen, and John Szarkowski, in Richard Bolton, ed., *The Contest of Meaning: Critical Histories of Photography* (Cambridge and London: MIT Press, 1992): 33. Originally published in *October* 22, (Fall 1982): 27–63.

2 "Steichen begins work in Museum: Greatly Expanded Program by Modern Act Director of Photography" 16 July 1947, The New York Times. Clipping from MoMA Archives.

3 "Today the news picture generally appears as a supplement to the written word. As the quality of reportorial photography develops and its use continues to accelerate, the written word may well become the supplement to the visual image." "The Exact Instant 100 Years of News Photography," Press Release, The Museum of Modern Art, 1949.

4 Edward Steichen, Foreword, *Memorable LIFE Photographs* (New York: The Museum of Modern Art, 1951): 3.

5 "Exhibition of Photography: 1839–1937," Press Release, The Museum of Modern Art, 1937: 1.

6 Sophie Hackett examines the presence of the machine aesthetic in the 1930s related to specific objects in Newhall's survey exhibition in 1937. Sophie Hackett, "Beaumont Newhall, le commissaire et la machine," *Études photographiques*, 23 mai 2009, [Online], Online since 18 May 2009. http://etudesphotographiques.revues.org/2656. connection on 17 December 2013.

7 The creation of this department was largely the result of the efforts of Beaumont and Nancy Newhall, Ansel Adams, and Rockefeller heir and art collector David H. McAlpin.

8 For further discussion about the history of the modern photographic exhibition (1920–1970) and mass media, see Olivier Lugon, *Expositions et Medias: Photographie, cinema, television* (Lausanne and Paris: L'Age d'Homme, 2012).

9 See John Szarkowski, "The Family of Man," in *Studies in Modern Art 4: The Museum of Modern Art at Mid-Century: At Home and Abroad* (New York: Museum of Modern Art: distributed by H. N. Abrams, 1994): 12–38 and Christopher Phillips, "The Judgment Seat of Photography," 1992.

10 Letter from Ansel Adams to Stephen Clark (President of the Board of Trustees MoMA), 29 April 1946, cited in Beaumout Newhall, *Focus: Memoirs of a Life in Photography* (Boston: Little Brown, 1993): 150.

11 Beaumont Newhall, *Focus: Memoirs of a Life in Photography* (Boston: Little Brown, 1993): 148.

12 Edward Steichen, *A Life in Photography* (New York: Doubleday, 1963): Ch. 13 n.p.

13 Olivier Lugon, "Steichen as Exhibition Designer," in Todd Brandow and William Ewing, eds, *Edward Steichen: Lives in Photography* (London: Thames and Hudson, 2007): 267–73.

14 A close colleague of Steichen's, Maloney was best known for his successful *US Camera Annual* (1935–1969), hard-cover volumes that showcased an extensive selections of a range of photography from the previous year including photo essays, portraiture, news photographs, portfolios, innovations in color, and more. Steichen was the head of *US Camera Annual*'s jury.

15 Ansel Adams in a letter to Stephen Clark, Head of the Board of Trustees of MoMA, 29 April 1946, cited in B. Newhall, *Focus*: 151.

16 Flyer advertising Aspen conference, 1951. Chicago businessman Walter Paepcke (1896–1960), chairman of the Container Corporation of America, created the Aspen Institute in 1950. Topics included "The nature of the photographic truth," "Can photographs help achieve social progress," and "Who makes the picture: photographer or subject?" The presence of John G. Morris, then picture editor of *Ladies' Home Journal* and Wayne Miller, then *LIFE* magazine photographer, formerly in Steichen's Navy Aviation Photographic Unit, and Steichen's protégé, represented the collaborative nature of the meeting.

17 "In the traditional art exhibition, also, the integrity of the individual work is more important than its role as evidence in service of the idea of the exhibition as a whole. 'The Family of Man' reverses this order of priorities, and sacrifices the part to the whole. Traditionally, this is what artists do, not curators." Szarkowski, "The Family of Man": 30.

18 This was done in collaboration with picture editor John G. Morris, *The Photo Essay* [MoMA Exh. #760, 16 March–16 May 1965] The exhibition was displayed in the Edward Steichen Study Center. http://www.moma.org/pdfs/docs/press_archives/3450/releases/MOMA_1965_0026_23.pdf?2010 (accessed 2 October 2014).

19 *From the Picture Press* [MoMA Exh. #1022, January 30–April 29, 1973], Press release, http://www.moma.org/pdfs/docs/press_archives/4948/releases/MOMA_1973_0018_4.pdf?2010 (accessed 2 October 2014).

2.22
Photojournalism: A Formal Paradigm for Contemporary Art*

Gaëlle Morel

In 2005 curator Hartwig Fischer shook up the art world with his exhibition *Covering the Real. Art and the Press Picture, from Warhol to Tillmans*[1] at the Kunstmuseum in Basel. This was a double-barreled retrospective, aiming on the one hand at a historical overview of the connections between contemporary art—including painting, photography, and video installations—and press images since the 1960s; and on the other at incorporating this approach into an innovative scenographic strategy, notably associating the showing of artworks with the projection of press agency news photographs received in real time.[2]

Thus the exhibition acknowledged the importance in art history of artists' appropriation of press imagery, and stressed the decisive stance of some contemporary photographers in relation to media output. In 1999 artists Roy Arden and Jeff Wall sized up the ascendancy of photojournalism: ". . . art photography was defined by photographers who wanted their work not to be bound by photojournalism, but still to make some claim to be reportage. But photojournalism was, and is, such a dominant social institution that it seemed that everyone positioned themselves in relation to it."[3] Artists instigated the use of press photography for creative ends in the 1920s, with Dadaist experiments in hijacking and tweaking newspaper pictures. As Fischer sees it, ". . . the museums have always lagged behind. For years they saw press pictures as unworthy of them. Even ten years ago the association I've put into practice was unthinkable."[4]

Covering the Real makes it clear that this utilization of photojournalism can be an effective tool for ambitious curatorial experiments: inclusion of press images with established use value means you can devise potentially distinctive art projects; and so the "anti-artistic"[5] practice of photojournalism—sometimes considered as devoid of any aesthetic implications—is in fact a crucial formal paradigm in both the field of artistic creation and that of its modes of display.

Artistic outcomes

As *Covering the Real* demonstrates, media images—disparaged, analyzed, engaged with, skirted, and/or assimilated—determine the aesthetic ambitions of a significant proportion of the art being made today.

Artists speculate about the economic, aesthetic, and moral rules governing this mass production of images, and the resultant assimilatory practices find fulfillment as much in the visual arts as in the strictly photographic realm. A common feature of some of the artists in the Basel show was their shifting of the functional character of the press image towards the artistic experience. Malcolm Morley's painting *At a First-Aid Center in Vietnam* (1971), for example, interprets Larry Burrows' famous *LIFE* magazine photograph of wounded American soldiers in the mud in Vietnam, alongside Andy Warhol silkscreens, Martha Rosler's anti-war photomontages, Sarah Charlesworth's reworked front pages dealing with the murder of Aldo Moro, Arnulf Rainer's black daubings overlaid on photographs from Hiroshima, and Wolfgang Tillmans' cutouts. Already *Public Information. Desire, Disaster, Document*, the inaugural exhibition at the San Francisco Museum of Modern Art in 1995, had looked at the attitudes and reactions of painters, photographers, and video makers to the flow of news images that characterizes Western societies today.[6] And in 2007 Alfredo Jaar and Pascal Convert were the subjects of retrospectives at, respectively, the Musée Cantonal des Beaux-arts in Lausanne and Mudam in Luxembourg. The work of both these artists is marked by appropriation and rechanneling of press imagery: between 1999 and 2003 Convert produced three massive wax sculptures—*Pietà du Kosovo* (Kosovo Pietà, 1999–2000), *Madone de Benthala* (Madonna of Benthala, 2001–2), and *Mort de Mohamed Al Dura* (Death of Mohammed Al Dura, 2002–3)—based on widely circulated media images. The works of photojournalists Georges Mérillon and Hocine Zaourar and cameraman Talal Abu Rahmeh, these "information icons", shot through with "cultural references such as the figures of a Christian martyrology",[7] were appropriated by the artist and transformed into fragile, relatively ephemeral monuments. Jaar brought together over 500 pictures taken in the working conditions of a photojournalist in Rwanda and placed them in hermetically sealed black boxes; shown in a dimly lit room, this "image graveyard"[8] resembles a kind of necropolis. The contexts in which the photographs were taken and the scenes they portray are noted and explained on the boxes. Jaar's statement addresses his photographs' "problematical *intelligibility* in the social context of art and information."[9]

This confrontation of press images and artistic practices is also taking place in contemporary art, with many photographers adopting a documentary approach that takes them to the same places as photojournalists and imposes the same working conditions. Bruno Serralongue, some of whose photographs were on show in Basel, "regularly attends events that, for a few days, will be making waves in the media."[10] His trips to Chiapas (1996) and the World Summit on the Information Society (2003) were opportunities to explore the codes, procedures and formal approaches of press photography,[11] and the resulting works are intended as a response to the process of cultural and patrimonial justification impacting a photojournalism now anointed by numerous exhibitions and by attempts to build up a collectors' market.[12] For Michel Poivert this prestige boost for press images reflects the temptation of a "history photography" that would seem to be slotting photojournalism into the status niche left vacant by painting.[13]

The Basel retrospective came shortly before an exhibition of seventeen panoramic photographs by Luc Delahaye at the Maison Rouge contemporary art foundation in Paris. Since 2001 this ex-Sipa and Magnum veteran has been traveling to the world's news hot spots and coming back with mostly frontal, wide angle, documentary-style images: the wars in Afghanistan and Iraq, the dismantling of the settlements in Palestine, mass being celebrated by Pope John Paul II at St Peter's in Rome, the Indonesian city of Meulaboh after the tsunami, all captured with a panoramic camera. Tackling high profile events with a weighty tool restricted to twelve shots per film, Delahaye establishes a distance enhanced by the size of the panoramic negative.[14] His images offer uniform lighting, no indications of how they should be

read or interpreted, and no ranking of their different visual elements. In the same spirit the captions are reduced to the bare essentials of place and date. Delahaye wants to differentiate his work from press photography while occupying the same media terrain as photojournalists. The implementation of this artistic project, hinging as it does on use of a camera that excludes any "snapshot" approach, is rooted in his emphasis on landscape and the importance of the out-of-frame. For Quentin Bajac, photography curator at the Centre Pompidou at the time, the interest of Delahaye's work lies in its generation of "contradictory tensions—presence of subject/absence to the world; proximity of witnessing/distance of the critical eye; documentary form/dramatic format."[15] Indeed, the format of his prints—mostly 120 x 240 cm—is suggestive more of a painterly than a photographic tradition of "history pictures."[16] Despite significant recognition on the international museum circuit, however, Delahaye also attracts critical fire: Dominique Baqué, for instance, accuses him of a formal glamorizing of newsworthy subjects that induces "a more than dubious spectacularization of the event."[17]

Curatorial practices

The same arguments apply to the scenography of *Covering the Real* and its inclusion of press pictures alongside the artworks as part of an inventive strategy that has been described as a "groundbreaking confrontation."[18] The works of the twenty-five artists were exhibited in the classical manner, but together with a large screen set up in the second-to-last room "so as to be visible throughout the visit, thanks to the aligned arrangement of the rooms."[19] The screen showed photographs sent to the Keystone agency in Zurich by correspondents all over the world and, as Hartwig Fischer put it in his specific claim to a break with curatorial tradition, "for the first time ever, the world-wide flow of digital press pictures is presented to the public in real time."[20] In parallel with these contemporary news photographs, deliberately uncaptioned press cuttings from different periods in the past were displayed in vitrines scattered through the nine rooms. The scenography, then, was quite out of the ordinary and signaled an urge to concentrate on the visual impact of the press images and the relationship set up between them and the works. The captions for the projected images could be consulted on a monitor at the entrance to the museum; similarly, in the catalog, the pictures destined for the press alternate indiscriminately with the artworks, with captions listed at the end.

The curator's selection was unanimously acclaimed by the critics, but the projection was seen by some as excessively seductive and causing a confusion of status between the press images and the artworks.[21] The criticisms of the Basel retrospective are reminiscent of those John Szarkowski had to field over the presentation of his 1973 exhibition *From the Picture Press* at the Museum of Modern Art.[22] The photographs in this exhibition, all of them from the New York *Daily News*, were removed from their original context. According to Szarkowski the formal and iconographic characteristics of press images had made a significant contribution to the development of the modern visual vocabulary, and he had made the use of press images the focal point of his modernist project;[23] their coverage of minor events and news items in particular was seen as potentially contributing to a formal enrichment of the medium. In the prestigious setting of the MoMA, Szarkowski showed this material just as he would have shown a work of art, while ignoring the circumstances of its production and diffusion.[24]

For Hartwig Fischer, "the 'public picture' is indeed a challenging forum for artists to redefine the aesthetic autonomy and social significance of their own work."[25] Thus the Basel event was a new experience, one intended to mingle objects of different kinds in the same space, but without reducing

the press pictures to the role of mere illustration and historicization of the works. Many museum exhibitions now readily combine artworks and press images, but as a straightforward means of contextualization. In 1996, for example, the major retrospective *Face à l'histoire 1933–1996, l'artiste moderne devant l'événement historique* at the Centre Pompidou was structured around a long "history corridor"[26] whose scenography by Michel Frizot included numerous original press publications. Clearly separated from the exhibition rooms, the magazines contextualized the works on show by retracing the news of the various eras concerned, and provided insight into the visual culture of the artists on show. This partitioning-off of the different spaces accorded the press photographs a strictly secondary role.

Beginning in the 1970s, artistic recognition for photography hinged on the acceptance or rejection of photojournalism within the museum context. In France enhancement of the cultural status of the medium involved increasing attention to press images, as photographers saw their work move from illustrated magazines to gallery walls and museums. Real recognition for the Magnum agency, for example, was perceptible in the regular showings of its photographers at the International Center of Photography in New York and the Centre National de la Photographie, which opened in Paris in 1982.[27] While not repudiating the functional character of their images, these photographers had frank artistic ambitions. In the course of the 1980s and 1990s, this emphasis on press photography drew considerable flak in France on the grounds that it was hampering artistic recognition for the medium. On more than one occasion the critic Michel Nuridsany backed this argument by quoting the artist Christian Boltanski, for whom "photography is photojournalism, and the rest is painting." In 1981, as the curator of the exhibition *Ils se disent peintres, ils se disent photographes*,[28] Nuridsany asserted that all photography, with the exception of reportage, belongs to the realm of art, and laid down certain rules for a rapprochement between the two. Photography, he said, must submit to the codes of art and not define itself through specific characteristics—documentary ones, in particular—which enable reportage photography to lay claim to the status of artworks. He rejected any in-between position as condemning photography to be "neither altogether journalism nor altogether art."[29] At the time, critic Jean-François Chevrier urged that photography be shown and acquired by museums along with the other visual arts, openly deploring the creation of institutions specifically devoted to the medium and its different uses and practices. The introduction of press photography into museums has long been seen as a pejorative factor for photography in general.

The *Covering the Real* exhibition demonstrates that this bringing together of artworks and press images now appears acceptable in a museum context. And despite their contradictory ambitions, the practice has also recently come to be seen as admissible by photojournalism institutions. In 2006 photographer Eric Baudelaire showed a reconstructed war scene at the "Visa pour l'Image" photojournalism festival in Perpignan. Commissioned by the Centre National des Arts Plastiques, his diptych *The Dreadful Details* (2006) is a realistic portrayal of an imaginary moment in the Iraq conflict: composing his scene with professional actors, Baudelaire used a Hollywood TV series stage like an outdoor theatre set. The sheer size of the prints (209 × 375 cm) and the diptych form generate a reminiscence of the painterly, as the photographer seeks to incorporate his work into both the history of art and the visual tradition of war imagery.[30] In his paired pictures he combines different dramatic scenes habitually highlighted by the media: broken, mutilated corpses; a weeping mother holding a dead child on her knees; and survivors reaching out in entreaty to American soldiers. He adopts, too, the code of the war image as shown in the press or on television, offering a concentrate of typical scenes "with no action . . . or spontaneous group movement; the characters are actors whose poses are either hieratic or falsely natural."[31] In the exhibition venue in Perpignan the work was shown alongside classically

produced press images, and this press-image/artwork confrontation is becoming increasingly common in contemporary art, photojournalism, and museum circles: two diametrically opposed genres regularly associated in the contexts of artistic practices and exhibition scenography. The *mise en scène* of *Covering the Real* results in a process of dehistoricization that alters the status of the projected press photographs, but above all enables speculation about the aesthetics of pictures habitually assessed according to purely iconographic criteria. Today's omnipresence of these images in the art field demands scrutiny of the visual principles underlying news pictures, principles long ignored on the grounds of "moral offence."[32] While not confusing works of art and press photographs, this appropriation nonetheless seems a decisive factor in, at last, giving media images a place in the overall history of forms.

Notes

* This chapter translated from the French by James Gussen.

1 Hartwig Fischer (ed.), *Covering the Real. Art and the Press Picture, from Warhol to Tillmans*, exh. cat. (Cologne: DuMont Literatur und Kunst Verlag, 2005).

2 Cf. Garance Chabert, "*Covering the Real*. Entretien avec Hartwig Fischer," in Gaëlle Morel (ed.), *Photojournalisme et art contemporain. Les derniers tableaux* (Paris: Editions des archives contemporaines, 2008): 13–24.

3 Jeff Wall and Roy Arden, "The Dignity of the Photograph," Paris, *art press*, November 1999: 17.

4 "L'actualité en images confrontée à des œuvres d'art," Michel Guerrin in conversation with Hartwig Fischer, *Le Monde*, 29 July 2005, quoted in Garance Chabert, "*Covering the Real*. Entretien avec Hartwig Fischer," in Gaëlle Morel (ed.), *Photojournalisme et art contemporain. Les derniers tableaux* (Paris: Editions des archives contemporaines, 2008): 18.

5 Michel Poivert, "Photojournalism as Cultural Object," Paris, *art press*, November 2004: 21.

6 *Public Information. Desire, Disaster, Document*, exh. cat. (San Francisco: Museum of Modern Art, 1995).

7 Michel Poivert, "Photojournalism as Cultural Object," Paris, *art press*, November 2004: 22.

8 Vincent Lavoie, *L'Instant-monument. Du fait divers à l'humanitaire* (Montreal: Dazibao, 2001): 144.

9 Georges Didi-Huberman, "Emotion Does Not Say 'I', Ten Fragments on Aesthetic Freedom," in Nicole Schweizer (ed.), *Alfredo Jaar: The Politics of Images*, exh. cat. (Zurich/Lausanne:JRP/Ringier Musée Cantonal des Beaux-arts, 2007): 60.

10 Pascal Beausse, "Photography versus the Image," *art press*, November 1999: 46.

11 Cf. Bruno Serralongue, "Droit de regard," *in* Gaëlle Morel (ed.), *Photojournalisme et art contemporain. Les derniers tableaux* (Paris: Editions des archives contemporaines, 2008): 45–55.

12 Poivert, "Photojournalism as Cultural Object": 21–24.

13 Michel Poivert, "La tentation d'une photographie d'histoire," in *Voir, ne pas voir la guerre*, exh. cat. (Paris: BDIC/Musée d'histoire contemporaine, 2001), pp. 337–340.

14 Cf. Gaëlle Morel, "Esthétique de l'auteur. Signes subjectifs ou retrait documentaire?" *Études photographiques*, no. 20 (June 2007): 134–147.

15 Quentin Bajac, "Le regard élargi. Les photographies panoramiques de Luc Delahaye," *Les Cahiers du MNAM*, no. 92, summer 2005: 30.

16 Michel Guerrin, "Les 'tableaux d'histoire' contemplatifs de Luc Delahaye," *Le Monde*, 2 March 2003: 17.

17 Dominique Baqué, "Reasons for a Lack of Focus," *art press*, January 2006: 89. Georges Didi-Huberman reacts to this accusation in "Emotion Does Not Say 'I', Ten Fragments on Aesthetic Freedom," in Nicole Schweizer (ed.), *Alfredo Jaar: The Politics of Images*, exh. Cat. (Zurich/Lausanne:JRP/Ringier Musée Cantonal des Beaux-arts, 2007: 64–65.

18 Michel Guerrin, "L'actualité en images confrontée à des œuvres d'art," *Le Monde*, 29 July 2005: 18.

19 Chabert, "*Covering the Real*. Entretien avec Hartwig Fischer": 18.

20 Hartwig Fischer and Bernhard Mendes Bürgi, "Preface," in Hartwig Fischer (ed.), *Covering the Real. Art and the Press Picture, from Warhol to Tillmans*, exh. cat. (Cologne: DuMont Literatur und Kunst Verlag, 2005: 6.

21 Cf. Chabert, "*Covering the Real*. Entretien avec Hartwig Fischer": 17–19.

22 John Szarkowski, *From the Picture Press*, exh. cat. (New York: MoMA, 1973).

23 Michel Poivert, "Le document, au cœur du dogme modernist," in Marie Muracciole (ed.), *Le statut de l'auteur dans l'image documentaire. Signature du neutre* (Paris: Jeu de Paume, 2006): 30–33.

24 Cf. Laetitia Barrère, *John Szarkowski. Le modernisme photographique au Museum of Modern Art de New York (1962–1991)*, Masters dissertation supervised by Claude Massu and Michel Poivert, Université Paris-I, 2005.

25 Hartwig Fischer and Bernhard Mendes Bürgi, "Preface," in Hartwig Fischer (ed.), *Covering the Real. Art and the Press Picture, from Warhol to Tillmans*, exh. cat. (Cologne: DuMont Literatur und Kunst Verlag, 2005): 6.

26 This scenography has been seen as a "refutation of modernism." See Hélène Causse, *La photographie de presse exposée en France (1977–1997). Le document-choc, la reconnaissance comme objet culturel et la légitimation artistique du reportage d'auteur*, Masters dissertation supervised by Michel Poivert, Université Paris-I, 2006: 55–57.

27 Cf. Gaëlle Morel, *Le photoreportage d'auteur. L'institution culturelle de la photographie en France depuis les années 1970* (Paris: CNRS éditions, 2006); and by the same author, "L'accueil du photoreporter dans le champ culturel français," *Études photographiques*, no. 13 (July 2003): 35–55.

28 Michel Nuridsany, *Ils se disent peintres, ils se disent photographes*, exh. cat. (Paris: Musée d'Art Moderne de la Ville de Paris, 1980).

29 "Denis Roche, l'icône photographique. Conversation avec Michel Nuridsany," *art press*, no. 98, December 1985: 4.

30 Telephone conversation between the author and Eric Baudelaire, 16 October 2007.

31 Pierre Zaoui, "La fresque aux icônes. A propos de *Dreadful Details* d'Eric Baudelaire," *Vacarme*, no. 37, fall 2006: 45.

32 Georges Didi-Huberman, "Emotion does not say 'I', Ten Fragments on Aesthetic Freedom," in Nicole Schweizer, ed., *Alfredo Jaar: The Politics of Images*, exh. cat. (Zurich/Lausanne:JRP/Ringier Musée Cantonal des Beaux-arts, 2007): 64.

2.23

Uneasy Witnesses: Broomberg, Chanarin, and Photojournalism's Expanded Field

Erina Duganne

In 2007, Tim Hetherington's photograph of a worn-out US soldier resting inside a bunker in Afghanistan's Korengal Valley was selected from more than 80,000 submissions as the World Press Photo of the Year. In terms of its initial circulation, the photograph was an unlikely candidate to win this award. Hetherington took this image while on assignment with Sebastian Junger for *Vanity Fair* magazine, as part of a year-long embed with the Second Platoon of Battle Company of the US 173rd Airborne Brigade in Afghanistan. Though Hetherington had hoped to use the photograph as the opening spread for Junger's January 2008 *Vanity Fair* article "Into the Valley of Death," a different photograph was ultimately chosen. Hetherington also did not submit this image separately to the World Press Photo contest. As a photojournalist who values storytelling above all else, he entered it instead as part of a twelve-image photoessay that went on to garner second place in the category of General News Stories.[1]

Given that Hetherington's photograph never circulated in the print media, how do we account for its selection as Photo of the Year and, more critically, what does this process say about the state of contemporary event-based news gathering? A keynote address given by former Jury Secretary for the World Press Photo contest, Stephen Mayes, two years after Hetherington's photograph won this coveted award, offers insight into this question. In his speech to the World Press Photo organization, Mayes characterized the nearly half a million photographs that he had encountered during his tenure as Jury Secretary as "a form of photojournalism that is now more romantic than functional." He further lamented that too much photojournalism "doesn't inform but merely repeats and affirms what we already know."[2] London-based artists Adam Broomberg and Oliver Chanarin, who served on the jury the year that Hetherington's photograph won Photo of the Year, reiterate Mayes's concerns. In an essay about their experience judging the contest, they describe Hetherington's photograph as "a predictable World Press Photo winner; an amalgam of all the images of war and death that we have embedded in our memory."[3] Like Mayes's impression that over the years he was seeing "the same picture again and again,"[4] the duo criticized Hetherington's use of the visual trope of the exhausted soldier as "casting the world in the same mold over and over again."[5]

Together these reflections on the World Press Photo contest highlight a crisis not only in the competition itself but also in the state of contemporary event-based news gathering more generally. Many critics have

identified this unrest as a product of the rapidly changing media environment. With the waning of traditional platforms of circulation and payment beginning with the folding of big picture magazines in the 1970s, along with the introduction of digital technologies in the 1980s and 1990s, it is widely held that photojournalism today has relinquished its traditional witnessing authority to other media. A 2009 *New York Times* headline that reads "Lament for a Dying Field: Photojournalism" echoes this contention. In the accompanying article, reporter David Jolly attributes widespread budgetary cutbacks in newspaper and magazine photography, the bankruptcy of international photo agencies, and the rise and speed of citizen journalism as bringing about traditional photojournalism's demise.[6] In what follows, I consider several recent photographic responses to the so-called death, or at least decline, of traditional photojournalism's witnessing potential. As part of this discussion, I examine what assumptions about photography's documentary aspirations they make and how, rather than signal the end of the photojournalistic object, they might be used to expand the medium's longstanding ability to visualize the world.[7]

Beginning in the late 1990s, one response to the mounting crisis within contemporary photojournalism was for photographers to forgo their reliance on instantaneity and immediacy for the more distanced and detached perspective of "after." Many practitioners who opted for this approach also exchanged photojournalism's lightweight, 35 mm or digital, hand-held cameras and their ostensible ability to quickly and immediately freeze events as they happen in time for medium- or large-format cameras, whose larger frames and cumbersome sizes require them to take slower and more detailed images. Identified variously as "post-reportage," a photography of "after," and "late photography," many photography critics and historians lauded this approach for its potential to transform, even challenge, the fundamental tenets that have conventionally informed the traditional institutions and practices of photojournalism.[8]

In situating "late photography" as the inversion of photojournalism, however, these same critics and historians perpetuate a kind of oppositional thinking dependent on a series of medium specific clichés about the differences between news and art photography. According to this logic, since photojournalism is a form of reportage, its photographers necessarily and automatically "capture" the real without any self-reflexivity or critical detachment. Artists, conversely, consider the nature of representation and its depiction of reality in a more oblique and hence contemplative manner. Whereas photojournalists must adhere to the immediacy and instantaneity of the "facts," then, artists, who can approach their works with slowness and detachment, produce more analytical and reflective forms of representation. "The photojournalist," so this reasoning goes, "has a professional and ethical imperative to capture the immediate circumstances, while the artist has the license of luxury to turn his camera away from these events, even to question the photograph's ability to accurately represent them."[9]

Adam Broomberg's and Oliver Chanarin's evaluation of the process of judging the 2007 World Press Photo contest relies on this same binary of photojournalism and art. In lieu of Tim Hetherington's more "predictable" photograph, Broomberg and Chanarin identify another submission, one that went on to receive honorable mention in the category of General News, as deserving of special recognition. Taken by photojournalist Christoph Bangert, the image depicts a shot-ridden German practice target sitting alone in a desolate Afghan landscape (Fig. 2.23a). What appeals to Broomberg and Chanarin about this image is the kind of reflection that it supposedly requires of viewers. Whereas the well-rehearsed visual trope of the exhausted soldier in Hetherington's photograph essentially thinks for viewers, Broomberg and Chanarin argue that the formal discrepancy between the "lush, green landscape" in the hand-painted German target and the actual desolation of the barren Afghan landscape surrounding it encourages viewers to reflect more critically about the relationship between these two entities and, more pointedly, about "the nature of war" itself.

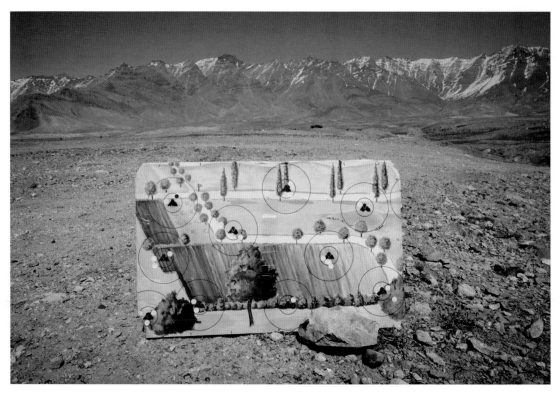

Figure 2.23a Christoph Bangert/laif. A target on firing range used by German NATO forces (Afghanistan 2007). Courtesy of Redux Pictures.

In both instances—Bangert's photograph and in the notion of "late photography"—the "reflection" and "analysis" required of them (usually associated with art) is elevated above the seemingly blunt "immediacy" and "instantaneity" of reportage (photojournalism). How might this oppositional thinking be overcome? Broomberg's and Chanarin's installation, *The Day Nobody Died*, produced the year after they served as judges for the World Press Photo contest, offers one model. For this series, instead of arriving after the fact, the artists traveled under the guise of embedded photojournalists with the British army to the front-line of the war in Afghanistan. In spite of their closeness to the action, however, Broomberg and Chanarin refused both photojournalism's traditional hand-held cameras and the large-format cameras of "late photography." In place of these devices, they selected a sealed, lightproof box of photographic paper. During each of the eight days of their embed, they unrolled a seven-meter section of this paper and exposed it to the sun for 20 seconds in response to such war-time events as the execution of a BBC fixer as well more mundane ones, including a visit to the troops by the Duke of York. The series of photograms that resulted—consisting essentially of abstracted bands of color, which the artists paired with matter-of-fact titles that describe the event "witnessed" in the images—were then hung on the white walls of the Barbican Art Gallery (Fig. 2.23b).[10]

Through these non-figurative photograms, Broomberg and Chanarin question the tendency within traditional photojournalism to assume that its reportorial powers derive from the physical and emotional proximity of its photographers and their ability to, thereby, witness their subjects firsthand. At the same

Figure 2.23b Adam Broomberg and Oliver Chanarin, *The Day That Nobody Died*, 2008, installation view. Courtesy of the artists.

time, the artists circumvent the oppositional thinking inherent in "late photography" by denying viewers the opportunity to see actual representations of pain and suffering whether they were taken during the course of an event or after the fact. Whereas "late photography" replaces the visual tropes of "closeness" and "immediacy" with "distance" and "slowness," the abstracted bands of colors in Broomberg's and Chanarin's photograms are the product of neither closeness nor distance. This is because, as the product of the light registered at the moment that these war time events occurred, the photograms, though literally as "close" as possible, render the visual codes usually associated with photography's witnessing potential—upon which both photojournalism and "late photography" depend—strange.

Through their installation, Broomberg and Chanarin, then, not only demystify the formal conventions through which the representation of war is produced but, more importantly, question the set of aesthetic assumptions upon which documentary and press photography depend. At the same time, in turning away from lens-based images, their critique results in a kind of rejection of the photojournalistic object itself. Broomberg and Chanarin have acknowledged this "anti-naturalistic" tendency in their work and have made it clear that "while we have real problems with the role of the professional observer we do believe that suffering demands a witness."[11] Just how the witnessing potential of the photojournalistic object might be opened up without rejecting its visualization outright is the approach of what many refer to today as "visual journalism."

According to photography critic Fred Ritchin, visual journalism, which includes "not only photography, video, and digital imaging, but a host of other strategies such as hypermedia, geo-positioning, augmented reality, and simulations," is a kind of image making that "allows for a wider-ranging approach in which the action photograph is only one component."[12] This means that, unlike "late photography," visual journalism does not stand in opposition to the instantaneity and immediacy of traditional photojournalism. Rather, its practitioners seek to combine its formal conventions with other forms of digital and multimedia content in innovative and engaging ways. David Campbell elaborates: visual journalism "is not a world in which one visual form has died, but a world in which multiple visual forms are alive and stronger than ever."[13] Until his premature death in 2011, Tim Hetherington chiefly worked within this broader field of visual journalism or what he called the "post-photographic."[14] His installation *Sleeping Soldiers*, first shown at the 2009 New York Photo Festival, exemplifies this expanded approach (Fig. 2.23c). For this work, Hetherington created a three-channel installation in which he layered video footage from his embed in Afghanistan's Korengal Valley, that depicts the Second Platoon of Battle Company engaged in combat, on top of still photographs of soldiers from this same Platoon at rest. Through this superposition of still and moving, repose and action, dreams and reality, Hetherington considers the psychological impact of war and the ways in which the experience of conflict, in a manner similar to the immersive experience of watching and listening to the three channel installation, infiltrates one's psyche such that the

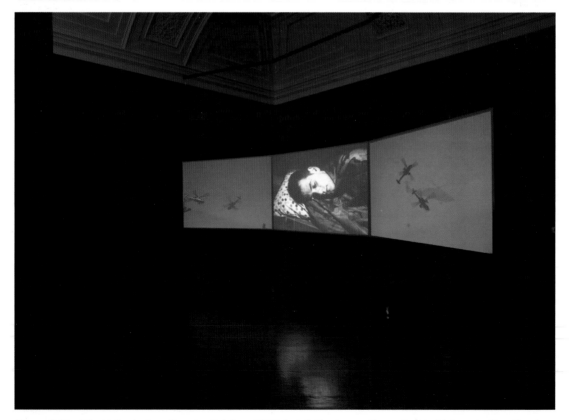

Figure 2.23c Tim Hetherington, *Sleeping Soldiers*, 2009, installation image, three-screen video projection. Courtesy of Magnum Photos.

distinctions between what is real and imaginary as well as what is reportage and analysis are no longer decipherable.

Through this melding of states of consciousness as well as visual strategies, Hetherington's installation at once documents the brutalities of war from the position of closeness while at the same time more distantly reflects upon its emotional complexities. In so doing, *Sleeping Soldiers* offers an important model for thinking beyond the photojournalism/art binary in a way that does not necessitate forgoing photojournalism's witnessing potential or art's assumed reflexivity. Yet, although the visual language of the photojournalistic object is greatly expanded within this installation, the circumstances, including political consequences, of its making are largely taken for granted. This means that, even though Hetherington's *Sleeping Soldiers* enlarges the visual scope of photojournalism beyond the formal tropes of instantaneity and immediacy as well as distance and reflection, in the end, the installation does nothing to disrupt the combined effects that these representations of conflict have had on our visual understanding of the war in Afghanistan, including, most importantly, the collusion of the US military with them. This is because, like Hetherington's World Press Photo of the Year, *Sleeping Soldiers* is the product of an embedding system that has likewise gone unchecked by the mainstream press. Rather than reflect the complex set of political and personal issues that make up the war in Afghanistan, the images disseminated about this conflict, including *Sleeping Soldiers*, have remained, as Campbell explains, "remarkably similar in both content and approach. US forces are the locus of the narrative and combat scenes are repeatedly pictured." These kind of one-sided pictures, as Campbell elaborates, "badly limit our understanding of the strategic dilemma that is Afghanistan" and "effectively structure the visibility of the war in a way that foregrounds competing American military interests."[15]

For Adam Broomberg and Oliver Chanarin, unmasking the political effects bound up within representations of war is crucial. It is for this reason that, in addition to non-figurative photograms, *The Day Nobody Died* also consists of a film matter-of-factly documenting the British army's transportation of the box of photographic paper from the artists' studio in London to the front-line in the Helmand Province in Afghanistan and back. In making this absurd, even "dadaesque," film about a sealed, lightproof box of photographic paper a central component of their installation, Broomberg and Chanarin challenge not just what the representation of war looks like but also the mechanisms through which these representations are produced and have come to have meaning in the world. By turning the act of photography into a kind of performance, or "theater of war," in which the British army becomes an unsuspecting participant, *The Day Nobody Died* inextricably links the act of witnessing with the war itself. "Like a barium test," the artists explain, "the journey of the box reveal[s] the dynamics of the machine in its quotidian details, from the logistics of war to the collusion between the media and the military."[16]

The problem that remains is Broomberg's and Chanarin's treatment of the photojournalistic object within this performance. Whereas the meaning of Hetherington's *Sleeping Soldiers* may be confined to, as photography critic Jörg Colberg writes, "our military and the job they do,"[17] one can argue that what makes this installation distinctive nonetheless is its use of photojournalism's traditional witnessing potential. Whereas Broomberg's and Chanarin's *The Day Nobody Died* largely negates this documentary ambition, Hetherington's *Sleeping Soldiers* explores what it might mean to expand photojournalism's field of operation so that photography's witnessing potential still persists but in a different form. Still, as the categories between photojournalism and art, professional and amateur, and the real and manipulated become increasingly distorted in today's rapidly changing media economy, in broadening the visual language of the photojournalistic object, we cannot at the same time forgo the importance of questioning the political impact that it also makes in the world. The key here is to figure out how to incorporate an

awareness of the effects of visualization (or picturing) without foreclosing the documentary aspirations of the form. It would seem that this kind of expanded thinking about photojournalism's witnessing potential is necessary now more than ever.

Notes

1 See "Picture Power: Tim Hetherington," last modified 14 February 2008, http://news.bbc.co.uk/2/hi/south_asia/7240590.stm. The photograph subsequently appeared as the concluding image for an online photo essay on *Vanity Fair's* website entitled "The Fight for the Korengal." See http://www.vanityfair.com/politics/features/2008/01/afghanistan_slideshow200801.

2 Stephen Mayes, "470,214 Pictures Later," Vimeo video, 49:34, 2 May 2009, http://vimeo.com/67511685.

3 Adam Broomberg and Oliver Chanarin, "Indifferent But Not Unconcerned," *Foto8 Blog*, 5 May 2008, http://www.foto8.com/live/unconcerned-but-not-indifferent/#.UkBttbyxOwk.

4 Mayes, "470,214 Pictures Later." Vimeo video, 49:34, 2 May 2009, http://vimeo.com/67511685.

5 Broomberg and Chanarin, "Indifferent But Not Unconcerned," *Foto8 Blog*, 5 May 2008, http://www.foto8.com/live/unconcerned-but-not-indifferent/#.UkBttbyxOwk.

6 See David Jolly, "Lament for a Dying Field: Photojournalism," *New York Times*, 9 August 2009, http://www.nytimes.com/2009/08/10/business/media/10photo.html?pagewanted=all.

7 My thinking about the possibility of an expanded model of the photojournalistic object owes much to the ideas in George Baker's influential essay, "Photography's Expanded Field," *October* 114 (Fall 2005): 120–40.

8 See Ian Walker, "Desert Stories or Faith in Facts?" in *The Photographic Image in Digital Culture*, ed. Martin Lister (London and New York: Routledge, 1995): 236–52; David Campany, *Art and Photography* (London and New York: Phaidon, 2003); and David Campany, "Safety in Numbness: Some Remarks on Problem of 'Late Photography,' " in *Where is the Photograph?* ed. David Green (Manchester: Photoworks/PhotoForum, 2003): 123–32.

9 Christy Lange, "Shooting Gallery," *Frieze* 132 (June–August 2010), http://www.frieze.com/issue/article/shooting_gallery/.

10 Additional installation shots and documentation about the project can be found on the artists' website: http://www.choppedliver.info/.

11 Adam Broomberg and Oliver Chanarin, "The Day Nobody Died," *FMR: White Edition* 8 (June–July 2009): 102. For a larger discussion of "anti-naturalism" in the work of Broomberg and Chanarin, see David Evans, "Occupying Brecht: Broomberg and Chanarin's War Primer 2," *The Photographers' Gallery Blog*, 15 June 2013. http://thephotographersgalleryblog.org.uk/2013/06/15/occupying-brecht-broomberg-and-chanarins-war-primer-2-david-evans/.

12 Fred Ritchin, *Bending the Frame: Photojournalism, Documentary, and the Citizen* (New York: Aperture, 2013): 57.

13 David Campbell, "'Multimedia,' Photojournalism and Visual Storytelling," *David Campbell's Visual Storytelling: Creative Practice and Criticism Blog*, 29 April 2013, http://www.david-campbell.org/2013/04/29/multimedia-photojournalism-and-visual-storytelling/.

14 See Tim Hetherington, " 'Restrepo' and the Imagery of War," interview with Michael Kamber, *Lens: Photography, Video and Visual Journalism Blog*, 22 June 2010, http://lens.blogs.nytimes.com/2010/06/22/behind-44/?_r=0. Hetherington along with photojournalist Chris Hondros were killed in April 2011 covering the war in Libya.

15 David Campbell, "Embedded in Afghanistan," *David Campbell's Visual Storytelling: Creative Practice and Criticism Blog*, 22 May 1999, http://www.david-campbell.org/2009/05/22/embedded-in-afghanistan/. For additional discussion of the embedding system in Afghanistan, see also, David Campbell, "The Elusive Enemy:

Looking Back at the 'War on Terror's' Visual Culture," *David Campbell's Visual Storytelling: Creative Practice and Criticism Blog*, 10 November 2011, http://www.david-campbell.org/2011/11/10/the-elusive-enemy-war-on-terror-visual-culture/ and David Campbell, "How Has Photojournalism Framed the War in Afghanistan?" *Burke + Norfolk: Photographs From the War in Afghanistan by John Burke and Simon Norfolk* (Stockport: Dewi Lewis Publishing, 2011): 153–5.

16 Adam Broomberg and Oliver Chanarin, "The Day Nobody Died," *Adam Broomberg & Oliver Chanarin*, http://www.broombergchanarin.com/the-day-nobody-died/ (accessed 1 October 2013).

17 Jörg Colberg, "Meditations on Photographs: Sleeping Soldier (Steve Kim, Korengal Valley, Afghanistan) by Tim Hetherington," *Conscientious Extended*, 7 March 2012, http://jmcolberg.com/weblog/extended/archives/meditations_on_photographs_sleeping_soldier_steve_kim_korengal_valley_afghanistan_by_tim_hetheringto/.

SELECTED BIBLIOGRAPHY

This bibliography is a guide to key texts organized by subject, with emphasis on Anglophone literature. Where there is a very recent volume with ample notes and bibliography on a given subject, we have been more sparing regarding references to that subject.

Foundational histories

Arpan, Floyd G, ed. "Photojournalism," Special issue of *Journalism Quarterly* 23.3 (1947).

Bessie, Simon Michael. *Jazz Journalism: The Story of the Tabloid Newspapers*. New York: E.P. Dutton & Co., 1938.

Costa, Joseph, ed. *The Complete Book of Press Photography*. New York: National Press Photographers Association, 1950.

Eastman, Max. *Journalism Versus Art*. New York: A.A. Knopf, 1916.

Eberman, Edwin and Daniel Mich. *The Technique of the Picture Story*. New York, McGraw Hill, 1945.

Ezickson, A. J. *Get That Picture! The Story of the News Cameraman*. New York: National Library Press, 1938.

Freund, Gisèle. *Photography and Society*. Boston: Godine Press, 1980.

Hicks, Wilson. *Words and Pictures: An Introduction to Photojournalism*. New York: Harper, 1952.

Hogarth, Paul. *The Artist as Reporter*. London: Studio Vista, 1967.

Horgan, Stephen H. "The Evolution of Daily Newspaper Illustrating," *Graphic Arts and Crafts Yearbook*, 1906: 223.

Jackson, Mason. *The Pictorial Press: Its Origin and Progress*. London: Hurst and Blackett, 1885.

Junger, Ernst. "War and Photography," *New German Critique* 59 (1993): 24–6.

Luce, Henry. "The Camera as Essayist," *LIFE*, 26 April 1937: 60–5.

Molzahn, Johannes. "Stop Reading! Look!" *Das Kunstblatt* 12.3 (March 1928): 78–82. Translated and reprinted in Anton Kaes, Martin Jay, and Edward Dimendberg, eds., *The Weimar Republic Sourcebook*. Berkeley: University of California Press, 1994: 648–9.

Mott, Frank Luther. *A History of American Magazines*. 5 vols. Cambridge, MA: Harvard University Press, 1938–64.

Newhall, Beaumont. *The History of Photography from 1839 to the Present Day*. New York: Museum of Modern Art, 1937.

Price, Jack. *News Pictures*. New York: Round Table Press, 1937.

Schuneman, R. Smith, ed. *Photographic Communication: Principles, Problems, and Challenges of Photojournalism*. New York: Hastings House, 1972.

Shikes, Ralph E. *The Indignant Eye: The Artist as Social Critic*. Boston: Beacon, 1969.

Stern, Philip V. D, and Herbert Ashbury. *The Breathless Moment: The World's Most Sensational News Photos*. New York: Knopf, 1935.

Szarkowski, John. *From the Picture Press*. New York: Museum of Modern Art, 1973.

Vitray, Laura, John Mills, Jr., and Roscoe Ellard. *Pictorial Journalism*. New York: McGraw-Hill, 1939.

Whiting, John. *Photography is a Language*. New York: Ziff-Davis, 1946.

General theoretical texts

Azouley, Ariella. *The Civil Contract of Photography*. Cambridge, MA: Zone Books, 2012.

Barthes, Roland. *Mythologies*. New York: Hill and Wang, 1972.

—— *Image-Music-Text*. New York: Hill and Wang, 1978.

Baudelaire, Charles, and Jonathan Mayne. *The Painter of Modern Life: And Other Essays*. London: Phaidon, 1964.

Belting, Hans. "Art History versus Media Studies." *Art History after Modernism*. Chicago: University of Chicago Press, 2003: 161–66.

Benjamin, Walter. *The Work of Art in the Age of Its Technological Reproducibility, and Other Writings on Media*. Cambridge, MA: Harvard University Press, 2008.

Berger, John, and Geoff Dyer. *Understanding a Photograph*. New York: Aperture, 2013.

Butler, Judith. "Torture and the Ethics of Photography," *Environment and Planning D: Society and Space*, 25.6 (2007) 951–66.

Dewey, John. *The Public and Its Problems*. New York: H. Holt and Company, 1927.

Domke, David, David D. Perlmutter, and Meg Spratt, "The Primes of our Times? An Examination of the 'Power' of Visual Images," *Journalism* 3.2, 2002: 131–59.

Edwards, Elizabeth, and Janice Hart. *Photographs Objects Histories: On the Materiality of Images*. London, New York: Routledge, 2004.

Hall, Stuart. "The Determinations of News Photographs." In Stanley Cohen and Jock Young, eds. *The Manufacture of News: Social Problems, Deviance and the Mass Media*. London: Constable, 1981: 226–43.

—— "The Social Production of News." In Paul Marris and Susan Thornhar eds. *Media Studies: A Reader*. New York: New York University Press, 2000: 645–52.

Hansen, Miriam. "Why Media Aesthetics?" *Critical Inquiry* 30, (Winter 2004): 391–5.

Haskell, Francis. *History and Its Images. Art and the Interpretation of the Past*. New Haven: Yale University Press, 1993.

Huxford, John, "Beyond the referential: Uses of visual symbolism in the press," *Journalism* 2.1 (2001): 45–71.

Kemp, Martin. *Christ to Coke. How Images Become Icons*. Oxford: Oxford University Press, 2012.

Kracauer, Siegfried, and Thomas Y. Levin. *The Mass Ornament: Weimar Essays*. Cambridge, MA: Harvard University Press, 1995.

Latour, Bruno. "Why Has Critique Run Out of Steam? From Matters of Fact to Matters of Concern," *Critical Inquiry* 30 (2004): 225–48.

Latour, Bruno, and Peter Weibel. *Making Things Public: Atmospheres of Democracy*. Cambridge, MA: MIT Press, 2005.

Lippmann, Walter. *Public Opinion*. New York: MacMillan, 1922.

Mitchell, W. J. T. *Picture Theory. Essays on Verbal and Visual Representation*. Chicago: University of Chicago Press, 1995.

Mitchell, W. J. T., and Mark B. Hansen, eds. *Critical Terms for Media Studies*. Chicago: University of Chicago Press, 2010.

Scott, Clive. *The Spoken Image: Photography and Language*. London: Reaktion, 1999.

Sekula, Allan. *Photography against the Grain: Essays and Photo Works, 1973–1983*. Halifax, NS: Press of the Nova Scotia College of Art and Design, 1984.

Sontag, Susan. *On Photography*. New York: Picador, 1977.

—— *Regarding the Pain of Others*. New York: Penguin, 2004.

Terdiman, Richard. *Discourse/Counter-Discourse: The Theory and Practice of Symbolic Resistance in Nineteenth Century France*. New York: Cornell University Press, 1985.

Trachtenberg, Alan. *Reading American Photographs: Images as History. Matthew Brady to Walker Evans*. New York: Hill and Wang, 1989.

Warner, Michael. *Publics and Counterpublics*. New York: Zone Books, 2002.

Press histories and news picture general surveys

"American Periodicals and Visual Culture," Special issue of *American Periodicals* 20.2 (2010).

Anderson, Patricia. *The Printed Image and The Transformation of Popular Culture, 1790–1860*. Oxford: Clarendon Press, 1991.

Barnhurst, Kevin, and John Nerone. *The Form of News: A History*. New York: Guilford, 2001.

Becker, Karin E. "Photography and the Tabloid Press." In Liz Wells, ed., *The Photography Reader*. New York: Routledge Press, 2003: 291–308.

Brennen, Bonnie, and Hanno Hardt, eds. *Newsworkers: Toward a History of the Rank and File*. Minneapolis, MN: University of Minnesota Press, 1995.

Brennan, Bonnie, and Hanno Hardt. *Picturing the Past: Media, History, and Photography*. Urbana: University of Illinois Press, 1999.

De la Motte, Dean, and Jeannene M. Przyblyski. *Making the News: Modernity & the Mass Press in Nineteenth-Century France*. Amherst: University of Massachusetts Press, 1999.

Faber, John. *Great News Photos and the Stories Behind Them*. New York: Dover, 1978.

Farwell, Beatrice, *The Cult of Images: Baudelaire and the Nineteenth Century Media Explosion*. Santa Barbara: Santa Barbara Museum of Art, 1977.

Fielding, Raymond. *The March of Time, 1935–1951*. New York: Oxford University Press, 1978.

Fox, Celina. *Graphic Journalism in England during the 1830s and 1840s*. New York: Garland, 1988.

Haver, Gianni, ed. *Photo de Presse*. Lausanne: Antipodes, 2009.

Halloran, Fiona D. *Thomas Nast: The Father of Modern Political Cartoons*. Chapel Hill: UNC Press, 2012.

Hassner, Rune, "Photography and the Press." In Colin Osman and Jean-Claude Lemagny, eds. *History of Photography*. Cambridge, UK: Cambridge University Press, 1988: 76–9.

Hopkinson, Ken Baynes, Allen Hutt, and Derrick Knight. *Scoop Scandal and Strife: A Study of Photography in Newspapers*. London: Lund Humphries Publishers, 1971.

Kalifa, Dominique, Philippe Régnier, Marie-Eve Thérenty, and Alain Vaillant, eds. *La Civilisation du Journal*. Paris: Nouveau Monde, 2011.

Kobre, Sidney. *The Yellow Press and Gilded Age Journalism*. Tallahasee: Florida State University Press, 1964.

Pettegree, Andrew. *The Invention of the News. How the World Came to Know About Itself*. New Haven: Yale University Press, 2014.

Renov, Michael. "Newsreel: Old and New—Towards an Historical Profile," *Film Quarterly* 41.1 (1987): 20–33.

Sandweiss, Martha A., Rick Stewart, and Ben W. Huseman. *Eyewitness to War: Prints and Daguerreotypes of the Mexican War, 1846–1848*. Washington, DC: Smithsonian Institution Press, 1989.

Schudson, Micheal. *Discovering the News: A Social History of American Newspapers*. New York: Basic Books, 1978.

Tatham, David. *Winslow Homer and the Pictorial Press*. Syracuse: Syracuse University Press, 2003.

Tausk, Petr. *A Short History of Press Photography*. Prague: International Organization of Journalists, 1988.

Zelizer, Barbie. *About to Die: How News Images Move the Public*. Oxford: Oxford University Press, 2010.

Photojournalism

Batchen, Geoffrey, M. Gidley, Nancy K. Miller, and Jay Prosser, eds., *Picturing Atrocity: Photography in Crisis*. London: Reaktion Books, 2012.

Carlebach, Michael L. *The Origins of Photojournalism in America*. Washington: Smithsonian Institution Press, 1992.

—— *American Photojournalism Comes of Age*. Washington: Smithsonian Institution Press, 1997.

Caujolle, Christopher, and Mary Panzer. *Things as They Are*. New York: Aperture, 2005.

Chapnick, Howard. *Truth Needs No Ally: Inside Photojournalism*. Columbia: University of Missouri Press, 1994.

Evans, Harold, and Edwin Taylor. *Pictures on a Page: Photojournalism and Picture Editing*. Belmont, CA: Wadsworth Publishing Co, 1978.

Fulton, Marianne, and Estelle Jussim. *Eyes of Time: Photojournalism in America*. Boston: Little Brown, 1988.

Gervais, Thierry, Christian Delage, and Vanessa R. Schwartz, eds. "Caught in the Act: Re-Thinking the History of Photojournalism," Special issue of *Études Photographiques* 26 (November 2010).

Gidal, Tim. *Modern Photojournalism: Origin and Evolution, 1910–1933*. New York: Macmillan, 1973.

Gould, Lewis L., and Richard Greffe. *Photojournalist: The Career of Jimmy Hare*. Austin: University of Texas Press, 1977.

Hannigan, William, and Ken Johnston, eds. *Picture Machine: The Rise of American News Pictures*. New York: Harry N. Abrams, 2004.

Hariman, Robert, and John Louis Lucaites. *No Caption Needed: Iconic Photographs, Public Culture, and Liberal Democracy*. Chicago: University of Chicago Press, 2007.

Lavoie, Vincent. *Photojournalismes. Revoir les canons de l'image de presse*. Paris: Hazan, 2010.

Lebeck, Robert, and Bodo von Dewitz. *Kiosk: A History of Photojournalism*. Göttingen: Steidl, 2001.

Lyford, Amy, and Carol Payne, eds. "Photojournalism, Mass Media, and the Politics of Spectacle." Special issue of *Visual Resources* 21.2, (2005).

Rothstein, Arthur. *Photojournalism*. Garden City, NY: Amphoto, 1979.

News pictures and social and cultural history

Apel, Dora. *War Culture and the Contest of Images*. New Brunswick, NJ: Rutgers University Press, 2012.

Berger, Martin A. *Seeing Through Race: A Reinterpretation of Civil Rights Photography*. Berkeley: University of California Press, 2011.

Berger, Maurice. *For All The World To See: Visual Culture and the Struggle for Civil Rights*. New Haven: Yale, 2010.

Bosma, Rixt A., Robert Capa, Joris Ivens, and John Fernhout. *Photography Meets Film: Capa, Ivens and Fernhout in China, 1938*. Amsterdam: Rijksmuseum, 2011.

Brothers, Caroline. *War and Photography: A Cultural History*. London: Routledge, 1997.

Duganne, Erina. *The Self in Black and White: Race and Subjectivity in Postwar American Photography*. Hanover, NH: Dartmouth College Press, 2010.

Enwezor, Okwui, and Rory Bester. *Rise and Fall of Apartheid: Photography and the Bureaucracy of Everyday Life*. New York: ICP, 2013.

Folgarait, Leonard. *Seeing Mexico Photographed: The Work of Horne, Casasola, Modotti, and Alvarez Bravo*. New Haven: Yale, 2008.

Keller, Ulrich. *The Ultimate Spectacle: A Visual History of the Crimean War (Documenting the Image, vol. 7)*. Australia: Gordon and Breach, 2001.

Lee, Anthony W., and Elizabeth Young. *On Alexander Gardner's Photographic Sketch Book of the Civil War*. Berkeley: University of California Press, 2007.

Levi Strauss, David. *Between the Eyes: Essays on Photography and Politics*. New York: Aperture Foundation, 2003.

Linfield, Susie. *The Cruel Radiance: Photography and Political Violence*. Chicago: University of Chicago Press, 2010.

Lubin, David. *Shooting Kennedy: JFK and the Culture of Images*. Berkeley: University of California Press, 2003.

Magilow, Daniel H. *The Photography of Crisis: The Photo Essays of Weimar Germany*. University Park, PA: Penn State University Press, 2012.

Mraz, John. *Looking for Mexico. Modern Visual Culture and National Identity*. Duke: Duke University Press, 2009.

Newbury, Darren, and Albie Sachs. *Defiant Images: Photography and Apartheid South Africa*. Pretoria: Unisa Press, 2009.

Quirke, Carolyn. *Eyes on Labor: News Photography and America's Working Class*. New York: Oxford University Press, 2012.

Roeder, George H. *The Censored War: American Visual Experience During World War Two*. New Haven: Yale University Press, 1993.

Rolleston, James. "After Zero Hour: The Visual Texts of Post-War Germany," *South Atlantic Review* 64.2 (1999): 1–19.

Rosenheim, Jeff. *Photography and the American Civil War*. New York: The Metropolitan Museum, 2013.

Schwartz, Vanessa R. *Spectacular Realities: Early Mass Culture in Fin-de-Siècle Paris*. Berkeley: University of California Press, 1998.

Shneer, David. *Through Soviet Jewish Eyes: Photography, War, and the Holocaust*. New Brunswick: Rutgers University Press, 2010.

Sliwinski, Sharon. *Human Rights in Camera*. Chicago: University of Chicago Press, 2011.

Smith, Terry. *Making the Modern: Industry, Art, and Design in America*. Chicago: University of Chicago Press, 1993.

Tejada, Roberto, *National Camera: Photography and Mexico's Image Environment*. Minneapolis: University of Minnesota Press, 2009.

Tucker, Anne Wilkes, Will Michels, and Natalie Zelt, eds. *War/Photography: Images of Armed Conflict and Its Aftermath*. New Haven: Yale University Press, 2012.

Weisenfeld, Gennifer S. *Imaging Disaster: Tokyo and the Visual Culture of Japan's Great Earthquake of 1923*. Duke: Duke University Press, 2012.

Wexler, Laura. *Tender Violence: Domestic Visions in an Age of U.S. Imperialism* (*Cultural Studies of the United States*). Chapel Hill: University of North Carolina Press, 2000.

Zelizer, Barbie. *Remembering to Forget: Holocaust Memory through the Camera's Eye*. Chicago: University of Chicago Press, 1998.

—— *Visual Culture and the Holocaust*. New Brunswick, NJ: Rutgers University Press, 2001.

Journalism and documentary

Abbott, Brett. *Engaged Observers: Documentary Photography since the Sixties*. Los Angeles: J. Paul Getty Publications, 2010.

Curtis, James. *Mind's Eye, Mind's Truth: FSA Photography Reconsidered*. Philadelphia: Temple University Press, 1989.

Lugon, Olivier. *Le Style documentaire. D'August Sander à Walker Evans, 1920–1945*. Paris: Macula. 2004.

Morris, Errol. *Believing Is Seeing: Observations on the Mysteries of Photography*. New York: Penguin Press, 2011.

Sampsell-Willmann, Kate. *Lewis Hine as Social Critic*. Jackson: University Press of Mississippi, 2009.

Stott, William. *Documentary Expression and Thirties America*. Chicago: University of Chicago Press, 1986.

Tagg, John. *The Disciplinary Frame: Photographic Truths and the Capture of Meaning*. Minneapolis: University of Minnesota Press, 2009.

Yochelson, Bonnie, Jacob A. Riis, and Daniel J. Czitrom. *Rediscovering Jacob Riis: Exposure Journalism and Photography in Turn-of-the-Century New York*. New York: New Press, 2007.

Picture production: Collectivities and systems

Cookman, Claude H. *A Voice is Born: The Founding and Early Years of the National Press Photographers Association*. Durham, NC: National Press Photographers Association, 1985.

Dejardin, Fiona M. "The Photo League: Left-wing Politics and the Popular Press," *History of Photography* 18.2, (Summer 1994): 159–73.

Evans, Catherine, and Mason Klein. *The Radical Camera: New York's Photo League, 1936–1951*. New Haven: Yale, 2011.

Hoelscher, Steven, ed. *Reading Magnum: A Visual Archive of the Modern World*. Austin: University of Texas Press, 2013.

Knightley, Phillip. *The First Casualty: The War Correspondent as Hero and Myth-Maker from the Crimea to Iraq*. Baltimore: Prion Books, 2004.

Loengard, John, ed. *LIFE Photographers. What they Saw*. New York: Little Brown, 1998.

Morris, John. *Get the Picture: A Personal History of Photojournalism*. Chicago: University of Chicago Press, 1998.

Neubauer, Hendrik. *Black Star: 60 Years of Photojournalism*. Köln: Könemann Press, 1998.

Ribalta, Jorge. *The Workers Photography Movement: Essays and Documents*. Madrid: Museo Centro de Arte Reina Sofia, 2011.

Young, Cynthia. *The Mexican Suitcase: The Rediscovered Spanish Civil War Negatives of Capa, Chim and Taro*. Göttingen: Steidl, 2010.

Picture production: Technologies and formats

Alexander, William. "The March of Time and the World Today," *American Quarterly* 29.2 (Summer 1977): 182–93.

Baughman, James L. *The Republic of Mass Culture: Journalism, Filmmaking, and Broadcasting in America since 1941*. Baltimore: Johns Hopkins University Press, 1992.

Beegan, Gerry. *The Mass Image: A Social History of Photomechanical Reproduction in Victorian London*. London: Palgrave Macmillan, 2008.

Benson, Richard. *The Printed Picture*. New York: Museum of Modern Art, 2008.

Cartwright, H.M., and Robert MacKay. *Rotogravure*. Lyndon, KY: MacKay Publishing Company, 1956.

Conway, Mike. *The Origins of Television News in America: The Visualizers of CBS in the 1940s*. New York: Peter Lang, 2009.

Gretton, Tom. "The Pragmatics of Page Design in Nineteenth-Century General-Interest Weekly Illustrated News Magazines in London and Paris," *Art History* 33.4 (2010): 680–709.

Harris, Neil. "Iconography and Intellectual History: The Halftone Effect." In *Cultural Excursions: Marketing Appetites and Cultural Tastes in Modern America*. Chicago: University of Chicago, 1980.

Hauptman, Jodi. "Flash: The Speed Graphic Camera," *Yale Journal of Criticism* 11.1 (1998): 129–37.

Ivins, William Mills. *Prints and Visual Communication*. New York: Da Capo Press, 1969.

Jennings, Michael. "Agriculture, Industry and the Birth of the Photo Essay in the Late Weimar Republic," *October* 93 (Summer 2000): 23–56.

Jussim, Estelle. *Visual Communication and the Graphic Arts: Photographic Technologies in the Nineteenth Century*. New York: R.R. Bowker Co, 1974.

Kainen, Jacob. "The Development of the Halftone Screen." *Annual Report of the Smithsonian Institution 1951*. Washington, DC: Smithsonian, 1952.

Keller, Ulrich. "Early Photojournalism." In David Crowley and Paul Heyer, eds, *Communication in History: Technology, Culture, Society*. New York: Pearson, 2002: 170–8.

McKernan, Luke. *Yesterday's News: The British Cinema Newsreel Reader*. British Universities Film & Video Council, 2002.

Mendelson, Jordana. *Revistas y Guerra 1936–1939/Magazines and War 1936–1939*, exh. cat. Madrid: Museo Nacional Centro de Arte Reina Sofía, 2007.

—— ed. *Magazines, Modernity and War*. Madrid: Museo Nacional Centro de Arte Reina Sofía, 2008.

Ritchin, Fred. *Bending the Frame: Photojournalism, Documentary, and the Citizen*. New York: Aperture, 2013.

Stein, Sally. "The Composite Photographic Image and the Composition of Consumer Ideology," *Art Journal* 41.1 (Spring 1981): 39–45.

Trotti, Michael Ayers. "Murder Made Real: The Visual Revolution of the Halftone," *Virginia Magazine of History and Bibliography* 111.4 (2003): 379–410.

Willumson, Glenn G. *W. Eugene Smith and the Photographic Essay*. Cambridge, UK: Cambridge University Press, 1992.

Zelizer, Barbie. "Journalism's Last Stand: Wirephoto and the Discourse of Resistance," *Journal of Communication* 45 (Spring 1995): 78–92.

Individual periodicals

Augspurger, Michael. A*n Economy of Abundant Beauty: Fortune Magazine and Depression America*. Ithaca: Cornell University Press, 2004.

Brown, Joshua. *Beyond the Lines: Pictorial Reporting, Everyday Life, and the Crisis of Gilded Age America*. Berkeley: University of California Press, 2002.

Curley, John C. "Bad Manners: A 1944 Life Magazine 'Picture of the Week,' " *Visual Resources* 28.3 (2012): 240–62.

Doss, Erika, ed. *Looking at LIFE Magazine*. Washington: Smithsonian Institution Press, 2001.

Frizot, Michel and Cédric de Veigny. *VU: The Story of a Magazine that Made an Era*. London: Thames and Hudson, 2009.

Hall, Stuart. "The Social Eye of Picture Post," *Working Papers in Cultural Studies* 2 (1972): 71–120.

Hill, Jason E. "The Efficacy of Artifice: *PM*, Radiophoto, and the Journalistic Discourse of Photographic Objectivity," *Études Photographiques* 26 (November 2010): 51–85.

Kozol, Wendy. *Life's America: Family and Nation in Postwar Photojournalism*. Philadelphia: Temple University Press, 1994.

Langa, Helen. "'At Least Half the Pages will Consist of Pictures': New Masses and Politicized Visual Art," *American Periodicals* 21.1 (2011): 21–49.

Lutz, Catherine A., and Jane L. Collins. *Reading National Geographic*. Chicago: University of Chicago Press, 1993.

Mather, Phillipe. *Stanley Kubrick at Look Magazine: Authorship and Genre in Photojournalism and Film*. Chicago: Intellect, 2013.

Panzer, Mary. "A Look at *Look*." *Aperture* (Summer 2009): 58–63.

Propp, Richard. *The Holiday Makers: Magazines, Advertising and Mass Tourism in Postwar America*. Baton Rouge: Louisiana State University Press, 2012.

Scanlon, Jennifer. *Inarticulate Longings: The Ladies Home Journal, Gender, and the Promises of Consumer Culture*. New York: Routledge, 1995.

Schreiber, Rachel. *Gender Activism in a Little Magazine: The Modern Figures of the Masses*. Farnham: Ashgate, 2011.

Sinnema, Peter. *Dynamics of the Pictured Page: Representing the Nation in the Illustrated London News*. Aldershot: Ashgate. 1998.

Squiers, Carol. "Looking at *Life*." In Liz Herron and Val Williams, eds, *Illuminations: Women Writing on Photography from the 1850s to the Present*. London: I.B. Taurus, 1996: 140–50.

Stein, Sally. "The Graphic Ordering of Desire: Modernization of a Middle-Class Women's Magazine, 1919–1939." In Richard Bolton, ed. *The Contest of Meaning: Critical Histories of Photography*. Cambridge, MA: MIT Press, 1993: 145–62.

Stomberg, John. "A Genealogy of Orthodox Documentary." In Mark Reinhardt, Holly Edwards, and Erina Duganne, eds. *Beautiful Suffering: Photography and the Traffic in Pain*. Chicago: University of Chicago Press, 2007: 37–56.

Vials, Chris. "The Popular Front in the American Century: Life Magazine, Margaret Bourke-White, and Consumer Realism, 1936–1941," *American Periodicals: A Journal of History, Criticism, and Bibliography* 16:1 (2006): 74–102.

Wolf, Erika . "When Photographs Speak, to Whom Do They Talk? The Origins and Audience of SSSR na stroike (USSR in Construction)," *Left History* 6.2 (2000): 53–82.

Zervigón, Andrés M. "Persuading with the Unseen? *Die Arbeiter Illustrierte Zeitung*, Photography, and German Communism's Iconophobia," *Visual Resources* 26.2 (2010): 147–64.

Zurier, Rebecca. *Art for the Masses: A Radical Magazine and its Graphics, 1911–1917*. Philadelphia: Temple University Press, 1988.

Specialized press

Allan, Stuart, and Barbie Zelizer. *Reporting War: Journalism in Wartime*. London: Routledge, 2004.

Baker, Nicholson, Margaret Brentano, and Joseph Pulitzer. *The World on Sunday: Graphic Art in Joseph Pulitzer's Newspaper (1898–1911)*. New York: Bulfinch Press, 2005.

Cohen, Patricia C, Timothy J. Gilfoyle, and Helen L. Horowitz. *The Flash Press: Sporting Male Weeklies in 1840s New York*. Chicago: University of Chicago Press, 2008.

Gervais, Thierry. "Witness to War: The Uses of Photography in the Illustrated Press, 1855–1904," *Journal of Visual Culture* 9.3 (December 2010): 1–15.

Hannigan, William. *New York Noir: Crime Photos from the Daily News Archive*. New York: Rizzoli, 1999.

Hartley, John, and Ellie Rennie. "'About a Girl': Fashion photography as photojournalism," *Journalism* 5.4 (2004): 458–79.

Higashi, Sumiko. "Melodrama, Realism, and Race: World War II Newsreels and Propaganda Film," *Cinema Journal* 37.3 (1998): 38–61.

Maresca, Peter. *Society is Nix: Gleeful Anarchy of the Dawn of the American Comic Strip*. New York: Sunday Press, 2013.

Marzio, Peter. "Illustrated News in Early American Prints." In *American Printmaking Before 1876: Fact, Fiction, and Fantasy*. Washington, DC: Library of Congress, 1975: 53–60.

Nead, Lynda. "Stilling the Punch: Boxing, Violence, and the Photographic Image," *Journal of Visual Culture* 10.3 (2011): 305–23.

Pelizzon, V. Penelope, and Nancy M. West. *Tabloid, Inc.: Crimes, Newspapers, Narratives*. Columbus: Ohio State University Press, 2010.

Schwartz, Vanessa R. "Wide Angle at the Beach: The Origins of the Paparazzi and the Cannes Film Festival," *Etudes Photographiques* 26 (November 2010): 220–40.

Sekula, Allan. "Paparazzo Notes." In *Photography Against the Grain: Essays and Photo Works, 1973–1983*. Halifax: Nova Scotia College of Art and Design, 1984: 23–31.

Squiers, Carol. "Class Struggle: The Invention of Paparazzi Photography and the Death of Diana, Princess of Wales." In Squiers, ed., *Overexposed: Essays on Contemporary Photography*. New York: The New Press, 1999.

Williams, Raymond. *Television: Technology and Cultural Form*. London: Routledge, 2003.

News pictures and artworks

Brodie, Judith. *Shock of the News*. Washington: National Gallery of Art, 2012.

Broomberg, Adam, and Oliver Chanarin. "Indifferent But Not Unconcerned," *Foto8 Blog*, 5 May 2008. http://www.foto8.com/live/unconcerned-but-not-indifferent/#.UkBttbyxOwk.

Buchloh, Benjamin H.D. "From Faktura to Factography," *October* 30 (Autumn 1984): 82–119.

Burns, Stanley B, and Sara Cleary-Burns. *News Art: Manipulated Photographs from the Burns Archive*. New York: PowerHouse, 2009.

Campany, David. *Walker Evans: The Magazine Work*. Göttingen: Steidl, 2013.

Cramerotti, Alfredo. *Aesthetic Journalism: How to Inform Without Informing*. Chicago: University of Chicago Press, 2009.

Donovan, Molly, *Warhol Headlines*. Washington: National Gallery of Art, 2011.

Eisenman, Stephen. *The Abu Ghraib Effect*. London: Reaktion, 2007.

Fischer, Hartwig, ed. *Covering the Real. Art and the Press Picture, from Warhol to Tillmans*, exh. cat. Cologne: DuMont Literatur und Kunst Verlag, 2005.

Fontcuberta, Joan, and Hubertus von Amelunxen, eds. *Photography: Crisis of History*. Barcelona: Actar, 2002.

Galassi, Peter. *Henri Cartier-Bresson: The Modern Century*. New York: The Museum of Modern Art, 2009.

Kriebel, Sabine. "Manufacturing Discontent: John Heartfield's Mass Medium," *New German Critique* 107, 36(2) (Summer 2009): 53–88.

Lavoie, Vincent. *Maintenant. Images du temps present*. Montreal: ABC Books, 2003.

Lee, Anthony, and Richard Meyer. *Weegee and Naked City*. Berkeley and Los Angeles: University of California Press, 2008.

Lind, Maria, and Hito Steyerl. *Greenroom: Reconsidering the Documentary and Contemporary Art*. Berlin: Sternberg Press, 2008.

Lobel, Michael. *John Sloan: Drawing on Illustration*. New Haven: Yale University Press, 2014.

Morel, Gaëlle. *Le photoreportage d'auteur*. Paris: CNRS Editions, 2006.

Reinhardt, Mark, Holly Edwards, and Erina Duganne, eds. *Beautiful Suffering: Photography and the Traffic in Pain*. Chicago: University of Chicago Press, 2006.

Rugoff, Ralph, Anthony Vidler, and Peter Wollen. *Scene of the Crime*. Cambridge, MA: MIT Press, 1997.

Stallabrass, Julian. "Sebastiao Salgado and Fine Art Photojournalism," *New Left Review* 223 (May-June 1997): 131–162.

—— *Documentary*. London: Whitechapel Gallery, MIT Press, 2013.

—— ed. *Memory of Fire: Images of War and the War of Images*. Brighton: Photoworks, 2013.

Strauss, David Levi. *Bild Gegen Bild = Image counter image*. Koln: Konig, 2012.

Wall, Jeff. "Monochrome and Photojournalism in On Kawara's Today Paintings." In Lynne Cooke, ed., *Robert Lehman Lectures on Contemporary Art*. New York: Dia, 1996: 135–56.

INDEX